Aegean Art and Architecture

Oxford History of Art

Donald Preziosi is Professor of Art History, UCLA where he developed and directs the art history critical theory programme, as well as the UCLA museum studies programme. He has lectured and conducted seminars for many years on the history of art history and museology, and on Aegean and Greek art and architecture in the United States, Europe, and Australia. Among his books are *The Art of Art History: A Critical Anthology* (1998); *Rethinking Art History: Meditations on a Coy Science* (1989); and *Brain of the Earth's Body: Museums and the Fabrication of Modernity* (forthcoming).

Louise A. Hitchcock is a Fulbright Scholar and Research Associate of the Institute of Archaeology, UCLA. She has presented papers on a broad range of topics in Aegean art and architecture, and participated in numerous excavations in Crete, Syria, and California. She has been the recipient of UCLA's prestigious Edward A. Dickson Fellowship and was a Fellow of the American School of Classical Studies in Athens. Her publications include *Minoan Architecture: A Contextual Analysis* (forthcoming); 'A Near Eastern Perspective on Ethnicity in Minoan Crete' (forthcoming); and 'Space the Final Frontier: Chaos, Meaning, and Grammatology in Minoan Archi(text)ure' (1997).

Oxford History of Art

Aegean Art
and Architecture

Donald Preziosi and
Louise A. Hitchcock

OXFORD
UNIVERSITY PRESS

Oxford University Press, Great Clarendon Street, Oxford OX2 6DP

Oxford New York
Athens Auckland Bangkok Bogota Bombay
Buenos Aires Calcutta Cape Town Dar es Salaam
Delhi Florence Hong Kong Istanbul Karachi
Kuala Lumpur Madras Madrid Melbourne
Mexico City Nairobi Paris Singapore
Taipei Tokyo Toronto Warsaw
and associated companies in Berlin Ibadan

Oxford is a trade mark of Oxford University Press

First published 1999 by Oxford University Press

British Library Cataloguing in Publication Data
Data available

Library of Congress Cataloging in Publication Data
Data available

0-19-284208-0 Pbk
0-19-210047-5 Hb

10 9 8 7 6 5 4 3 2 1

Picture Research by Virginia Stroud-Lewis
Designed by Esterson Lackersteen
Printed in Hong Kong
on acid-free paper by
C&C Offset Printing Co., Ltd

To Sinclair Hood

Contents

Acknowledgements

The authors would like to acknowledge the excellent research assistance of UCLA Aegean doctoral students Cynthia Skvorec and Freya Evenson, and to thank Professors Paul Rehak and Erwin Cook for their generous and thoughtful advice on earlier drafts of this book. We alone accept responsibility for any errors in the text.

D. P.
L. A. H.

Introduction

1

There is a land called Crete in the midst of the wine-dark sea, a fair rich land, surrounded by water, and there are many men in it, past counting, and ninety cities. They have not all the same speech; their tongues are mixed. There dwell Achaeans, there great-hearted native Cretans, there Cydonians, and Dorians in three divisions, and noble Pelasgians. Among their cities is the great city Knossos, where Minos reigned when nine years old, he that held converse with great Zeus.

<div align="right">Spoken by Odysseus, Odyssey, Book XIX, 172–9.</div>

The recent discoveries in Crete have added a new horizon to European civilization. A new standpoint has been at the same time obtained for surveying not only the Ancient Classical World of Greece and Rome, but the modern world in which we live. This revelation of the past has thus more than an archaeological interest. It concerns all history and must affect the mental attitude of our own and future generations in many departments of knowledge.

<div align="right">Arthur Evans, from the Preface to Hawes and Hawes,
Crete: the Forerunner of Greece</div>

Our knowledge of the peoples and cultures that the first excavator of the Bronze Age city of Knossos, Sir Arthur Evans, named 'Minoan', is now a century old. Its existence had been suspected since 1878, when the Cretan antiquarian, Minos Kalokairinos, found the remains of large storage jars on the site of Kephala, several miles south of the modern port city of Herakleion. The find sparked an intense competition to identify and uncover the prehistoric city of Knossos that was not resolved for over two decades. In those intervening years, the island was ravaged by a war that finally ended centuries of Turkish occupation. Arthur Evans was able finally to purchase the entire site from its owners in 1899. Excavation began in March 1900; what came to light was beyond what anyone had imagined.

Detail of 1

In a certain sense, the Minoans are as much a twentieth-century academic artefact as they were the inhabitants of a world up to 5,000 years removed in time. While some had suspected the existence of these extraordinary Cretan cities prior to 1900, most had expected that eventually there would come to light the traces of a fortified citadel or two similar to those already known on the Greek mainland.

Yet as Crete began to be excavated more intensively in the early years of the twentieth century, and as the number of ancient sites began to multiply with each season of exploration and discovery, it soon became apparent that Homer's description of Crete as a land rich in 'ninety cities' and 'men past counting' may not have been a great exaggeration. Some sites contained remains that were not only older than those of the prehellenic citadels in Greece (Knossos itself, it turned out, had been settled since early Neolithic times and has proven to be one of the world's oldest continuously inhabited settlements), but they seemed to provide evidence of a society whose art and architecture were in form and style strikingly different. To scholars of the time, such differences would have suggested the presence of distinct ethnic groups.

As the discoveries of prehistoric sites on the mainland seemed to give archaeological flesh to more and more of the 'Heroic Age' portrayed by the Homeric epics and other early Greek texts, so too did the new excavations on Crete seem to give shape and substance to tales of the Minotaur and the Labyrinth; of Theseus and Ariadne; of Minos and Icarus. The subtlety and complexity of Cretan art and architecture seemed to lend material credence to the stories of that great Cretan artist–inventor whom the later Greeks called Daedalus: the designer of mazes, automata, and flying machines; the primordial inventor of writing and of art itself. The old legends, in short, may not have been nostalgic fantasies of a lost golden age spun out of whole cloth, but rather seemed to be dim memories of a very real, rich, and vibrant civilization antedating the world of the Greeks by many centuries. The Minoans, not the Greeks, were now the 'first Europeans'.

But who exactly were these Minoans of Crete? Evans named them after one of the legendary rulers of Knossos, King Minos, who in Greek mythology was one of three brothers born to the father of the gods, Zeus, and a Levantine princess with the (Greek) name of Europa. Their union was said to have been consummated on the shore of the Bay of Matala in south-central Crete (near the Bronze Age port at Kommos), to which Zeus (in the guise of a white bull) had swum with the princess on his back. Minos' two brothers were named Rhadamanthys and Sarpedon, and the later Greeks installed this male trinity as the wise old guardians of their underworld.

For Evans, the term Minoan was, above all, an emblem of this people's difference from the world of the mainland 'Mycenaeans'. What was being unearthed at Knossos, and what had been discovered in 1901

by Italian excavators at Phaistos to the south (and very rapidly thereafter by others elsewhere on the island), were traces of what Aegean scholars had long predicted, and which archaeologists had been looking for: the cosmopolitan source, centre, and origin of the civilization whose (later) margins were sung about by Homer.

There is still a very great deal that we do not know about these peoples. We do not know what names the prehistoric Cretans, Greek mainlanders, or other Aegean islanders may have had for themselves. We cannot be sure that any single name we assign to them—even as a convenient way of referring regionally to the stylistic history and development of their artefacts and cities—properly reflects any historically fixed or singular ethnic or racial identity. We do not know how the population of Crete during its two-millennium-long Bronze Age might have been distinct from their contemporaries in Greece, the Aegean islands, or Anatolia, or whether they were in fact a single people, at one or another period. Homer's much later listing of the 'men past counting' named at least seven different groups living in Crete at the time of the Trojan War, at the end of the Aegean Bronze Age, and it is not unreasonable to suppose that the situation was similar at earlier times in the history of the island.

Outside the Aegean, the area and its people(s) were known in Egypt and the Near East. Men in Minoan (or generically Aegean) costume bearing gifts appear in some Egyptian wall paintings: one among many possible traces of social and/or economic exchange between the regions. The name *Keftiu* found in Egyptian texts, the Akkadian name *Kaptaru*, and the name *Caphtor* found in Hebrew sacred texts have all been understood as referring to Crete, or possibly the Aegean area more generally—what Egyptians also referred to as the 'islands in the midst of the Great Green'. In recent years, the dramatic discovery in the Nile Delta of traces of wall paintings in a Late Minoan style (see Chapter 6) have added new fuel to speculation about the actual historical identities and interconnections of peoples throughout the eastern Mediterranean.[1]

Ethnic—or at least linguistic—heterogeneity in the Aegean and in Crete ('they have not the same speech; their tongues are mixed') may be reflected in the existence of several systems of writing found on the island during the Middle and Late Bronze Ages, although their relative chronologies remain a matter of some dispute. While working at Knossos, Evans had uncovered many examples of several distinct writing systems; in fact, he had long been familiar with the markings, and had speculated early on, prior to his first visit to the island (and, as it turned out, correctly) that they may have had a Cretan origin. These included an earlier hieroglyphic-like script, in what Evans saw as two different versions (A and B), and two syllabic or alphabetic systems. Only one of these—the Linear B script used both

on Crete and the mainland in the Late Bronze Age—has been satisfactorily deciphered as an early form of Greek. The earlier syllabary (Linear A) remains undeciphered and seems not closely related to the language of the Linear B script. It may bear some similarities to languages such as Luvian, known in western Anatolia in later times, whilst incorporating loan-words from other languages or language-families in the eastern Mediterranean, as was a common occurrence throughout the region. Inscriptions in languages such as Cypro-Minoan, and 'Eteocretan'—literally 'true Cretan'—spoken in later Greek times are also known: it (or these) may well represent a survival of one of the Bronze Age tongues spoken on Crete down into the third and second centuries BCE.[2]

The environment

The island of Crete may itself have been an archipelago of related and unrelated peoples, occupying the many distinct regions that from antiquity to early modern times were often more easily accessible to each other by sea than over land. Given the island's size (nearly 200 km long, the fourth largest in the Mediterranean), and the fragmented complexity of its land mass (characterized by intersecting mountain ranges with numerous small valleys and isolated arable upland plateaux), as well as its position forming the long southern boundary of the Aegean Basin, Crete would rather have been more like a third mainland: a whole world in itself, which might have supported many diverse groups living in relative isolation from each other in some periods, or joined in various kinds of alliances (or conflicts) at others.

In short, like Greece to the northwest and Anatolia (present-day Turkey) to the northeast, Crete was a geographically variegated world, a potential homeland and place of refuge for many groups. It is reasonable to expect that from the Neolithic through the Middle Bronze Age, there were many shifts in population, patterns of settlement, and connections and separations of any one group with and from another or others; there appears to be less variation in the Late Bronze Age. Not all of these changes are necessarily reflected or embodied in changes, transformations, or distinctions in the archaeological record—a fundamental problem endemic to all forms of historical, art historical, and archaeological interpretation.

The human built environments of the Aegean are intimately connected to their settings, and cannot be adequately understood or appreciated without them. A glance at the map on p. 5 will suggest that, geographically and ecologically, the Aegean Basin is a very diverse region, made up of scores of islands of habitable size (and a great many more that are not), scattered, for the most part within sight of each other, between the two land masses of Greece and Turkey.

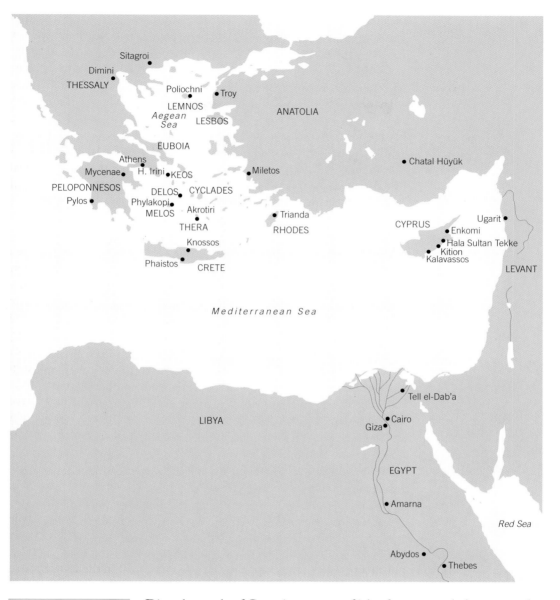

Map 1

The Aegean and
neighbouring areas

Directly north of Crete is a group of islands commonly known as the
Cyclades, so called because they appear to circle the small central
island of Delos, a key religious sanctuary in Hellenic Greek times with
traces of Bronze Age remains. During the Early Bronze Age, as we
shall see, the Cyclades supported artistic practices which were (at least
in some media) partly distinct from those elsewhere.

The Greek and Turkish mainlands have highly complex and jagged
coastlines, made up of hundreds of bays and promontories. In fact, the
islands of the Aegean are the submerged peaks of a large network of
mountains running southeast from the Balkans through Greece and

disappearing down into the sea. The southernmost Aegean island, Crete is as far from Athens to the northwest as it is from the coast of Libya to the south; at various times in its history, Crete has been an economic and cultural intermediary between Greece and the Aegean and the wider region of the eastern Mediterranean.

Climatically, the region is relatively uniform, with little extreme variation from east to west; variations are often more marked vertically, between the coastal areas and valleys of both mainlands and the mountainous uplands. Some mountains maintain snow-covered peaks for half of the year, even as far south as Crete. The northern portions of Greece and the more northerly islands are more densely forested, and are generally cooler in winter than the areas to the south, which remain temperate to warm most of the year. In general, the climate of the Aegean Basin, from Crete in the south to Macedonia and Thrace in the north, shades gradually from a warm Mediterranean zone to a temperate continental one. The great island of Cyprus to the east, another meeting place for various peoples and cultures, shares the climatic conditions of the southern Aegean.

As with the larger Mediterranean islands, Crete, Cyprus, and Rhodes resemble their adjacent mainlands in ecological variety. In some places Crete is quite rugged, and in fact has some of the highest mountain peaks in Greece, forming part of a continuous chain running through the island from west to east. There are unique isolated upland plateaux on east and west, and one of the deepest gorges in Europe is in the southwest. Inaccessible parts of the west of the island have retained the dense evergreen forest cover which some believe covered much of Crete as well as southern Greece in antiquity, but which has been lost to overgrazing and charcoal making before modern times, and to rapid urbanization in the twentieth century.

Crete, Cyprus, and Greece are made up of extremely varied, often rough and rocky terrain, fragmenting habitable and arable land into many small isolated pockets. Only about 20 per cent of the Greek peninsula itself is arable; extensive areas of farmland are more common in the northern and north-central parts of the peninsula, as they are in Anatolia, along the western coast. What usable farming land there is in the Cyclades is contained today in extensive terracing of these essentially rocky limestone islands. In Crete, and apart from some upland plateaux, it is only in the south that there is any very extensive flat land, the Mesara Valley or Plain, some 50 km long, which opens out to the sea on the west.

Traces of human habitation are found in the Aegean as early as Palaeolithic times (before *c*.10,000 BCE) but it is mainly beginning with the Late Neolithic and Early Bronze Ages that settlements occur all over the region, even in isolated and remote valleys and upland areas. Scores of small settlements are found on the mainland and the

islands beginning in the Early Bronze Age, and during that period there is evidence of fairly routine and extensive interconnections between sites in the islands, Greece, and Crete. Some island and mainland sites were strongly fortified and densely built, and continued to be inhabited (although perhaps not with the same populations) for many centuries afterward.

The Bronze Age population of the Aegean was at its greatest during the Late Period, and some cities may have been quite densely populated. At its height, the city of Knossos may have had more than 50,000–75,000 inhabitants, but such estimates remain highly speculative, given our fragmentary knowledge of the site. Knossos has been inhabited since Early Neolithic times, c.6000 BCE.

Discovering the Aegean world

Our contemporary understanding of the art and architecture of Greece, Crete, and the wider world of the Bronze Age Aegean is the complex product of excavation, interpretation, and reconstruction carried out since the late nineteenth century by researchers from many countries. As with any professional field of study, many of the earlier observations and conclusions of Aegean archaeologists and art historians have come to be questioned by later scholars. Many of these changes are reflected in the programmatic and theoretical organization of this book. They have had two equally powerful and partly related causes: new archaeological discoveries and new theoretical and methodological developments.

During the time period conventionally framing what has traditionally been referred to as the birth, growth, maturity, and decline of Aegean civilization (roughly c.3000–c.1100 BCE), archaeological discoveries have expanded our knowledge of the wider world on whose western margins the population of the Aegean lived. The world to the east experienced profound and continuing transformations of a political, social, ethnic, cultural, and technological nature. Powerful and at times aggressively expansive kingdoms and empires emerged and declined, and some peoples seem to have been as much on the move at certain periods as they were sedentary at others.

Continuing work throughout the eastern Mediterranean has helped to clarify (and often dramatically alter our understanding of) the complex and changing relationships of the Aegean world to the wider arena within which Hittites, Egyptians, Assyrians, and other peoples played out their hegemonic internal struggles, expansionist politics, and economic adventures. Important new cities and archives have come to light in the Near East in recent years. Also, more and more traces of what appears to be an Aegean presence in Egypt, Anatolia, and the countries currently occupying the Levantine littoral also come to light yearly. These new discoveries have prompted a

Chronological chart

	EGYPT	CRETE	CYCLADES	MAINLAND GREECE
3000 BCE	**Old Kingdom**	**Prepalatial (EM I–III)** Houses: Vasiliki, Myrtos *Tholoi*: Mesara	**Early Cycladic** 'frying pans' marble idols	**Early Helladic** House of the Tiles, Lerna
2000 BCE	**Middle Kingdom** Twelfth Dynasty (1991–1786 BCE) Imported MM II pottery Hyksos invasion (?)	**Protopalatial (MM I–II)** Old palaces: Knossos, Phaistos, Mallia Kamares ware Destruction of old palaces by earthquake (MM II/III)	**Middle Cycladic** Minoan trade and settlements	**Middle Helladic** Arrival of Greeks (?) Minoan pottery
1700 BCE	**Second Intermediate Period** Hyksos rule Tell el-Dab'a frescoes	**Neopalatial (MM IIIA–B)** New palaces at Knossos and Phaistos begun	Settlement at Akrotiri on Thera	Grave Circle B, Mycenae
1600 BCE	**New Kingdom** Eighteenth Dynasty (1570 BCE)	**Late Minoan (LM IA)** Palace at Knossos rebuilt after earthquake	**Late Cycladic** Height of Minoan influence Houses with paintings Thera volcano erupts	**Late Helladic I** Grave Circle A, Mycenae
1500 BCE	*Keftiu* representations on Theban tombs	**Late Minoan (LM IB)** Marine-style pottery		**Late Helladic II** *Tholos* tombs Vaphio tomb
1450 BCE		Destruction of Minoan sites **Late Minoan (LM II)** Mycenaeans at Knossos (?) Warrior graves Palace style pottery Late frescoes		**Late Helladic IIB**
1400 BCE		**Late Minoan (LM IIIA)** Destruction of palace at Knossos (1375 BCE(?)) Reoccupation of palace	Mycenaeans in control	**Late Helladic IIIA** Mycenaean palaces Expansion of Mycenaen trade to Levant
1300 BCE	Nineteenth Dynasty First raid of Sea Peoples	**Late Minoan (LM IIIB)**		**Late Helladic IIIB** Great age of Mycenaean palaces and frescoes Burning of palaces
1200 BCE	Ramses III (1198–1166 BCE) Defeat of Sea Peoples	**Late Minoan (LM IIIC)**	Mycenaean refugees to islands (?) Cyprus and Levant	**Late Helladic IIIC** Some reoccupation

re-evaluation of older materials and interpretations: this book reflects a number of these new perspectives.

We are beginning to understand some of the ways in which the Aegean archipelago was a component in a larger mosaic of peoples and cultures throughout the eastern Mediterranean. A number of once sharp artistic and cultural distinctions between Minoans, Mycenaeans, and others have come to be blurred. Yet the overall picture remains far from clear, and it seems evident that the Aegean may have been more closely tied to the wider Mediterranean (or at least Near Eastern) world at certain times in the 2,000-year period covered by this book, and more isolated from the outside world at others.

This increase in our knowledge and understanding has both re-flected and contributed to certain important paradigm shifts that have been taking place more widely in the practices of cultural history, archaeology, and anthropology, and in the theories and methodologies of art history and museology, during the last quarter of the twentieth century. Ideas of agency, causality, and influence, as well as fundamental assumptions about the nature of the relationships between cultural phenomena and social, racial, ethnic, gender, national, and individual identities, are undergoing continuous rethinking.

Both the purview and functions of interpretative practice in fields such as archaeology and art history are being transformed in ways that could not have been anticipated, or easily predicted, a gener-ation ago. In both disciplines, more sustained attention has come to be paid to a wider range of materials and contexts in the enterprise of historical reconstruction, and there has come about a greater explicit attention to the tacit theoretical assumptions underlying modern disciplinary practice.

Some of the more significant changes to have occurred in the ap-proach to understanding the past have had to do with the reassessment of theories of the nature and constitution of national or ethnic identit-ies, in particular in their relationships to forms of social and cultural life. The racial ideologies of a century ago could, with little effective opposition, support Arthur Evans and others who crafted a richly detailed picture of a singularly brilliant, artistically unique, techno-logically advanced, and racially or ethnically distinct people ruling Crete and the Aegean, as different from their contemporary peers in Egypt and the Near East as they were from their warlike mainland Mycenaean 'inferiors'.

Such perspectives regarding the nature of the relationships between a people and the styles of its art and culture were grounded in very par-ticular hypotheses, of which the most prominent was the notion that artistic style was a direct reflection and reliable trace of the unique, singular, and inimitable inner spirit, essence, or soul of a people. This belief was widely adhered to during the era of the nineteenth-century

formation of modern nation states, and was supportive of burgeoning national and colonial heritage industries, encompassing a wide range of practices from artistic connoisseurship to tourism to museology. Much of it remains tenacious in the contemporary popular imagination, in both developed and developing countries.

A good deal of nineteenth-century academic practice of a historical and interpretative nature was by and large sympathetic to the needs of European (and other) nationalisms, reflecting and supporting the growth of ethnic, regional, and national heritage industries. Distinctiveness or uniqueness of ethnic or national identity was linked in pragmatic ways to the technologies of social discipline and colonial administration, including the management of diverse ethnic populations, both at home and abroad. Distinctions in race, ethnicity, or national character could be supposed to be proven or demonstrated by materially definable differences in artistic style and cultural expression.

The modern practices of archaeology, art history, anthropology, and museology, in short, developed within the context of the rise of modern nation states and their imperial extensions, and have contributed concretely to their social and educational needs. During the latter half of the twentieth century, their academic progeny have retained many of their older social functions while beginning to evolve beyond the more explicit racisms and ethnocentrisms of their nineteenth-century models.

At present, in the humanities and social sciences, many such foundational assumptions are being actively rethought and reassessed. The claim that for each particular people (self-distinguishable on the grounds of specific styles of art, religion, language, culture, or forms of governance) there should exist a materially distinct homeland was always historically problematic and not entirely uncontested; nevertheless, its general principles came to provide the implicit subtext of modern historical scholarship.

The generation of scholars who discovered and disseminated knowledge about the Bronze Age cities of Crete, Greece, and the Aegean islands generally presumed that there were direct and reflective connections between biology and culture: between race or ethnicity, social structure, ethical advancement or decline, and artistic and cultural 'expression'. Indeed, the very possibility of systematically or scientifically reading archaeological material as historical data was firmly tied to such a belief: the presence of a distinctive artefact style could be assumed with confidence to be a palpable index of a particular society, ethnicity, or race. Formal changes in style could be read (by the properly trained eye) as indices of other changes in society: gradual transformations might be linked, plausibly, to the internal dynamics of unfolding aesthetic principles or production technologies, whilst abrupt changes might signal changes in population through migration, replacement, or conquest.

In the nineteenth and early twentieth centuries, changes in artistic style and material culture were closely linked to current ideas about biological evolution, technological progress, and the rise and decline of peoples, races, and nations. Such notions were themselves implicit in the very concepts and practices of the modern discipline of Art History, as advanced in the late eighteenth and early nineteenth centuries by Winckelmann, Kant, and Hegel.[3]

The intellectual environment in which Arthur Evans (1851–1941) [1] grew up was strongly shaped by the scholarly interests and pursuits of his eminent father, John Evans, in archaeology, numismatics, and geology, as well as by his family's friendships with Charles Darwin (1809–82) and Augustus Henry Lane Fox (1827–1900). The latter (who in later years took the name of Pitt Rivers) developed widely influential, systematically formulated ideas about the cognitive evolution of peoples as demonstrated by the historical development of their artefacts.[4]

By the time that Evans had begun to excavate Knossos, he was Keeper of the Ashmolean Museum in Oxford. In the mid-1890s, when he was supervising the reorganization and transfer of the museum collection from the old Ashmolean building in Broad Street (now the Museum of the History of Science) to its present location in Beaumont Street, the new Pitt Rivers Museum was being constructed as an annexe to the Oxford University Museum in South Parks Road. It was designed to exemplify in minute and encyclopedic detail its founder's ideas about typology, universal human cultural evolution, and their relationships to ethnic (and ethical) advancement or decline.[5]

The discoveries in Crete that began a century ago—and even more so than those at Mycenae and Troy a generation earlier—were nothing less than stunning, and rapidly had a profound effect upon the modern popular understanding of early European antiquity. All of these discoveries powerfully shaped modern European images of its own origins and heritage. Suddenly, European civilization was not only as ancient as that of Egypt, but also in its own way distinct and original in form and spirit. But this new Minoan civilization could not be fixed in place as a provincial reflection of any of the societies of the Near East, nor could it be easily attached to its successors in Greece or elsewhere (except perhaps as their superior and exemplar). It was, in fact, an enigma. For Evans and others at the time, it appeared to provide a whole 'new horizon to European civilization', and 'a new standpoint' not only on antiquity, but on the modern world, thereby 'concerning all history'.

Starting in the 1870s, archaeologists working at Mycenae, Tiryns, Troy, and elsewhere in the Aegean had begun to uncover a world whose material traces seemed to make visually palpable the textual world of the Homeric heroes. These fortified citadels were likely to have been the real homes and graves of the legendary Ajax, Atreus, and

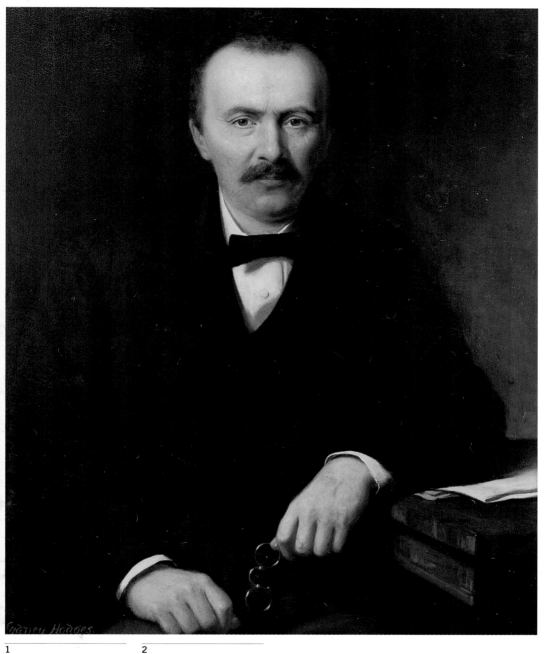

1
Portrait of Sir Arthur Evans
(1851–1941) surrounded
by Minoan artefacts. Evans,
keeper of the Ashmolean
Museum in Oxford, began
the first excavations of the
Bronze Age city and Palace
of Knossos in 1900.

2
Sydney Hodges
*Portrait of Heinrich
Schliemann*, 1877.
Schliemann is best known
for his excavations at Troy
and Mycenae.

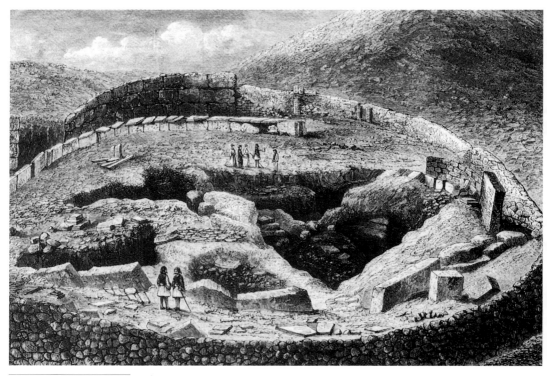

Panoramic view of
Schliemann's excavation
in the Acropolis of Mycenae.
In the foreground is Grave
Circle A, within which can
be seen four of the *stelai*
(tombstones) found scattered
in the citadel's cemetery.

Agamemnon; of Clytemnestra and of Helen of Troy. Engravings and photographs of these ruins began to illustrate European and American school textbooks of Homer and the Greek playwrights, and of ancient grammar and history, during the final two decades of the nineteenth century, and have become a permanent part of the iconography of that educational genre ever since.

During the last two decades of the nineteenth century, scholars such as Heinrich Schliemann [2] (1822–90) had been attracted to Crete, being convinced by the increasing dissemination of prehistoric pottery, gems, and other small artefacts on the Greek and European markets that an important Mycenaean-era site remained to be discovered. The most likely site was agreed to be that of the ancient city of Knossos, whose later Greek and Roman ruins had been known for some time, and which was known in Homeric times as 'the great city . . . where Minos reigned', in Odysseus' words [3].

But what Evans began uncovering in 1900 at Knossos (the rights to whose excavation he acquired in intensive competition with German and French archaeologists) was a world not only older, but to all appearances greatly superior in art, architecture, and technology to that of mainland Greece. To Evans' generation, this Minoan world was a unique, artistically brilliant, and technologically advanced cosmopolitan culture, with its own very distinctive art and architecture and its own systems of writing, on a par with its contemporaries in Egypt and

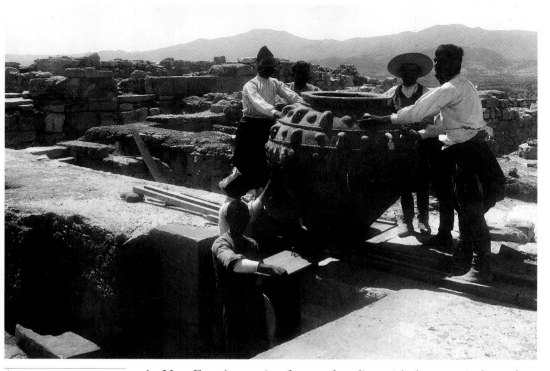

Workmen with a *pithos* (storage jar) from the Minoan Palace at Phaistos. The photograph was taken at the time of the early excavations at Phaistos, begun in 1900 by Federigo Halbherr (d. 1930) and Luigi Pernier (1874–1937) several weeks after the close of Evans' first season at Knossos.

the Near East, borrowing from and trading with them, yet independent and unattached, unaffected by their political and military upheavals, and their periodic imperialisms. Some in fact saw in Crete a world of refuge from the latter: a kind of Bronze Age melting pot of refugees.

Virtually overnight, the discoveries in Crete cast into a dour and provincial shadow the world of what the previous scholarly generation had come to call the 'Mycenaean' mainland citadels, with their warrior chieftains, their burial hoards of golden plunder, and their (to Minoanist or Hellenocentric eyes) rather amateurish painting and clumsy folk sculpture. The aesthetic contrasts between the art works of Crete and mainland Greece were so striking in the eyes of the first generation of Minoan archaeologists as to suggest the presence either of two quite distinct peoples or races, or of two related peoples distinguished by occupying opposite ends of a spectrum running from the urbane and civilized to the rustic, militaristic, and primitive.

So much would have been consistent with archaeological and ethnographic attitudes at the time, and thus it had seemed to Evans and his team, who rapidly uncovered at Knossos much of what they had come to refer to as the 'Palace of Minos' within several excavation seasons. Their impressions seemed to be echoed by the finds at Phaistos [4] and nearby Haghia Triadha by the Italian scholar Federigo Halbherr, and by Greek, French, and American archaeologists working elsewhere. In the east of the island, at Gournia, the American

archaeologist Harriet Boyd Hawes [5] had excavated an entire small town, and British excavators were working at larger eastern settlements such as Palaikastro and Kato Zakro. Within a few short years, and by the end of the first decade of the twentieth century, a number of widely circulated and influential comprehensive overviews of the Minoan or Aegean civilizations had been published. Evans published his own encyclopedic overview of the entire Minoan civilization in four thick volumes, *The Palace of Minos at Knossos*, from the early 1920s to the late 1930s.[6]

Minoan art seemed to delight in the naturalistic rendering of the richness and variety of nature, and seemed to portray a rich and peaceful world with women in colourful costumes dancing bare-bosomed under trees in public squares, and slim young kilted men exercising their skills in acrobatic bull leaping. The world being read in Minoan paintings and ceramics by early archaeologists (and even some art historians) was one of humans in harmony with a natural world of cats, monkeys, and pheasants cavorting in lush landscapes of flowers by flowing streams, and of dolphins, sea urchins, fish, and octopuses swimming through well-rendered undersea worlds. In the art of Crete, there were few if any scenes of strife, and no obvious traces of fortification walls ringing Minoan cities—a situation which seemed to differ sharply from most other cities of the eastern Mediterranean and

5

Photograph of American archaeologist Harriet Boyd Hawes (1871–1945) sorting sherds at Herakleion, 1902. Hawes was best known for her work in eastern Crete, particularly her excavation of the Minoan town of Gournia.

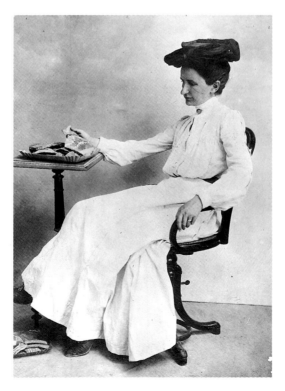

Near East of the time. Of weapons there seemed to be few remaining, either in the ruins of buildings or in graves, at least until later times.

By contrast, Mycenaean visual art seemed to delight mainly in scenes of war and carnage; in silhouetted figures in chariots perpetually leaving home to smite enemies, like some small-scale provincial pharaohs; and in (mostly) men crudely drawn and living out their adventures not in lush natural landscapes but rather in a voided world of blank and neutral terrain peopled by their own militant egos. In art historical terms, Mycenaean art could readily attach itself to the early Hellenic arts of the monochrome Greek 'Dark Ages', of the Protogeometric and Geometric Periods, with their silhouetted pottery scenes of war, burial, and lamentation.

Minoan art seemed to portray a vastly different social world quite detached from all this: an Eden-like land of its own without art historical ancestors or cousins, and with only lesser and diminished progeny. Early scholars saw Crete as the garden homeland of the First Europe—itself named, after all, for the Princess Europa on whom the god Zeus fathered the first Cretan 'king', Minos. Evans was convinced he had discovered 'the first throne of Europe' in the stone seat in a suite of rooms off the northwest corner of the central court of his Knossian 'palace' [6].

6
The so-called 'Throne Room' of the Minoan palace at Knossos, in the course of its excavation, in Evans' first season on the site, 1900.

These caricatures were enshrined for most of the twentieth century in the canonical and formulaic presentations of several generations of art history survey books. Here the Minoans and Mycenaeans routinely made a brief cameo appearance before the survey began its mainline European academic railway journey and evolutionary chronology northwestward from Greece and Rome through the Middle Ages and Renaissance to the world of (Euro-American) Modern Art. Students might readily learn how to distinguish the artistic styles (and thus the peoples) labelled Minoan and Mycenaean by what was once called the instant octopus test—a Minoan octopus would always spread itself sinuously around the surface of a pot, delighting in its curves and volumes, whilst a Mycenaean one always stood upright, jagged, or mute, as if having just been stunned by a powerful electric shock (compare **61a** and **61b**).

And the Minoans (or Mycenaeans) could always serve as foils to the crisp and lucid 'classicism' of later Athenian architecture and sculpture, depending upon the tastes of the textbook writer. As one of them put it in the 1950s, 'the Minoans . . . may have been lovers of the picturesque at all costs; in fact their architecture resembles their other arts in showing no sense of form'.[7]

When artefacts that to modern archaeological eyes appeared to be of palpably superior artistic skill were unearthed on the mainland or elsewhere, their stylistic affinities with objects of Cretan manufacture were commonly foregrounded, and hypotheses were routinely put forward (at least by Minoanists) regarding the importation (or piracy) of luxury goods from Crete. Some writers would speak of the residency at Mycenae or Tiryns of Minoan artists or craftsmen working for mainland military overlords and their courts: a diaspora of rich Minoan artistic and technological talent before and after the collapse of the Cretan 'palace' economies in the Late Bronze Age.[8]

Another facet of the Minoans-versus-Mycenaeans popular and scholarly competition, particularly during the last quarter of the twentieth century, was the highlighting of apparently sharp distinctions between Crete and mainland Greece in the visual depictions of men and women. In Cretan art, and in contrast to the visual arts of the Mycenaean world (as well as to the art of contemporary Egypt and the Near East), women appeared to play a rather prominent role in what came to be read as representations of social life. At least there appeared to be no strongly marked inequality in what were taken to be more or less literal depictions of men and women. The art of the Mycenaeans, and thus by presumption their social world, seemed very much that of a rigidly patriarchal society, deeply invested in all the trappings of military machismo, with virtually no images of women apart from 'goddess' figurines and what appeared to be 'divine' females on rings, pots, and seals.

The Mycenaean Greek world—even before the decipherment of the Linear B tablets found on Crete and the mainland as an early form of Greek—was plausibly linked to the well-documented patriarchal and misogynistic society of the later Hellenic Greek period. The world of Minoan Crete seemed to some observers to have been either more strongly egalitarian, or possibly even matriarchal or matrilocal in organization. In Minoan art, and even more obviously after the discovery and excavation of the site of Akrotiri on the island of Thera with its remarkable wall paintings, women and girls seem to be everywhere, in both 'mortal' and 'divine' roles, and in positions of social prominence or at least high public visibility. In some miniature frescoes from Knossos (see **47**), women are depicted larger and more individuated in the foreground of public festivals, against backgrounds made up of masses of undifferentiated males.

Such interpretative tendencies had very obvious links to, and both reflected and appeared to validate, certain polemical positions in various ongoing debates on gender and sexuality in recent times, once again reminding us that our picture of the Bronze Age Aegean is in no small measure a twentieth-century artefact, tailored to, and understandable within the frameworks of, the social needs, attitudes, and functions of modern social–historical interpretation. All historical reconstructions function in the present to construct and define our own world as a product of one or another desirable (or undesirable) legacy.

Images of Minoan women and of signs and symbols associated with Minoan Crete have recently played roles in contemporary feminist, gay, and lesbian symbologies, ideologies and historiographies. To some in the late twentieth century, Minoan Crete came to be seen as the realm of a Mother Goddess driven underground or silenced by phallocratic (or male homosocial) Hellenes, a process imagined to have begun with the rise of the Mycenaean Greeks. Such scenarios seemed consonant with our archaeological and historical knowledge of early Hellenic sanctuaries, where in some cases (for example at Delphi or Olympia) an earlier focus upon a female divinity (Hera or Gaia) came to be eclipsed, submerged, or marginalized by the cults and monumental temples devoted to certain male gods (Zeus, Apollo).[9]

It may well be the case that the relative position of genders in Minoan society (or societies) was anomalous with respect to the more markedly patriarchal practices of mainland Greece and the Near East. And the social mores intuited from readings of Minoan paintings did seem to suggest a world that may have been different from what can be inferred from reading the misogynistically strict code of behaviour inscribed on a wall in the Cretan city of Gortyna in the fifth century BCE but presumably reflecting an earlier tradition, one taken by some to represent the social attitudes of a Dorian immigrant or ruling class on the island.[10]

But once again, as at any time and place, what in modern times might be routinely read as visual representations do not in these contexts necessarily re-present any actual social roles, relationships, or desires, whether dominant or marginal. There are, for example, a number of features of Aegean painting which appear at times to modify or run counter to certain widely shared Bronze Age conventions of coloration and dress in the depiction of men and women. In some paintings, what appear to be men or women are depicted either with the coloration or (to our eyes) the commonly expected clothing of another gender.

How we are to interpret such depictions (if indeed the term depiction is itself applicable) is by no means obvious or clear, and the textual and archaeological evidence for social life and behaviour is not only extremely fragmentary in this as well as in other realms of Aegean life, but what little remains of these peoples living three to five millennia ago is more often than not very ambiguous indeed. Even more fundamentally, the nature of representation and depiction, not to speak of the social and perceptual functions and roles of image making and viewing, are unlikely to be similar to those of post-Renaissance Europe.

Indeed, even over the past five centuries in Europe alone, there have been profound shifts in forms of socially dominant modes of visual perception, and in the conventional ways of seeing and construing images—all of which may alert us to the problems of projecting our own ideas onto what we take to be depictions or representations in Minoan or Aegean art. These problems will be addressed in more concrete detail in connection with the description and interpretation of Aegean artefacts in each of the subsequent chapters. For the moment, suffice it to say that the nature of gender relations and of many other facets of social life in the prehellenic Aegean is unclear at many times during its long history; this and related subjects of social structure and governance are dealt with below in Chapter 4.

At any rate, the kinds of questions being raised here intersect with our own ideas and predispositions regarding the nature of the relationships between culture, behaviour, and individual and collective identity. It is to these more fundamental problems that we will now turn, as a necessary preamble to a historical introduction to the arts and architectures of the Aegean world.

Art and art history

We have so far been speaking of Aegean (or Minoan and Mycenaean) 'art' and 'architecture'. In point of fact, such terms are distinctly modern ones. They exist and are meaningful to us because of the ways in which they function in the systems of concepts and categories—the cognitive instruments—that we customarily use to fabricate and maintain our own social worlds. Not only do these words evoke particular ranges of reference, but they also carry with them multiple zones of

connotation which vary, often dramatically, over time and space. Such complexities multiply even further if we look at variations in the range of connotations of the term 'art' in the various modern European languages, not to speak of distinctions in usage according to age, nationality, ethnicity, class, occupation, and so on.[11]

Moreover, to extend this range of variation and distinction across three or four thousand years (let alone a couple of hundred) raises some questions as to the pertinence or usefulness of these terms in the first place. This observation is especially true if the terms are employed as universal or even general categories, beyond their intended modern functions originating in the European Enlightenment and in eighteenth-century aesthetic and moral philosophy. An obvious prerequisite to any historical study such as that represented by this book would be a clarification of what is at stake in such an endeavour. If Aegean 'art' is a misnomer, then this would mean more than simply the likelihood that the Minoans, Mycenaeans, or Aegean peoples in general may not have 'had a word' for what we designate today by this term.

Neither the Greeks nor the Romans, in fact, did have a word corresponding exactly to the term art, in the modern sense of fine art, as a kind of product or practice rather than as a property of a wide variety of things and activities. In Hellenic Greek times, the term we commonly take to be roughly comparable, *tekhne*—the root of the modern term technology—had a much wider range of reference than our word art, and might be used as much in connection with pottery making and painting, as in referring to the skilful and organized manner in which an olive orchard (or city) might be planned and laid out. The Latin word *ars*, which is the formal origin of the modern English word, and the word for art in the modern languages derived from Latin, appears to have had a range of reference as broad as the Greek *tekhne*. There seems to have been nothing exactly comparable in Greek or Roman antiquity to our notion of art, in the common sense of the modern fine art commodity we are familiar with.[12]

What is important about all of this is that it should cause us to reflect upon the invention, diffusion, and functions of the modern concept of art in connection with its projection not only upon the material culture of societies outside the European orbit, but also upon the artefactual worlds of other times and places within Europe itself. It is important to recall the roles and functions that art and art history have had over the past two centuries in defining and constructing our own present, our own modernities. These and related issues are explored in a companion volume in this series;[13] the following outlines a number of the key questions which need to be examined in connection with issues pertaining to the enterprises of historical and archaeological reconstruction. As we shall see, these problems are central to a fundamental understanding of our modern professional enterprises.

In the first place, the modern use of the term art is directly and intimately tied to a concept of artistic historicity—the idea that art as such might actually have an internal or formal history of its own, which might be reconstructed and outlined both from the beginning of human times to the present, and universally, so to speak, within the framework of all societies and cultures. The possible existence of such a universal history of art, indeed, the very hypothesis that what is meant in modern times by art is something that every society has, follows as a corollary of the postulated belief that the formal features or characteristics of the arts, or in general of any aspect of the material culture of a people or group, are distinctively representative of that people.

Such a belief is tied to a parallel postulate, namely that at some level of organization common to the entire ensemble of art works of a time or place there may be found certain common traits or principles of organization or manufacture; in short, a common 'style'. The history of art came to be constituted as parallel to, and as a visual surrogate for, the historical development and evolutionary progress of societies and of their ideas, beliefs, values, and interests.

Such notions may represent a projection from empirical observations and general hypotheses about stylistic or formal consistency in the corpus of work of a single artist or craftsperson over his or her career, and they are tied closely to traditional Western notions of authorship and individuated subjectivity, particularly as articulated in Renaissance humanism. European professional interest in these issues dates from the fifteenth and sixteenth centuries and the birth of modern connoisseurship—itself closely tied to the growing need of wealthy collectors to authenticate the antiquity of Roman, Etruscan, and Greek objects beginning to circulate (along with countless forgeries) in European market places as prized possessions signifying elite social status, education, and aspirations.[14]

With the eighteenth-century development of aesthetic philosophy, and, building upon it, the nineteenth-century development of the academic discipline of art history, significant similarities were seen to exist between the consistent features or stylistic tendencies in the work of an individual and those of a related group or society (or by extension an ethnic group or race). The aims, functions, methods, and structure of the discipline of art history, in other words, cannot be understood apart from its role as one facet of the massive nineteenth-century historicization of individual and collective lives: the increasingly thoroughgoing and systematic linkage of experience to shared narratives of national growth, evolution, and progress. In this regard, the academic profession of art history shared with earlier traditions of interpretation certain assumptions which some trace back to the aims and practices of the exegesis or explanation of religious texts.[15]

Well into the twentieth century, modern art history, connoisseurship, art criticism, and museology were very closely tied to explicit notions about national, ethnic, and ethical character, evidence for which was presumed to be made plain by the informed, systematic reading of cultural artefacts. As ethnic or national groups, Venetians might thus be clearly contrasted with Florentines, the Dutch with the French, the Germans with the Italians, the Chinese with the Japanese or Koreans, or the Greeks with the Etruscans and Romans, on the basis of demonstrable distinctions in painting, poetry, and architecture. Characteristics of whole geographical regions might be plausibly related to consistencies in artistic style claimed to persist across centuries or even millennia.

It is here that we may appreciate the potentially very great value of professional disciplines such as art history, archaeology, and ethnology to the evolving nation states of Europe and elsewhere over the past two centuries, in appearing to offer palpable and empirically verifiable 'evidence' for the persistence and fixity of national, ethnic, or racial character. In the movement to forge and instill a common and consistent national civic character for the citizens of newly emerging or recently democratizing states in Europe and elsewhere, the key component was the construction of common legacies: a heritage that could be ideally imagined and shared by a populace which might still be divided along class, linguistic, ethnic, or religious lines, but which might find its place in narrative histories and museum and tourist itineraries.

The roles of 'art' and of 'art history' in this vast enterprise of fabricating the modern nation state (and of transforming the populations of emergent states into citizens) should be evident in that they provided a concrete means for literally envisioning a shared heritage; for staging historical narratives on both grand and local scales; and for outlining the historical evolution of a people or nation, a city or region, or a particular tradition in ideas, values, or manufacture. Not a few traditions which came to be taken as extending back into the mists of time were nineteenth-century fabrications.[16]

If an artefact could be presumed, consistently and reliably, to reflect or in some way embody individual and collective attitudes, values, or desires, then, as a historical document and as a relic of specific times, places, or peoples, it might be put together with stylistically related others as components or building-blocks in the construction of an image of national character, or as an event in the ongoing evolutionary adventure of a people or nation. Each artefact might be staged as an episode in the unfolding story of a people's progress, or as a solution to a linked series of aesthetic or technological problems, in a chain of events and inventions whose product or outcome was our own present, our modernity. At the same time, the artefact or art work might be staged as an object of some desire, as a window opening on to some

moment or period in the life of an individual or nation, or as an occasion for meditation or contemplation.

As the notion of art came to be an instrument for the study of all peoples, so too did its institutionalized discourse, art history, come to serve as a pragmatic modern concordance of ethics, aesthetics, ethnology, and social and political history. In any case, what was essential in the fabrication of such cultural 'histories' was the delineation of causal relationships which might be seen to exist between the (quite literally) millions of artefacts from all over the world being collected together in Europe since the sixteenth century, and amassed in both public and private spaces, and multiplied in countless reproductions and illustrations increasingly circulated around the world.

This construction of cultural histories entailed a massive labour of classification on the part of generations of art historians, archaeologists, and anthropologists in the nineteenth and twentieth centuries aimed at fixing in place the exact interrelations of all this artefactual material, to permit the writing of narrative scenarios of affiliation, influence, and stylistic descent. The relationship of these objects (and by extension of the peoples they represented) to the shape and condition of modernity (that is, the European present) was what was centrally at stake in these developments.

In this modern enterprise of rendering visual objects legible or meaningful, the past was coming to be staged as a preamble and prologue to the present, and thus as an object of genealogical desire: that from which the properly socialized modern citizen might learn to desire his or her descent. To leave Europe was, quite simply and literally, to enter the past—a past represented by peoples at various (earlier) stages of social and cultural evolution.

The history of this movement in public education began in earnest in the early nineteenth century in every European country; by the end of the century, it had spread to many parts of the world connected to Europe politically and economically. It entailed many disparate forms of increasingly systematized modes of observation, analysis, interpretation, display, explanation, and instruction. The academic disciplines of art history, archaeology, history, and anthropology were explicitly designed to function within such a social environment, and both to service and define its needs.

Objectives of this book

The reconstructed worlds of Mycenaean Greece, Minoan Crete, and the Bronze Age Aegean Basin were initially staged within the analytic and interpretative frameworks just outlined. A century later, while a good deal of the stage machinery has been dismantled or put into shadow or storage, the stage itself remains largely intact (if somewhat extended), although (as we shall see) new forms of theatre have begun

to evolve. This book is one such restaging or retelling. It is organized in the following manner.

Programmatically, this book has two principal objectives.

In the first place, *Aegean Art and Architecture* is written with the understanding that the visual and material cultures of a society—including what in modern terms might be referred to as its 'art' and 'architecture'—constitute forms of individual and social technologies or instruments for the active construction, maintenance, and transformation of individual and social realities. The visual or material culture of the Bronze Age Aegean—and here a useful generic term might be simply the built environment—will be understood as encompassing the broad range of objects and artefacts of all kinds as well as their changing spatial and temporal interrelationships: pots, paintings, gemstones, buildings, furniture, graves; artefacts both portable and fixed in space and place.

Our aim is to avoid framing this artefactual world as simply the passive reflection, trace, or residue of ideas, attitudes, or mentalities presumed to somehow pre-exist their material expression. Rather, this book attempts to articulate the built environments of the prehistoric Aegean region as simultaneously constitutive and reflective—as much instruments that function to fabricate and maintain social realities as themselves products of such ongoing and dynamically changing realities. At any given place and time there will most likely coexist both older and newer, locally produced and imported, artefacts, styles, and practices—a situation which in no small measure problematizes the construction of social–historical chronologies based on the sequencing of single genres or styles.

One motivation for such a perspective concerns the relationships envisioned between the reader and interpreter in the present—both the authors of this volume as well as its readers—and our objects of study. We position ourselves in a sense midway between two antithetical modern or modernist perspectives on the 'reading' of objects from the past.

On the one hand is a position which holds that the meanings of an object are fixed in place forever as the imprint of the 'intentions' of their makers—rather like the geomagnetic properties of a pot fired at a particular time and place, which are perpetually retained. Here, the task of the modern interpreter, art historian, or archaeologist is to read, deduce, or extract such intentions (its original 'built-in properties') from the particular object itself. Such deductions might then be taken to constitute a reconstruction of those original meanings and intentions. Often this perspective is extended to incorporate contemporary 'contextual' meanings or functions of an object—the object thus constituting a 'text' and its circumstances of production and reception, with usage making up its complementary or supplementary milieu or 'con-text'.

In either case, this position privileges the object (and/or its context) as the only legitimate source of the object's meaning, and it situates the reader or interpreter, whether art historian or archaeologist, as one whose task is to articulate and give voice, as far as possible, to that (often hidden or deeply embedded) meaning. Such a perspective relies for its plausibility upon an underlying, and frequently unvoiced (and distinctively modern), model or metaphor of communication, wherein the archaeological object is construed as a 'medium' of communication or expression of ideas or values on the part of its maker (or, by extension, of the maker's society at large), which the user or viewer is challenged to decipher or decode by attending closely to the object. (The perspective also validates the professional role and social function of the trained analyst, art historian, connoisseur, or collector, who then serves a wider audience as sanctioned interpreter.)

The nature of this analytic perspective may be brought into sharper focus by considering its opposite—the notion that the meaning of an object is entirely or largely in the eyes and imagination of its beholders or users. Once again, as with the first perspective, this position has a certain degree of plausibility, given the range of meanings, connotations, functions, or uses that any artefact might be subject to by those who use them. Precisely because of the (relative) object-permanence of artefacts or art works, they remain to be used and reused, and thought about in potentially new and possibly quite unforseen or unintended ways over time—unlike a spoken utterance, which materially disappears unless it is recorded.

The position taken by this book constitutes in one sense an alternative to this epistemological opposition which holds that the meaning or significance of an artefact must be either entirely embodied in (and reconstructable primarily from) the object itself, or primarily in the perception of the object's users or viewers. By granting a degree of plausibility to both interpretative perspectives, we acknowledge the existence of an artefact's original intentions and functions, while holding that these intended meanings may not be fully reconstructable from the object itself or from any seemingly complete reconstruction of its material contexts. It also allows for the possibility of multiple or even conflicting intentions and meanings for a given object, even in its original historical situations, and for the coexistence, at the same time and place, of conflicting or alternative styles and attitudes.

At the same time, we acknowledge the historical situation that the uses and understandings of an artefact are subject to change and transformation over time, and that the object's significance is a complex function of the interactions between it and its (potentially very varied) users, including ourselves, rather than constituting any one permanently fixed meaning, transcending every environment and situation in which the object is encountered, as was once canonically assumed to be the

case in the majority of twentieth-century art history survey textbooks, or in mass-market art books, or in the protocols of modern art criticism.

In short, our aim is to open up the field and range of meanings of the Aegean built world so as to appreciate the dynamic and changing nature of the meanings and functions of artefacts in their original historical environments, as well as in the object's relationship to ourselves and the ways in which (for example) Minoan artefacts function for us in the modern world as instruments for the construction of historical narratives about origins, evolution, and European cultural heritage.

Underlying all perspectives on 'how things mean' will always be found sets of specific metaphors, or ideological and epistemological positions, on 'where' the meaning or significance of an object is imagined to lie relative to the form of the object, the mentalities of its maker(s) or of the maker's society at large at a given time or place, and the stance and attitudes of the viewer or user contemporary with the object or subsequently, after a generation or (as here in this book) after 3,000 to 5,000 years. The notion that meaning is the content of a form, with a concrete locus is, once again, a particularly modern perspective, and a consequence of a very specific (and very specifically modern) system of visual metaphors. Once again, a sensitivity to the underlying metaphorical substrate of our own interpretative vocabularies may serve to open up the possibilities of viable alternative readings as well as the varied functions such readings may have in the present.

A second principal aim of *Aegean Art and Architecture* is to avoid fabricating the kind of idealized continuous narrative history of the Aegean that has hitherto characterized the bulk not only of art historical but also of archaeological reconstructive writing. By this is meant that the use of a set of stylistically associated material remains as a surrogate for (or as emblematic of) societies and peoples themselves and their historical developments. In other words, we seek to avoid using what might be typologically constructed as the evolution of artefact styles as a simple or direct reflection of some imagined or projected parallel evolution of social mores, ethical progress, or cognitive advancement. In this, our project runs counter to the prevailing thrust of art historical (and archaeological) practice in the nineteenth and earlier twentieth centuries. *Aegean Art and Architecture* is not a historical novel.

Here we take a position on the writing of histories which acknowledges the possible existence at times of consistent and coherent stylistic trajectories in the chronological development of Aegean built environments, but does not claim that any such stylistic developments are necessarily wholly reflective or representative of broader social events and developments. Such a position follows from our acknowledgement that the actual constitution of a built environment at any point in time will be a mélange—often quite complex—of coexisting objects of different origins in space and time, and associated with

potentially contrary and distinct stylistic, philosophical, or ideological tendencies. In this respect, the unilinear evolution of styles of artefacts is more often than not an idealized art historical fiction, and a reflex of very particular needs and desires for the fabrication of coherent national or ethnic identities in the modern world.

The perspective taken here is intended to call attention to the fact that any such idealized narrative history abstracted from a formatted system of artefacts stylistically linked together over time is grounded in the assumption of direct and reflective relationships between a built environment and a people. This assumption, as indicated above, is a specifically modern aesthetic perspective on meaning and expression that is historically rooted in the image of the nation state as a metaphor for the ideal individual (and vice versa).

Discussing all of these perspectives is intended here to highlight the fundamental fact that the past is constructed and 'read' or made sense of in and for the present. The complex relationships between past and present are central to any society's fabrication of its identities and missions—whether four millennia ago or today.

Organization of the book

Instead of separating objects into discrete categories, *Aegean Art and Architecture* is organized chronologically (according to significant historical periods of social and cultural development) to focus upon a wide variety of objects (from sealstones to pots to buildings and settlements) in the three major geographical areas (Crete, mainland Greece, and the Cycladic islands in the Aegean) which in current understanding constituted relatively distinct cultural zones or spheres during the Bronze Age.

Rather than comprising an exhaustive survey of many archaeological sites (there are in fact hundreds on Crete alone, and the Bronze Age remains uncovered throughout the Aegean Basin number in the thousands), the book will examine in some detail particular settlements whose remains, given the current state of archaeological knowledge, seem to us to be characteristic of a period or place. Because the book is intended as an introduction to the built environments of the Bronze Age Aegean, for those with little or no previous knowledge of the subject, emphasis is placed on widely known and better-documented structures, paintings, and portable objects, with an occasional glimpse of more recent, but lesser-known and important discoveries, both in the Aegean and elsewhere.

Our choice of sites, and the scope of the study, is necessarily constrained by two factors. First, the size and format of the book are predetermined, being specifically designed to serve as one text in an organized series of Oxford History of Art books intended as general introductions to the art and architecture of the world. The book

presupposes little or no familiarity with the subject, and is designed to provide any reader with the necessary resources for further study of an advanced or detailed nature. *Aegean Art and Architecture*, in other words, is what it explicitly declares itself to be: an introduction to the subject.

Secondly, our choice of material is constrained by the nature of the existing knowledge (very fragmentary) and published coverage (often astonishingly spotty) of various periods and places. Thus, while very little may be known about Minoan burial practices in the Second Palace Period, Mycenaean evidence is plentiful. Some sites have been thoroughly excavated but only summarily published (if at all: the amount of material to be processed remains staggering, given obvious limitations of resources and personnel relative to the size of the task). For some periods, architectural remains are still virtually non-existent, while ceramic remains are plentiful. The sites discussed here were selected because they were thought to be most useful in introducing the reader to the possible ways in which objects may have functioned in their original environments. A variety of possible scenarios of interpretation will be given, introducing the reader to some of the underlying assumptions and hypotheses which have governed interpretation during the modern history of discovery and exploration in the Aegean.

This book is designed, above all, to serve as a pragmatic instrument for learning about various aspects of this truly remarkable period and region, and as an introduction to the field which links up programmatically with more specialized and focused studies. A special bibliography and guides for further study of particular topics will be found at the end of the book. At the same time, footnotes and other reference materials will direct the reader to other related subjects, and they will also serve to introduce explanations of particular images or structures which differ from some of those put forward here.

Each chapter is organized chronologically, and the discussions for each period emphasize the design, uses, meanings, and formal developments (if any) of images, buildings, and other artefacts. When feasible, regional variation in style, use, and workmanship will be examined, as well as evidence for the local and regional dissemination of objects, forms of design practice, and approaches to the organization of social space. Comparative examinations will be made, where possible, of contemporary artistic and cultural practices in the Aegean and Anatolia, Cyprus, Mesopotamia, and Egypt, as well as the evidence for interconnections at various periods.

The schematic chronology of the Aegean Bronze Age at the beginning of this book (see p. 8) also provides the terminology used in the book for various periods and regional variations. The absolute dates of many of the periods named therein are a matter of some (in some cases very great) controversy, and have been so for much of the twentieth

century, but the relative chronologies should prove to be a reliably useful guide for our discussions.[17] The period covered here—some two and a half thousand years—begins in the Neolithic or New Stone Age, before *c*.3300 BCE, and ends in the Early Iron Age, *c*.1000 BCE.

The next chapter looks at the Neolithic Period in Greece and the Prepalatial Early Bronze Age, and is divided into presentations of settlements and burial practices. The Neolithic settlement at Dimini in Thessaly is examined in some detail as an introduction to themes of artistic production and art historical interpretation recurring throughout the book. In southern Crete, the Early Bronze Age settlement at Myrtos, Fournou Koriphi has been the subject of recent extensive study, and has yielded important knowledge about Early Minoan social and economic life; the site of Vasiliki in eastern Crete has yielded traces of frescoes and of building technologies which continue to develop in later periods. On the mainland, the important settlement at Lerna in the Argolid is examined in detail and we will look at its architecture and sealings archive. The second part of the chapter is devoted to a discussion of burial practices in the three geographical regions and the finds associated with Early Bronze Age burial, including gold objects and marble figurines.

Chapter 3 examines the First Palace Period of the Middle Bronze Age on Crete and in Greece. The first section looks at the development of the so-called 'palaces' at important Minoan settlements such as Phaistos, with its significant ceramic remains, well-preserved and documented architecture, sealings archive, and unique objects such as the undeciphered pictographic Phaistos disk. Other buildings discussed are the imposing administrative compounds at Mallia, Quartier Mu, and at Monastiraki; the unique circular hilltop building at Chamaizi; and the walled site of Ayia Photia in east Crete. The second section discusses the vernacular building traditions of Crete and the mainland, and the final part of the chapter is devoted to ritual practices in the west courts at Knossos, Phaistos, and Mallia; and to a discussion of frescoes, figurines, and the peak sanctuary at Petsophas.

Chapter 4 focuses upon the Second Palace Period on Crete, in the islands and on the mainland. It examines in turn: public art and the so-called 'palatial style' in architecture at larger and smaller settlements, as well as recent discoveries which have called into question older distinctions between building types; the question of Cretan and mainland spheres of influence in the Cycladic islands, on Kea, and at Akrotiri on Thera, which is important for the state of preservation of its buildings and fresco paintings; religious practices, shrines, and sacred caves and their associated finds; and, finally, burial practices, notably the shaft graves at Mycenae.

Chapter 5 examines the question of Mycenaean domination and the Minoan tradition by looking closely at continuity and change in the

arts, and in burial practices. The first section discusses the carefully documented Mycenaean palace compound at Pylos; the Mycenaean phase of the palace at Knossos and the continuation of the Minoan fresco traditions; the Mycenaean *stoa* at Haghia Triadha; and the ship-sheds at the nearby port of Kommos. The second part of the chapter looks at the monumentalizing of burial practices at Mycenae, and at the Treasury of Atreus *tholos* tomb; the Haghia Triadha sarcophagus, with its painted offering scenes that have fuelled speculation by generations of scholars about Minoan religious or philosophical beliefs; the Mycenaean shrine at the town of Phylakopi on the island of Melos; and the circuit walls of Mycenae and Tiryns.

The final chapter, 'Disruptions, (Dis)Continuities and the Bronze Age Legacy', examines evidence for the survival of the Aegean world in later Greek history, and discusses artefacts, technologies, religion, and public ceremony. The chapter is divided into three parts. The first part is devoted to the eastward migration of Aegean traditions, and discusses Hittites and Mycenaeans at Miletus/Millawanda on the west coast of Anatolia; and what has been called an 'international style' in portable artefacts circulating throughout the Mediterranean. The second part considers the modern tradition of speculation about Bronze Age artefacts that appear to foreshadow practices familiar in Greek social and religious life. Several sites are examined closely to shed light on these issues: Kavousi, Kato Syme, and Lato on Crete, and Kea in the Cyclades. In addition, the Bronze Age heritage of later Greek sanctuaries is examined.

The final part—'Daedalus returns to Crete'—is a brief survey of the Iron Age legacy within Greece of the arts and technologies of the Bronze Age Aegean that find their way back to Greece from the Near East after the cultural hiatus and social and political disruptions at the end of the Bronze Age. The chapter concludes with a discussion of the ways in which the discovery and continued exploration of the cultural remains of Minoan Crete, Mycenaean Greece, and the Cyclades has challenged (and continues to challenge) not only Eurocentrist notions about the originary properties of Hellenic art, but also fundamental assumptions regarding art and art history themselves.[18]

In this regard, Arthur Evans may have been prescient in his observations of 1909, quoted at the beginning of this chapter, that the discoveries in Crete had 'more than an archaeological interest' in that they 'must affect the mental attitude of . . . future generations in many departments of knowledge'—even if these effects have gone much farther, historically, methodologically, or theoretically, than either he or anyone else could have predicted a century ago.

The Neolithic Period and the Prepalatial Early Bronze Age

2

We shall find that the past as it was is not what comes at the end of the trip; we are on a return ticket.

Michael Shanks and Christopher Tilley,
Reconstructing Archaeology, p. 15

Settlements

Two tales of one city: the context of interpretation and the interpretation of context at Neolithic Dimini

The agriculturally rich plains of Thessaly in northern Greece was a probable location for where an 'urban revolution' in Neolithic Greece took place. An important site of this revolution was Dimini—a small settlement that included a large central building with a courtyard on top of a little hill, surrounded by smaller houses or activity areas on the slope, and enclosed by a series of stone ring walls [7]. The central building is made up of a large rectangular hall with a hearth and four columns supporting the roof. This room is entered from the outside by way of a forehall and a porch [8].

Modern scholars have commonly referred to such a structure as a *megaron*, which is the Greek word for hall, the term evoking images of the heroic world of Homeric poetry. The settlement dates to the period known as Late Neolithic III–IV (*c*.3700–3300 BCE). Dimini served as Greece's earliest example of a modest town planning scheme. The remains constitute the largest corpus of excavated, preserved architectural remains from the Greek Neolithic Period. Previous interpretations of this settlement from the early and late twentieth century provide examples of how different methodological frameworks affect our modern understanding of the past.

Dimini was originally excavated in the early 1900s by the prominent Greek archaeologist Christos Tsountas.[1] As a means of trying to understand the significance of our fragmentary past, historians often

turn to the use of models. These models can be derived from many sources, including the literary testaments of other cultures, patterns derived from the observation of history, and analogies or comparisons with traditional cultures that have survived into the present. Tsountas, for example, used the Homeric epic poems, the *Iliad* and the *Odyssey*,

7

Reconstruction of the Late Neolithic site of Dimini in Thessaly, looking east, *c*.3700–3300 BCE. Dimini is important for its evidence of an 'urban revolution' in Neolithic Greece. This reconstruction shows the prominent position of the large central building on top of the hill, overlooking other smaller buildings lower down on the hillside.

8

Plan of the settlement of Dimini. The plan shows houses and activity areas during various levels of occupation in the Neolithic Period.

N

Activity area B

Activity area A

House ksi

House N

Megaron

Court

Activity area G

Activity area D

0 5 10m

as models for interpreting the meaning and social organization of the settlement at Dimini. Based on these, he reconstructed the central building on top of the hill as a splendid palace or hall where a king lived among his riches. He believed that this palace would have been surrounded by extensive fortifications some 3 m high to which supplementary fortifications were added after a violent destruction.

Dimini was re-excavated in the 1970s by the archaeologist George Chourmouziadis.[2] In contrast to Tsountas, Chourmouziadis used the writings of Karl Marx and an approach known as systems theory as his interpretative models. The use of systems theory involves analysing a culture as a system that can be broken down into a series of subsystems or subunits.[3] Marxist analysis places an emphasis on the study of economic production of the necessities of life to explain the mechanisms of social change or the internal nature of a given social order, which are taken as directly reflective of systems of production. The economic bases of social existence are seen as the major generative influence on a group's belief system. For example, the focus of religion on the nurturing powers of a Great Goddess might be read as an emphasis on fertility, that is, human, animal, and agricultural production and reproduction, in sustaining the life of the society.

At any rate, Chourmouziadis interpreted Dimini quite differently from Tsountas. He saw the settlement as a series of household systems working in cooperation with each other to meet the needs of the settlement until such time as the 'owners' of the large central building or *megaron* instituted a system of private property. Chourmouziadis assumed that the people of Dimini had once lived in a state of primitive communism in which the resources of the community were shared equally—a system later shattered by social and economic circumstances reflected in the construction of the *megaron*.

The notion of a new imbalance in social ranking after the appearance of the *megaron* is based on the fact that it is strikingly larger and situated in a more prominent (central and physically higher) position than the other structures in the settlement. The hypothesis is metaphoric in nature in that it assumes a structural or visual similarity between the physical characteristics of the great house in relation to its environment of smaller structures and a social system of greater or lesser power and rank. Chourmouziadis believed that the changes that brought this about were the natural result of increased population and economic output, so that the central court became the 'private property' of the 'owners' of the *megaron*. Social change or economic development would have taken place through the mobilization of production by a central authority.

There was a certain amount of cogency in Chourmouziadis' assumptions. His description of the site, however, was generic and

schematic, making it difficult to evaluate his interpretation, or to reconstruct the steps that he took to arrive at it. Without a detailed description of the architecture or the context of the finds, his publication of the site remains shrouded in mystery.

Chourmouziadis' interpretations regarding the formation of a precapitalist society at Dimini relied on a series of assumptions concerning the organization of the site, the functioning of its economy, the evolution of ideas in the study of prehistory, general historical theories concerning the relationships between individuals and society, and the presence of what he calls a 'natural' economy. He believed that such an economy afforded no possibilities of wealth that might provoke aggressive manifestations on the part of neighbouring communities. His view of early Dimini as a precapitalist paradise evoked a sense of nostalgia not fundamentally different from Tsountas' view of the site as a Homeric citadel three-quarters of a century earlier.

The juxtaposition of two competing interpretations of Dimini by two prominent archaeologists highlights the reconstruction of art historical narrative and discourse as an ongoing and multilayered process that is subject to diverse modern social, historical, cultural, and institutional influences. Many different models and types of description are often employed in the study of prehistory (the term itself was first used in 1851) including narration, quantification, and graphic and historiographic reconstruction.

Any approach to the study of the past is a theory of the past and of historical development and evolution. Prehistorians work from a world view that was formulated in the present although they might be trying to understand the world view of peoples of the distant past. Theories of prehistory are powerfully shaped by contemporary social and institutional circumstances and agendas, so that what constitutes significant historical evidence of the past for art historians will differ, often markedly, from what archaeologists or anthropologists judge important in the task of reconstructing ancient societies. The interpretative frameworks or theoretical and methodological perspectives from which the past is reconstituted, moreover, are themselves evolving.

Different temporal frameworks also play an important role in how we approach the past. In some instances, a scholar might be more concerned with recording and sometimes analysing a series of historical events, changing cultural processes, or changing styles (sometimes called a diachronic approach). In other instances, a scholar might choose to focus on a particular moment in time and study the context of monuments and art works, conceptual structures such as cult or economy, or the relationship of the individual to society: a more synchronic approach.

Consider again the evidence from Dimini and the archaeological context of its monuments. As mentioned above, the site is dominated

by a large central building, the *megaron*, composed of a large hall with a horseshoe-shaped hearth that is roughly centred, with four columns supporting the roof as indicated by extant post holes. The hall is connected to a forehall and smaller porch by a series of centrally placed doorways. It has been suggested that this porch was a later addition from the Final Neolithic or Early Bronze Age. A side room abutting the rear hall of the *megaron* probably functioned as a storage annexe. The central building is fronted by a court and surrounded by a series of smaller, single-room, rectangular buildings containing a variety of internal features. Other types of installations such as pottery kilns are also distributed on the hill.

Of the smaller rectangular rooms arranged around the edge of the court, about half contained undecorated pots for the storage of commodities. The other half contained decorated pots as well as figurines and jewellery. Traces of fire and burning were found in rooms from both groups. Such distinctions indicate that different structures had different functions or that households used more than one structure.

These smaller constructions were dubbed 'activity areas' by Chourmouziadis and 'houses' by others. They are arranged on the lower parts of a gently sloping hill and are enclosed by a series of ring walls known as *periboloi*. The disparities in size and arrangement of the buildings in the settlement indicated to him some form of social hierarchy taking the form of asymmetrical or unequal relations between the occupant(s) of the larger structure and those assumed to occupy the smaller buildings around it.

Rather than the grand and romantic Homeric fortifications imagined by Tsountas, it is more likely that the *periboloi* encircling the settlement served as retaining walls that provided support for the construction of the buildings. The reason is that at little more than a metre high and 1.5 m thick, these stone walls in themselves would not have served effectively to keep anyone in or out of the settlement. Of six of these *periboloi*, only three are complete. They are arranged in pairs and pierced by doorways at regular intervals which served to organize and define the settlement by dividing it into quarters. Along with several structures within the uppermost enclosure wall, they also serve to define the central court. It is not inconceivable that they may have served to deploy some sort of traffic or processional scheme. At the very least they would orchestrate communication between different parts of the mound, at times channelling movement towards particular parts of the hill while at other times denying access to other areas.

Among the smaller houses or activity areas between the *periboloi* is House N. Located to the northeast and behind the *megaron* between two of the *periboloi*, it is a small rectangular structure that contained storage and food-processing areas as suggested by a bin, a mortar, and

Seated Middle Neolithic female figurine in clay, region of Pharsala, fifth millennium BCE. Figurines of this type have been interpreted in various ways, from religious to decorative. Note the seated position, the large breasts, belly and hips, and the schematic features of the face.

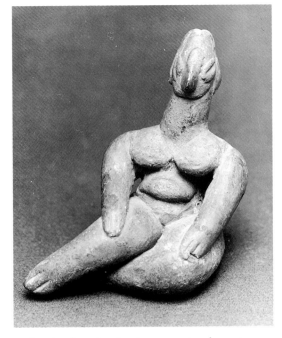

carbonized grain. It also contained steatopygous female figurines not unlike the one illustrated here [9]. The term steatopygous is often used in reference to female Neolithic figurines rendered with a high concentration of fat deposits in the lower regions of the body. They are often depicted squatting or seated with very schematic facial features that in some instances contrasts with a greater degree of naturalism in the rendering of animals. Incised or painted designs on some of these figurines (in the form of zigzags, chevrons, parallel lines, lozenges, and spirals) might represent clothing, jewellery, or body parts such as the pubic triangle indicated in this figure. Whether male or female, such figurines often emphasize the reproductive organs as well.

Interpreting them from the particular kind of materialist perspective discussed above, Chourmouziadis saw these figurines as representing biological and social functions in a deification of the human. Other scholars have interpreted them as entirely religious,[4] placing different types of female figurines in different stages in the life cycle of a goddess as youthful, slender, mature, or pregnant, as vessel, bird, or a symbol of regeneration. More recent studies have rejected such interpretations as arbitrary and simplistic,[5] preferring to consider a range of possible meanings across a spectrum of modern categories from the religious to the decorative that change depending on the context of the figurine and its modelling and marking.

Within such a scheme, a plurality of meanings, termed polysemic or multivalent, might be possible for a single figurine during its period of circulation within different social contexts. Although the breasts,

belly, and hips of the figurine depicted here are exaggerated, the features of the face are rendered schematically with an appearance that one might even plausibly term 'phallic'. An incorporation of male and female characteristics into a single figurine might be seen as a powerful symbol of life-giving power distinct from certain modern dualisms of male versus female. The context of the Dimini figurines is taken up again below.

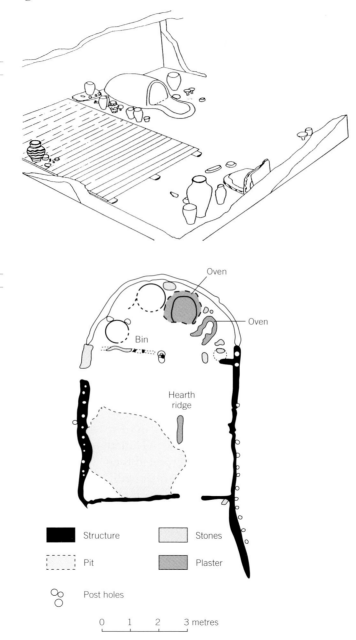

10

Interior layout of a typical Neolithic room, showing a clay-covered hearth inside.

11

Simplified plan of the 'Burnt' House from Sitagroi, Late Neolithic.

Note: plans and diagrams are shown with North at the top of the page unless otherwise indicated.

Oven

Oven

Bin

Hearth ridge

Structure Stones

Pit Plaster

Post holes

0 1 2 3 metres

Spherical vase from
Dimini, Late Neolithic. The
combination of spirals, curved
lines, and polygons decorating
the vase are characteristic of
Late Neolithic pottery.

House Ksi on the site is similarly located to the northwest of the *megaron* in activity area B. It too contained areas devoted to storage and food processing as well as a large circular hearth, and sunken areas in which to place storage jars. This area also included Houses 7–9 which contained storage jars.

House (activity area) G, located within the southwest portion of the same *periboloi*, contained two connected clay hearths, a kiln containing a large quantity of pottery and areas devoted to food processing and storage as indicated by stone tools and carbonized seeds and grain. The placement of a pottery kiln in one building but not in others provides scholars with an important clue to understanding the social organization of the people who lived at Dimini. The fact that certain areas are given over to certain types of activities indicates division of labour, craft specialization, and cooperation in the carrying out of the routines of daily life. The coordination of these different activities would lead to social complexity and hierarchy through the purposeful organization of collaborative effort among members of the community. Constructing particular features that are used in common by all of the inhabitants such as the *periboloi* also implies a certain level of social cooperation.

Many of the Dimini structures contained hearths made of stones that were possibly coated with clay [**10, 11**]. Bins constructed out of stone slabs, and pits coated with clay, served as storage areas. Children were buried beneath house floors, replicating a practice that has been found in Neolithic settlements in the Near East. The climate of the region, which today includes frequent rainy weather, has led scholars to conclude that the roofs at Dimini were slanted or gabled with a covering of clay and reeds.

Space on the hill appears to have been organized around the processing and storage of food, and the production of stone and bone tools and pottery. The tools included axes, grinders, chisels, millstones, sickles, scrapers, borers, blades, and spatulas. The most frequently attested pottery shapes from Dimini tend to be bowls, strainers, and ladles that are found in kitchen areas and storage jars found elsewhere. Common design elements include complex repeated geometric patterns marked, in later designs, by use of the curve in combination with squares, lines, and polygons; this may be seen in a spherical vase from Dimini [**12**]. Clay was also used for spindle whorls and loomweights which were used in the production of textiles.[6]

A general similarity of styles can be found in the pottery designs of northern Greece such as found at the sites of Sitagroi and Dikili Tash in the Drama plain.[7] Northern pottery is, however, distinctive for its use of graphite paint which gives the designs a metallic lustre as represented in the graphite-painted pyramidal stand from Sitagroi [**13**]. Other distinctive designs include spiral meanders, straight and

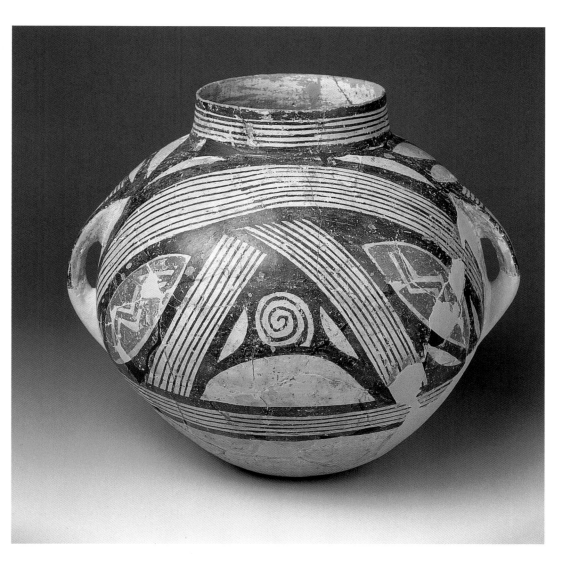

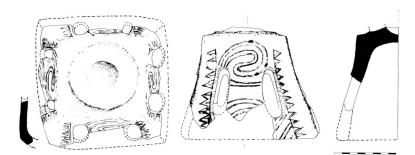

13

Pyramidal stand from Sitagroi, Late Neolithic. The metallic lustre of the design was achieved through the use of graphite paint, common to much of the Late Neolithic pottery from northern Greece.

14

Late Neolithic pottery types from Sitagroi, with a variety of common designs, such as spirals and straight and curvilinear lines.

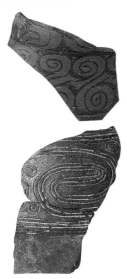

curvilinear lines, and pendant circles distinctively rendered in black paint on a red ground or with incisions infilled with a white paste [**14**].

It is important to note that the mound at Dimini which serves as the focus of this discussion only constitutes 10 per cent of a site which appears to have included simple dwellings in the surrounding lowlands. The mound itself may have functioned as a centre for the production of manufactured goods, the exchange of foodstuffs for such goods, and the performance of ritual for the strengthening of communal bonds with the bulk of the inhabitants living elsewhere.

It has already been pointed out that recent studies of this site have emphasized economic functions and the provision of facilities for production to the near exclusion of other aspects of social and cultural phenomena. Recently, archaeologist Ian Hodder has suggested that the construction of large Neolithic settlements actually pre-dates the domestication of animals and the adoption of settled agriculture, a situation which, if correct, would problematize an economic model of interpretation such as that mentioned above. Hodder believed that there was a symbolic aspect to domestication that was embodied in the house or *domus* (a 'female' domain) so that domestication becomes a symbolically powerful metaphor for a materially pragmatic taming (domination) of the wild.

The practice of storage itself might plausibly be seen as simultaneously incorporating symbolic and utilitarian components which may well have been unknown or unrecognizable to modern 'readers'. The practice of storage is closely bound up with notions of gender and domestication. Hodder attempted to develop a body of applied theory for the study of the long-term duration of symbolic structures. He identified over time in the Neolithic Period an increasing control of storage brought within the idiom and metaphor of the *domus* (which is the Latin word for house) in society.[8] He broadly defined the *domus* to include not just the house but also the activities carried out within the home; the house's life-world, so to speak.[9] He related household activities to the economic strategies of survival and power relations in the European Neolithic, and contrasted the *domus* to the *agrios*.

Agrios is a term used abstractly with reference to the outside, the wild, the world of the hunt, that can be contrasted to the cultured, nurturing, and domesticated world of the home. *Domus* and *agrios*, then, would be relative and complementary terms, manifesting a potentially very wide variety of material forms and expressions in visual artefacts and settlement organization.

Within such a theoretical perspective, then, the presence of female figurines in the Neolithic *domus* could be linked to a wide range of domestic activities including cooking and the storage (dominance) of grain. In this respect, there might be a strong link between women, food production, and storage. As part of this constellation of activities,

storage becomes a gendered activity associated with nourishment and productivity.

Whether we choose to emphasize economic production or the symbolic expressions of domestication, it is clear from the absence of monumental religious structures, the presence of figurines, and the existence of infant burial within the nurturing confines of the home that religious belief may not have been distinct from daily experience in the modern sense of a binary opposition between sacred and secular activities.

It is unclear whether the making of house models such as the one seen here [15] from Thessaly with a chequerboard motif represents a factual representation of a Neolithic house. Yet their very existence suggests a certain interest in symbolically representing the house, perhaps as an emblem of the beliefs, activities, personalities, and productions of a life-world.[10] It is interesting to note that this practice does not seem to continue in later Bronze Age Greece although it continues to occur both in Crete and in the Near East.

This brief survey of several key features of the visual culture of the Greek Neolithic, and of our modern constructions and interpretations of it should provide an example of how the past is something that is written in and into the present. Tsountas wrote a history of the Neolithic that mirrored a romantic nostalgia for a heroic Hellenic past as described in Homeric epics and other poems. Chourmouziadis created a distinct idealized past that evoked a picture of a precapitalist paradise of communal equalities and balance. He supported his interpretation of the evidence using science (as embodied in systems theory) and Marxist ideology as a means of legitimizing his claims.

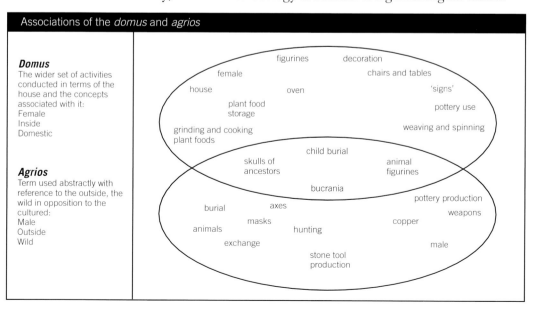

Associations of the *domus* and *agrios*

Domus
The wider set of activities conducted in terms of the house and the concepts associated with it:
Female
Inside
Domestic

Agrios
Term used abstractly with reference to the outside, the wild in opposition to the cultured:
Male
Outside
Wild

figurines decoration
female chairs and tables
house oven 'signs'
 plant food pottery use
 storage
grinding and cooking weaving and spinning
plant foods
 child burial
 skulls of animal
 ancestors figurines
 bucrania
 pottery production
 burial axes
 masks copper weapons
 animals hunting
 exchange male
 stone tool
 production

15

Clay model of a house from
Thessaly, Middle Neolithic,
decorated with a painted
chequerboard motif.

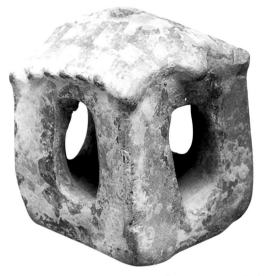

It is important to remember as we read the past, that it is written
about and represented to the public by individuals living in the present.
Furthermore, we construct our past and our present in relationship to
each other so that choosing a past also implies or suggests choosing a
likely or desirable future. Consider the appropriateness of terms such
as ownership, private property, *megaron*, goddess, or religion with
regard to these very ancient societies, remembering that these are relat-
ively modern terms being projected on to the distant past: the compon-
ent parts of a theory of history and of historical evolution.

The Early Bronze Age Greek mainland
There is no uniform pattern to the spatial organization of buildings in
the Aegean Basin during the Neolithic Period. In most areas, habita-
tion sites consisted of one or more rooms with shared walls, often with
many such spaces added together. When structures occur in isolation,
they tend to be mostly squarish, with a protected entryway created by
extending one wall beyond another, in the manner of what early excav-
ators called a 'but-and-ben' type of construction, characteristic of
simple sheep or cattle enclosures in the British Isles.

Large, internally complex rectangular buildings begin to appear in
significant numbers during the Late Neolithic and Early Bronze Age
on the Greek mainland, in the Cyclades, in western Anatolia and its
nearby islands, and on Crete. Rectangular buildings, commonly en-
tered on their short side(s), with axially connected rooms, are found in
many parts of the region during this period, from Troy and Poliokhni
in the northeast corner of the Aegean to central Greece and the
Peloponnese in the southwest.

There are two notable variants of this building form. The first is
what has come to be termed, as we have discussed, the *megaron*. It is

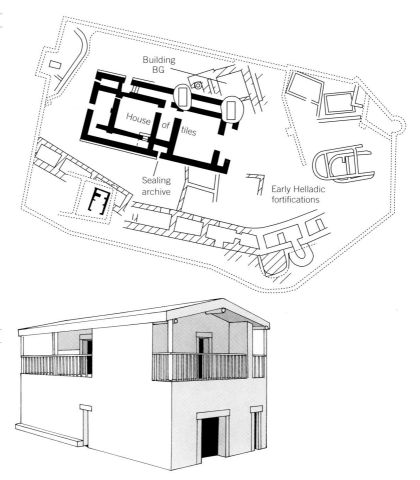

Site plan of Lerna III, Early Helladic, showing the fortifications and several building periods. Note the layout of the 'corridor-type' house known as the House of Tiles, so named because of the numerous roof tiles found in the building's ruins. This type of house appears on the mainland in the Early Helladic II Period (*c.*2900–2400 BCE). It stands over an earlier, similar house (BG) with a different orientation.

17

Reconstruction of the House of Tiles, Lerna III, Early Helladic II. The House of Tiles, built of mud brick over a stone foundation, is the best known 'corridor house', and dominates this small fortified coastal site.

composed of a series of rooms entered on the structure's short end into a porch (sometimes, if wide enough, with a supporting post or two), with an inner room or sequence of rooms interconnected along the same straight axis. The *megaron* is a type which has a long history in the Aegean (see Late Neolithic Dimini above), and prefigures the monumental and decorated core of the Late Bronze Age Mycenaean palaces a millennium later. But in contrast to the Aegean Neolithic but-and-ben constructions, *megaron*-type buildings are found across a much wider region of the eastern Mediterranean and Balkans.[11]

The second variant is what has been called the corridor house, distinguished from the former by long narrow spaces (sometimes with traces of stairways) on the outer sides of an axially aligned set of rooms within. While the *megaron* appears in the Late Neolithic and Early Bronze I Period, the more elaborate corridor houses begin to appear on the mainland later, during the half-millennium-long second phase of the Early Bronze Age (Early Helladic II, sometimes referred to as the Lerna III Period, *c.*2900–2400 BCE).

One of the largest and most impressive of these corridor houses is the House of Tiles, dominating the fortified coastal settlement of Lerna in the southwestern Argolid [**16**]. It was so named because of the enormous quantity of fired clay roof tiles found in the building's ruins during its excavation in the 1950s.[12] Measuring some 12 × 25 m and with its front end facing the shoreline, it was built of mud brick over a substantial stone foundation course, with traces of wood-sheathed door jambs, and of stucco-plastered walls in some rooms. Obviously a building of considerable importance, it was two storeys in height and may have had several verandas upstairs, partially covered by its pitched roof, as suggested in the reconstruction shown here [**17**].

Although there has been no clear consensus about the building's use and significance, the presence of extensive deposits of seal impressions both from the House of Tiles and its immediate predecessor, House BG, suggests that the settlement was of regional importance in the recording, processing, and distribution of commodities [**18**]. Building BG is more closely associated with the fortifications at Lerna and is significant for its monumentality and its intriguing clay hearth with a central cavity in the form of a double axe [**19**]. The double axe is significant as it assumes later importance as the dominant religious symbol in Minoan civilization, although we caution the reader that this hearth is heavily reconstructed and other examples are not entirely convincing. Such hearths were commonly decorated with stamped rims and they were frequently associated with Early Bronze Age structures on the mainland. Some attempt has been made to interpret them

18

Drawings of three clay seal impressions found in the House of Tiles at Lerna. The motifs are generally geometrical patterns, but occasionally natural forms are depicted; note the seal with a spider in the centre. The presence of many seal impressions in the House of Tiles suggests that Lerna was important in the recording, processing, and redistribution of commodities.

19

Ceremonial hearth with *labrys* (double axe) carving, Lerna, Early Helladic II, from House BG, the predecessor to the House of Tiles. The rim of the hearth is decorated with stamped seal impressions.

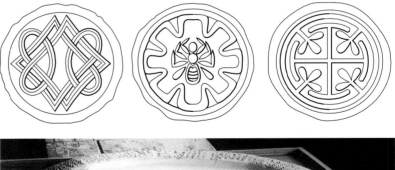

as household shrines.[13] That Lerna played an important role in distribution and exchange during much of its history is suggested by the presence here of artistic motifs, pottery, and other portable objects produced during the Early, Middle, and Late Bronze Ages in places as far away as Crete, Troy, and the Cyclades [20]. In this regard, Lerna's House of Tiles is one of an increasing number of similar (and similarly impressive) complex structures, often within fortified settlements, that begin to appear throughout the Aegean region during the second period of the Early Bronze Age.

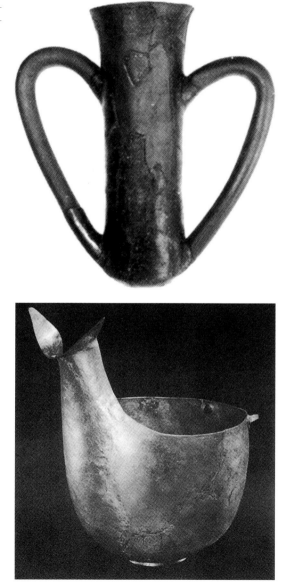

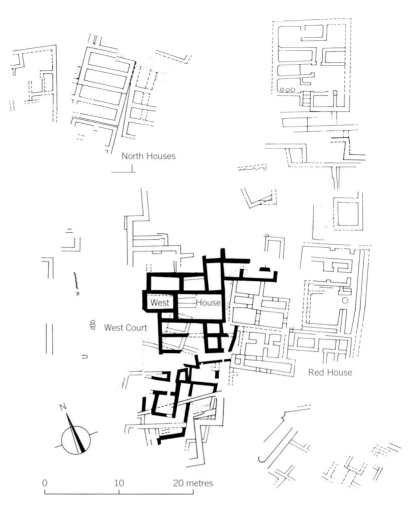

Site plan of Vasiliki, east Crete,
Early Minoan II. The walls
filled in with black are dated to
the Early Minoan IIB Period.

North Houses

West House

West Court

Red House

N

0 10 20 metres

Crete

One such comparable settlement may have been the Early Minoan II building compound known in the archaeological literature as the House on the Hill at Vasiliki in eastern Crete [21].[14] Recent investigation suggests that the compound was made up of conjoined structures, possibly belonging to related families. It was built piecemeal over time, a situation similar to that of the nearby (and much larger) site of Myrtos discussed below, although Vasiliki is rather more regular in layout and construction than Myrtos.

As illustrated, Vasiliki is a site with confusing traces of walls and rooms scattered over the apparently unfortified area. The House on the Hill compound has long been of interest for several design features that to some seem to anticipate aspects of the design of the great central buildings (the 'palaces') of the subsequent Middle Minoan Period. These include: (1) a small paved western court or plaza; (2) a carved

kernos or cupule stone, probably of some ritual or gaming significance, set into the court paving;[15] (3) unusual care given to the exterior wall treatment of the western façade; (4) a labyrinthine arrangement of internal spaces; (5) coloured stucco walls; and (6), despite different building campaigns on the several sections of the compound, a sense of a grid-like consistency to the evolving overall plan.

The function of the building (if in fact it had a single function) is, however, far from clear, although the aforementioned design features may suggest comparison(s) with one or more of the functions of the building's 'palatial' ('temple'?) successors. In any case, Vasiliki may have been an important regional centre of activity during the Early Minoan Period, and may be seen as a miniature version of other Pre-palatial sites on Crete, including much larger sites such as Phaistos or Mallia, or even the already vast settlement (some 5 hectares) now buried beneath the great palace building at Knossos.

The presence of coloured stucco wall surfaces at Vasiliki has been seen as an early step in the technology that led to the production of the later figural wall frescoes that are so prominent and ubiquitous in the Middle and Late Aegean Bronze Ages, in the Cretan and Mycenaean palaces and villas, and in the remarkable houses being uncovered on the island of Thera (Santorini). (See Chapters 4 and 5.)

Myrtos, Fournou Koriphi

Myrtos, Fournou Koriphi is an Early Bronze Age, Prepalatial settlement located on the south coast of eastern Crete [22]. As the only settlement excavated from this time period, it has been intensely studied. The function of its individual buildings, the nature of its social structures, and its relationship to the later emergence of monumental architecture have been debated intensely.[16] Myrtos continues what seems to be a Neolithic Aegean tradition of linking storage, ritual, and female fertility by means of art and material culture in a manner not unlike that which has been suggested for Dimini. Similar practices will persist through to the end of the Bronze Age.

One interesting object, the so-called Goddess of Myrtos [23], that may be associated with a cluster of rooms located at the southwest end of the site, provides a close look at the relationship between ritual practice and storage. The Goddess has a hollow bell-shaped body and a solid neck.[17] The only opening is through the jug held by spindly arms. The surface, including the moulded breasts, is decorated with red paint and incorporates a central triangular section that might be interpreted as the pubic area or a textile covering of the pubic area.

The excavator ruled out a simply utilitarian function for this object because of its long thin neck, spindly arms, and apparent design as a pouring vessel of some kind. He cited the long thin neck as evidence that it represented a deity, as most Early Minoan figurines of humans

22

Reconstructed plan of a house from the Early Minoan settlement at Myrtos, Fournou Koriphi, on the south coast of Crete. Room 92 may have been a shrine.

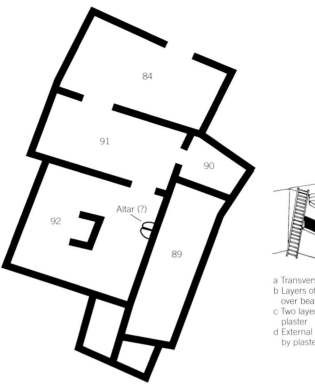

a Transverse wooden beams
b Layers of reed-canes laid over beams
c Two layers of sun-baked plaster
d External corner 'rounded' off by plaster

23

The so-called 'Goddess of Myrtos' vessel, with a hollow, bell-shaped body and solid clay neck. Found near a bench (possibly an altar) along the east wall of room 92, she holds a small jug, which constitutes the spout of the vessel, and her body is decorated with red paint.

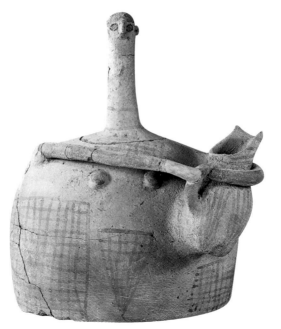

24

Myrtos, Fournou Koriphi, storage room 80, showing a pot cupboard in its northwest corner.

were rendered in 'roughly correct proportions'.[18] The Myrtos Goddess has been taken by some as evidence for Minoan religious continuity from the Early Bronze Age onwards. It was found unbroken in room 92 (see **22**) slightly above the floor and next to a bench-like feature made of stone slabs resting against the east wall. This feature has been interpreted as an altar. Not surprisingly, room 92 has been identified as a shrine.

The room probably formed the main chamber of a house that may be reconstructed based on architectural similarities to other structures.[19] It is of interest that this spatial arrangement is a less regular version of the plan of later square houses with a single column that form an important part of the vernacular tradition of house design on Crete (see Chapter 3). Like room 80 [**24**], room 92 contained a wide assortment of vase forms including several amphoras, jars, bowls, a cooking pot, a couple of jugs, and two *pithoi* or large storage jars.[20] It is significant that (shrine?) room 92 was directly connected with storage room 91.

Room 91 has been convincingly reconstructed as an oblong storage room and was found crammed full with 66 vases, mainly fineware, as well as some large storage jars. This understandably led the building's excavators to interpret the chamber as a storeroom for the adjacent shrine, holding vases possibly connected to activities surrounding this Goddess.[21] This arrangement appears comparable to repositories of stone vessels found in the later Minoan palaces. At the same time, the

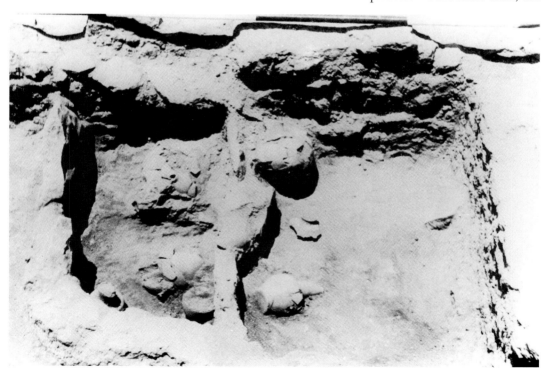

25

Plan of the Early Bronze
Age II citadel of Troy IIc. The
heavily fortified settlement is
dominated by a large central
megaron flanked by four
smaller ones, all within an
inner walled and apparently
colonnaded courtyard. Both
the inner and outer citadels
are accessed by a *propylon*
or roofed gateway on the
southeast, and there is a
second, smaller gate on
the southwest.

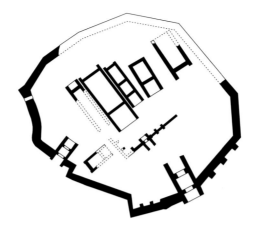

suite of rooms calls to mind notions of ritual symbolism connecting the
domus, female fertility, and storage conjectured to have existed in
Neolithic Dimini. A similar pattern of associations is discussed in con-
nection with the Second Palace Period in Chapter 4.

The Cyclades
The plan of Lerna (see **16**) bears some interesting formal similarities to
those of contemporary sites in other parts of the central and northern
Aegean, such as Kastri on the island of Syros, Troy II in northwestern
Anatolia [**25**], and Poliokhni on the nearby island of Lemnos.[22] These
four sites provide a useful sample of the kinds of settlement patterns
common throughout the Aegean Basin apart from Crete during the
Early Bronze Age.

In each case, the settlement is well fortified, with thick stone-sup-
ported outer walls; bastions of round (Lerna, Kastri) or square (Troy,
Poliokhni) form; heavily protected and/or hidden entranceways; the
grouping of rooms or buildings into what were probably family com-
pounds separated by alleys, streets, or courtyards; and with implica-
tions of social and/or functional hierarchy in the contrasting sizes and
quality of construction (Lerna, Poliokhni, Troy). Lerna and a number
of other mainland sites are dominated by a large finely constructed
corridor house, while in the northeast Aegean, the fortified coastal
settlement of Troy, dominated by a large *megaron* compound, contrasts
with nearby Poliokhni on Lemnos, in which the portions of the town
excavated to date contain *megaron* compounds of relatively similar size
and plan, with no one structure dominating the landscape.

This type of fortified settlement with *megaron* or corridor-type
house forms remained fairly constant from the end of the Neolithic
Period to the end of the Bronze Age, a period of some 2000 years, in all
regions of the Aegean Basin apart from Crete (where the *megaron* form
only appears in the Late Bronze Age).

Amorgos, Dhokathismata style, Early Cycladic II Period. Female figurine of Parian marble, 0.3 m high. Of unknown significance, these marble figurines, mostly female, are found in graves. Once thought to represent female spirits or divinities (hence the term 'Cycladic idol'), they vary from being highly schematic to relatively naturalistic. Male figurines either carry weapons or play musical instruments such as flutes or harps.

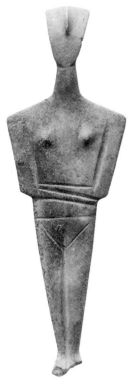

The Greek mainland

The most common type of burial in the Early Bronze Age was the shallow cist-grave of roughly rectangular plan, bounded by walls made of upright stones, and covered with large stone slabs. Examples are found at virtually every coastal Greek mainland site, including Lerna, suggesting connections between the inhabitants of these coastal towns and the nearby islands.

The cist-graves normally contained a single burial, accompanied by occasional grave gifts such as pottery, jewellery, and other items presumed to have been part of (or imitating) the accoutrements of the deceased person's life.[23]

The Cyclades

Cemeteries in the Cycladic islands, with some exceptions (Chalandriani on Syros, with some 1,000 graves),[24] are relatively small, comprising the cist-tombs of single families or other small local groups. The graves themselves are fairly consistent in form, made up of a sunken rectangular pit lined with stone slabs and/or rough stones, and covered with a stone slab roof. The deceased may have been interred with some ceremony, which involved the placement of offerings, usually bits of jewellery, a weapon or two, and some stone or clay pottery, beside the body. On occasion, unusual articles such as those shown in illustrations **27**, **28**, and **29** have been found among the grave goods. There is a great deal of variation in the size and quality of tomb construction, and in the quantity and quality of grave offerings.

The object shown in **26**, dating to the Early Bronze II (Early Cycladic II) Period and found on the island of Amorgos, is an example of a common white marble female folded-arm figurine, at one time referred to by archaeologists and art historians as Cycladic idols, when it was conjectured that they represented spirits or goddesses.[25] The type occurs in a large number of female and male variants, from the highly schematic to the relatively naturalistic. Their function, usage, and cultural significance remain unclear.

Such objects occur in only a few graves, usually singly, occasionally in groups; a few are male, often seated or standing flautists or harpists, some wearing a dagger. Many appear to have had bodily features or jewellery incised and/or painted; some females appear to be pregnant; and a small number are quite large, nearly half-life-size (1.5 m). These may have been used in household shrines or in ceremonial or cult contexts.[26] The type was widely imitated on the Greek mainland and on Crete. More schematic versions occur throughout the Early Bronze Age in western Anatolia. Flattish female figures such as the one shown

Syros, Chalandriani, Early Cycladic II Period. The flat surface of a clay utensil in the shape of a modern frying pan, decorated with incised, white-filled spirals and the profile of a ship with a fish at one end. The triangular portion of the object has been taken to represent a female pubic triangle, above a double-footed handle. The significance of these Cycladic 'frying pans' is unclear.

here may have been meant to be viewed lying down, perhaps imitating the position of the deceased.

These finely made white marble idols have come to form a distinctive set of artefacts with very great appeal to modern collectors and fine art connoisseurs around the world, and they have come to be taken as uniquely distinctive of a Cycladic culture or cultures during the Early Bronze Age that still remains so poorly known in other ways, despite recent advances in archaeological knowledge. So few of these marble sculptures have been found in well-documented archaeological contexts, and so very many have been circulated throughout the world by unscrupulous dealers, art collectors, and art historians complicit with illegal antiquities networks, that speculation about the origins, functions, and historical significance of these remarkable objects, however rhetorically attractive to contemporary tastes, often rests on very limited solid evidence. It is possible that some of the more unusual idols may in fact be modern forgeries.[27]

Found on Syros, the Early Cycladic II object in **27**, whose shape suggested to early excavators that of a clay frying pan because of a raised rim on the reverse, is a fine example of an object whose function or significance is unknown, but which has been the source of rich and ingenious speculation. Decorated with a typically Cycladic running spiral motif (possibly here representing the sea or pubic hair) incised into the dark clay, in the middle of which is the profile of a ship with schematic oars and a fish on its prow, the object also has an incised triangle at its footed end. In some examples of this type can be found a schematic female pubic triangle, suggestive of fertility symbolism to some archaeologists. It is possible that these 'frying pans' also had some cosmetic function, the rimmed enclosure on their backs serving as a palette to mix cosmetics, not unlike the (zoomorphic) slate palettes found in Predynastic Egypt.[28] However, hard evidence for such a purpose is lacking. If water were to be poured into these enclosures, the effect may have been rather mirror-like.

The inventiveness exhibited in the folded-arm figurines and so-called frying pans shows yet another unique expression in this vase [**28**] identified alternatively as a bear or a hedgehog drinking from a bowl. It is from Chalandriani on Syros. Many have remarked on its humour and liveliness. The intensity of labour that went into producing it, its delicacy, and uniqueness also point to a special function. It fits into a broad Mediterranean tradition of producing animal-shaped vessels.

This Early Bronze Age model of a granary from a tomb on the Cycladic island of Melos [**29**] is believed to be a series of cosmetic jars in the form of a granary complex. We have almost no evidence of Cycladic architectural forms, so it's tempting to see such representations as realistic. The form is certainly reminiscent of actual settlement complexes from Chalcolithic (Copper Age) and Early Bronze Age

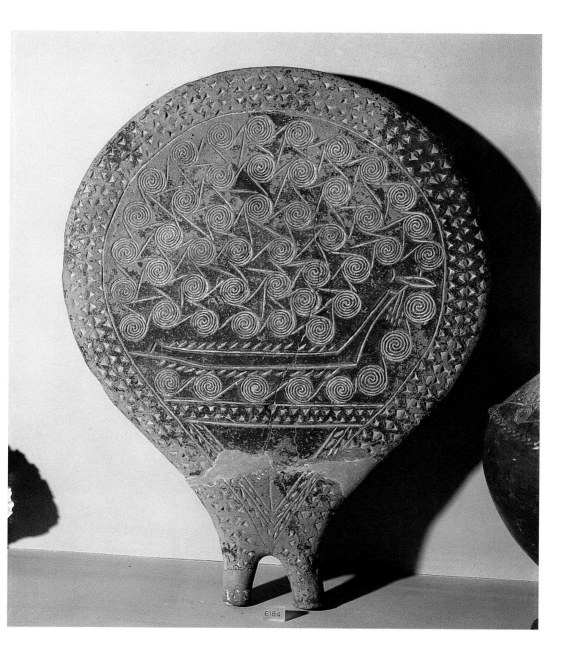

6184

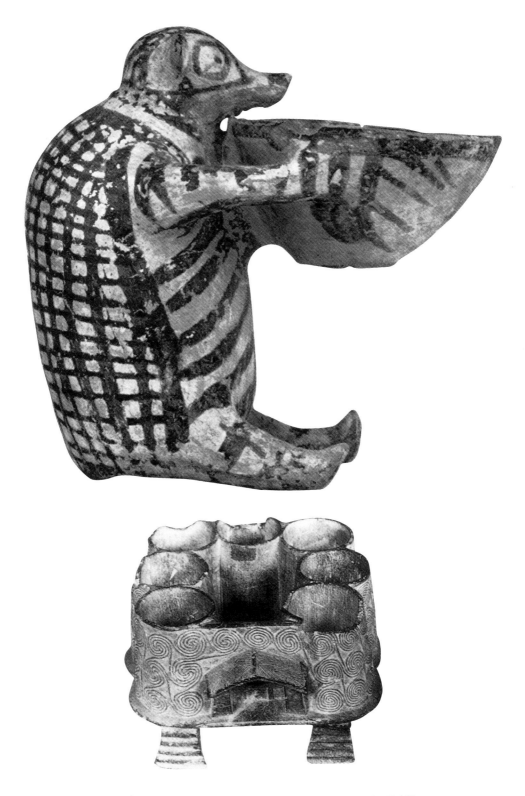

28

Syros, Chalandriani, Early Cycladic II Period. Vase in the shape of a small bear or hedgehog decorated with dark paint on a light ground. The animal carries a deep bowl which opens into its neck.

29

Walled granary model from the island of Melos, Early Bronze Age. Chlorite.

Cyprus. Granaries are believed by some to be the focal point of rituals connected with the planting season and the harvest in the later Minoan Period (see Chapter 3) when such rituals were seemingly connected with the means of a community's survival and focused on agriculture, death and regeneration, and fertility. Carved out of serpentine with incised spiral decoration, this model probably had a lid.

Early Bronze Age burials on Crete

Prepalatial cemeteries on Crete are as significant for what they tell us about the religious beliefs of the population as they are for their refined tomb architecture and their gold and ivory grave goods. The tomb-types under discussion here are the product of different regional styles or traditions. Rectangular or square house tombs with one, two, or more chambers tend to be the product of a central and east Cretan tradition while round or *tholos* tombs are the product of a south-central tradition associated with the Mesara Valley, a region dominated in the Middle and Late Minoan Periods by the city of Phaistos.

Built tombs were popular until the end of the Prepalatial period when burial in *pithoi* or storage jars was introduced. The building of small square or rectangular tombs in the shape of houses replaces an earlier practice of interring the dead in caves and in rock shelters. The house tombs at Gournia [**30**] in northeast Crete in the region of the Bay of Mirabello will serve as the prime example of this northern and eastern tradition. They were originally excavated in the early 1900s, then systematically restudied in the 1970s, in both instances by a team of American archaeologists.

Their arrangement is quite simple, following the arrangement of Neolithic but-and-ben houses with a roughly square space divided into two parts by a spur wall running down the middle with an opening at one end. The entrance to the house tomb is generally at the short end

30

Gournia, northeast Crete, Early Minoan II, built tombs I and II; plan and reconstruction. Tombs in the north and east of the island during this period were mainly rectangular and house-like in plan and elevation, built on a rough stone and mortar foundation, with upper walls of mud brick, and with a timber-supported flat roof.

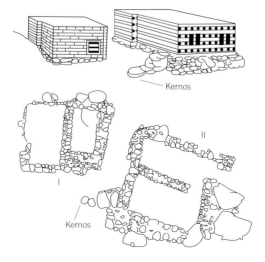

Kernos

II

I

Kernos

of one of the rectangular rooms created by this spur wall. The location of the spur wall is indicated externally by the projection of the façade of one room and the corresponding recess of the other room. This practice of creating recesses and projections would be incorporated into the later palaces on a monumental scale, thus creating a play of light and shade thought to be pleasing to the viewer.

The lower walls of the tomb were constructed of available field stones as well as larger boulders held together by mortar consisting of mud, pebbles, and broken pottery. These elements would be arranged to create a flat surface for finishing the upper part of the walls with mud brick. The roof would be constructed of wooden beams, mud, reeds, and coated with plaster.

A low platform extending beyond the outer corner of Tomb II at Gournia contained a flat, discoidal stone with 22 small hollows or cupules placed near the edge of the stone. All of these hollows are small and shallow, although one is noticeably larger than the rest. Such a stone is known as a *kernos* or cupule stone. *Kernoi* appear in the Prepalatial Period on Crete where they are found in association with both tombs and houses. They tend to be associated with the later palaces and one is even attested at the Postpalatial settlement at Kavousi. The cupules are reminiscent of the hollows made by grinding grain and many want to connect these *kernoi* with the religious practice of leaving a token grain offering to a deity. Others have interpreted them as gaming stones with the cupules serving as receptacles for tokens for an improvised game. If seeds were used as gaming tokens, it might be possible to reconcile both interpretations.

House tombs elsewhere, as at Mochlos, frequently made use of the natural terrain by constructing the tomb against the side of a cliff, thereby incorporating living rock into the architecture. Such a practice is appropriate for a civilization that incorporated so many aspects concerned with nature into its religion. Building against the cliff-face also served a practical purpose in terms of facilitating construction that is still taken advantage of in more modern constructions. The tomb builders at Mochlos incorporated several other features that we tend to associate with the Minoan palaces on a grander scale. These include the frequent use of large upright slab blocks known as orthostates and the frequent and intentional use of different coloured stone including black limestone, and red and green schist. One tomb even has a stepped approach leading to a paved terrace that could conceivably have served as a gathering place for those related to the deceased. Attention to such details indicates a concern with planning, even though additional rooms might be constructed at a later date to accommodate the needs of the population.

The cemetery at Mochlos contained some of the most elaborate Prepalatial objects found anywhere. These included jewellery such as

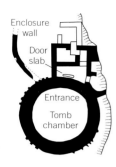

31

Kamilari, south-central Crete, Early Minoan II, *tholos* tomb. Made of roughly worked stone, the tomb was entered on the east through a series of small chambers which had become ossuaries at a later date; this outer area was partly enclosed by a stone wall.

32

Mallia, Chrysolakkos cemetery, Early Minoan gold bee pendant, with very fine granulation and filigree decoration. The two bees are manipulating what appears to be a globule of honey.

gold pins and diadems, votive double axes, sealstones, silver cups, other ritual vessels such as bull *rhyta*, less elaborate vessels made of terracotta with painted decoration, bronze tools and weapons, and stone bowls and palettes.

The skeletal remains from Mochlos and elsewhere have provided modern scholars with a great deal of insight with regard to the treatment of the dead. It has been suggested that one room of the tomb chamber would be used to inter the deceased who would be provided with personal possessions, adornments, and food and drink to sustain him or her in the journey to the afterlife. Once the body of the deceased had decayed, the bones might be swept aside into an adjoining room while the skull would be put aside among other skulls, sometimes with a small offering of food or liquid as a final tribute. The care and attention with which the dead were treated would have helped individuals to maintain a sense of continuity with their past.

The earlier Prepalatial round or *tholos* tombs of the Mesara Valley in southern Crete represent a separate regional tradition that continues into the Protopalatial Period with the construction of the Kamilari *tholos* [**31**].[29] This south Cretan tradition has been tentatively connected to Cypriot influence where round houses were a common feature in the early periods. Minoan *tholos* tombs were free-standing

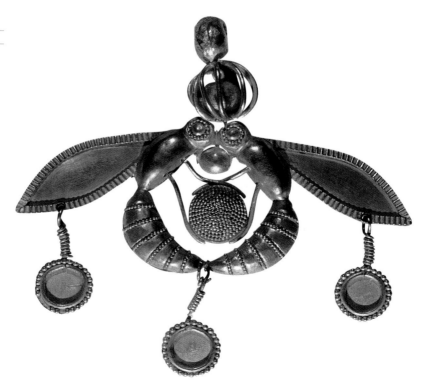

and should not be confused with the later beehive-shaped tombs of Mycenaean Greece, also referred to as *tholoi* although their influence on these later tomb-types continues to be debated.

The inward-leaning walls of the *tholos* tomb at Kamilari are constructed of roughly worked blocks still preserved to a height of 2 m. The rough workmanship of the stone and lack of preserved stone from the collapsed roofs of some Minoan *tholoi* argues against them having corbelled or beehive-shaped roofs like later mainland Greek tombs. Flat roofs of wood and stone or conical roofs constructed of mud brick remain possibilities although no evidence of mud brick is preserved. However, enough fallen stone was found at Kamilari to indicate that it probably had a vaulted ceiling that later collapsed. The entrance to the tomb chamber on the east fits the general pattern found at other such tombs that might connect beliefs about the afterlife to the rising of the sun.

The main chamber at Kamilari was reached through a series of maze-like antechambers that were used as ossuaries in subsequent periods. The doorway was topped by a massive lintel block and covered with a stone slab. Although Kamilari was robbed in antiquity, the character of the finds included in Minoan *tholoi* seems to correspond to the types of items found at other sites such as Mochlos. Evidence of burning at Kamilari and indications of hearths elsewhere have been interpreted as either for fumigation or a practice of funerary banqueting. The notion of banqueting is reinforced by the hundreds of cups and vases found in and around the Kamilari *tholos*. As in the rectangular house tombs, the bones of decomposed bodies were swept aside while the skulls were collected separately.

The Chrysolakkos funerary complex at Mallia is a square, multi-chamber structure with a court that was renewed and reused in subsequent periods, obscuring the internal arrangement of the original building.[30] Cult equipment such as *kernoi* and offering tables as well as the limited amount of skeletal remains has suggested to some that the building was connected to the funerary cult and the treatment of the dead prior to final burial elsewhere in the vicinity. The name Chrysolakkos, meaning Gold Hole, is thought to be a reference to the looting that was carried out here in modern times.

One object that was overlooked was the famous gold bee pendant [32] that depicts two symmetrically arranged bees appearing to place a globule of honey in a comb. Pendant disks, perhaps serving as an artistic shorthand for the honeycomb, are suspended by gold wire from their wings and conjoined tails. The entire arrangement is suspended from a spherical filigree cage holding a gold bead and attached to a small hoop. The honeycomb, pendant disks, and stripes on the bees' lower bodies are rendered with minute beads of gold in a technique known as granulation.

The bee pendant is important for a couple of reasons. First of all, it is one among numerous pieces of Pre- and Protopalatial art works including sealstones and pottery motifs exhibiting bilateral symmetry. The presence of such works implies that the later rejection of bilateral symmetry by Minoan craftspersons in their art and architecture represented a conscious desire to create more complex and naturalistic compositions. Secondly, the granulation and filigree techniques used on the pendant and other pieces were learned through contacts and cultural exchanges with the Near East. Such contacts indicate that the Minoans were active participants in this cultural milieu from an early stage in their cultural development.

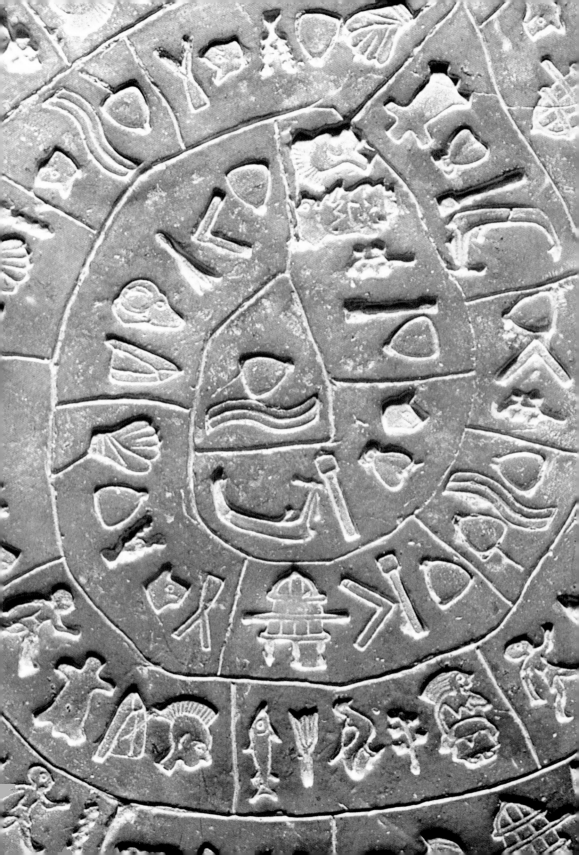

The First Palace Period

3

Middle Bronze Age palaces and villas

We remain ignorant of the exact circumstances that led to the increases in population on Crete at the end of the Early Minoan Period which appear to have accompanied the impressive growth and coalescence of the cities of Knossos, Phaistos, and Mallia with their great central building compounds, marking the Middle Minoan Period. Called 'palaces' by their first excavators, these finely conceived and constructed monumental buildings have no precedent in Crete itself in terms of scale and complexity, although certain of their design features were prefigured in some late Early Minoan buildings in various parts of the island, as mentioned above.

At any rate, the Minoan palaces, as they are still commonly referred to, are in every way remarkable structures that, ever since their dramatic discovery a century ago, have come to be emblematic of the aesthetically antithetical notions that the term Minoan has meant in modern times. For some, Minoan palaces are hopelessly labyrinthine and confused agglomerations of spaces devoid of architectonic logic or functional clarity. For others, these massive building compounds clearly exhibit a brilliance in harmonic design and precise execution, combined with an exquisite sensitivity to landscape siting and natural formation.

Today, a century after their discovery, the latter assessment has gained wider acceptance, while the former is understood as not incorrect in some instances. The fact of the matter is that the palaces and other large structures were in use in some cases for the better part of a millennium, often surviving multiple earthquakes and subsequent rebuildings and reorganizations. But the evidence of remarkable sophistication in the original conception of the central buildings at Phaistos, Mallia, and Knossos, and of great care and precision in their planning, layout, and construction, is unmistakable [**33**]. The same may also be said for many other urban buildings and great country houses, particularly during the Neopalatial Period.[1]

Detail of 37

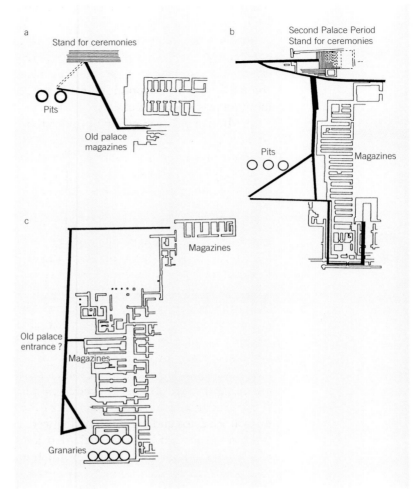

a
Stand for ceremonies
Pits
Old palace
magazines

b
Second Palace Period
Stand for ceremonies
Pits
Magazines

c
Magazines
Old palace
entrance ?
Magazines
Granaries

Comparative plans of the
western blocks and west
courts of the Minoan palaces
at Phaistos, Knossos, and
Mallia, showing the triangular
raised causeways in the paved
west courts, and, at Phaistos
and Knossos, the stepped
'theatral areas' on the north,
and the sunken *koulouras*
(pits) next to the causeways.
At Mallia, the triangular
causeway is adjacent to a
series of above-ground silos.

Although the designation 'palace' will be retained here for conveni-
ence, it is increasingly evident that these great multistoreyed buildings
bear little resemblance to the residential headquarters of Mycenaean
rulers of the Late Bronze Age mainland—the buildings to which they
were initially compared when first discovered. Nor are there any clear
parallels to palatial constructions in Egypt or the Near East in the cur-
rent archaeological record. But the problem with calling the Minoan
buildings 'palaces' is that the term foregrounds only one likely (and not
uncontested) function of these compounds. There is no solid evidence
that these were the residences—permanent or temporary—of queens,
kings, or priests, or other political or religious functionaries.

The Minoan palaces were distinctly multifunctional centres of their
respective cities, combining what we might designate today as reli-
gious, commercial, manufacturing, social, political, ceremonial, and
other activities, some public, others private, in a common structural

framework with many different gradations of separation from and connection to the rest of the urban fabric. Although the openness and accessibility of the buildings to the rest of their cities has often been exaggerated, the fact is that their many different kinds and sizes of interior spaces, terraces, stepped platforms, and courtyards comprise a complexly articulated mosaic of interwoven activities; these are porous monuments rather than castles.

A Minoan palace may best be understood as a theory or diagram of an ideal integration of the component parts of Minoan life and society, assembled together in a sophisticated architectural package, itself harmoniously integrated into its environment. In that respect, it was a microcosm or model of the Minoan world.

Phaistos

One of the most dramatically situated Minoan settlements, the city known by its later Greek name of Phaistos (PA-I-TO in the later Linear B tablets) stands on the eastern end of a large promontory overlooking the great Mesara Valley plain in the southern part of the island.[2] At the western end of the same outcrop of hills, just under an hour's walk away, and with a view to the Bay of Mesara beyond to the west, stands the large Second and Third Palace Period complex of buildings known today as Haghia Triadha.

To the north of both sites, beyond a series of low hills in the foreground, is the great double-topped Mount Ida, the tallest in the line of Cretan mountains in the central part of the island. The major structures at Phaistos and Haghia Triadha were laid out in relationship to this twin peak; and it seems likely that the two successive palaces of Phaistos were built so as to specifically frame the mountain's double top, which would have loomed over the original north façade of their central court, when viewed from its centre (see **44** and Chapter 4). Ida's significance in Minoan social or religious ceremony is suggested by the presence of a long-used cave sanctuary, known today as Kamares, whose entrance is itself visible from the Phaistos site.[3]

The eastern edge of the promontory of Phaistos has been the site of extensive habitation from the beginning of the Early Minoan Period to the Hellenistic Period and beyond. In the early Middle Minoan Period, construction began on what was to become the extensive First Palace compound of Phaistos, still partially visible under and on the western margins of the impressive remains of the finely built Second Palace. The latter was constructed over the central portion of the ruins of the first building, after the First Palace was covered over by a thick foundation layer of cement. The platform laid down to support the second building effectively preserved large portions of the First Palace's western section, including the large west court and what has been called its theatral area on its northern side (see below).

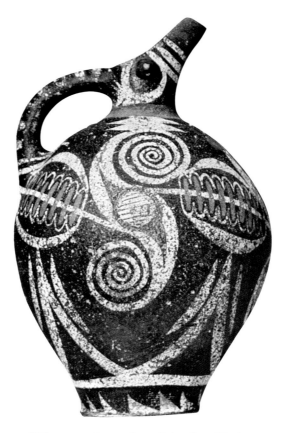

34

Kamares-style jug from Phaistos, Middle Minoan II, height 27 cm. Kamares ware, named after the cave sanctuary on Mount Ida where it was first found, is a type of pottery decoration prevalent during the Protopalatial Period. This wheel-made ware is characterized by its fine clay and often very thin ('eggshell') walls. The intricate polychrome decoration, with red and white geometric and floral designs on a black ground, may be an elaboration of earlier light-on-dark pottery.

What remains today of the first Phaistos compound are walls and pavements shown in grey in our plan, outlined walls belonging to the later Second Palace [**35**]. The building was conceived as a unit and constructed over time on several terraces ascending to the north, and may have covered most of the eastern end of the high promontory; it extends more than 200 m from west to east and north to south. A substantial section of the hill fell away at an unknown time, destroying the southeastern quarter of the buildings, and thus the original extent of each in that area is unknown.

The extant portions of the First Palace include a carefully laid out indented western façade with a series of adjacent small rooms, some opening out on to the western terraces; a trapezoidal west court on a middle terrace, with a triangular raised causeway at its centre, connecting what was probably a major western entrance to the building with a theatral area on the north side of the court, and (just short of a series of rooms of unknown function on the east) the upper end of a ramp descending to the level of the lower (southern) terrace. The middle west court was bordered on the south by four *koulouras* or round stone-lined pits [**36**], forming part of a retaining wall separating the middle and lower courts. The theatral area on the north side was built against a

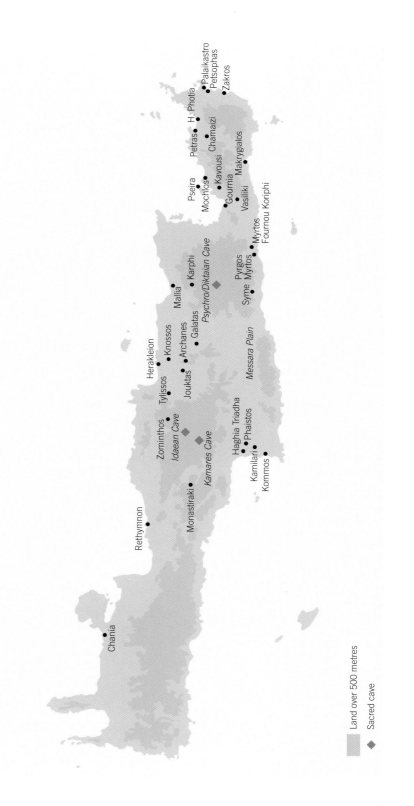

Map 2

Bronze Age Crete
showing major sites

Palaikastro
Petsophas
H. Photia
Petras
Zakros
Chamaizi
Makrygialos
Pseira
Kavousi
Mochlos
Gournia
Vasiliki
Fournou Koriphi
Myrtos
Karphi
Pyrgos
Myrtos
Psychro/Diktaian Cave
Syme
Mallia
Galatas
Archanes
Messara Plain
Knossos
Herakleion
Jouktas
Tylissos
Haghia Triadha
Zominthos
Phaistos
Idaean Cave
Kamilari
Kamares Cave
Kommos
Monastiraki
Rethymnon
Chania

Land over 500 metres

Sacred cave

Detailed plan of the western
wing, including the cult area,
of the First Palace of Phaistos,
of the early Middle Minoan
Period. Walls and pavements
shown in black represent the
Second Palace, while the
outlined grey walls represent
those of the earlier First Palace.

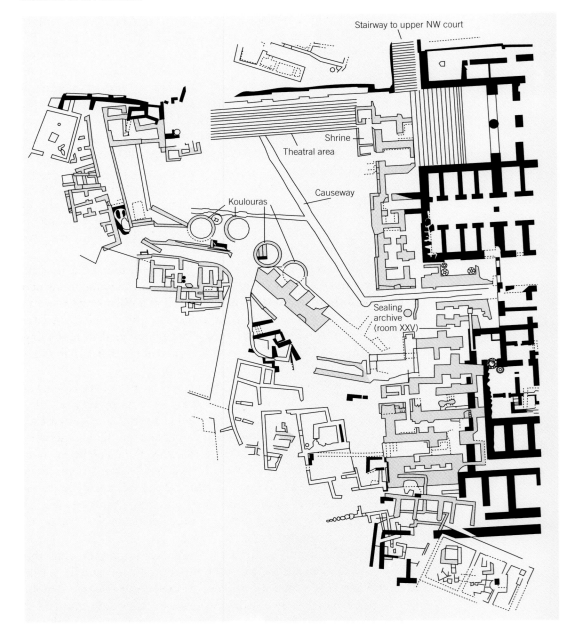

Stairway to upper NW court

Shrine

Theatral area

Causeway

Koulouras

Sealing
archive
(room XXV)

retaining wall separating this middle terrace from a paved upper platform to the north. Nearly all of this terracing and First Palace construction was covered over by the Second Palace, when a new cement surface was laid down to support the second building.

This uppermost (northwest) court was connected to the middle (west) court by a stairway from the western part of the palace; it contained a raised causeway running north–south, and a retaining wall on the northwest, suggesting the existence of yet another, even higher, terrace in that area. The southern side of this terrace is largely empty of building remains, apart from the foundations of a later Greek building. To the northeast are walls and rooms partly covered by later (Second Palace) construction, including rooms (on the extreme northeast of the promontory) which may have formed part of an original northeast entrance system to the First Palace; one of these areas may have formed part of the building's records archive, as clay fragments of inscriptions in the undeciphered Minoan hieroglyphic script, and the (to date unique, and also undeciphered) Phaistos disk were found here [**37**]. Dating possibly to the Middle Minoan IIIB Period, or the eighteenth century BCE, the disk is impressed on both sides with pictographic symbols arranged in a spiral. The signs are grouped and divided from each other by lines and may possibly denote words or phrases. The only parallels for these signs are incised on a double axe from the Arkalochori Cave.

In the south-central part of the First Palace were found traces of the original central court pavement, with remains of the foundations of a colonnade forming its western flank, as well as a pillar crypt room to the southwest. The plan clearly indicates the way in which the later construction of the Second Palace was accommodated to remaining traces of the First Palace, using some of its extant walls or wall foundations, and some original pavements.

Very little is known about the functions of the First Palace; most of what remains points to storage rooms on the western edge of the building (a circumstance repeated at all the other palaces in each period), with some magazines in the northwest corner later modified to serve as small shrines that opened out to the west court. We do not know how the various paved courts may have been used, or what the differences in usage might have been between the west and central courts. But as we shall see below, the Phaistos west court contains features repeated at Knossos and Mallia in the First Palace Period, suggesting similar or complementary community functions.

This First Palace at Phaistos was clearly a very important social and cultural centre dominating much of south-central Crete and the fertile Mesara Valley plain, and most likely also whatever sea-trade might have focused upon its bay. We do not know the circumstances that led those responsible for Phaistos to abandon the original organization of

36

The west court of the First Palace at Phaistos, showing the raised causeways and theatral area.

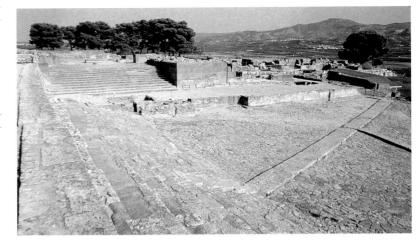

37

One side of the undeciphered Phaistos disk, dated to the Middle Minoan IIIB Period. Both sides of the Phaistos disk are impressed with what appear to be pictographic signs, arranged in a spiral and divided into groups by transverse lines.

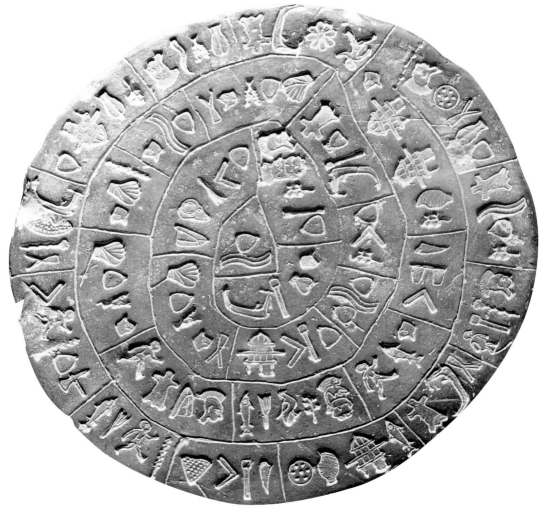

their impressive compound after its destruction by earthquake and build a distinctly different construction on top. But that decision has left us with a clear picture of two distinct conceptions of architecture and design in the Middle and Late Minoan Periods, changes that are not as stark or as sudden elsewhere.

Mallia: Quartier Mu

Building A in Quartier Mu at Mallia in central Crete [38] is an imposing administrative structure that dates to the First Palace Period. Quartier Mu is critical to understanding the emergence of Minoan palace architecture because it contains a series of important buildings incorporating ceremonial, administrative, and craft activities, including a workshop for making sealstones. Building A in Quartier Mu is possibly the earliest building to incorporate many of the design features that we have come to associate with the Minoan palaces.

With some slight variations, a group of rooms within Quartier Mu replicates the plan of the Throne Room at Knossos, which indicates the importance of this building. These rooms include an elaborately paved forehall with light-well leading into a hall which overlooks an exceptionally deep (nearly 2 m) lustral basin (a small sunken room reached by a flight of steps) entered from an adjoining room, and a suite of service rooms along the side. A room to the west of this

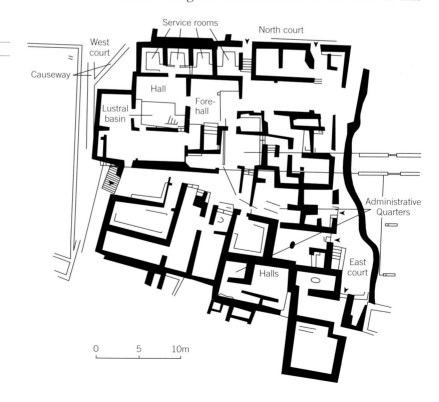

38
Mallia, plan of Quartier Mu showing the large administrative structure, Building A. Dated to the First Palace Period, Building A abuts several other structures, some of which were workshops, and fronts on the small paved courts on the east, west, and north. The small west court has a raised causeway running north–south.

Drawings of Cretule sealings
with Minoan hieroglyphs from
Phaistos. Sealings such as
the ones illustrated were
an important instrument
of Minoan administration,
concerned with recording
the storage and distribution
of various kinds of agricultural
and manufactured products.
That this was a large-scale
system of administration is
evidenced at Phaistos, for
example, where a sealing
archive (dated to Middle
Minoan IIB) located in room
25 was found with over 6,500
clay nodules.

complex contained a rectangular hearth with a cupule or depression. Such hearths are typically associated with sanctuaries. A small chamber just inside the west façade and near the west entrance contained a *kernos* stone with many cupules believed by some to have functioned as an offering table. A similar feature is found near the south entrance in the Mallia palace.

Building A also incorporated the indented west façade, west court, and raised triangular causeway that are associated with the First Palace Period, as we shall see below. Documents of various types including medallions and tablets inscribed with Minoan script and impressed with sealings were found in the southeast wing of Building A. Such documents were used to keep a record of goods and to track their movement. Many of the sealings were found near the east entrance, indicating an exchange of goods. Magazines in the southwest wing contained numerous large storage jars or *pithoi*, adding to the palatial character of the building.

Monastiraki

The settlement of Monastiraki [**40**] is also the site of an imposing administrative complex of the Protopalatial Period.[4] Situated in the middle of western Crete and overlooking the Amari Valley, Monastiraki was ideally located to facilitate trade between Phaistos and the fertile Mesara Valley to the south and sites located in the vicinity of modern Rethymnon on the north coast. Some of its pottery is said to resemble that of Phaistos. A clay building model constitutes another valuable find.[5] The director of the Greek excavations, Athanasia Kanta, interpreted the monumental structures at Monastiraki as a 'palace'. Thus far, many palatial features have been uncovered, confirming Monastiraki's position as an ancestor of the sophisticated complexes we see in the succeeding era.

What has been uncovered consists of a series of complexes partially located on the hilltop and partially terraced into the side of the hill. Cutting into the side of a hill to construct a terrace to build upon was a typical Minoan construction technique. The side of the hill provided a natural support for the rear wall of a room which could in turn provide greater support for an upper storey, which would itself often be connected to adjacent ground-level rooms on the adjoining hilltop. Such multilevel constructions are found throughout Bronze Age Crete.

The lower north terrace at Monastiraki contained a series of rectangular storerooms containing *pithoi*. Recent excavations uncovered a monumental, though unconventional, reception hall on the upper terrace above the storage area. The cut limestone door jambs and a large column base indicate the importance of the hall (see **40**). This structure opened onto a paved west court—a feature common to palatial buildings.[6] A complex of 60 interconnected storage rooms located to

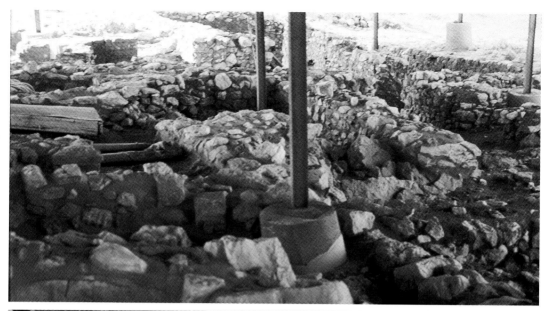

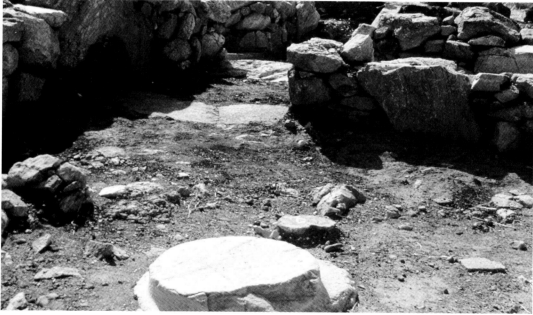

40

Photographs of Monastiraki, showing the reception hall and administrative complex, dated to the Protopalatial Period. The site is important for reconstructing trade patterns within the island, and for understanding the nature and organization of the first palaces.

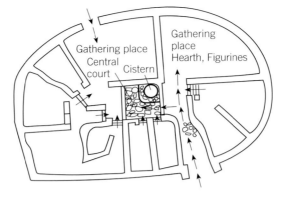

41

Plan of the Oval House at Chamaizi in eastern Crete, Middle Minoan I. Note the small paved court and cistern in the building's centre.

the southeast indicates a sophisticated design programme reminding one of the legendary associations of Minoan architecture with mazes and labyrinths. It is still unclear whether these areas were physically connected, but they seem to be clearly associated through their related functions of storage, reception, and administration.

This last area contained approximately 700 clay sealings fallen from an upper storey. Such a find testifes to the presence of a sophisticated administrative system in what had seemingly become a tradition of the Protopalatial Period. With no earlier precedents, it might have been influenced by either a mainland tradition as we saw at Lerna or a Near Eastern tradition.[7] The fact that the building went out of use by the Neopalatial Period might be attributed to its unusual location in the hinterland, far removed from any harbour at a time when many commodities seem to have been transported by boat.

Chamaizi

Located in east Crete, the Oval House at Chamaizi includes a number of unique features which have given rise to conflicting interpretations. These include its position on top of a conical hill, and its unusual ovoid ground plan conforming to the shape of the hill. The building contained features such as a hearth and figurines which suggest to some that this may have been a religious or ceremonial building, whether or not it may also have been a residence [**41**].[8]

Containing a dozen interior spaces around a small paved central court with a cistern in one corner, the building was divided into two distinct zones, each with its own entrance. It may have had two storeys, and some of what has been interpreted as cult equipment has fallen from the upper storey, including male and female figurines, miniature jugs, and a round offering table. The large northeast room contained a hearth, and the presence of loomweights in the building suggests that textiles were produced here, although most likely not on a large or commercial scale.

Aerial view of the fortified
building at Ayia Photia, Middle
Minoan IA. Note the rounded
projections or bastions on the
circuit wall which may have
been used for viewing and/or
defence. They differ from
bastions found elsewhere in
the Aegean in being solid
constructions.

Ayia Photia

Ayia Photia [42] is an important but still little known Middle Minoan IA site in east Crete, situated on a headland some 5 km east of the city of Sitea. Ayia Photia is unique both for its circuit wall and its early incorporation of a number of palatial architectural features.[9] The remains of the circuit wall are preserved on three sides along with the remains of several semicircular bastions.

Though larger on Crete, the rounded projections on the circuit wall may well be the functional equivalent of the semicircular bastions found in Early Cycladic architecture as at Kastri on Syros and Early

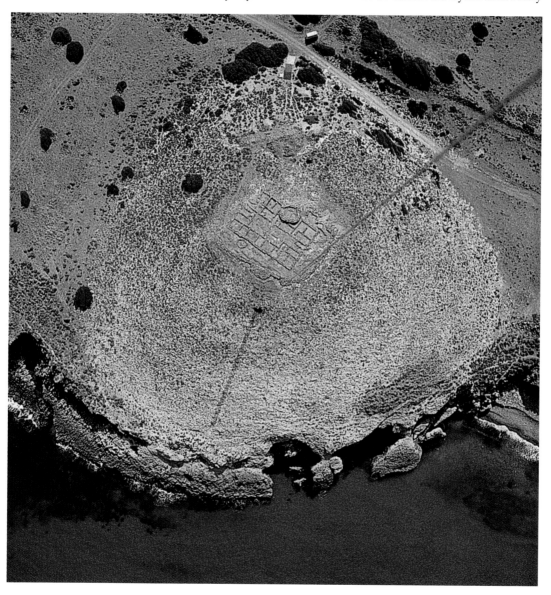

Helladic architecture such as Lerna on the mainland.[10] It has been suggested that the many Early Cycladic finds from the nearby Early Minoan cemetery indicate a Cycladic presence in the area.[11] It should be noted that the main difference between the bastions at Ayia Photia and those of its Aegean island cousins is their solid interior. There is also a contextual difference: the orientation of the Ayia Photia bastions towards the sea suggests that they were used as much for viewing or observation as for defence.

The one-storey rectangular building measures approximately 18 × 27.5 m, and includes over 30 spaces organized around a long, narrow central court. The main entrance to the court was on the west end and another entrance was later added on the east end. A stone-lined pit or *kouloura* situated to the northeast is a feature typically found in the west courts of the First Palaces. The simple regularity of Ayia Photia's rectangular shape is rare in later palatial-style villas, which normally have very complex systems of projecting and recessed wall façades, but it is common in more vernacular buildings and in annexes to large Neopalatial buildings.[12] Ayia Photia is itself comparable in size to such annexes.

The recesses visible in the north wall are another feature commonly found in the palaces and palatial villas. One archaeologist believed that such recesses indicated the presence of windows in Minoan buildings, particularly on an upper storey, as few Minoan buildings reveal traces of ground-floor windows.[13] The presence of recesses in the north wall alone might further indicate that this was the formal public front of the building and that it received more attention from the builders; in any case, this would have been the most visible side to anyone approaching the site from the sea.

Another feature of the plan that is characteristic of Minoan architecture is the arrangement of spaces. There are just eight or nine architecturally distinct groups of rooms—sets of rooms that communicate with each other but not with the other rooms except by crossing the central court. One example of this is the suite of three rooms in the northwest corner of the building. They do not communicate with the central court, but only with the five rooms or spaces to the east. This second group of spaces opens onto the central court, but does not communicate with the other rooms to the northeast. Together, these two groups of rooms form the largest cluster within the building.

Whether each group of rooms corresponded to a social unit (such as a nuclear family) or to a functional distinction or both is unknown. In the case of both, each social unit would be responsible for particular jobs within the household. This in turn might be understood by considering the types of pottery and tools found in each room or in each cluster of rooms, and then looking for similarities and differences. We know that the finds from the building included domestic pottery such

as cups, pots, and jugs; stone tools including obsidian blades; raw materials for stoneworking; hearths, a bronze axe, and a loomweight.[14] Determining how these objects contributed to the overall functioning of the household will depend on understanding their contextual relationships—which will have to await the final publication of the site.

The vernacular tradition in Greece and Crete

Generally speaking, the designs and spatial organizations of buildings on Crete and on the Greek mainland contrast with each other in several ways. Most mainland structures are rectangular in plan, often with one side notably longer than the other, of which the *megaron* and the corridor house are notable variants. As we have seen above, the *megaron* form has a long history in most of the Aegean apart from Crete, only appearing there in the later Third Palace Period. Organized around a central long axis, mainland houses are most commonly entered on one short side, the principal interior spaces arranged in sequence along the central axis, as at Dimini or Lerna (see **8** and **16**).

By contrast, Cretan structures, whether simple or complex in outline, tend towards the squarish, with no central interior axis. In plan, smaller buildings often consist of a square-within-a-square, occasionally with a pier or column at the centre of one room; an example is the small structure at Rousses [**43**], perhaps a religious establishment of some sort, possibly a warehouse facility for ceremonial implements rather than primarily a shrine or a residence.

43

Plan of the 'sanctuary' of Rousses, Middle Minoan III–Late Minoan I. In room 1, a fragment of stone double horns ('horns of consecration') was found. Room 2 contained fragments of many cups in a layer of black ash. Stone offering tables were also found in this building. The structural frame of the building, consisting of a square-within-a-square plan, was frequently used in Minoan vernacular architecture, with spatial proportions and sizes varying according to different functional needs.

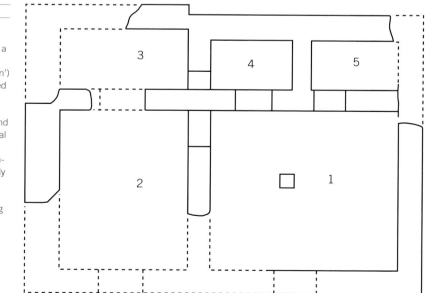

Ritual practices

The west courts of Knossos, Phaistos, and Mallia

The three main regional centres of the Protopalatial Period are located at Knossos in north-central Crete, Mallia about 37 km to the east, and Phaistos [**44**] in south-central Crete. Their size, architectural layout, and artefactual remains indicate that they served as important regional administrative centres, sites of public gathering, sites of public and private religious expression, and probably as places where goods and services could be exchanged. Each of these sites had substantial settlements dating to the Prepalatial Period, although Knossos was by far the largest of these. Architectural changes, rebuildings, repairs and reuse, and modern archaeologico-touristic reconstruction at Knossos[15] make its Protopalatial remains in some instances difficult to detect, understand, and interpret, and what is visible today is primarily a Neopalatial building.

Economic interpretations based on formal resemblances found at Knossos, Phaistos, and Mallia and later fresco evidence have played a conflicting role in the interpretation of these buildings. Although they were superficially similar, the three major settlement compounds contained subtle differences in their earlier layouts which become more marked in the Neopalatial Period.

The palatial west court is a characteristic feature of the Minoan central urban compound which particularly undergoes variation in the presence and distribution of the architectural features typically associated with it.[16] These features included raised triangular causeways or walkways and *koulouras* (pits) (see **36, 33**).[17] In addition to these, there is a stepped theatral area at the Phaistos palace; all of these features were buried under Neopalatial Phaistos.

44
Aerial view of the palace at Phaistos, showing the compound's orientation towards Mount Ida on the north.

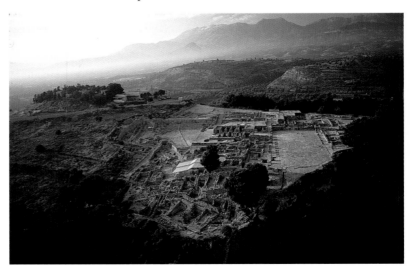

While it has been commonly accepted that the palaces' west courts served as gathering places for some kind of public function, the purpose of these public gatherings has been the subject of conflicting interpretations.[18] Some scholars would like to see these court and causeway systems as the sites of harvest festivals related to each palace's greater economic function as a centre for the (community?) storage of grain and other foodstuffs.[19] Others would like to see the west courts as the sites of ritual dancing among a 'Sacred Grove' of trees.[20] Finally, the idea that the palaces served as centres for the redistribution of grain has recently come under strong criticism.[21] Part of this lack of clarity may be due to the largely unquestioned assumption that each of these compounds carried out identical rituals and played identical roles in the local, regional, and island-wide economy, whereas it is also conceivable that palatial form and function were more autonomous.[22]

The interpretation of the *koulouras* (pits) at Knossos and Phaistos as grain repositories is apparently based on formal analogy or comparison with Mallia. The Mallia structures are quite different from Phaistos and Knossos in actual appearance, although they do appear deceptively similar in plan. The apex of the triangular causeway on the west court at Mallia ends next to what the building's excavators termed eight silos.[23] It is widely accepted that these silos were used for grain storage.[24] The silos at Mallia differ from the pits at Knossos and Phaistos in being raised above ground, and four of them contain central pillars to support a roof which would have served to keep the grain dry. At Mallia, the end of the triangular causeway may have served as what one archaeologist called a 'behavioural focus' directing an individual walking along the causeway to the silos.[25]

A possible activity involving these features might have included a procession of individuals depositing grain in the silos or perhaps even receiving a ration. In the first scenario, farmers might be imagined as exchanging their produce for specialized craft items or imported goods, whereas in the second scenario we might envision craftspersons connected with the palace receiving a food ration in exchange for their productive labour. It has been suggested that formal rituals occurred at least twice a year: once in the spring when grain was brought to the palace after the harvest, and again in the autumn when seed was distributed for sowing.[26]

In contrast to the arrangement at Mallia, the stone-lined pits at Knossos and Phaistos were sunk into the court and preserve no evidence of a roof or any kind of moisture-proofing sealant. The relationship of the causeway to the *koulouras* at Phaistos more closely resembles that at Mallia in that the apex of the causeway ends at the *koulouras*. However, if visitors followed the broader and more finely paved leg of the Phaistos causeway they would be led directly from the theatral area to the main south entrance of the First Palace.

45

Hypothetical reconstruction
of the so-called 'Window of
Appearances' in the west
façade of the palace at
Knossos, Middle Minoan III.

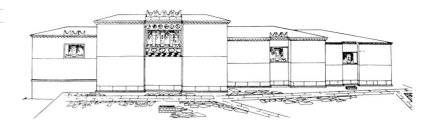

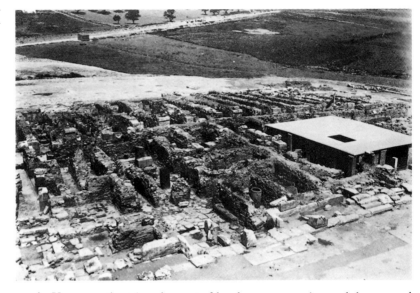

At Knossos, the triangle created by the causeway is much larger and
directs the visitor along a slightly different route. One leg of the cause-
way leads directly to the main south entrance of the palace. The other
leg bypasses the *koulouras*, passing close to only one of them until it
ends at the west façade of the building. One scholar favours a ceremony
focusing on a Window of Appearances on the upper floor at Knossos
[**45**, **46**].[27] Such royal windows of appearances were known later in
Egypt. It was believed that the Knossian window would have been
connected with an epiphany ritual (referring to the appearance of
the image of a deity).[28] The leg of the causeway which passes the
koulouras does not end in front of this conjectured window but, oddly
for this interpretation, at a blank wall to the south of it. Another way of
understanding movement along this causeway would be to see a
procession walking from north to south in front of the west façade,
then branching off toward the *koulouras* or proceeding straight into the
palace, or perhaps both. Needless to say, such scenarios may be
multiplied indefinitely.

As indicated above, the interpretation of the *koulouras* at Knossos
and Phaistos as grain repositories is based on superficial similarities
with Mallia. The grain storage interpretation of these *koulouras* has

47

47
Detail of miniature 'Sacred Grove' fresco of women dancing, Knossos Palace. The scene depicted most probably records events taking place in or around the palace. The contrast between the large, light-coloured seated women at the front of the audience, and the sea of smaller, darker-skinned standing males behind them is striking, the size differential suggesting a special status of the females as goddesses or priestesses. The women's polychrome flounced skirt or apron is depicted many times in Minoan and Theran frescoes.

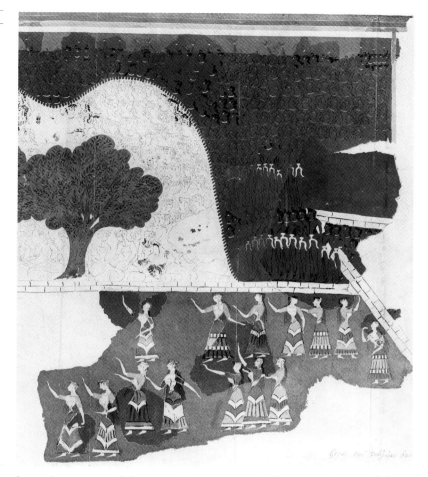

been incorporated into modern economic interpretations of these Protopalatial palaces. For instance, it has been estimated that the *koulouras* at Knossos could hold a year's supply of wheat, enough to feed 1,000 people, while those at Phaistos could hold enough wheat to feed 300 people.[29] Some have seen the *koulouras* and the entire west court systems of Phaistos and Knossos as areas of controlled public activity, mediating between the city and the palace.[30]

Others have been tempted to see the *koulouras* functioning as planters for trees such as those depicted on the so-called Sacred Grove fresco from Knossos [**47**].[31] Based on an analogy with the Knossos fresco, one scholar also interpreted the *koulouras* at Phaistos as planters for trees which would serve as windbreaks and sunscreens for the exposed southern flank of the west middle court. Recent detailed studies of the *koulouras* have in fact called into question the idea that those at Phaistos and Knossos ever held grain.[32] This conclusion was reached on the basis of ethnographic studies, replicative archaeological studies, and their structural unsuitability for keeping grain dry (i.e. no evidence

of lining or capping). These studies indicate that rubbish pits or tree planters are far more reasonable interpretations.

Support for the interpretation that the *koulouras* were used as planters for trees may also come from the prevalence of tree iconography believed to be in ritual settings such as atop altars.[33] Much of this iconography is found on Minoan seals, although the Sacred Grove (or Sacred Dance) fresco is the most often-cited example because its placement of trees in an architectural setting calls to mind the Knossian west court with its causeways, with spectators watching what some take to be ritual or ceremonial activity.[34] Not least of the many problems involved with interpreting the Sacred Grove fresco in these ways, however, is the fact that it is very extensively restored.

There does not appear to be evidence for the three trees that are reconstructed. One scholar reconstructs two and even this number could conceivably be reduced to one.[35] Another problem is that the relationship of the location of the trees to the beginning of the triangular causeway on the fresco does not correspond to the actual location of the *koulouras* in relationship to the triangular causeway—although there is no reason to assume that Minoan fresco scenes were intended to accurately reproduce actual landscapes or urban settings. However, it seems that the placement of the tree(s) could conceivably be altered to enhance this relationship.

Paradoxically, using the west court as evidence to reconstruct the fresco would render the fresco less relevant as a piece of independent evidence from which to interpret the features of the west court. A recent account of artistic representations of Minoan architecture places the location of the Sacred Grove fresco in the theatral area at Knossos as this location would perhaps more suitably accommodate the placement of the crowd, and more closely match the depiction of the causeway in the fresco.[36]

The assembly and dancing depicted in the fresco has been interpreted as a ritual connected with an epiphany or appearance of a 'Great Goddess'. The connection of this ritual to a festival of the Goddess is largely linked to the subject matter and interpretation of frescoes from many other periods at Knossos.[37] Accepting these connections would seem to imply that the function of Knossos remained unchanged and relatively fixed for a period of some 600 years, despite the many changes in the architecture and iconography of the building. While not out of the question, such an assumption may in fact raise more problems than it appears to solve.

One other possibility is that the pits at Knossos and Phaistos were used if not practically then at least symbolically for very short-term grain storage in ritual ceremonies connected with the local or regional harvest. Since the Sacred Grove fresco has been dated to around the very beginning of the Neopalatial Period, it remains a tantalizing

possibility that at least some of the *koulouras* at Knossos may have been secondarily reused to hold trees after being primarily constructed for use in harvest festivals.[38]

We have no difficulty accepting the idea of a 'harvest festival' at Mallia as discussed above. The situation at Knossos and Phaistos, however, is somewhat more complex and we have outlined here some possible alternatives. We also believe that it is significant that the west courts at Knossos and Phaistos underwent a number of changes at the end of the Old Palace Period, whereas the formally similar west court at Mallia seems to have been left relatively intact. Those changes were as follows.

At the end of the Old Palace (Protopalatial) Period (MM III, *c.*1700 BCE), the western court, causeway system, and most of the theatral area at the palace at Phaistos were paved over with a form of Minoan cement that raised the level of the court some 1.3 m.[39] Phaistos was rebuilt and Knossos was remodelled (see Chapter 4), presumably after damage caused by an earthquake. In the rebuilding process at Phaistos, these features were not replaced. Any use of the causeways and *koulouras* for public ceremonies at Phaistos would have been discontinued and public ceremony would have centred on gatherings in the vicinity of the monumental *propylon* entry and a (now relatively featureless) west court (see Chapter 4).

The *koulouras* at Knossos were filled in with rubbish including earth, rubble stone, and sherds which were dated to near the end of the Old Palace Period.[40] The pits were paved over shortly afterwards, although apparently the causeway itself remained in use. Based on their internal remains, Evans interpreted the *koulouras* as rubbish pits that were cleared out periodically. Many archaeologists, however, believe that the pits were too carefully laid out and built to be devoted to rubbish collection, but this may well be a distinctly modern perception. It is important to note that the discard habits and patterns of the Minoans have not yet been systematically studied; this issue is touched upon in Chapter 4. In light of this, Evans' idea that the *koulouras* functioned as rubbish pits also merits serious reconsideration.

The central building compound at Gournia (see **63**) was built during the New Palace Period. Its abbreviated west court—which measures only approximately 5 × 15 m—is little more than a widening of the road. Although it is also lacking the combination of pits and causeway, an upright stone placed in a wall recess along the west court is intepreted as a *baetyl* or an aniconic (non-mimetic) image of a deity. A cupule or depression in a stone slab associated with this *baetyl* has recently been interpreted as a place to deposit offerings.[41] These features render the function of the west court at Gournia distinct from those at the larger palaces.

The changes that occur in the west courts of the Minoan palaces over time suggest that there were changes in the public functions and

uses of these buildings between the end of the Old Palace Period and the beginning of the New Palace Period. Based on changes in the features, we might suppose that there was a change in ritual, or an introduction of new rituals, at every major centre except Mallia. These changes might possibly be connected to economic functions.

One scholar has conjectured that food storage becomes increasingly centralized as storage facilities for food surplus are removed entirely from communal view to within the palace walls.[42] It should be noted here that this interpretation depends on accepting the assumption that the *koulouras* functioned as granaries. If the *koulouras* in fact functioned as granaries, the Mallia silos may have been maintained because they were tightly incorporated within the architectural fabric of the palace proper, presenting a less ambiguous message of authority than the *koulouras* at Knossos and Phaistos.

Since one leg of the causeway at Knossos ended up in front of a monumental façade, it enhanced or reinforced an image of centralized control over an agricultural or other type of store held on the other side of a blank, imposing wall, inaccessible to those outside. The complicated system of setbacks and recesses, the blankness of the wall, and the careful working of the ashlar blocks that form the lower courses, set the west façades at Knossos, Mallia, Gournia, and Phaistos apart from the other three sides of the megastructure. This has led one scholar to speak of a 'monumental' function specific to this façade.[43]

There is some indication that the economy of Minoan Crete was becoming more complex with the greater development of intra-island and international trade networks by the Neopalatial Period. A recent analysis of Minoan coarseware pottery indicates that storage jars, probably containing dry goods, and originating in east Crete in the region of Gournia, and amphoras (normally used to hold liquids), originating in central Crete, were turning up in other parts of the island.[44] One of the centres of the more international side of this trade network was located at the Minoan coastal city today called Kato Zakro at the east end of the island (see **65**).

It is not insignificant that at the palace of Kato Zakro, the main entrance is located on the northeast, whereas at Knossos it is located at the southern end of the west court. The west wing at Kato Zakro thus did not serve as the major public front of the palace (as was the case at Phaistos, Knossos, and Mallia), thereby lessening its importance. The workmanship of the stone blocks which comprise the west façade of Kato Zakro is in fact much less fine or elaborate in that the stone blocks are rough and unfinished. Those at the other palaces, notably Knossos, Mallia, and Phaistos, are the 'most finely built and composed'.[45]

Judging by some of the unique features found at Kato Zakro, such as its cistern and built wells, along with its carefully laid-out plan, it seems more than likely that those responsible for the construction of

the building compound would have had the resources to construct a western façade as refined architecturally as those in central Crete. Yet evidently they did not bother. The impact of whatever type of court area originally existed at Kato Zakro would have been further diminished by the later addition of an annexe to the west wing which extended more than one-third the length of the west façade and increased the width of the west wing by approximately one-third.

Some of the architectural differences between Kato Zakro and the larger palaces may be attributed to its unique geographic location on the east coast of Crete, which makes it the closest Minoan port to the Levant. Six oxhide (copper) ingots and elephant tusks found in the west wing indicate a Minoan trade connection with the Near East. The main entrance to the Kato Zakro Palace is on the northeast, connected to the main northeast-to-southwest road which has been traced some 40 metres away from the building, and which may have led all the way to the northeastern end of the bay.[46] This would have provided the Kato Zakro building with a physical link to the harbour. Here we might imagine processions of traders being ceremoniously welcomed to the palace with a cargo of raw materials or other trade goods from the east, which could be traded or trans-shipped to the rest of the island or the Greek mainland, or turned into luxury items which were then traded.

The roughly contemporary Bronze Age societies of the neighbouring regions—the Mycenaeans of mainland Greece, the Hittites of Asia Minor, and the Mesopotamian city states of the Near East—are more appropriate sources for comparative historical data than comparisons with later classical Greece because they formed part of a wider Bronze Age Mediterranean culture with shared technologies such as metallurgy, monumental architecture, writing and administration, wheel-made pottery, and textiles. This may also have included common or comparable religious beliefs related to human and animal fertility, possibly tied to a common set of economic practices based on settled agriculture and livestock raising.[47] It has also been pointed out that both Aegean and Near Eastern societies emerged out of similar Neolithic farming cultures.[48] Based on these characteristics, it has been plausibly argued that Bronze Age Crete can best be understood when viewed in the larger context and tradition of independent Near Eastern city states.[49]

Within this larger context we know that it was not uncommon for ritual practice to be focused on a particular city's tutelary deity throughout the Bronze Age Near East as well as in classical Greece, a situation that increases the probability of some kind of cross-cultural development of such practices in Minoan civilization. It should be noted that some of the earliest evidence for Greek worship of localized deities is found in a Mycenaean text from Knossos where oil is being

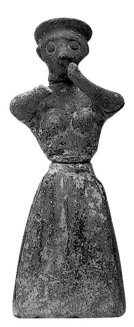

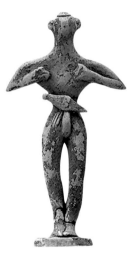

offered to Diktaian Zeus. It was suggested above that these changes,
and differences in the public areas of the palaces, might well be con-
nected with the performance of different rituals. These in turn might
be connected to the worship of tutelary or local deities or the celebra-
tion of particular ceremonies connected with the economic life of the
particular palace and town (such as regional and long-distance trade at
Kato Zakro). The discussion of other Neopalatial architectural and de-
sign features which may provide insights into these questions will be
taken up in detail in Chapter 4.

Petsophas

As we have seen, the Minoan palaces tend to have groups of rooms de-
voted to work, storage, ritual, and ceremonial gathering organized
around a central court with an external court on the west. The central
courts differ in size and in the types of architectural details present.
However, a proportion of approximately 2:1 in the layout of these
courts, and a north–south orientation—often on what has been inter-
preted as a sacred mountain (Ida at Phaistos, Troastolos at Kato Zakro,
or Juktas at Knossos),—tends to remain constant.

On these mountains as well as at peaks located below the mountain
tops, archaeologists have found evidence that they served as informal
gathering places for some forms of religious celebration. As the palaces
gained status and power over time, these high gathering places became
more formalized, suggesting palatial control. By the Neopalatial
Period, this took the form of a built altar, terraces to level out the ap-
proach, and perhaps some storage rooms. The art works and other of-
ferings left at these shrines became more elaborate as we shall see in the
next chapter. These mountain places have come to be known as peak
sanctuaries.

In the Old Palace Period, Petsophas was the site of a peak sanctuary
associated with the large Minoan city of Palaikastro in east Crete
(where no palace has been found).[50] Early peak sancturaries such as
Petsophas reveal evidence of fires, animal sacrifice, and communal
feasting that took place within a defined precinct. The importance of
Petsophas is indicated by the many terracotta figurines [**48**] found both
within its enclosure walls as well as amidst the rocks and crevices of the
surrounding terrain.

The figurines tended to be rather small, 10–15 cm in height.
Protopalatial male figurines were often depicted with slender waists
and with hands folded on the chest, a gesture more commonly made
by Neopalatial female figurines. To this general scheme, the artist
might add details in the form of a loincloth, a belt with a dagger,
jewellery, with schematic ears, nose, and other anatomical features
formed out of clay pellets. Female figurines also tended to be depicted
with slender waists and a flaring bell-shaped skirt. A fan-shaped

headdress sometimes adorns the head, with other features modelled schematically, like those of the males.

Female gestures are distinct from those of males, the arms extended either outward or upward, with the hands sometimes bent towards the face. The more complex figurines were made from several pieces of clay and had more details indicated. A marked tendency to depict females in a more simplified manner than males carries over into the bronze figurines in the following period. Other figurines such as cattle and the occasional bird also occur, as do votive limbs, vessels, and even an altar. Offerings of this type might indicate symbolic gift giving or a desire to receive aid for some affliction.

The rather uniform modelling of the features of these figurines, and the simple and swift rendering of details in brown, black, and white, were seen by early scholars as examples of folk art or as crude versions of finer works. It had been assumed by some that their function as votive objects may have taken precedence over their appearance or conformity to a particular aesthetic; but in any case such qualitative distinctions belong to our own times and values.

Summary

The Protopalatial Period was evidently an exciting time of change and social and cultural development on Crete. The architectural experimentation we saw at the conclusion of the Early Bronze Age was coming to an end, with more and more common design patterns and structural regularities finding their way into Minoan building, despite unusual and unique structures such as the Prepalatial buildings at Ayia Photia and Chamaizi. The palaces were emerging as full-scale administrative, commercial, ceremonial, and religious centres. As we will see in the forthcoming chapters, the sealings which played such a critical role in this administrative structure are becoming a distinctive art form in their own right, one which has provided us with intriguing snapshots and glimpses of Minoan social and religious practices and beliefs. At this time also, the Minoans were placing an increasing emphasis on settling coastal sites, while older inland centres (such as Monastiraki) appear to diminish in importance. These developments accelerate in the following Neopalatial Period, the subject of the next chapter.

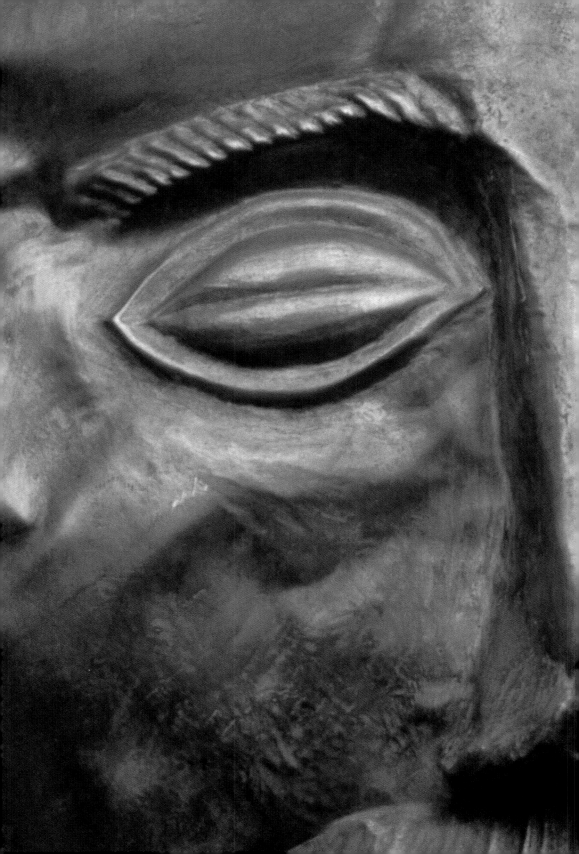

The Second Palace Period

Public art, private art, and the palatial architectural style

A century of discoveries in Crete and the Aegean, and an increase in comparative studies of Minoan culture in relation to the wider world of the societies of the eastern Mediterranean, has altered and enriched our understanding of Minoan art, architecture, and cultural life in ways that could not have been predicted a generation ago.

During the twentieth century, most archaeologists assumed that the Minoan palaces were the residential seats of powerful local or regional rulers ('kings' or 'priest-kings'), who, in addition to controlling often very extensive manufacturing and trading enterprises, were also in control of the religious or ceremonial life of the communities they governed. Understood as the centres of political, social, religious, and economic life, the Minoan palaces seemed to be a dim, archaic mirror of the monarchical world of early modern Europe—or at least of Sir Arthur Evans' late Victorian England—precious evidence, for some, of 'the first Europe' and of tangible cultural continuity in Europe from a time contemporary to that of the great pharaonic civilization of Egypt.

Today it is clear that the term 'palace' is problematic, and its use may have misled us as much as it may have helped us to understand the complexity and distinctiveness of these quite remarkable Bronze Age structures. The fact of the matter is that we do not know for certain just how the great central building compounds of Knossos, Phaistos, and Mallia (and the comparably conceived and designed structures in smaller towns such as Kato Zakro, Gournia, Zominthos, Makrygialos, and Petras) were actually used.[1] Nor is it yet clear what exactly their relationships were with the towns and regions in which they stood, or indeed if such relationships were constant or constantly changing.

For a very long time, specialists have sought to understand these structures, the cities and towns which they served or dominated, and Minoan society more broadly, within interpretative frameworks more

Detail of 95

49

Plan of the palace at Knossos, Neopalatial or Second Palace Period. The palace is the largest of the Minoan palaces excavated. The site on which it stands was more or less continually inhabited from the Neolithic to the Roman Period.

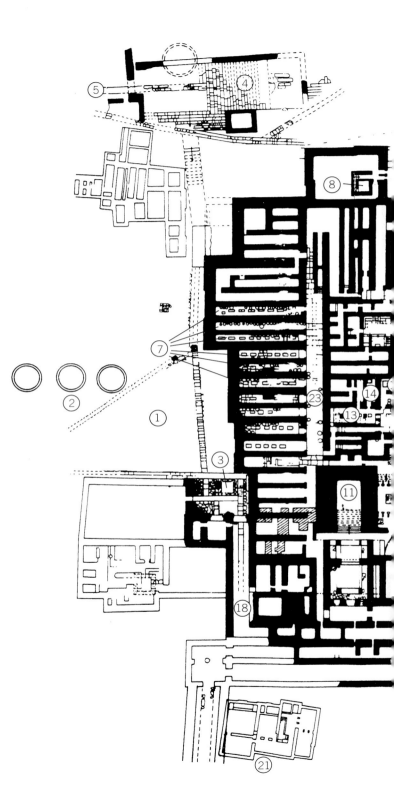

Key

1 Causeway
2 Pits (First Palace)
3 Southwest entrance
4 'Theatral' area
5 'Royal' road
6 North entrance
7 Storage magazines
8 Northwest lustral basin
9 Hypostyle Hall
10 Throne room
11 Stairway (conjectural)
12 'Temple' repositories
13 Pillar crypts
14 Vat room
15 Grand Staircase
16 'Hall of the Double Axes'
17 Smaller hall
18 Corridor of Processions
19 House of the 'Chancel Screen'
20 South East House
21 South House
22 Tripartite shrine
23 Corridor of Magazines

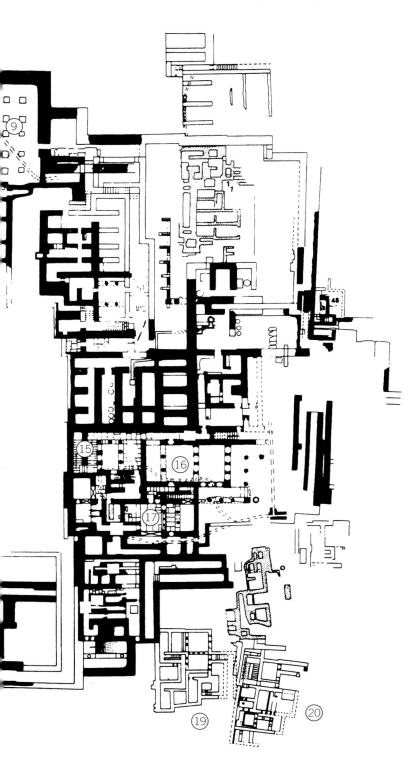

suitable to our own modern circumstances, where (to take one example) distinctions or contrasts between sacred and secular practices and forms may have greater pertinence. At the same time, because the Bronze Age Greek mainland was understood at the end of the nineteenth century to be a land dominated by powerful local or regional leaders (actually named Homeric heroes like Agamemnon, Atreus, or Nestor) based in heavily fortified castles (the Mycenaean citadels; see Chapter 5), it was reasonably assumed by some that Bronze Age Crete was politically and economically similar in organization, if rather dissimilar (to many observers, superior) in its arts, architecture, and urban design.

An overview of the Minoan palaces was provided in Chapter 3. As we shall see, by the Neopalatial Period each 'palace' and 'villa' was conceived as a great work of art in its own right, and—whether they were monasteries, palaces, factories, trading headquarters, or community centres (or at one or another time one or more of these)—the Minoan palaces were the most extraordinary works of art of the entire Aegean Bronze Age.

The Second Palaces: Knossos, Phaistos, Gournia, and Kato Zakro

Knossos

As the site of the largest and most famous of the Minoan palaces, Knossos may also have been the most powerful city on the island for much of the Middle and Late Bronze Age [**49**]. Its history as a palace is extremely complex and is still in part poorly understood. The site of Kephala on which it stands was more or less continually inhabited from the Neolithic to the Roman Period. In contrast to Phaistos, where two major palace building periods are clearly defined both materially and by design (see Chapter 3 above, and below), the Palace of Knossos was a single building with a long, complicated history of repair, renovation, and rebuilding, some of it large scale, some of it minor, all in response to destructions caused by earthquakes and fires.

Although to speak of a Knossian 'Second Palace' may be a misnomer, there was earthquake destruction at the transition from the Middle to Late Minoan ceramic style periods (sometime in the seventeenth century BCE) of sufficient magnitude to precipitate an extensive rebuilding of the palace. This was followed by destructions and rebuildings in the Late Minoan IA and IIIA Periods. The building visible today is an amalgam of these Late Bronze Age reconstructions of the original (nineteenth century BCE) Middle Bronze Age building, made more or less permanent by early twentieth-century CE cement restorations and reinterpretations in the form of those reconstructions.

Most parts of the newer Knossian Palace that are visible today were constructed in two stages, in the Middle Minoan III and Late Minoan

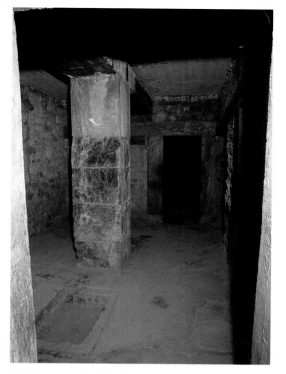

IA Periods. To this time (roughly the seventeenth century BCE) belong the monumental west façade, with its indented and projecting segments of modular proportions; the major entrance porticoes on the southwest, north and northeast, the ceremonial rooms, including the pillar crypts and Tripartite Shrine in the west-central block, between the west magazine area and the central court; antecedents of the later (LM IIIA) Throne Room complex at the north end of the west-central block (see **51**); and, on the east, the Hall of the Double Axes, Queen's *megaron* (see **52**), and the monumental stairway connecting these lower-level halls with the central court.

Both Knossos and Mallia include pillar crypts [**50**] located at or near the centre of their western wings. Incised in both cases with double-axe (*labrys*) marks, the Knossian crypts are adjacent to a room which contained buried objects thought to be part of the foundation deposit of the original palace (the Vat Room deposit). The significance of the centrality of these rooms has been the subject of some discussion; they are positioned in a manner that also echoes the central rooms with benches at Phaistos.[2] At the same time, the pillar crypts of Knossos and Mallia are closely associated with storage areas, and it may have been the case that their ceremonial or ritual functions encompassed passages to, through, or past those quarters.

The illustration of the Throne Room shows the very famous reconstructed wall fresco on the north wall, with griffins (fantastic half-lion,

half-bird creatures) flanking the seat [**51**]. Such a heraldic, flanking convention is known throughout the eastern Mediterranean and Near East from the fourth millennium onward, and, if the Knossian example is comparable to non-Minoan ones, we may interpret the position of the fantastically flanked seat itself as a supernaturally powerful place: whoever sat here would be protected by these symbolic beasts, and partake of their special powers.

The Throne Room also incorporated a sunken chamber on the south side of the room, accessed by a small stairway, opposite the throne. These lustral basins occur in many Minoan palaces and villas, and their function has long been the subject of debate among archaeologists and art historians. These sunken basins at Knossos (and elsewhere) are empty of accoutrements, in most cases. There is a parapet or low balustrade on one or more sides, suggesting that whatever took place in the basins was observable or could be directed and overseen from above.

Most observers concur that the basins were significant ceremonially or ritually, and the recent discovery of examples on the island of Thera, accompanied by wall paintings apparently depicting initiation rites (in one spectacular case, a puberty initiation ceremony for adolescent girls, see below), appears to confirm these conjectures. Some have seen these sunken chambers as antecedents of the secluded room known as an *adyton* in later Hellenic Greek temples and shrines. At Knossos, lustral basins also occur near building entrances (on the northwest and southeast) in the First Palace as well as here in the Throne Room.

The great hall systems on the eastern side of the palace, long taken to be domestic quarters distinguished along gender lines—the larger inevitably being men's (or the king's) chambers, the smaller the women's

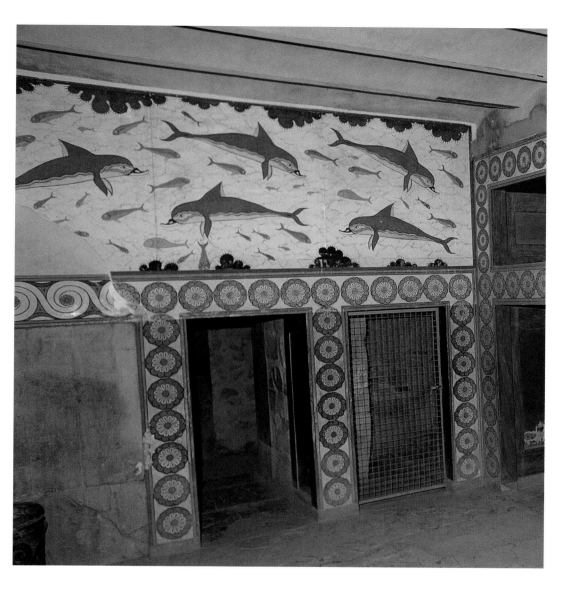

(or, here, the Queen's *megaron*)—may very well have been palace offices. They may have served as reception halls for important visitors and as meeting chambers for city or palace officials, or for groups of individuals engaged in one or another facet of the running of the place —the supervision of its stores and manufactures, the trans-shipment and dissemination of textiles, foodstuffs, produce, raw materials, religious articles and so on. By night, they may have doubled as sleeping areas, with long since disintegrated cushions laid out for this purpose. Such hall systems often occur in pairs, with larger and small units either parallel or perpendicular to each other (see Phaistos or Haghia Triadha), or (in the case of the palace at Zakro, below) separated by a courtyard. The Knossian Queen's *megaron* [52] is composed of the conventional components: a hall surrounded by windows and exposed to the elements, a forehall, and a light-well. The substitution of windows for pier-and-door partitions (PDPs) [53] distinguishes it from the larger Hall of the Double Axes.

One of the more remarkable and intriguing of the painting fragments known collectively as the 'miniature frescoes' found in the palace ruins is the scene—largely reconstructed—that has come to be called the Grandstand fresco [54]. Probably fallen from an upper storey room in the building's west wing, it depicts parts of a horned-roof tripartite pillared shrine with seated women on either side, all surrounded by a sea of male faces. The shrine is of a type well known in Minoan art, as is the women's bare-breasted, flounced-skirt costume. Some see the Grandstand fresco as illustrating a large community scene in a palatial or city court—possibly the Knossian central court, at the exact centre of whose western façade was uncovered the foundations of a tripartite pillared niche (the 'Tripartite Shrine').

54

Grandstand fresco, palace at Knossos, Second Palace Period. Note the tripartite pillared shrine with roof decorations in the form of double horns (so-called 'horns of consecration'). The broad white strip below evidently marks out a courtyard, most likely the palace's central court. This type of shrine is well known in Minoan art.

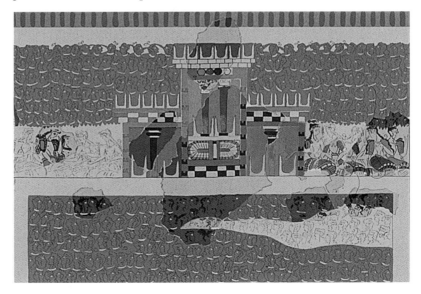

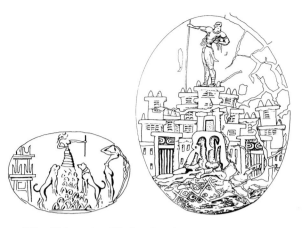

55a

The so-called 'Mother of the Mountains' sealing, found in a deposit of similar sealings in the Knossos Tripartite Shrine area. The woman is standing on a mountain or hilltop and is flanked by antithetic lions. Behind her is part of a building, perhaps a reference to the palace. Compare this with the central part of the Thera fresco in **80**, where a woman is seated on a raised dais flanked by a griffin. Common also in the contemporary Near East, this kind of hierarchical tableau with a raised figure flanked by powerful animals frequently signifies divine status.

55b

The 'Master Impression' sealing, Chania, Late Minoan I–II. This important clay sealing depicts a series of multistorey buildings set in a rocky landscape, and crowned with a series of double horns. On the highest roof stands a male figure (a god or ruler) with a staff, in a pose identical to the 'Mother of the Mountains' figure. To some observers, the horns on the roofs resemble beehive-shaped granaries. The town is set within a rocky landscape by the sea, in a manner resembling those in the Flotilla fresco from Akrotiri on Thera, seen in part in **77** below.

The Tripartite Shrine has been seen as situated in a close relationship with the storerooms based on its location on the west side of the central court.[3] This is reinforced by its approximate alignment with the pillar crypts, another feature regularly associated with storage. The deposit of sealings associated with the Tripartite Shrine provides an additional symbolic link to the storage and exchange of commodities. Most of these sealings depict the so-called 'Mother of the Mountains': a female, presumably a goddess, standing atop a scale mountain (a Near Eastern convention) and extending a staff in the so-called 'gesture of command' [**55a**].[4] She is flanked by antithetic lions (a position in other illustrations occupied by a central pillar or sacred tree), possibly signifying her special (most likely divine) status. Compare this to the central portion of the Thera fresco in **80** below, with its seated goddess between two fantastic creatures. Here she is faced by a worshipper making the so-called 'Minoan salute'. The placement of the 'goddess' on a mountain top serves as a symbolic reference to Minoan peak sanctuaries while the columnar structure adorned with 'horns' may refer to the palace.

Other scenes reconstructed from fragments of the miniature frescoes appear to show similar activities, but in different places or against different backgrounds. The most famous shows a scene of women dancing before a group of similarly costumed seated women, again surrounded by sea of male figures, all near trees and raised causeways, in what may be allusions to the Knossian west court (see **47** above). These and similarly colourful and vibrant scenes may record types of ceremonies characteristic of the Knossian city communities during the Second Palace Period, in a manner not unlike the remarkable records of ceremonial and ritual practice seen in the more recently discovered and well-documented and reconstructed wall frescoes of Akrotiri on the island of Thera, discussed later in this chapter.

As we shall see, not a few familiar and widely published Minoan paintings or fresco fragments are controversial, their reconstruction

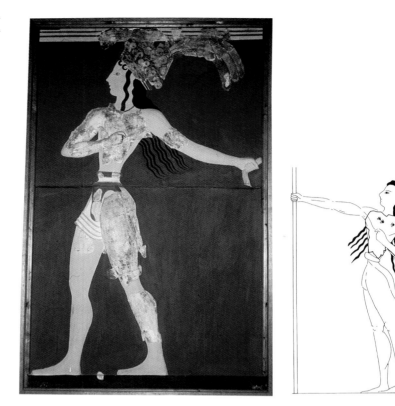

The so-called 'Priest-King'
fresco and new reconstruc-
tion, Palace of Knossos,
Second Palace Period.
The first of these two figures
shows the fresco as it was
originally restored, a striding
young prince wearing a
feathered crown. Only the
crown, the torso, and most
of the left leg are original. It
has recently been suggested
that the fragments used to
restore the Priest-King do
not belong to the same figure.
The drawing next to this is a
recent reconstruction, sug-
gesting that the torso of the
Priest-King belongs to a figure
with a commanding gesture,
not unlike those in **55a** and
55b. The actual gender of
the person remains open
to question.

often extremely conjectural. A good example of this is the collection of relief fragments that Evans called a 'Priest-King' [**56**]. The Priest-King was found at different levels in a basement room below what has been reconstructed as the North–South Corridor leading from the Corridor of the Processions (see Chapter 5) to the central court. The original remains include a crown of lilies normally associated with Minoan sphinxes, the upper torso which preserves a lock of hair, the lily necklace, and clenched right hand brought back diagonally across the chest, a small part of the left arm, most of the kilt and cod-piece, the left leg excluding the foot, and a fragment of the right thigh, all rendered in low relief against a red background.

Evans[5] initially assigned the fragments to three different figures, but later restored them as a single figure leading a sacred animal. As the Minoans adopted the Egyptian convention for indicating gender differences in wall paintings, that is, red to indicate males, white to indicate females, Evans and others have taken it for granted that the figure was a male, making the assumption that the fragments had faded from their original 'reddish brown'.

This account has become increasingly unsatisfactory to Minoan archaeologists over the past 30 years. Although a few still cling to the belief that the Priest-King represented a crowned girl athlete leading a

bull in a ritual procession prior to participation in bull sports, others suggest that he is standing in a more commanding or confrontational pose based on the observation that the lily crown is worn only by sphinxes and priestesses, but never by men.[6]

This more recent reconstruction is based, in part, on the so-called 'Master Impression' (**55b**) a sealing from the site of Chania in west Crete.[7] Here, a male figure standing atop an architectural façade holds a staff in his outstretched arm, while his other arm is bent behind him with his hand resting in the small of his back.

However, the evidence remains too fragmentary for a definitive restoration of the Priest-King and the gender of the Priest-King remains open to question. After all, the Eighteenth Dynasty Eygptian female king, Hatshepsut (*c.*1503–1483 BCE) inserted herself visually and symbolically into the dominant discourse by having herself depicted as a male king, the god Osiris, and as a male sphinx. Framed within this larger Bronze Age context, it is not unreasonable to suggest that the Priest-King was in fact a Priestess-Queen having herself depicted as a male, a bull leaper, and a sphinx thematically linked by the lily necklace and the lily crown. A male appropriating female symbols of fair skin and a lily crown to legitimize patriarchal ascension is another possibility.[8]

It appears that in this Second Palace Period, Minoan buildings were extensively and richly painted with frescoes depicting important or characteristic scenes of daily and ceremonial life: scenes which in some cases may have taken place in or near the areas of the paintings themselves. In this regard, Minoan visual practices share characteristics of fresco and relief decoration seen throughout the Bronze Age eastern Mediterranean, and most notably in Egypt, where the full realization of certain important buildings such as tombs or temples included painted or relief scenes recording—and thus making permanent and perpetual—the activities they contained at a specific ritual time or cyclically over time.

Phaistos

The plans and functional organizations of Knossos, Phaistos, and Mallia are similar enough to suggest that they were initially designed and executed for each community by the same team or guild of professional planners and builders, or at least by teams with an agenda shared by their different client cities. Each of them appear to have been functionally conceived, and architecturally designed and harmonically laid out in very similar ways, suggesting an island-wide programmatic reorganization of each of the three cities in the early phases of the Second Palace Period. Extensive studies of the palace remains in recent years indicate that, despite local variations in the placement, size, or number of some functional components, the major palaces superficially mirrored each other's organization, and to a greater extent, appearance.

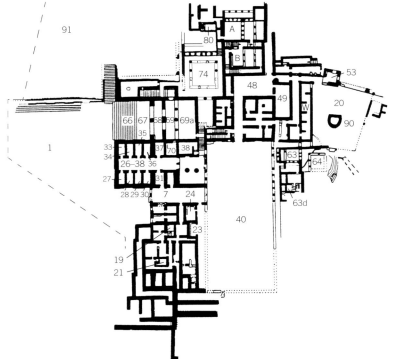

57

Plan of the Second Palace of Phaistos. Some First Palace walls were incorporated into the Second Palace. The new compound exhibits features common to many major Minoan buildings; a pillared hall north of the central court, pier-and-door partition halls on the east and northwest, sunken lustral basins on east, northwest, and west, the block of storage magazines on the west, and the north–south alignment of the central court. The numbering of the rooms here follows that of the original excavators.

At Phaistos, after the destruction of the First Palace discussed in Chapter 3, a new building was erected on a cement platform laid over the remains of the earlier one, and the level of the older west court was raised, covering part of the original theatral area on the north side [**57**]. The new building presents a strikingly different appearance from Knossos and Mallia in the reorganization of its magazine storage area on the west; the construction of a large stepped platform (the Grand Stair) with a pier-and-door partition screen; and the construction of several Minoan hall systems (complete with lustral basins) on the northwest and east and the unusual addition of two more lustral basins on the southwest. What existed of the south wing is unknown because this entire section of the compound fell over the promontory cliff probably sometime in late antiquity.

The very finely built northern hall system consists of two parallel halls, a larger and smaller one, reminiscent of the two halls in the east wing of Knossos (the Hall of the Double Axes and the Queen's *megaron*), or of the double hall systems at Kato Zakro, Mallia, and Haghia Triadha. As at Knossos, the smaller hall is exposed to the elements.

The ceremonial centre of the Second Palace was near the centre of the west wing of the building, continuing what appears to have been the situation earlier at Phaistos, and at Knossos and Mallia. The hypothetical planning grid in **58** indicates the original modular square of 200 Minoan units (identical to the earlier palace and to the other

two major palaces), out of which the east half was given over to the central court, and the west half to the west wing with its benched meeting rooms and lustral chambers. The central axis of the plan replicates the incised double-axe mark so frequently attested on the walls and pillars of the Minoan palaces and villas (see **50**). The thick dark lines in our figure indicate which First Palace walls were incorporated into the new plan, which, it appears, served as base-lines in the layout of the new compound.

An interesting design feature of the Second Palace is the deeply indented west façade articulated out of the square planner's grid. This finely built ashlar masonry façade was harmonically articulated, its sections measuring, from south to north, 21, 34, 55, and 89 Minoan units, replicating in a literal fashion the proportions of the Fibonacci (or golden section) proportional series (1, 1, 2, 3, 5, 8, 13, 21 . . .), known and widely employed both in Crete and contemporary Egypt.[9] Similar —though more simply articulated—proportional schemes were used in designing the monumental west façades at Knossos and Mallia,

58

Central planning grid of the Second Palace of Phaistos. The builders of the second compound used the extant northern walls of the First Palace (shown in thick black) as reference lines for the new modular layout.

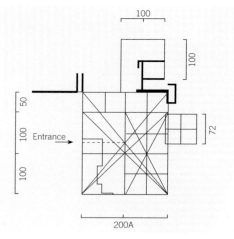

59

Grand Staircase of the Second Palace of Phaistos. The stair may also have served as a site for ceremonial activities.

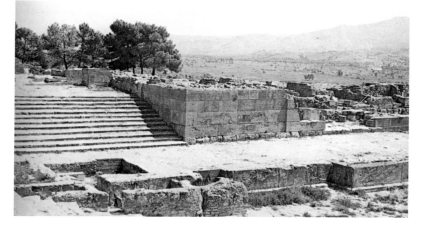

60

Floral-style jug with a naturalistic rendering of wild grasses. Second Palace of Phaistos, Late Minoan IB, height 29 cm. The dark-on-light floral-style pottery begins in LM IA, replacing the earlier Kamares-style polychrome light-on-dark ware.

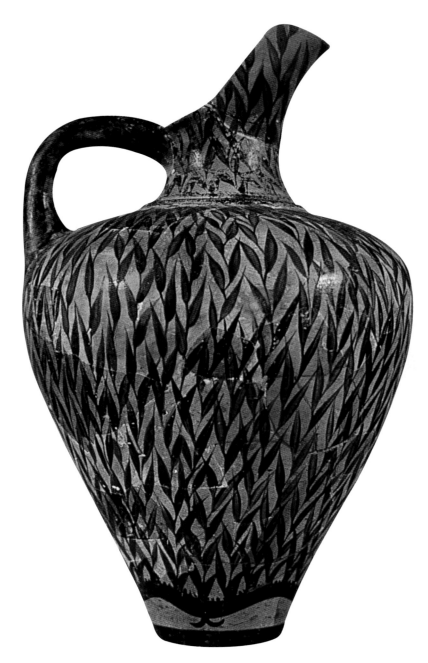

61a

Minoan stirrup jar with octopus in the so-called 'marine style' from Gournia, east Crete, Late Minoan IB.

61b

Postpalatial stirrup jar with octopus from a tomb at Tourloti, east Crete, LM IIIC. In the early days of Aegean archaeology, the stark stylistic differences in the rendering of these octopuses was taken as a marker of ethnic differences between (Minoan) Cretans and (Mycenaean) mainlanders.

suggesting the importance of the palatial west walls as the more public or ceremonial front façades of these buildings.

The Phaistos Grand Staircase [59] may not have been a major monumental entrance to the Second Palace as much as a site for some more outward-oriented ceremonial activities, possibly replacing the now mostly buried old theatral area to the west. At its east end is a light-well, and a small door in the southeast corner, connecting this section with a narrow stairway leading down towards the magazine area and central court, and up to a fine peristyle court adjacent to the second level of the northern hall system. The (missing) room or rooms carried over the Grand Staircase's pillars and piers may well have served as an observation platform for west or central court activities, although their actual function remains a matter of speculation.

The jug [60] and stirrup jar [61a] are very fine examples of Minoan pot making and pot painting, and also illustrate a continuing fascination with the detailed and lively depiction of flora and fauna. The vivid naturalism of such paintings has long been set against the schematic depiction of similar motifs in Mycenaean painting [61b], the contrast commonly having been used by archaeologists and art historians of the earlier part of the century as emblematic of qualitative distinctions between not only the painters but also the peoples of Crete and the mainland.

Gournia

Excavated a century ago by Harriet Boyd Hawes, the central building compound at Gournia (near the coast of the Bay of Mirabello in east

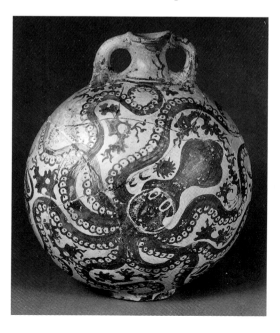

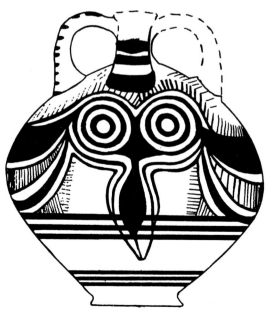

62

Restored view of the palace at Gournia from the southeast, based on a recent detailed re-examination of the building's remains.

63

Hawes' plan of the palace at Gournia and surrounding area, Second Palace Period. Note the palatial features such as the indented west façade fronting on a small western court, storage magazines on the west, and the small stepped area or viewing platform fronting on the large rectangular court.

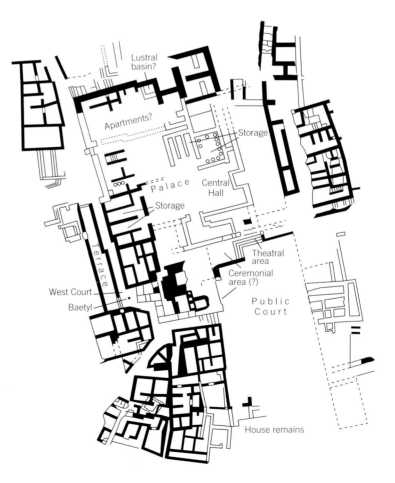

Lustral basin?

Apartments?

Storage

Palace

Central Hall

Storage

Terrace

Theatral area

Ceremonial area (?)

West Court

Baetyl

Public Court

House remains

Crete) occupies the top of a hill on whose slopes was a modest town where several dozen households were devoted to farming and fishing, and the manufacture of locally consumed commodities. Because the building contained a number of features in common with, or appearing to be miniature versions of, those of the three major palaces, Gournia has long been referred to as a palatial compound, assumed to be the residence of the town's ruler or ruling family.

About one-tenth the size of Knossos, the palace at Gournia fronts on a large rectangular court to the south, and contains a small paved west court; ashlar-block west façade in two sections of the building; a line of rectangular magazines on the west; traces of halls within, and what is evidently a small ceremonial area fronting on the northwest corner of the large court [**62, 63**]. Illustrated here are a contemporary two-storied reconstruction view from the southeast and the original excavators' plan. The ceremonial area is shown surmounted by a horned roof, and to its left is a small pillared room opening on to the public court or town square, reminiscent of the Tripartite Shrine area on the west façade of the Knossian central court. Near this was found a *kernos* stone, possibly for the deposit of offerings. Except for the area of the larger court, the Gournia palace is closely surrounded by the houses of the town.

This Second Palace Period compound clearly adapts features common in its larger counterparts to local conditions, suggesting once again a shared system of formal elements in Minoan architectural and urban design. Here these features can be seen reduced to their most basic forms, whilst maintaining relationships amongst them that are regionally distinct. Thus, despite its very constricted area, the west frontage consists of a paved court—really a widening of a city street; ashlar treatment of the wall fronting on the paved area; with storage magazines along this west section. Also, there is a ceremonial area fronting on a large rectangular court—which here, rather than being entirely internal to the structure, is an interface between the compound and the rest of the town. The large court is longer north–south than east–west, as at all the other palaces, and, although much of the interior heart of the compound has eroded away, having occupied the highest part of the hill, enough remains to indicate that it most probably contained hall systems and light-wells.

Gournia illustrates an important feature of Minoan design: the fact that what is common to Minoan buildings is not only the presence of certain formal features, but also, and equally, their topological arrangements or positions relative to each other, despite differences in size, or orientation, placement of doorways and corridors, and possibly also in usage. Certain relationships, in other words, seem to remain constant despite variations in form, size, materials, and other qualities. This theme is discussed in more detail below.

Kato Zakro

Discovered some three decades ago at the southern end of a Minoan town already known for a century, the Palace of Kato Zakro has yielded many impressive finds, and has added a great deal to our knowledge of Minoan Crete's foreign relations, for it is clear that the town was an important sea-trading city [**64**]. About twice the size of the Gournia compound, Kato Zakro lies approximately 100 m from the present-day shore of a fine protected bay, at the east end of what today is the flood-plain of the great gorge of Zakro cut deeply into the mountains to the west.

The plan of the building is at first glance fairly canonical [**65**]: it reveals a north–south aligned central court, approximately 100 × 40 m,

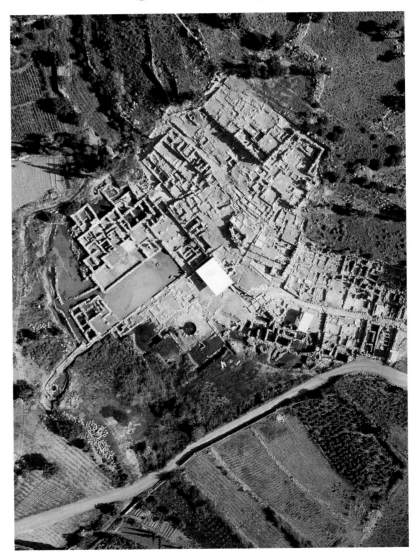

64

Aerial view of the Palace of Kato Zakro in east Crete, Second Palace Period. The palace and town of Kato Zakro was an important centre for sea-trading.

65

Plan of Kato Zakro Palace, east Crete, Second Palace Period. Note the traditional palatial features such as the rectangular central court aligned north–south, a pillared hall to the north of the court, and the double hall systems to the east and west of the central court. Unique to Kato Zakro are a large, round, stone-lined cistern or pool on the east side, and two wells or spring chambers on the southeast. Compared with the other palaces, a greater proportion of the Kato Zakro compound is given over to workshop space.

fronted by a partial colonnade on the north and east; a pillared hall (possibly a kitchen) on the north side similar to the hypostyle halls at Knossos and the First Palaces of Phaistos and Mallia; very fine double hall systems to the east and west of the central court and a series of storage rooms, workshops, what some see as a central shrine, archive, and treasury, in the west wing. The building differs from the other palaces in having a large, round, stone-lined cistern or pool on the east side which may have been surrounded by a circle of columns; two wells or spring chambers on the southeast in which were found many offerings, such as cups containing olives and volcanic pumice, as well as a

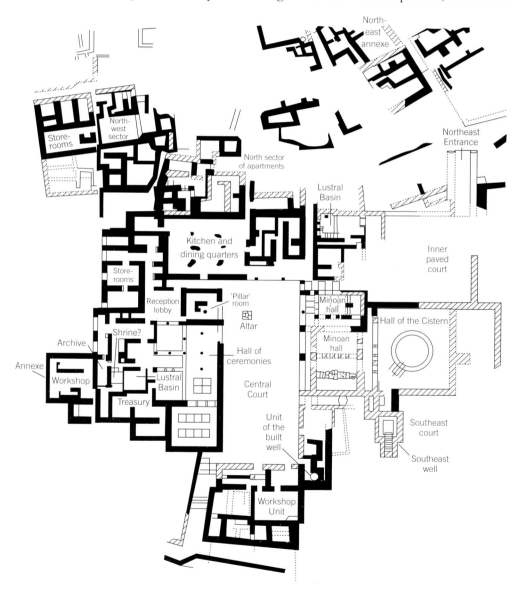

pyramidal double-axe base. In addition, a greater proportion of its square footage was given over to workshops (to the south of the central court, and a specially built annexe on the west) than in the other palaces. Also, a very small proportion of the westernmost section of the building, on the northwest, was given over to storage magazines; extensive modifications to this section of the building have transformed what may have been a fairly canonical western magazine area.

As discussed in Chapter 3, there is little or no trace remaining of a monumental west façade, or of an associated west court; the northern part of the compound is contiguous with other town construction; and the main palace entryway is not on the west, as elsewhere, but on the northeast, in the direction of what was most likely the town port or landing-stage. Kato Zakro was as much a distinct zone or quarter of its city as it was a distinct building compound, and much of the activity carried out there would have been given over to trade and manufacture, and to the processing and trans-shipment of goods. It had a ceremonial centre in the form of a lustral basin near the centre of the west wing, and a stone pavement with a central hole near the northwest corner of the central court opposite a pillar crypt may have had some ceremonial

66

Stone (chlorite) bull's-head *rhyton*, found smashed in the ruins of the west wing hall of the Palace of Kato Zakro. Second Palace Period.

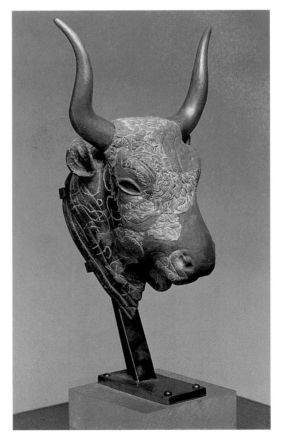

67

Veined marble double-
handled jar from the Palace
of Kato Zakro. Fragments of
many such vessels in difficult-
to-work materials have been
found in the palaces, suggest-
ing that the production and
distribution of these luxury
items was centred therein.
At Kato Zakro, the drilled
stone cores of such vases
have also been found in
the workshop areas.

purpose. A room containing Linear A (**75**) tablets was located in the west wing near the hall system. The palace compound looks very much like the headquarters of the town's evidently quite prosperous import–export business.

Two unusual finds from the western hall system of Kato Zakro are shown here. The first, an extraordinary bull's-head *rhyton* [**66**], partially restored, and the second, a veined marble two-handled jar [**67**], illustrate the degree to which Kato Zakro was engaged in the production and distribution of luxury goods. Stone cores, hollowed out of vessels such as the latter, were found in the palace workshops. The *rhyton*, a drinking vessel occasionally depicted on written tablets, was probably meant to be smashed after a ritual libation; none found to date are complete or undamaged.

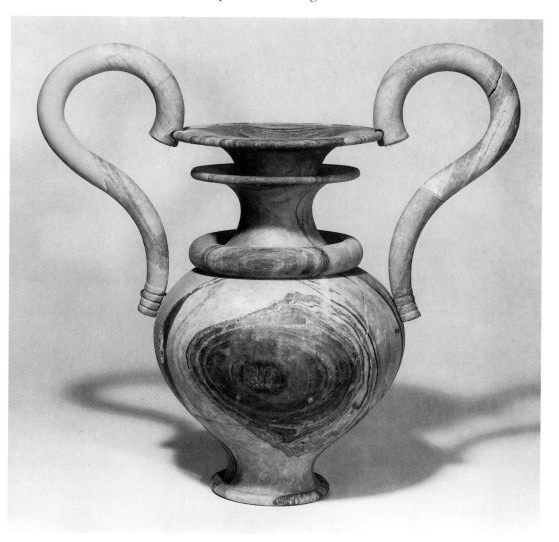

Minoan villas: function and design

It is a truism that the layout of no two Minoan buildings is exactly alike—a situation that appears to contrast more vividly with what may be seen elsewhere during the Bronze Age both in Egypt and the Near East. The unifying principles underlying the design of Minoan structures concern the relationships between the spatial and functional parts of a building, and the ways in which a building's features (many of which are themselves duplicated in many buildings) are packaged together as three-dimensional artefacts. Building layouts vary by the type of features included, and by their location, size, distribution, number, and relationship to the placement of doorways and corridors.

A great deal of visual and architectonic variation was accomplished by the manipulation and the placement of doorways, corridors, suites of rooms, stairwells, courtyards, and terraces. Nevertheless, a comparative examination of many Minoan structures has revealed that, within a particular time period and geographical region, there are certain constancies in formal and functional organization. We have no idea why it may have been the case that Minoan buildings of all types in the Second Palace Period were variations on a theme rather than being identical in plan. While it is clear that the possibilities of such variations in design may be related to certain levels of wealth and power in Minoan society, there might well have been other markers of status and power, such as the use of identical plans but at very different sizes and scale, as was more commonly the case elsewhere in the eastern Mediterranean.

Entering one Minoan building does not necessarily equip the visitor with enough information to successfully navigate his or her way through others. What we tend to overlook or take for granted is that ground-plans reveal a building in quite a different way from the experience of moving through it room by room. Plans provide a synoptic or aerial view of a building's wall boundaries and bounded spaces. Looking at a plan is like having an entire story placed in front of your eyes at the same time, rather than having to turn the page to find out what will happen next—a rather more suitable metaphor, given that architectural experience is not merely spatial but, more fundamentally, a space–time performance.

Tylissos House C

A Neopalatial villa in central Crete known as Tylissos House C provides a good illustration of the degree of subtlety and complexity found in the planning and design of Minoan buildings. Much has been made of the fact that such buildings often lack external fortification walls.[10] We would suggest that Minoan buildings were designed in such a way that they often constituted their own internal defence systems. A partial plan of just the entry corridor to Tylissos

Tylissos House C, isometric plan and detail of entry corridor, Middle Minoan IIIB/Late Minoan IA–IB. The subtlety and complexity of Minoan spatial organization is well illustrated by this finely conceived and carefully constructed villa, with its nesting of functional zones, its ingenious control of traffic and access, and its harmoniously balanced façades.

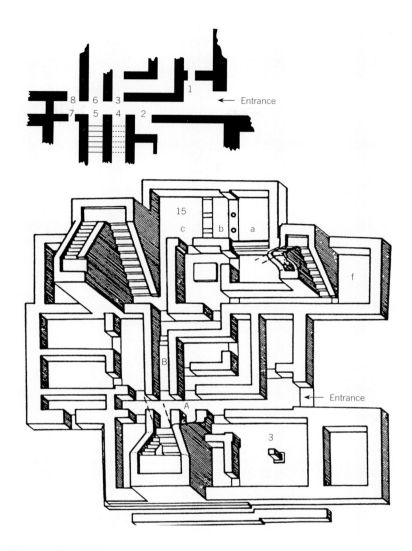

House C will help to illustrate the complexity of experiencing a Minoan building [**68**].

It is not really clear from looking down this corridor which one of its seven otherwise identical doorways leads to what has been taken as the most private domestic quarter of the villa, the hall system at the top of the plan (rooms a, b, and c). Only the synoptic view provided by the isometric reconstruction provides readers with enough information to know that they should turn down corridor B. If you were an unwelcome visitor in a Minoan building, the inhabitants could have easily cut you off from certain parts of the building by merely closing a door.

Corridors play an especially significant role in creating a sense of privacy in that people no longer have to walk through rooms to get from one part of the building to another. The increased use of corridors'

in the Neopalatial Period suggests an additional level of sophistication in house design. With corridors, the opportunities for interaction with other inhabitants are sharply reduced, and privacy would have been notably increased. The incorporation of corridors and the accompanying sense of greater privacy in Minoan villas is one of the more striking changes in house design from the First Palace Period, with its typical square-within-a-square ground-plan discussed in Chapter 3.

House C exhibits many of the features that are most characteristic of Neopalatial design. Two or possibly three storeys in height, House C has at least two rooms only accessible from a second storey, and one accessible only from outside and not connected to other internal spaces. The building contains a Minoan hall of three rooms (15a, b, and c, the first being a small light-well or court); an interior suite of rooms adjacent to the hall, one of which had a raised pavement, possibly for a portable hearth, and the other of which had a window opening on to court a; a latrine (f); a squarish pillar room which may have been a combination workshop–shrine and storeroom (3); a suite of storage magazines on the west side of the building; a room-within-a-room at the centre of the house, and three different stairwells—all within an area some 22 m on a side. The main entrance is on the east, to space 1, to the right of which may be a porter's room.

House C is made up of finely cut ashlar stone blocks, with recesses and projections on all sides of the building, each of the four façades thus presenting a different profile, of subtly graded sizes. The building reveals very great care and precision in design and execution, the final plan having been carved out of a square grid, each room and wall corresponding to simple fractions or multiples of the planning grid.[11] The building was conceived and realized as a series of functional zones mapped on to suites of rooms with separate points of access, all around a common core: a small room within an L-shaped corridor, occupying the geometric centre of the plan. The central room's function or significance is unknown.

Surrounding this central suite is a longer L-shaped corridor, with many doorways to channel and direct traffic in multiple ways, to create private spaces, or to open certain areas to activities of various kinds. As is common in Minoan buildings of the period, there are multiple possibilities of movement and connection. Tylissos C is a compact example of Minoan design principles seen in buildings large and small during this period.

The villa annexe complex at Haghia Triadha
The villa annexe complex at Haghia Triadha [**69**] is significant for its fresco paintings, stone and bronze artefacts, palatial design features, and its important Linear A archive. A nearby *stoa* provides another example of architectural innovation and regional style. It belongs to the

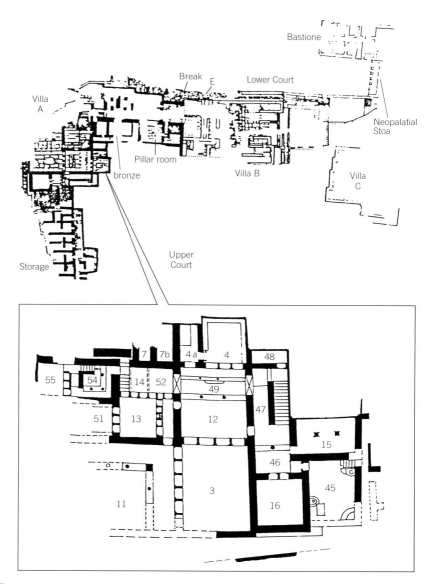

Haghia Triadha, plan of Villa A
and Annexe B with details of
pier-and-door partition halls of
Villa A. Second Palace Period.
The numbering of the rooms
here follows that of the original
excavators.

later (Mycenaean) Period and will be discussed in Chapter 5. We will
begin with a discussion of the villa, its frescoes and some of the art
works found in its ruins.

Haghia Triadha was excavated very early, at the beginning of the
twentieth century, but was only recently fully published.[12] The remains
of the structure form a large L-shape around the lower northern and
western flanks of a promontory, on top of which was a large rectangular
courtyard running roughly east–west. There was a row of magazines
on the west, a double pier-and-door partition hall system (often in the
modern archaeological literature referred to as a *polythyron* (multiple
doorway)), and a peristyle court on the north. There was also a pillar

room and additional storage on the northwest, a court, and ashlar façade walls. The recessed west façade of the storage magazines clearly reflects the design canon of the larger palaces.

Stretching some 85 m from east to west, Haghia Triadha is larger than the Little Palace at Knossos, or a building that has been seen as a roughly comparable large residential structure, Mallia House E. The plan (and much of the Haghia Triadha building) is difficult to comprehend at first glance due to a large axial structure (or *megaron*; see Chapters 2 and 5) from the Mycenaean (LM III) period built over the ruins of the earlier villa.

Originally interpreted as the summer residence of the 'king' of Phaistos,[13] itself a mere 3 km walk to the southeast on the modern road, there has been some dispute in the recent literature as to whether Haghia Triadha was in fact a villa or a palace.[14] Minimally, it has been referred to as 'half a palace' and some have argued that Haghia Triadha was palatial in design, if only in the sense that it replicates features found in the large palaces.[15]

More recent studies have suggested that it may actually have been a compound made up of two distinct villas, now referred to as A and B, based on the formal duplication of pier-and-door partition hall systems, and distinct storage areas in both the north and the west wing.[16] This hypothesis is further based upon the discovery of a material break between the two buildings, in which the rubble wall north of room 62 can be seen to join, but does not actually bond.[17] It has been suggested that Villa B may have functioned as an annexe to Villa A, for there are interesting contemporary parallels at Knossos and Tylissos.[18]

There are two main entrances to Villa B at its northwest end. The easternmost of these provides access to the ground floor, and the westernmost entrance would have led to the upper storey, where we would propose that a bridge existed over Villa B to connect it with Villa A on the west—a situation which may parallel those seen elsewhere. Two other possible entryways to Villa B on the east were blocked off at a later time in the building's history. Other changes blocked the original eastern entrance to Villa A. These later constructions not only suggest the need to create additional storage space, but they also restricted access to Villas A and B.

The size and rectangular shape of Villa B makes it comparable in outward form to other annexes including the Unexplored Mansion at Knossos and House B at Tylissos.[19] Further similarities include its close association with a large villa building with palatial features, including an indented façade outline, Minoan pier-and-door partition hall system, and pillar room such as found in the Knossian Little Palace and Tylissos House A. Like the Knossian complex, the Haghia Triadha complex is closely associated with a palace.

Haghia Triadha has been recently interpreted as the centre of an estate that functioned within the larger administrative system of the palaces. This interpretation is based on Near Eastern analogies, and considering the presence of a Linear A archive and stores of clay sealings, as well as taking into account the nature of the other artefacts found in the structure—including stone vessels, a cache of copper ingots, and bronze figurines.[20] Haghia Triadha A contains an elaborate and complex Minoan hall system, which includes rooms 3, 12, 49, 4, and 4a, 11, 13, 14, 51, and 52. These have been interpreted by excavators as an audience hall (3, 12, 49, 4), a bedroom (4a), and a smaller hall system (13, 14, 52, 51) with associated fresco decoration found specifically in room 14. Rooms 11, 3, 12, and 49 can be seen as two sets of Minoan hall systems superposed at right angles.[21] A parallel for this arrangement may be seen at nearby Phaistos in the northwest wing, while the relationship between rooms 4 and 4a resembles the relationship between the so-called Queen's *megaron* and the supposed bathroom at Knossos. It should be noted, however, that there is no evidence for steps to indicate that the bathroom at Knossos ever functioned as a lustral basin, and the bathtub visible today in this room was in fact found in the Queen's *megaron*, and dates to the LM II or Third Palace Period.

Room 4a is a cubicle connected to an inner benched room of the pier-and-door partition hall. It has been interpreted as a bedroom because of a slightly raised stone dais. A female votive bronze figurine found a few centimetres above the floor,[22] and a cache of bronze tools found in this room, possibly fell from a room or rooms above. The benched hall (room 4) which is connected to room 4a can accommodate up to 17 people, and a pier-and-door partition enables rooms 4 and 4a to be closed off from the larger Minoan hall system of rooms 3, 12, and 49. Would this seating arrangement for such a large number of people be compatible with sleeping in room 4a? Further, why would such a small part of the house be devoted to a sleeping area? Or is sleeping an activity that could have been carried on in any large room as one sees in many traditional villages in the Middle East today? These questions are worth bearing in mind, when one considers the function of this architectural feature, as our interpretations of these formal features are often difficult to disentangle from modern assumptions about appropriate architectural function.

A second set of PDP halls, consisting of rooms 13, 14, 52, and 51, is connected to the larger hall described above by a narrow corridor which links rooms 11, 12, 13, and 52. Hall 14 contained three fresco panels. Three compartments along the south wall of room 13 were blocked off to through traffic. A hole in the central compartment is connected to a reservoir below. The centrality of the room within the building and the absence of a drain suggest that this hole may have served as a receptacle for libations or liquid offerings.

70

Fresco of cat and pheasant, Haghia Triadha Villa complex. This fresco, found with three other fresco panels in Room 14, depicts a cat stalking a pheasant with leaping *agrimia* (wild goats) and other cats.

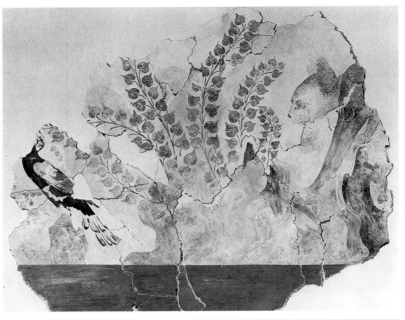

71

Fresco depicting a woman, possibly a goddess or worshipper, crouching at an altar; from room 14, Haghia Triadha Villa A.

The fresco panels in room 14 included a cat stalking a pheasant [**70**] with leaping *agrimia* (goats) and other cats; a female crouching near an architectural structure [**71**]; and a kneeling female figure picking crocuses.[23] It has been tempting to see played out here iconographic or thematic oppositions between hunting and gathering; male and female; or even nature versus culture (*agrios* versus *domus*) programmatically staged within the same room, with different walls carrying distinct parts of a fresco cycle. The association between women and crocuses is discussed below on p. 125 in relationship to the fresco cycles of house Xeste 3 at Akrotiri on Thera.

Room 14 was the most secluded room in this group unit, and was divided from room 52 by a narrow partition wall with access provided only through room 13. These rooms contained remains of elaborate stone vessels that had fallen from above during the destruction of the building, including the famous Harvester vase, the Boxer *rhyton*, an alabaster boat and obsidian conch (from room 13), *alabastra* (squat jars with curved profiles), a marble chalice, and a pedestalled lamp (from room 14). It has been suggested that room 14 at Haghia Triadha was a bedroom, based on its secluded location and its relationships to other rooms, while room 52, which had a basin, was possibly a bathroom.[24]

A *rhyton* (plural, *rhyta*) is a vessel that is believed by most scholars to have been used in ceremonies or rituals for pouring liquid offerings. They usually had a larger opening at the top and a small one at the bottom. The best-known shape is the conical *rhyton*, of which the Boxer vase is one. They also take the form of animals and animal heads, most notably in the shape of a bull's head. The Harvester vase is shaped rather like an ostrich egg. *Rhyta* are made out of various materials including stone, clay, and metal. Both the *rhyta* illustrated are carved from the stone serpentine and both were found in scattered fragments.

The Boxer *rhyton* [**72**] recalls scenes of young boxers found in the frescoes of Akrotiri, there taken as alluding to initiation practices among young males, perhaps complementing female initiation practices, also depicted in Akrotiri frescoes (see below). The preserved remains of the Boxer *rhyton* include four registers that depict several scenes of boxing or wrestling, while a fourth register depicts a man being savagely gored by a bull. As in many other representations, the athletes are depicted as youthful and vigorous with slim waists and long flowing hair. They are wearing the Minoan breech-cloth with a codpiece arrangement.[25] All are carved in low relief. With regard to this last image, a suggestion has been put forward that the bull may symbolize Knossian power,[26] because bulls are prominent at Knossos. Others have suggested that bull sports, sacrifice, or other uses of the bull (such as skins for shields) indicate an appropriation of or sharing of the bull's power.[27]

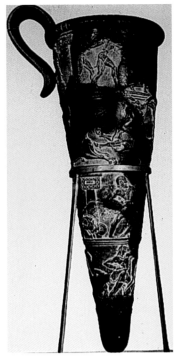

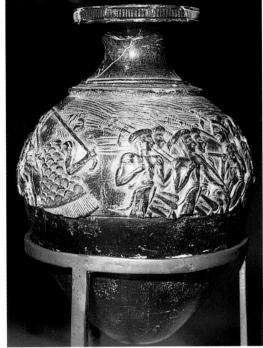

The so-called Harvester vase [**73**] depicts a group of 27 males in-
cluding four bare-headed singers, with the rest wearing breech-cloths
and carrying hoes. They are led by a figure described as a 'long-haired
priest in a scaly ritual cloak'.[28] Various interpretations have suggested a
processional dance, a triumph of warriors, a sowing festival, a harvest
festival; a seed-time festival performed by a procession of revellers, or a
religious procession of sowing and ploughing which bears a 'remark-
able resemblance to the English Plough Monday Processions'.[29]
Looking at this vase from a different perspective calls to mind a some-
what different image, namely a propagandistic depiction of either
corvée (forced labour) which is well attested in contemporary Near
Eastern economies, especially at Mari,[30] or as in the mainland
Mycenaean economy where land was provided in exchange for obligat-
ory service.[31]

Stone *rhyta* are rarely found intact, which has suggested their ritual
breakage, particularly of animal-headed *rhyta*.[32] The notion of ritual
breakage is taken up again later in this chapter (see p. 138). Conical
rhyta could be used to transfer liquids by lowering them into a *pithos*
full of oil, and then placing one's hand over the top to prevent spillage
from the bottom.[33]

Like the Harvester and Boxer *rhyta*, many Minoan stone vases are
made from serpentine, which could be acquired locally. One of the
more notable imported stones used in the production of vessels was

74

Bronze figurine, Haghia Triadha Villa A. This figurine was found in room 7a with two bronze *agrimia,* six male bronze figurines and two pyramidal stone double-axe bases.

obsidian from the Aegean island of Ghyali. The character of the stone is such that it does not fracture regularly, and it was not favoured by the Minoans for tool making. However, its translucence and surface apparently appealed to Minoan taste. By tracking the distribution of Ghyali obsidian as raw material and *debitage* (waste) rather than as finished product, one archaeologist has been able to chart its trade route throughout the Aegean.[34] By the time it reached Crete, this route ran along the north coast stopping at Knossos, Mallia, Palaikastro, Mochlos, Pseira, and probably at Kato Zakro. The fact that finished vessels were found in southern Crete as far apart as Haghia Triadha and Pyrgos is further evidence of an intra-island trading network, as suggested above in Chapter 3.[35]

The elaborate gypsum paving, fresco decoration, and manipulation of circulation in the pier-and-door partition halls at Haghia Triadha, and their close relationship to scribal and administrative activity (particularly in room 55) suggest functions more complex than that of simple habitation. The interpretative literature now seems to indicate that at a number of sites, archive rooms can be found in a close relationship to the Minoan hall. There is a similar placement of archive rooms in close proximity to the Minoan hall at both Mallia and Kato Zakro.[36] Another, later, archive room of sealings was located above the treasury at Knossos in association with a Minoan hall.[37] The Minoan hall system, which has traditionally been interpreted as a largely residential or ceremonial area, might also (or instead) be understood as an office.

It seems obvious that scribes or administrators must have taken an active political role in running Minoan society. This introduces notions of agency and action into this set of spaces. (As we shall see in Chapter 5, the situation at Mycenaean Pylos is somewhat different in that the archive room is more closely associated with the exterior of the building than with the interior *megaron* hall proper.)

Room 16 at Haghia Triadha is a second, often-overlooked pier-and-door partition hall connected on the south to the more elaborate set of halls discussed above. Instead of being used for residence or the performance of ritual, it was used for storage activities, to facilitate access, and may also have been associated with food preparation through its relationship with room 45 to the south. It includes a hall, pier-and-door partitions, a forehall with a column, and a paved section corresponding to a light-well, which led to a staircase to the upper storey. It contained *pithoi*, bronze double axe heads, and a hoe.

The storage area in the east part of Villa A included two long, narrow cubicles (7 and 7a) that were joined at a right angle to form an L-shaped room. Room 7 contained 19 copper oxhide ingots while room 7a contained two bronze *agrimia* (wild goats), a female figure [**74**], and six male bronze figurines, as well as two pyramidal stone double-axe bases. These last were small stone bases with a hole in the

top for holding a double axe affixed to a pole. This combination is represented on the famous sarcophagus from Haghia Triadha (see p. 178). It may have been connected to room 17, a small square room with a pillar. Although room 17 was found to be empty, the excavators have interpreted it as a storage magazine.[38]

This assemblage of art works, artefacts, and architectural features exemplifies a larger overall pattern in Minoan buildings. This pattern takes the form of a recurring association of storage activities, pillars, the double axe, and in this case, bronze storage. We will take up the possible significance of these relationships below (p. 132).

In sum, a wide range of activities existed at Haghia Triadha: work, administration, entertainment, the consumption of food, trade relations, habitation (possibly sleeping: rooms 4, 4a, 14), and cult activities (room 13). In addition, the architectural design was symbolically charged with a recurring association of the pillar crypt, the storage of bronze, and the double axe; frescoes depicting women, lilies and crocuses, balanced by a hunting scene. This iconography seems to have been important to the Minoans, and was placed in association with a room with a tank for the deposition of liquid. Subtle manipulations of space, air, and light are to be found in certain places: rooms 3, 4, 13, and 14 could be completely closed off, while rooms 12 and 11 could not be fully sealed.

The terminology and typology of Minoan palatial buildings

Many of the recent archaeological discoveries on Crete (such as the court-centred buildings at Petras and Makrygialos in the east and Zominthos in the central part of the island) have called into question older distinctions between villa and palace as well as certain past assumptions about their construction. For example, we tend to associate finely worked ashlar masonry, often in limestone or gypsum, with the Minoan palaces and palatial villas. We need to recall that moving stone was one of the most laborious tasks undertaken in ancient building, so that Minoan builders tended to rely primarily on local stone.[39] There was great variety in the materials and techniques used in Minoan buildings. For example, sandstone predominates at Mallia, and gypsum, so prevalent at Knossos and Phaistos, is absent at both Tylissos and Kato Zakro.[40] Finely worked ashlar masonry is absent in the indented west façades at Kato Zakro and Makrygialos which instead use roughly worked megalithic blocks, and at Zominthos, where a dry wall technique was employed.[41] At 1,600 square metres in size, Zominthos is surely palatial, yet not in the use of materials or construction techniques. The indented west façade found at these sites is a palatial design feature, but the technique in executing it varied considerably.

One scholar has distinguished as many as five types of masonry found in Minoan vernacular architecture.[42] But with its palatial size

and vernacular technique, Zominthos confounds any proposed polite versus vernacular opposition we might be tempted to see, 'polite' having been defined as architecture designed and built by professionals following national or international styles, often using exotic materials and innovative or adventurous techniques to achieve 'aesthetically pleasing' effects.[43] This definition may be useful for understanding certain types of buildings; yet an aesthetically sophisticated design was not always executed with exotic materials or with expert technique.

Not all Minoan buildings, and certainly not all parts of the same building, received the same degree of attention. Although it is likely that architects may have been itinerant, labour, with varying degrees of skill and experience, is more likely to have often been locally based. The finely articulated west façade of the Second Palace at Phaistos stands in sharp contrast to the trapezoidal layout of the otherwise elegant gypsum-veneered Minoan hall.[44] Anyone who has ever tried to build a house in recent times surely knows that builders and building contractors seldom exactly realize the same building as that (presumably) intended in an architect's plan.

The so-called Cult Villa at Makrygialos presents some of the same difficulties found at Zominthos with regard to design classification. Makrygialos is located on the east edge of the south shore of eastern Crete, on the Bay of Kala Nera. It was excavated in the 1970s and is dated to the Neopalatial Period.[45] Makrygialos incorporated an even greater number of palatial design features than Zominthos. These include a central court with a north–south orientation, a colonnade, an altar, possibly a west court, an indented west wall façade, storage magazines in the structure's west wing, and possibly a pillar room or crypt. The central court is distinctive, and, in plan and in its orchestration of design features, the plan of Makrygialos calls to mind a major Minoan palace. However, features commonly associated with the palaces and palatial villas such as Minoan pier-and-door partition hall systems and ashlar masonry are conspicuously absent.

Discoveries such as these have increasingly rendered problematic the various classificatory schemes that Minoan archaeologists and art historians have long depended upon. It may be useful to suggest a more flexible approach that can be modified to accommodate new discoveries while taking into account differences that result from both regional variation and needs that are particular and local, rather than universal and general. We might look at the different architectural features that make up the formal organization of a building as components in a system of features, some of which are invariant over time and space, others of which may be subject to variation or change. Such components or features would be based on morphological characteristics such as the pillared hall, central court, incised double-axe mason's marks, or benched rooms, each of which is capable of taking on multiple

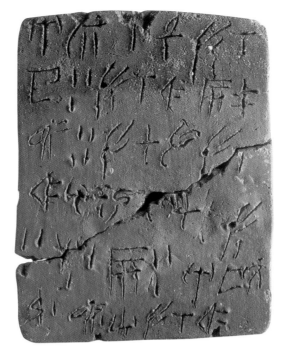

functions, meanings, or connotations in spite of roughly similar loca-
tional contexts. Such a list can be continuously augmented as new
forms and features are discovered, enabling the articulation and docu-
mentation of local, regional, or trans-regional styles and typologies.

It should be clear at this point in our introduction to Aegean art and
architecture that the picture that we have of Minoan architecture is
rapidly changing. Evident increasingly are regional variations in de-
sign and style, which appear to have existed within broader similarities
that may have transcended local differences. The oppositions between
villa/palace, vernacular/polite, planned/agglutinative are in no way as
clear-cut as once imagined. The lavish Minoan villa fully equipped
with ashlar façades, canonical Minoan hall, lustral basin, and pillar
crypt is a stereotype that is more likely to be found at Knossos or in our
imagination than anywhere else—attesting to the power that Arthur
Evans' Knossos has exercised over generations of visitors and scholars.

The Minoan and Mycenaean spheres of influence

Akrotiri on Thera: Pompeii of the ancient Aegean
One of the most spectacular archaeological discoveries of the second
half of the twentieth century was made in 1967 by Greek archaeologist
Spyridon Marinatos on the site of Akrotiri, in the southwestern corner
of the volcanic island of Thera (Santorini), some 100 km north of
Crete. Destroyed by the catastrophic eruption of the island in the

76

The West House at Akrotiri on the island of Thera (modern Santorini), Second Palace Period, Late Minoan IA. Note the large window, referred to by some as a 'window of appearances', fronting on a small public square in the town.

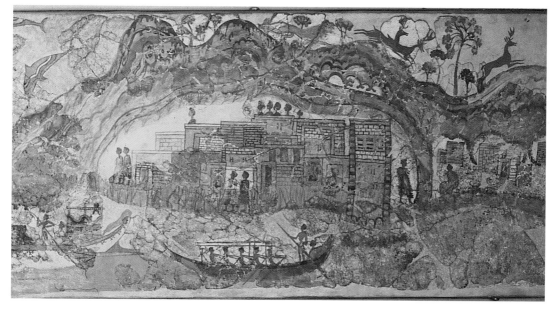

77

The 'Flotilla' fresco from room 5 in the West House at Akrotiri, Second Palace Period, Late Minoan IA. This fresco depicts several ships sailing between island towns. Note how the buildings (some crowned with double horns) are massed together to suggest a dense townscape set in a rugged terrain, in a manner familiar on Crete. There have been numerous interpretations of the subject matter of this reconstructed fresco, none fully compelling.

middle of the second millennium BCE, the Second Palace Period town at Akrotiri was buried under many metres of volcanic pumice, which effectively preserved many features of the settlement, much in the manner of Pompeii's burial by the eruption of Vesuvius in 79 CE.

Enough erosion of the protecting pumice had taken place by the 1960s in this corner of the island to reveal traces of the old city. Houses (with many Cretan features) along with many of their contents were preserved up to and in some cases above their second storeys [76]. Akrotiri has produced some of the most complete paintings and buildings known from the Aegean Bronze Age. Nonetheless, to date only a fraction of the original city has been uncovered, and it will be many years before a complete picture of this remarkable site is revealed. Akrotiri appears to have been a harbour town, the port facilities most likely having been to the west of the site.

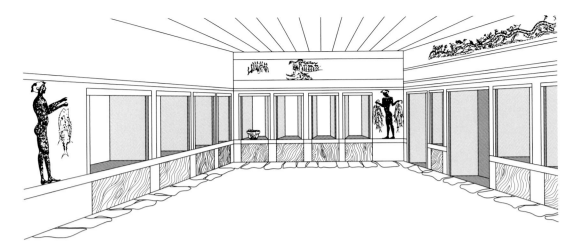

78

Reconstruction of room 5 of the West House, Akrotiri, Thera. Note the position of the frescoes, showing naked fisherboys converging with their offerings, possibly upon a small altar in the corner.

The structures excavated thus far appear to be a mixture or perhaps even a combination of shrines, houses, and buildings given over to manufacture and storage. The shrines consisted for the most part of ceremonial rooms and service quarters, in some cases on different storeys, with most walls in the former areas completely covered with life-size figures singly or in groups, lively landscape and marine frescoes, scenes of gender initiation rites, and views of island cities from the sea. The style and thematic contents of these extraordinary paintings are identical to what has been previously known in Crete itself only in much-restored fresco fragments from Knossos, or on sealstones and jewellery. Thera has provided us with the first extensive contextualized picture of Minoan (or Minoanizing) wall painting and its relationships to social ceremony and ritual.

Illustration **77** shows a detail of one of the marine frescoes from room 5 on the second storey of the West House Shrine. This Flotilla fresco probably covered much of the upper portion of at least two walls in the room, alternating with a landscape frieze with a stream and animals. The northwest corner of the room, framed by two rows of multiple windows, appears to have been the focus of some ceremony or celebration, suggested by the depiction of two naked fisherboys carrying loads of fish in the direction of a clay offering table or tripod placed on the window sill of the westernmost window [**78**]. The boys are shown with shaved heads, except for two areas where snake-like locks were left; similar depictions of pre-adolescent girls are also known from Akrotiri. A similar convention for indicating children was used in Egypt. The sections below the windows were painted to imitate veined marble.

The Flotilla fresco (which was on the south wall, not shown in the reconstructed view of the room) depicted a series of about a dozen long ships sailing between islands, on each of which is a harbour city, each made up of massed stone buildings, stairways, and horned altars (see **77**). The overall fresco seems to depict an important inter-island

ceremony. Island residents are shown here in our detailed view watching the procession from windows, on rooftops, and in front of buildings. The sleek ships are either under full sail or being rowed by many oarsmen, and all contain passengers, some standing, others seated under canopies. Each ship has a helmsman and a cabin in the stern for the person in charge of the vessel; these boxes or palanquins are also depicted separately and at a large scale in a fresco in room 4 in the West House. The fresco also shows many landscape details behind and to the side of the island towns, including rushing streams, lush vegetation, and running animals such as lions and deer (lions are also painted on the sides of some ships). The rocky nature of the islands is clearly highlighted, and a sense of contrasting costumes (rough country cloaks versus town clothing) can be seen in some parts of the fresco. Adult women are depicted in a familiar Minoan fashion, with flounced multicoloured skirts, with breasts bare (see also **83** below).

The portion of the fresco shown in the reconstruction of room 5 [**78**] is only preserved in part, the central portion partially visible in our illustration showing a scene difficult to interpret, with a sea battle below, marching spear-bearing warriors leaving a town in the middle, and what may be a shrine with dancing women, trees, and a procession of cattle and herdsmen above.

House Xeste 3 (see plan and reconstructed interior [**79, 80**]) appears to have included a shrine devoted in large part to female puberty initiation ceremonies. The reconstruction of room 3 shows a complex space divided by pier-and-door partitions, creating several interior zones that could be shut off from each other, as well as a sunken chamber (lustral basin or *adyton*) in the northeast corner, accessed by an L-shaped stair. On the wall above the sunken chamber is a fresco depicting a young girl seated on a rock nursing a bleeding foot; behind her is an adult, bare-breasted woman carrying a necklace in her hand, evidently a gift to the adolescent. To the right of both of them, but not illustrated here, is a young girl wearing a translucent veil, averting her gaze from the bleeding girl; she may represent a prepubescent girl. To the far right of the scene is a horned altar, with blood dripping down its façade. The subject matter of the entire ceremony has been interpreted by some as the first menstruation of young girls, the celebration of which undoubtedly took place in this shrine.

The flowers depicted in the landscape are crocus (possibly used as a painkiller for menstrual cramps and as a dye—saffron—for the yellow cloth worn by females); to the left and around the corner was a frieze of naked boys bearing metal vessels, walking in the direction of the main *adyton* scene. On the floor above is a remarkable fresco of young girls picking crocus flowers and bringing baskets of them to a seated adult female figure, most likely a goddess. A detail of one flower-gatherer is shown in **81**; she is depicted picking flowers on a rocky

79

Plans of the West House and House Xeste 3, Akrotiri, Thera. The service and ceremonial quarters are spread out on two storeys at the West House, but are adjacent to each other on the same floor at Xeste 3. The latter arrangement is more common on Crete, but the former is not unknown.

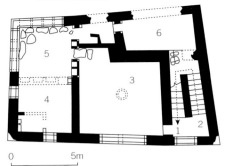

Ceremonial rooms

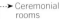

0 5m

Ceremonial rooms

80

Reconstruction of room 3 and upper floor of House Xeste 3, Akrotiri, Thera. The scenes taking place in the frescoes and the presence of an *adyton* or lustral basin may indicate that this room was a shrine that may have been used for female initiation ceremonies.

Service quarters

0 5m

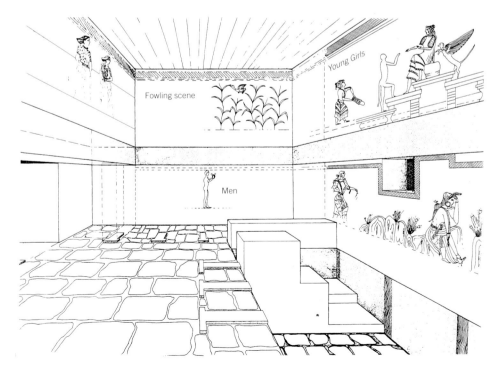

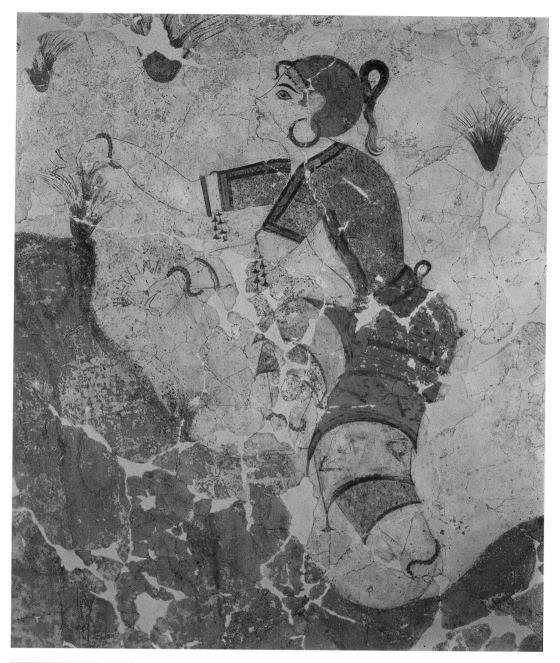

81
Young girl gathering crocus
flowers; fresco from room 3,
House Xeste 3, Akrotiri, Thera.
Based on the shaved head
and snake-like locks of hair,
the girl is believed to be an
adolescent.

escarpment, wearing a very richly coloured and textured skirt and bodice. She is wearing a good deal of jewellery–several bracelets, pendants from her upper arms and sleeves, as well as large hoop earrings. Her hair is very complexly coiffed in what is taken as a pre-adult manner, with most of the head shaved, a single rear lock looped in serpentine fashion, and frontal wisps over her forehead band. Her eye is clearly made up, as are her lips.

She is to the rear of the central seated figure, walking in her direction; the girl on the left side of the painting is similarly attired and made up, and carries a basket of crocus flowers, no doubt as an offering to the central figure. It seems reasonable to conclude that the central seated adult female is not an ordinary woman. She is depicted between two more or less fantastic animals—a bluish monkey making an offering to her, and a rampant (half-bird, half-lion) griffin at her back, perhaps in a protective heraldic gesture.

Monkeys (usually painted blue) are known in many Minoan depictions; for example those in the fresco [**82**] from the upper storey of House Beta shown cavorting in what appears to be Theran landscape seem to be vervets, native today to Nubia, indicating more than casual contact between the Aegean and the upper Nile Valley at this period either through direct contact or by way of Egypt as an intermediary.[46]

Illustration **83** shows a portion of a life-size female figure from room ɪ in the House of the Ladies in Akrotiri, so called because of this and an accompanying scene. Of unknown function, the House of the Ladies also contained a large fresco of papyrus plants in an adjacent alcove. Here an adult woman with a full head of hair wears a flounced Minoan skirt and an open bodice which reveals a large breast. She is carrying what appears to be another apron and may be offering it to a second, possibly seated woman. On the wall opposite this are traces of a similar scene, and it may refer to a robing ceremony which may on occasion have been carried out in this anteroom. Above all the figures on both walls is a wavy blue line separating the robing scene from a field of blue stars connected by red dotted lines.

The paintings at Akrotiri on Thera are quite extraordinary, both for their compositional and naturalistic qualities, and for the new glimpses they are giving us of aspects of Bronze Age Aegean life hitherto unknown or only known by inference. It is coming to be understood much more clearly how intensely and encyclopedically the Therans (and Minoans) seem to have recorded and celebrated their lives and social worlds through art and material culture. In this respect, it may well be that they bore no small resemblance to their contemporaries in Egypt and perhaps elsewhere in the eastern Mediteranean (as we shall see later, Minoan-style painting left its trace in Egypt itself). Most of the Thera frescoes will continue to be subject to intense discussion and debate for many years, but most observers agree that they add a rich,

vibrant dimension to what we are learning about the Aegean world of the second millennium BCE.

Ayia Irini on Kea: House A

Located just 25 km from the mainland Attic coast, Kea is the first in the group of Aegean islands known as the Cyclades (those that in later Greek times were perceived as circling round the central island of Delos, sacred to Apollo). Although the surface of Kea is just 121 sq. km, it is very mountainous with several fertile valleys. The island was the site of an important Neolithic and Bronze Age town located on the peninsula of Ayia Irini (St Irene) near the modern village of Voukari. Ayia Irini is notable for the numerous Minoan architectural features and fresco motifs found at House A along with evidence for Minoan craft technology. These contrast with a local building technique, and design differences in the neighbouring houses, which show mainland Mycenaean influence in terms of their fresco motifs. Ayia Irini is also remarkable for a temple that continued in use into the (Hellenic) Iron Age.

Previous comparisons between Minoan buildings and House A have tended to emphasize the more obvious design features of Minoan buildings such as pier-and-door partition halls and lustral basins.[47] However, there are some 60 different recognizable design features found in Minoan buildings, in different combinations at different places and times.[48] A number of Minoan houses lack either pier-and-door partitions or Minoan halls as described above. Some of these houses form part of the vernacular tradition discussed in Chapter 3 and include the well-attested house with the column,[49] while more well-known examples include the house at Sklavokambos, the Unexplored Mansion (which functioned as an annexe to the Little Palace at Knossos), and the villa at Makrygialos as discussed above.

Ayia Irini House A (**84**) included a significant number of distinctively Minoan features.[50] Previous emphasis in the archaeological literature on the significance of the use of local materials and construction techniques in building House A has neglected to consider differences likely to have arisen between the architect and planner (who may have been from, or been trained on, Crete) and those who executed the plan using familiar local materials and ways of building. Even on Crete there are wide variations in the execution of particular building plans and in the materials used.[51] The distribution of particular architectural features is quantitative while the differences in their execution by builders is often more qualitative in nature.

Many new discoveries have increased our knowledge of Minoan architecture since the publication of House A at Ayia Irini in 1984. These include new architectural discoveries on Crete at Kommos, Makrygialos, Mochlos, Monastiraki, Petras, and Zominthos;[52] the re-

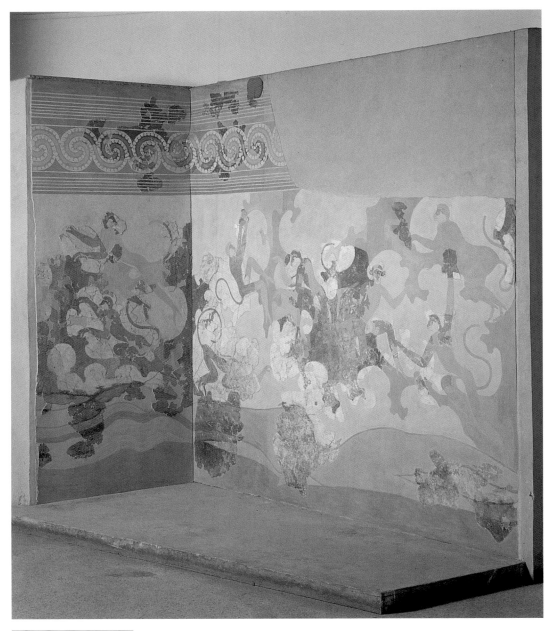

82

The 'Blue Monkey' fresco
from room 6, House Beta,
Akrotiri, Thera. Blue monkeys,
such as those depicted here,
are often represented in
Minoan frescoes both in
Crete and Thera and may
indicate contact with Africa.

study of old material;[53] new synthetic studies;[54] and last, but not least, the excavation of many Minoan-style features at Akrotiri.[55] Some of the unique features of these buildings have been discussed above. Such new discoveries make it easier to more clearly apprehend and evaluate the number of Minoan-style architectural features found in Ayia Irini House A.

Quantitative differences relating to the presence or absence of particular features as well as in their spatial arrangement suggest qualitative differences in the ways buildings may actually have been used by the Minoans themselves. For example, there were four lustral basins at

83

Bare-breasted female figure from room 1 of the House of the Ladies, Akrotiri, Thera. This life-size woman appears to be carrying an apron and may be offering it to a second woman. Above her is a wavy blue line which separates all of the figures on both walls of this room from a field of blue stars connected by red dotted lines.

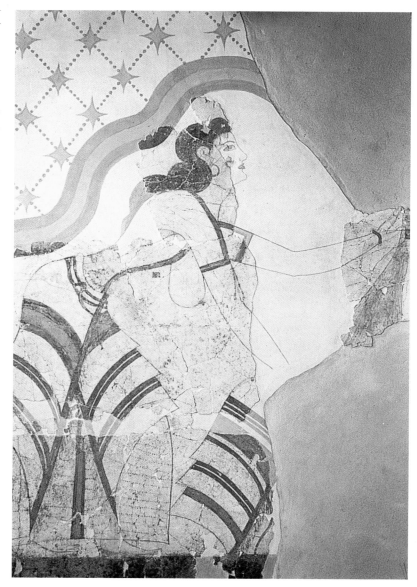

84

Plan of Houses A and F, Ayia Irini, Kea, Second Palace Period. The town is composed of buildings which in some cases (such as House A) resemble Minoan houses, while others (such as House F) are more rectangular and axially constructed.

Phaistos, but only one in the palace at Mallia. Clearly, something different was occurring at both places. As the only house at Ayia Irini incorporating a substantial number of Minoan features, it would be unlikely that House A incorporate every feature found in the Minoan corpus on Crete.

Let us look more closely at the Ayia Irini structure. We often associate light-wells in Minoan architecture with the occurrence of pier-and-door partition halls as discussed above. This association makes the appearance of a light-well unaccompanied by these features, as in room 23 at House A, seem unusual. Like House A, however, a number of Minoan buildings have light-wells that are not associated with pier-and-door partition halls. Examples of this can be found adjoining the benched rooms in the so-called country villa at Pyrgos Myrtos, in room 12 of the villa at Nirou Khani, and most notably at the Palace of Knossos where there are at least three examples.[56] These include the Court of the Distaffs; the Queen's *megaron* which is often confused with a Minoan hall, but is in fact a benched room with many windows; and the light-well of the east wing Grand Staircase.

The light-well in House A is associated with a frescoed hall above the pillar room (room 31) and together they form a secluded unit. The spatial depth of this hall, that is, its distance from the entrance, compares with that of certain houses at Knossos and Mallia and may emulate palatial arrangements, as has been quantitatively demonstrated recently.[57] A more accessible second hall (rooms 37–38) opens off the courtyard (room 36). Another scholar has made a strong case for the regular distribution of two halls in Minoan houses.[58]

In sum, House A incorporates some 19 architectural features that can be found in Minoan houses on Crete. In addition to the dual halls, and the hall and light-well combination as discussed above, these included: a labyrinthine circulation pattern, the non-axial layout of rooms, some attempt at cut or ashlar masonry in wall façades as well as an increased use of limestone,[59] the presence of indented-trace wall façades, an irregular ground-plan not unlike that common in Minoan buildings, and cut-slab pavement, including red plaster in its interstices (a common feature at Knossos and Phaistos, but not attested elsewhere in the Cyclades).[60] Other features include a U-shaped stone drain;[61] slots for a wooden door frame, again, rendered in stone; and a pillar room fashioned in local technique and associated with storage practices.

The placement of pillar rooms or crypts near a storage area or their actual use as storage areas is a regular feature that occurs in many Minoan buildings. The size of the rooms is often so small that the pillar is structurally unnecessary. These small, dark pillar rooms or pillar crypts have been interpreted as an architectonic representation of an aniconic deity worshipped in earlier, prehistoric times as stalactites and stalagmites in sacred caves.[62] Frescoes also show double axes embedded

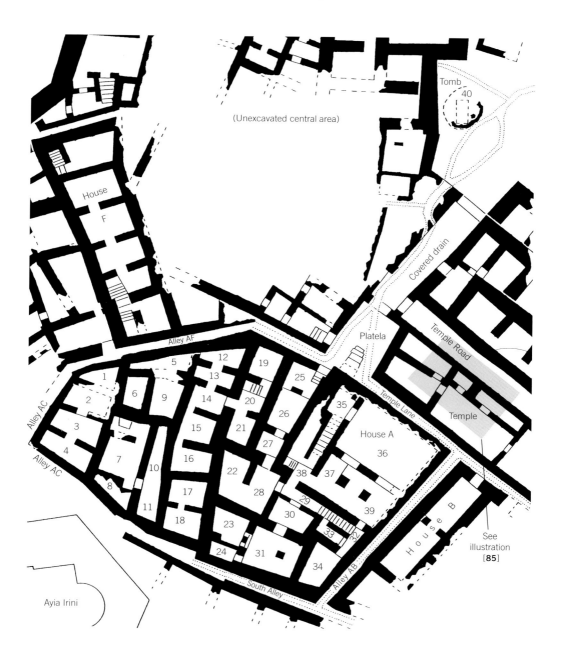

(Unexcavated central area)

Tomb
40

House
F

Covered drain

Alley AF

Platela

Temple Road

Alley AC

5

12

19

Temple Lane

1

13

25

2

6

9

14

20

35

Alley AC

3

15

21

26

Temple

4

7

10

16

22

27

House A

36

8

17

28

38

37

House B

11

30

39

18

23

29

See
illustration
[85]

24

31

33

32

34

Alley AB

South Alley

Ayia Irini

in column capitals. Similar patterns of association are known from caves where double axes and dagger blades were found embedded in stalactites.[63] It is worth considering the possibility that the pillars in these rooms stood as markers of perpetual liturgy. Their occurrence in association with storage areas suggests sanctification and/or protection of these areas. This aspect of perpetual liturgy is also suggested by the frequent association of Minoan bronze figurines with sacred caves and pillar rooms.[64]

House A also employs terraced construction techniques similar to those discussed in Chapter 3 in connection with Monastiraki. House A's court need not be central to the rest of the building to be regarded as a Minoan feature: similar off-centre courts are found at Nirou Khani and Myrtos Pyrgos. The staircase-and-entry combination (35) and auxiliary staircase (29) in House A was a common feature at Akrotiri that is also found on Crete, as is the bipartite division of the building into storage/work and living areas with a west orientation for the storage/work rooms, and the presence of figural frescoes.

Frescoes in the more secluded hall above room 31 included motifs that would have been common on Crete, including a bluebird frieze, 'adder marks', spirals, floral/rosettes, and possibly a griffin wing.[65] Interestingly, the splash pattern which decorated the more public or accessible hall (room 39) opening off the court was also found in room 6 of the Temple (discussed below) perhaps serving to create a visual link between the House and the Temple. It is probably no accident that the hunting and chariot scenes represented elsewhere on the site by dogs, fallow deer, horses, chariots, and men in Mycenaean garb contrast with the style of Cretan provincial houses and has suggested mainland influence to some.[66] Other houses on the site have very different room arrangements. Most notable in its contrast to House A is House F which consists of a series of rooms arranged in a linear fashion, one behind the other [84].

The fixed hearth in the courtyard (room 36) of House A (not pictured here) may reflect a mainland influence; however it also recalls the altar in the central court at Mallia. A number of activities including ceremony, food preparation, and industry connected with metallurgy could have been carried out there. It seems to be a more likely candidate for such activities than the enclosed and unventilated room 30 where some other explanation should be sought for the burnt debris found there. The axiality and later addition of the west suite of rooms, 1–4, suggests that they were probably locally designed and executed. Although Cummer and Schofield, who published the building,[67] compare the 'toilet' in room 24 to the 'toilet' in the Domestic Quarter at Knossos, it bears little structural resemblance to that feature.[68]

House A incorporated a recognizably Minoan exterior in terms of overall form and disposition, and a familiar Minoan interior in terms

of its fresco decoration, architectural features, and internal circulation patterns. The incorporation of a Minoan spatial arrangement, Minoan architectural features, and the use of Minoan objects at Ayia Irini House A suggest modes of temporal patterning in the behavioural routines of daily life that are recognizably Minoan.

An analysis of coarseware pottery from Ayia Irini has demonstrated that a variety of industrial objects copied Minoan shapes, but were locally produced.[69] Notable among these are objects called fire-boxes which may have been used for the production of aromatic substances. A strong foreign presence at Ayia Irini has been suggested based on the introduction of weaving technology and an increased standardization of various items. It has been suggested that weaving practice and textile production was under the control of a strong local elite that used Minoan cult paraphernalia and manipulated Minoan religious symbols to reinforce power, status, and symbolic ties to Crete.[70] The Minoan architectural features incorporated into House A would have served as one more powerful set of symbols alluding to strong Minoan cultural influence. The social conditions generated by such influence may have been far more favourable to the Minoans and the elites on Kea than any actual political domination.

It is of interest that some houses at Akrotiri incorporated Minoan architectural features, and that at least one was clearly altered to make it more Minoan-looking. This did not occur at Ayia Irini or Phylakopi, where only a single house incorporates Minoan architectural features. This may have been a result of Akrotiri's place in the 'western string' of islands and its close proximity to Crete, indicating more frequent exchanges, more Minoan ritual practices, and possibly a stronger Minoan residential presence.

There have been many attempts to interpret these influences, sometimes referred to collectively as evidence for a Minoan Thalassocracy or sea-empire of sorts, by tracing Minoan–Cycladic power relations, elucidating degrees of influence, listing or quantifying Minoan traits, or studying economic relations.[71] The indigenous and foreign elements have been debated with the foreign elements interpreted as either dominant or emphasized, or dismissed as irrelevant.[72] This should be taken into account in considering what may be at stake for modern observers in evaluating 'non-Greek' Minoan influence and 'Greek' Mycenaean influence in various parts of the Bronze Age Aegean.

Religious practices

The Bronze Age temple at Ayia Irini, Kea

The Kea Temple was a regional development that merits discussion for the atypicality of its layout, its spectacular hoard of Minoan-style terracotta statues, and its long history of importance to Aegean and later

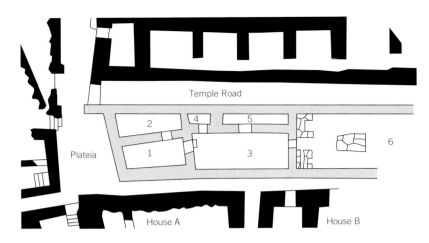

Temple Road

Plateia

2 4 5

1 3 6

House A House B

85

Plan of the Temple from Ayia Irini, Kea, Second Palace Period through the eighth century BCE.

Greek religion. The Temple does not date earlier than the fifteenth century BCE. It continued in use into the Graeco-Roman period, and it had become a shrine dedicated to the god Dionysos by the sixth century BCE if not earlier.[73]

The preserved remains of the Temple form a long and narrow trapezoidal structure in which the northwestern wall is not square, but angles inward towards the south [85]. This difference in orientation led the excavator, John Caskey, to suggest that rooms 1 and 2 which make up the northwestern end of the building were laid out before the main axis of the existing structure was established. The location of the entrance is uncertain, although it may have been at the southeastern end of room 6 which was lost as a result of encroachment of the sea.[74] Room 6 is a rectangular hall which takes up the full southeastern end of the structure and appears in plan to contain several built stone installations. It opens on to room 3 at its northwestern end. Room 3 is also a rectangular hall which is laid out so as to accommodate two small and narrow rooms (4 and 5) which run along its northeastern side. Room 3 opens on to room 1 from its north corner, and room 1, in turn, opens on to room 2. There is a small court or gathering place at its closed west end which is connected to roadways running along the north and south sides of the Temple. The court is oriented roughly to the north and appears to be twice as long as it is wide. Its location, orientation, and proportions recall (at a modest scale) similar design features in the Minoan palaces.

In addition to acting as a place for the community to gather, the court might have served as a location for public ritual or as a staging area for processions connected with cult activities in the Temple. Such processions could have moved simultaneously down the north and south roads, meeting up in front of room 6. Another possibility is that the processants circumambulated or walked around the building. Procession frescoes from Knossos and Akrotiri indicate that such

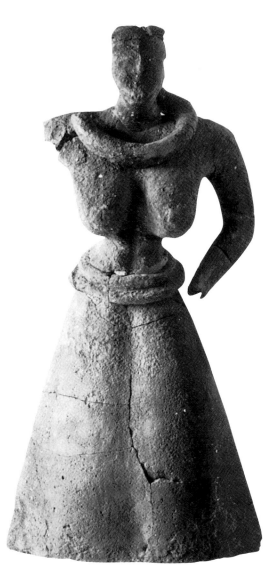

Terracotta female figurine, Ayia Irini, Kea, Late Neopalatial Period. Found with parts of at least 31 other female terracotta statues in room 1, ranging in height from about 0.7m to about 1.35 m. The original excavators have suggested that the women depicted represent dancers, while others argue that they are divinities. Note the hands-on-hips gesture which is found on one Minoan bronze figurine and on a number of seals found in Crete and on the mainland.

activities were not uncommon.[75] An analysis of the plan indicates that if a visitor (worshipper?) entered the building from room 6 at the southeastern end, he or she would then proceed into room 3, and only then gain access to the other rooms.

Parts of at least 32 female terracotta statues were found in room 1, a space thought to be capable of accommodating as many as 100 statues [**86**]. Their date corresponds roughly to the later part of the Neopalatial Period (Period VII of the Temple roughly corresponds to LM IB). The statues range in height from about 0.7 m to about 1.35 m. All of them are standing, and with one exception they have their hands placed on their hips in what John Caskey called a 'dancing' position.[76] Miriam

Caskey prefers to interpret the figures as dancers rather than divinities, citing their relative similarity to each other and the unlikely possibility that 50 statues should represent a single goddess or that so many goddesses could be represented.[77] This dancing posture could also indicate an attempt by the artist to model or depict the legs beneath the skirt. This position or gesture of standing with the hands placed on the hips is found on one Minoan bronze figurine and on a number of seals in addition to the terracottas. It appears to be exclusive to females.

Certainly, the Kea Temple represents its own unique context which merits a systematic study. However, it is not clear why 50 statues gesturing in similar or identical ways should not represent 50 goddesses. A much later Bronze Age parallel can be cited in the open air Hittite shrine at Yazilikaya where a relief depicts a procession of 66 deities separated by gender, and largely indistinguishable except for the seven highest deities which are emphasized by their size and their attributes.[78] This is not to suggest identical situations for Kea and Yazilikaya; we certainly understand little enough about Aegean religion(s) to make sweeping generalizations about this material based on what seems unlikely to modern eyes.

The only Minoan bronze religious figurine which makes this hands-on-hips gesture is a female purported to be from a temple context at Palaikastro. At least four different seals depict females making this gesture.[79] In two instances, the female is rendered in hierarchic scale between two other figures making the same gesture [**87**].[80] In the third seal (photograph [**87**]) both figures are bent over as if subordinated to the central figure.[81] The flanking figures might be interpreted as attendants, priestesses, worshippers, or minor deities in the case of the flanking females. Two of these seals also depict altars in association with free-standing *baetyls* (columns or standing stones) and 'sacred' trees. Such representations have been connected with the worship of aniconic deities.[82] The central figures on the seals making the hands-on-hips gesture may represent epiphanies (appearance of a deity) based on their size, location, and association with the altars. Based on the evidence of the seal representations, the terracotta statues might be interpreted as attendants, deities, deities and minor deities, or as stand-ins for a particular class of worshipper.[83]

Parts of seven female terracotta statues were found in room 2, and many of their pieces join pieces of statues found in the room 1 debris. It has recently been suggested that the breaking of ceremonial vessels shaped like the head of a bull (*rhyta*) formed a part of Minoan ritual symbolizing the sacrifice of a bull.[84] Ethnographic evidence has connected breakage, especially of prestige items, to a host of different cultural practices including the ritual disposal of religious objects, sacrifice, appropriation of power, and death of the owner. The idea that such practices could be extended to statues is worth considering. If the

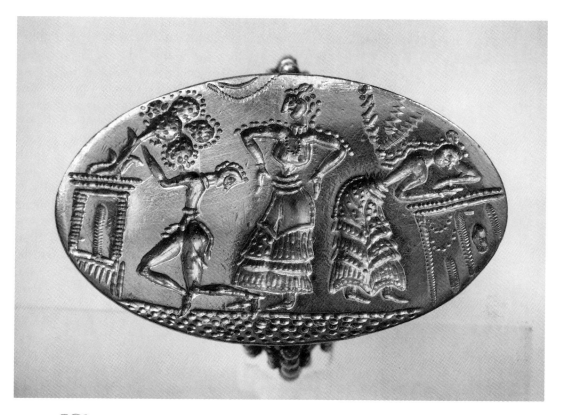

87

Photograph and drawing of seal impressions showing the hands-on-hips gesture, from Mycenae, Late Helladic. Note the subordinate position of the two bent-over figures in relation to the standing goddess in the photograph, and the hierarchic scale of the female in the drawing.

statues represented particular worshippers, their breakage might have been connected with the death of the individual represented. Another possibility is that the local inhabitants treated the broken pieces as relics that were too precious to discard in a normal fashion and which became mixed up in the course of the building's long history. Or perhaps the distribution of the fragments was just a product of chance.

It is important to distinguish between the archaeological evidence, which is (relatively) constant, and the theories and interpretations which try to make sense of the evidence. Despite the attractiveness of the current explanations, we must keep an open mind that new discoveries and/or future generations of scholars coming up with new insights may develop equally plausible or even better explanations. New insights may be gained by looking at the evidence from a different perspective, by confronting the evidence with different interpretative models and comparative analogies, or by constructing a more detailed and logical argument to refute an explanation that seems insufficient.

A single male bronze figurine from the Ayia Irini Temple dates to the same period as the terracotta statues.[85] It was found along with a small bronze boat in room 5 of the Temple.[86] Room 5 served as a storeroom for cult equipment located under a stairwell in the Neopalatial Period.[87] As we have seen, bronze figurines in architectural contexts

tend to be located in or near storage areas. The larger rooms, 3 and 6, which contained no Neopalatial debris, were apparently cleaned out. Although this particular bronze is not illustrated here, the gesture is depicted above on the so-called Mother of the Mountains sealing from Knossos (see **55a**) where it is being made by a male worshipper. It consists of raising the fist to the forehead while the other arm remains at the side and is commonly referred to as the 'Minoan salute'. It is most often made by male bronze figurines in ritual contexts such as sacred caves (see below) and peak sanctuaries.

The significance of other gestures is not always so clear-cut. The characteristics of this figurine can be clearly contrasted in opposition to those of the terracotta statues as follows: male/female; small/large; gesture of worship/gesture of authority; context: closet?/context: cella?; subordinate/dominant; hidden/visible. Whether the terracotta statues were worshippers or deities (or both), the evidence from the Temple indicates that the celebration of females was emphasized.

Reconstructing ritual and ideology at Kato Syme
The site of Kato Syme is located in southeastern Crete on the slopes of Mount Dikte where it overlooks the south coast of the island from a height of 1,130 m. Kato Syme is the site of an important Neopalatial sanctuary (Late Minoan I *c.*1650–1450 BCE) that was founded in the Protopalatial Period and was rebuilt and added to over time continuing in use until the Roman Period [**88**]. The fact that it was associated with a large spring, possibly sacred, and located on the mountainside rather than on a mountain peak suggests that its rituals and cult were of different significance from those at other open air or peak sanctuaries.

The Neopalatial sanctuary is represented by three architectural phases and includes a 'monumental complex' open to the sky which was composed of three distinct elements.[88] These elements include a massive enclosure wall defining a rectangular area (approximately 530 sq. m), a paved road (2 m wide) leading to the interior of this area and a rectangular, built structure (12.2 × 7.7 m) in the middle of the enclosure wall. The road follows a dog-leg approach. The central structure would have been open to the sky, as there was no evidence of internal supports for a roof.

It is believed that the ground-plan of the rectangular structure conformed to the representation of the tripartite shrine as depicted on the so-called Peak Sanctuary *rhyton* from Kato Zakro [**89**] as reconstructed by J.W. Shaw.[89] The enclosure wall distinguishes Kato Syme from the Kato Zakro representation. The presence of the wall around the rectangular structure of the sanctuary between these two architectural features indicates that participants would have been free to either move back and forth, or circumambulate the sanctuary building in the performance of ritual action.

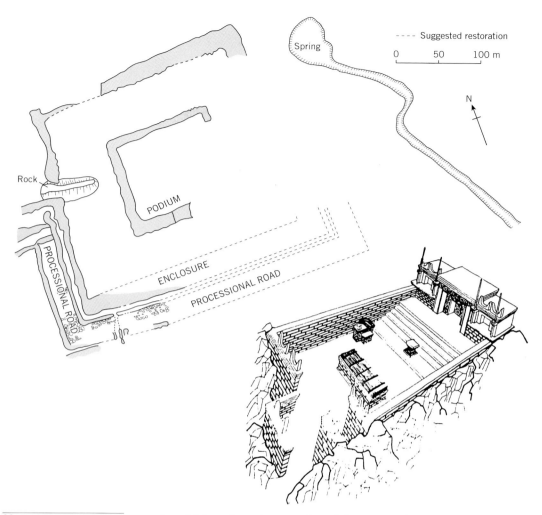

N

Spring

- - - - Suggested restoration

0 50 100 m

Rock

PODIUM

PROCESSIONAL ROAD

ENCLOSURE

PROCESSIONAL ROAD

88

Plan of the Neopalatial sanctuary of Kato Syme, Crete, Second Palace Period, and a representation of a shrine on a stone *rhyton* from Zakro Palace. It is believed that the ground-plan of the sanctuary of Kato Syme conformed to the representation of the tripartite shrine depicted on the 'Peak Sanctuary' *rhyton* from Kato Zakro, seen in the next illustration.

A midden deposit was found between the enclosure wall, or *temenos*, and the sanctuary. A midden is a layer of black, greasy soil which includes animal bone remains. It is often taken to indicate human habitation connected with the preparation and consumption of food. In this type of context it would seem to indicate communal feasting connected with the rituals and ceremonies taking place around the enclosure. Such feasting is further indicated by the presence of cups and pots within the midden.

Among the most notable finds from the sanctuary are at least seven bronze figurines and many libation tables, a few with Linear A inscriptions. Bronze seems to be a material especially favoured for dedicatory figurines in the Neopalatial Period. The widespread distribution of bronze figurines in the period might be seen as one more indication of the increasing wealth of Minoan civilization, as further indicated by the proliferation of villas. The character of the finds from Kato Syme

The 'Peak Sanctuary' *rhyton* from the Palace of Kato Zakro, Second Palace Period. The vessel, made of chlorite, was found in fragments in the west wing of the palace. It depicts in finely carved low relief a stone tripartite peak sanctuary surmounting a broad stair, with double horns along the roof lines and on what seem to be altars in the foreshortened front courtyard. Set in a rugged mountain landscape replete with *agrimia* and birds, the building also has four tall poles bracketed to the shrine's front façades. Traces of gold leaf have been found adhering to the vessel, suggesting that it was at least partially covered in gold.

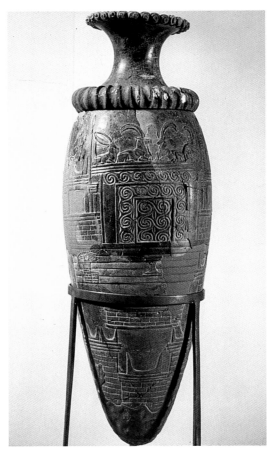

would tend to suggest an elite status for those moving about the enclosure.[90] Furthermore, the relationship between luxury materials and peak sanctuaries indicates palatial influence. This is further indicated by the regulatory role which the so-called palaces played in the production and distribution of luxury goods such as bronze to the stratum of society that had access to them.

The fact that male bronze figurines outnumber female ones by a ratio of two to one indicates the presence of an elite stratum of Minoan society that was predominantly male procuring bronze figurines and making offerings at the peak sanctuaries.[91] Again, turning to context on a larger scale, we know that the placement of votive figurines and statues in sacred areas to represent or stand in for the worshipper was a common practice in the Near East and in later, classical Greece. For example, a statue of the Neo-Sumerian King Gudea from Mesopotamia carried the inscription 'It offers prayers'.[92]

One of the figurines from Kato Syme stands out particularly. It was a male bronze figurine holding its hands to its chest [**90**].[93] The only other male bronze that makes this gesture wears a conical cap. Conical

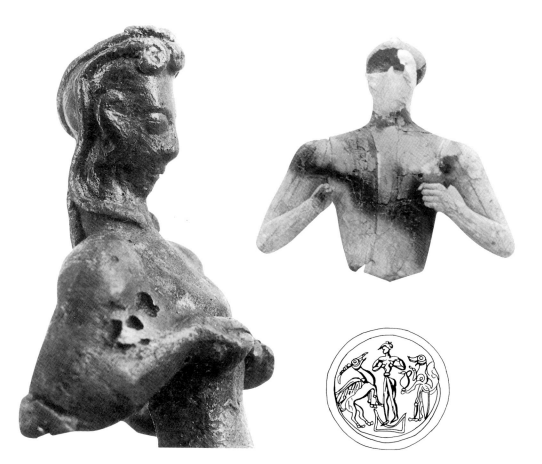

Bronze male figurine from Kato Syme, chryselephantine (gold and ivory) statuette from Palaikastro, and a Minoan seal showing a similar hands-to-chest gesture; all Second Palace Period. While the bronze figurine has been interpreted as an adorant, the Palaikastro statuette and the male figure on the seal have both been interpreted as cult figures or divinities.

caps were often worn by kings in the ancient Near East. This particular figurine is highly detailed. The eyes are rendered with incised pupils. The long, snaky locks of hair, and the large eyes and ears, may have constituted individuating features, perhaps a particular individual who was a political or religious leader. It is described as having come from the 'sacred enclosure', although its precise location is unclear.

Like most Minoan bronze figurines this one from Kato Syme is dated stylistically to the Neopalatial Period.[94] Style is the criterion most often used to date the figurines, the reason for this being the lack of stratified information. Strata are layers of soil containing archaeological artefacts that accumulate one above the other with the earliest strata at the bottom and the latest at the top. In Minoan archaeology, these strata are often dated by correlating the designs on the pottery found within them to a particular period in time. Unfortunately, many of the Minoan bronze figurines come from strata that have become mixed up, or from poorly documented or clandestine excavations. As a result, it becomes necessary to look at the style of the figurine and compare it to those few that come from securely dated layers or strata.

We would like to suggest that the presence of this particular figurine within the sacred enclosure further emphasizes an elite connection. Bronze was the material favoured for dedicatory figurines in the Neopalatial Period. The use of bronze, the high degree of workmanship, the individuating features, and the rarity of its gesture among representations of males, would indicate that this particular figurine placed at Kato Syme represented a specific individual of higher status than other male bronze votives where the typical gesture is a hand raised to the forehead in the manner of a salute.

This particular gesture of holding the hands to the chest is made predominantly by female bronze figurines found mainly in caves and villas. However, in its only occurrence on a seal (see **90**) it is being made by a male. In this composition, he stands between 'horns of consecration' and is flanked by a winged goat and a Minoan genius.[95] This image has also been interpreted as a 'youthful male god' based on his relationship to the horns, his central position, and the flanking by supernatural animals which places him in what has been termed the 'realm of the fantastic'.

It has also been observed that this gesture is made by the stone and chryselephantine (ivory and gold) male figurine recently discovered at Palaikastro (see **90**).[96] The statuette is remarkable for its realism and attention to detail including minute stippling of the hair rendered in steatite and the delicate rendering of the veins and toes. The technical skill of its maker is unrivalled in the art of the Bronze Age. Based on the interpretation of the seal figure as a divinity, the Palaikastro statuette has been interpreted as a cult figure, rather than as a worshipper. It has even been suggested that the statuette may have represented a youthful Zeus.[97]

This interpretation is based on classical Greek myth, archaeological evidence that the Roman temple site of Diktaian Zeus overlies Minoan Palaikastro where an Archaic Greek 'hymn to the Kouros' was found, and on four offering tables from the peak sanctuary at Petsophas overlooking Palaikastro on which DI-KI-TE was inscribed in Linear A. Does the evidence suggest continuity of cult or the projection back in time of a Greek past into a dynamic, changing pre-Greek Bronze Age?

In trying to determine whether the status of male representations holding their hands to their chests is divine, we would like the reader to consider two other examples of supernatural animals flanking human figures. In the so-called Throne Room at Knossos (see **51**), the occupant of the throne was flanked by griffins. A similar, though not identical, situation can be found at Mycenaean Pylos. It has been suggested that a re-enactment of an epiphany (the appearance of a deity) took place in the Knossian Throne Room with a priestess occupying the throne.[98] Still, it remains uncertain whether the occupant of the Knossian throne was a male or a female, a king or a queen, a priest or a priestess, or some other type of official.

The situation at Pylos is somewhat different since the Greek title of 'wanax' or monarch is known from Linear B tablets found at Pylos.[99] One tablet also lists the word for throne or *to-no*. What, then, happens to a ruler who is placed in association with supernatural animals? Does this make the wanax divine or place him under divine protection? How strongly do the secular and the religious become conflated? In ancient Sumer, kingship was handed down from heaven, whereas in Egypt, the king or Pharaoh was a living god.[100]

The point we are making is that the status of a figure placed between supernatural animals is not as straightforward in its interpretation as we might like it to be. Do the male bronze figurines, the seal example, and the Palaikastro statuette all placing their hands on their chests represent Minoan deities; do they represent early examples of Minoan ruler portraiture; or do they represent political leaders impersonating a deity? Or might they represent all of these things depending on their composition and context? What about the figurine from Kato Syme? The high degree of workmanship, the careful rendering of facial details, and the gesture which seems to be made only rarely by males of a particular status might be seen as indicating an important person, possibly a ruler, participating in a ritual involving circumambulation and feasting. Although we prefer to interpret the figurine as the representation of a ruler, the reader should feel free to draw his or her own conclusions based on the information provided or by following up the references given in the footnotes.

The Diktaian Cave at Psychro

As noted above, most of the Minoan bronze figurines attributed to peak sanctuary contexts are dated to the Neopalatial Period. The greatest concentration of bronze figurines is known from and attributed to cave shrines or sanctuaries. Female figurines are more frequently found in caves where they occur in equal number with male bronzes despite the fact that male bronze figurines outnumber females by a margin of two-to-one. This stands in contrast to the greater numbers of male-associated offerings such as weapons.[101] Far more male figurines are found at peak or open air sanctuaries. The less visible context of caves and villas for female figurines might be taken as indicative of an ideology of separate spaces.

Caves were initially used as habitation areas in the Prepalatial Period. However, by Middle Minoan I (*c.*2000–1800 BCE), caves began to take on cult functions. Among the earliest cave shrines are the Diktaian Cave at Psychro, and the Skoteino, Trapeza, and Kamares Caves. However, the finds at Kamares are limited to the pottery which bears its name. The offerings left in these sanctuaries tend to be found in layers of carbonized material, between crevices, and around stalagmites and stalactites. This last is especially true in the

cave of Eileithyia, the birth goddess, now a Christian site visited by Cretan women.

The largest concentration of bronzes is attributed to the Diktaian Cave [91] near the modern village at Psychro.[102] It is located above the Lasithi plateau in eastern Crete on the slopes of the Diktaian mountain range, at an elevation of 1,025 m. Although identified as the Diktaian Cave, the legendary birthplace of Zeus by both Evans and Hogarth, the later written evidence is contradictory and the designation remains uncertain. The cave at Psychro may have been one of many sanctuaries connected with the worship of Zeus. As we find elsewhere, the cave at Psychro was initially used for habitation in the Prepalatial Period. Such a use of the cave raises the question of whether some aspects of Minoan religion evolved out of ancestor worship commemorating past inhabitants.

The cave at Psychro consists of three areas: a built terrace (approximately 4–5 m wide × 40 m long) leading to the entrance of the cave; an upper chamber (approximately 25 m wide × 20 m deep) that continued to receive offerings of bronze objects until the Geometric Period; and a lower chamber which ends some 65 m down from the entrance in a pool of water surrounded by crevices, stalactites, and stalagmites. The upper chamber included a Neopalatial altar and storeroom. The finds from the lower chamber dated predominantly to the Neopalatial

91

Plan and photograph of the Diktaian Cave, near the modern village of Psychro, Crete. Evans believed this cave to be the one traditionally associated with the birth of the god Zeus, but it may have been one of several associated with the god.

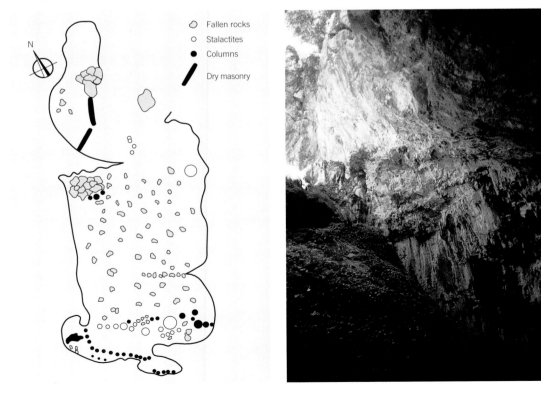

Fallen rocks
Stalactites
Columns
Dry masonry

Miniature gold votive double axes from the Arkalokhori Cave, Crete, Second Palace Period. Votive bronze double axes reminiscent of these gold ones were found in the Diktaian Cave among other gifts or offerings such as miniature vessels and figures of humans and animals.

Period and included some 500 bronze implements including bronze knives, spearheads, razors, tweezers, and double axes, as well as pottery and other items. All in all, the range of finds falls into five broad categories: (1) items connected with ritual feasting such as cups, jugs, and food remains; (2) gifts or offerings of a symbolic nature such as miniature vessels, and human and animal figurines, and votive double axes reminiscent of the gold ones from the Arkalokhori Cave [**92**]; (3) weapons such as daggers; (4) personal possessions which included jewellery; and (5) tools such as knives, chisels, and axes. While we may tend to associate the dedication of jewellery with females, in Minoan representations both men and women wear jewellery.

A visit to the interior of the cave is normally a cold, damp, dark, and slippery experience, and in the summer it presents an extreme contrast

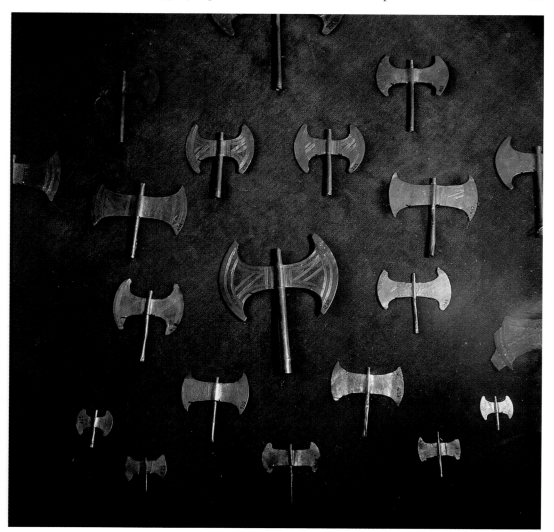

to the outside which is hot, dry, and bright. The feeling such a visit evokes is one of otherworldliness and mystery. The stalactites in the cave, already mentioned above, received special attention in the form of double axes and dagger blades which were found embedded in them.[103] As noted above, fresco representations similarly show double axes embedded in the column capitals of Minoan buildings.

Many scholars believe that the pillar crypts associated with the Minoan palaces and villas once evoked experiences of darkness and mystery similar to a visit to a cave sanctuary. These small, dark pillar rooms or crypts might be seen as architectonic representations of aniconic deities worshipped as stalactites and stalagmites in sacred caves.[104] Could the pillar and/or double axe have been an aniconic cult statue, a site of *baetylic* cult? In a number of instances,[105] the plan of the pillar crypt seems to be replicated on the upper floor with a column substituted for the pillar. Nanno Marinatos has connected these upper floor rooms with vessels used for holding and pouring liquids.[106] She has chosen to interpret these as concerning the cult of a celestial deity connected with light, while the pillar crypt below should be connected with a chthonic (earth) deity connected with darkness. Both are, in turn, related to rituals connected with death and regeneration. The underworld aspects of the cult practices in the Diktaian Cave have similarly been contrasted to the more open air aspects of cult practice at Kato Syme and elsewhere.[107] Marinatos' interpretation also illustrates the same contrast that a visit to the cave evokes with the outside world.

We might reiterate that the pillar crypts in many Neopalatial palaces and villas are located close to storage areas, and in some cases[108] are even used as storage rooms. These often also include a recurring association with the double axe either as object or as an incised mark; sometimes they also include the placement of bronze figurines as discussed above. In addition to serving as sites for the performance of ritual, pillar rooms may also have served as sites of perpetual liturgy, and as sources of protection and sanctification of the storage area through the appropriation of symbols associated with the rituals carried out in the caves.

Burial practices

Sometime during the Second Palace Period on Crete, the mainland site of Mycenae became a powerful and wealthy centre, supporting a warrior class whose influence was to spread throughout the Aegean, profoundly transforming the entire region during the last 400 years of the Aegean Bronze Age. When the power centres of this Mycenaean civilization fell at the end of the second millennium BCE, the transformed remains of its culture, mixed with other indigenous and imported social and cultural practices, comprised the foundation of the world of Hellenic Greece (as detailed in Chapter 6).

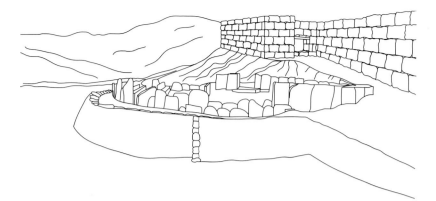

Mycenae came to be but one of a network of power centres scattered across the mainland, the island, and Crete, and was never, as far as we can ascertain, the capital of an empire similar to those of their contemporaries in the Near East such as the Hittites or the Assyrians. When uncovered by Heinrich Schliemann in the 1870s, several years after his discovery of Troy, the shaft graves of Myceanae's ruling warrior class were found to contain spectacular finds which fired the imagination of an entire generation of scholars familiar with Homer's epic poems the *Iliad* and the *Odyssey*, which described the military and amorous exploits of their heroes and gods. The Mycenae graves being uncovered during the last quarter of the nineteenth century made dramatically palpable to many the lives of Agamemnon, Atreus, and Clytemnestra.

Illustration **93** depicts a reconstruction of a portion of what was to become a vast cemetery of Mycenae's ruling class, during an early phase in its development, close to the later walls of the citadel. During a short period in the history of Mycenae, most wealthy burials consisted of deeply dug rectangular shafts at the bottom of which were stone- or wood-lined and roofed enclosures. These chambers contained the body of the deceased, accompanied by many (often quite spectacular) grave gifts and offerings. The shaft was filled in with earth and rubble after interment, and, in the case of the earlier burials, the site of the grave was marked by an upright *stele* or tombstone. Two sets of these shaft graves have been excavated: a later one (now known as Grave Circle A, shown reconstructed here) uncovered by Schliemann, and an older and more recently discovered one (called Circle B). The nine famous monumental beehive or *tholos* tombs of Mycenae (see Chapter 5) post-date the later grave circle.

The illustration [**93**] shows Grave Circle A after it was rebuilt on a monumental scale and prior to being encircled by an extension of the city wall, when its surface level was raised to allow access from the main citadel thoroughfare, with the original *stelai* repositioned at the new high ground level (discussed in Chapter 5).[109] Illustration **94** shows the

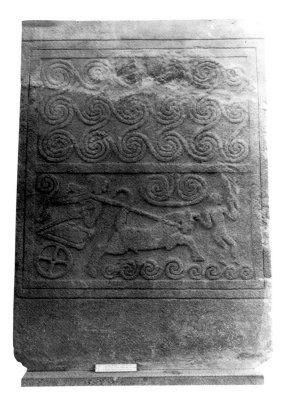

limestone *stele* from Grave V, one of about 14 known sculpted *stelai* (two survive from the earlier Circle B, the rest from Circle A). Some nine unsculpted ones have survived. It once was thought that the sculpted tombstones, nearly all of which contain scenes of battle or hunting by men or animals, belonged to male burials, with the plain ones marking female graves; but there is no clear archaeological evidence for such a conjecture.

The *stele*, about one metre broad, depicts a charioteer in the lower panel rushing headlong in the direction of an individual (soldier?), who is carrying an upright sword thought by some to represent funeral games. There is a motif of running spirals below the chariot, and a double-spiral above the horse; the upper panel is completely filled with running spirals, repeating a motif found throughout the Aegean and Crete from the Early Bronze Age onwards. The relief is simple, sharp, shallow, and schematic, and would have made a dramatically crisp silhouette in the sunlight.

Many of the shaft graves contained hundreds of luxury items, as well as highly decorated and embellished objects of daily or military use. Some examples are shown in the next two illustrations. Illustration **95** shows a spectacular gold full-size death mask. Made of hammered gold sheets, these masks would have covered the faces of the deceased, completing a finely made costume of durable materials.

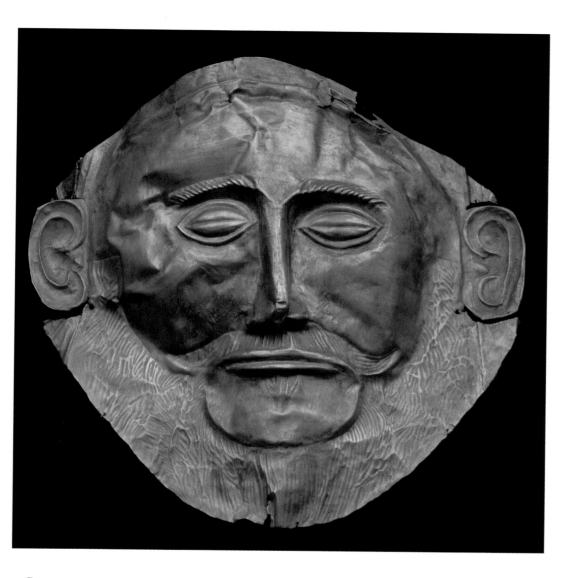

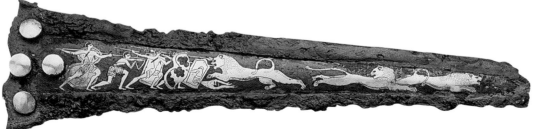

The eyes appear closed on this example, as was the more common practice, although occasionally they were open. The faces are individuated to a certain extent, conveying direct or schematized impressions of the face of the deceased person, and intended (unlike a portrait) literally to protect and render permanent the face's contours.

These masks are but a few of the many hundreds of gold items found in the shaft graves, ranging from jewellery and weapons to inlays and appliqués for (mostly disappeared) furniture and costume. Illustration **96** shows the bronze blade of an inlaid dagger from Grave IV. It is inlaid with gold, silver, and black niello (an alloy of silver and sulphur) and shows a lion hunt; it is approximately 24 cm long.

The scale of the wealth displayed in the shaft graves at Mycenae, and the power of the warrior classes for whom such objects were made, had no immediate precursors in Greece, and the growth of regional centres such as Mycenae heralds an entirely new age in the Aegean. Whoever these rulers were, their activities were later recorded in a new script—Linear B—a departure from the language (Greek) of the (still undeciphered) Linear A script of Minoan Crete.

As we shall see in the next two chapters, these Mycenaean Greeks were to usher in a new age on Crete during the Late Minoan Periods II and III, both assimilating and transforming the social practices, art, and culture of the Minoans themselves, thereby serving as the agents of the dissemination of Aegean culture throughout the wider eastern Mediterranean. Those interactions with the Near East continued and considerably broadened the earlier exchanges between the Minoans and their eastern contemporaries so that by the end of the Bronze Age—the traditional date of the Trojan War and the widespread destruction of the Mycenaean and Cretan citadels and cities in the twelfth and eleventh centuries BCE—the Aegean world will become, artistically, economically, and culturally, a part of that wider eastern Mediterranean world, both areas having been changed in consequence.

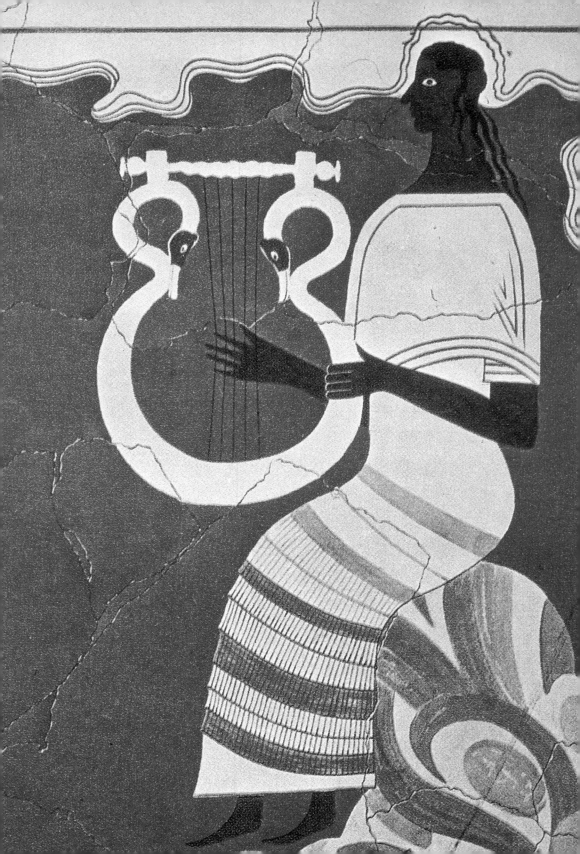

Mycenaean Domination and the Minoan Tradition

<div style="float:left">5</div>

The Mycenaean palace at Pylos

The so-called Palace of Nestor at Pylos is among the most carefully documented sites we have looked at.[1] It is significant for a number of reasons including its fresco programme, painted plaster features, careful architectural layout, the well-documented context of its finds, and a significant archive of Linear B tablets. The following discussion will examine the issues involved with the reconstruction of its fresco programme, building techniques, the context of portable objects from the building, and the function of the palatial compound.

If we were to think of Pylos in modern terms we might conceptualize it as the corporate headquarters of the Late Bronze Age Peloponnese. Pylos is ideally situated on the hill of Ano Englianos with a nearby harbour facility, fertile surroundings, and a central location in Messenia in western Greece.

Although Pylos was mentioned by the geographer Strabo (63 BCE?– 24 CE), who argued for a more northern location near Elis, it was not accepted as Nestor's Pylos until Wilhelm Dörpfeld excavated three *tholos* tombs north of Navarino Bay in 1907. The presence of such tombs suggested an elite stratum of society which would have lived in a monumental structure. This hypothesis led to the formation of a joint Hellenic–American expedition in the 1920s with Carl Blegen of the University of Cincinnati leading the American contingent. Exploratory digging began on 4 April 1939. On that first day, five clay tablets bearing Linear B inscriptions were found. These were the first Linear B tablets discovered on the Greek mainland.

Blegen was one of the early archaeologists to formulate a strategy for the excavation of his site that was systematic and aimed to achieve swift results. He began his first season by laying out eight long and narrow exploratory trenches in various directions to ascertain the limits of the palace. Over 600 Linear B tablets were recovered that first season, which was interrupted by the Second World War and not resumed until 1952.

The palatial compound [**97**] at Pylos consists of four separate structures that are initially dated to Late Helladic IIIA or around 1300 BCE. Their destruction is placed between 1230 and 1200 BCE. According to Blegen, the building sequence begins with the southwest building, followed by the main building, the wine magazine, and the northeast building. The exterior wall of the main building has been reconstructed on all but the northeast side.

The heart of this compound was the main building. It is not large and, at 30 × 55 m, it would fit easily within the central court at Knossos. The core element of the main building is the so-called *megaron*. This term and its modern connotations were discussed briefly in Chapter 2. Although the term might be more suitably applied to Pylos because of its alleged historical significance, a number of scholars have suggested abandoning the term altogether.[2] The *megaron* at Pylos represents a more refined and regularized variation of the structure found at Dimini as well as early Troy. It may be said to consist of a hall and porch structure of rectangular outline where the porch is approximately one-half the depth of the inner hall with access to a corridor along its side giving access to a series of small rooms. The internal arrangement of the main hall was dominated by a large circular hearth surrounded by four columns. As discussed earlier, all *megarons* incorporate slight variations of this basic arrangement.

Many of the building techniques employed at Pylos appear quite similar to those used earlier by the Minoans. These include the use of a timber and rubble core in the interior walls, which were usually covered with plaster. The exterior walls were constructed of ashlar blocks of *poros* limestone, many containing dovetail mortises or clamp cuttings to secure them to the rubble core and the use of square dowels to hold horizontal timbers along the outer face of blocks with the occasional use of mortar. Like Minoan ashlars, the ashlar blocks at Pylos are cut back in a V for easy fitting so that the joints between the blocks could be filled with clay and small stones. Mud bricks were used to construct the upper storey walls and were also used for repairs. An ashlar block with a double-axe mason's mark carved on it has been found beneath room 7. This block and a horn of consecration built into a palace wall may indicate strong Minoan influence prior to the construction of the Mycenaean *megaron*.

A wealth of objects stored in the palace provide scholars with valuable clues regarding the function of the building. Scattered throughout were bits of ivory, silver, gold, worked stone, and bronze. Although many of these items were burned beyond recognition, these bits of bronze were believed by Blegen to constitute door fixtures corresponding to the stone thresholds and door jambs attested throughout. The terrible fire that spread throughout the building at the time of its destruction is discussed below.

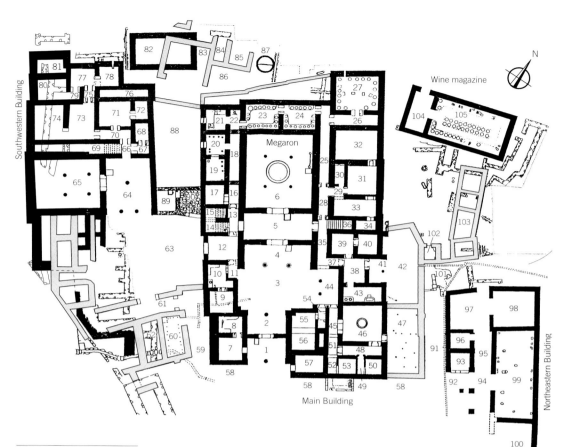

97
Plan of the palace at
Pylos, Late Helladic IIIA,
*c.*1300–1200 BCE. The
compound includes four
separate structures: a two-
storied main block with a
large *megaron* hall fronting
on a court, with a throne on
the east wall facing a central
circular raised hearth; a
sanctuary building to the
southeast; a storage building
on the northeast; and a large
two-storied western block
with a *megaron*-like hall at
its centre. The western wall of
the west block is built upon the
top of a retaining wall, which is
indented in a manner similar
to the western façades of the
earlier Minoan palaces. The
detail shows the painted
plaster floor in imitation of
rock work. Note the single
octopus below the hearth.

98

The 'Tripod Tablet', a Linear B tablet from the palace at Pylos, dated to the thirteenth century BCE, which confirmed the decipherment of this script as an early form of Greek.

99

Linear B tablet from the Palace of Knossos, Third Palace Period. Like many such tablets, this one is a list of sheep, goats, pigs, and cattle, and was part of the extensive administrative apparatus of the palaces both on Crete and the mainland.

Massive quantities of pottery were concentrated in certain areas of the palace. Tall, stemmed drinking cups known as *kylikes* as well as the bases of cups and bowls were particularly plentiful. Some 600 were found in rooms 9 and 10 alone. An attempt has been made to connect these items with the ritual banqueting that is depicted in the fresco programme here. Another possiblity is that they were being stored for export. The stockpiling of oil and wine was indicated by the Linear B tablets and confirmed by the presence of storage jars found in the palace and in the wine magazine to the northeast of the palace. A concentration of bronze projectile points found in the Northeastern Building located to the southeast of the main building indicates a state of preparation for military activity. Let us now take a look at these various aspects of the compound in greater detail.

The *megaron* is entered through an H-shaped *propylon* or entryway (1–2) with a single axial column between *antae*. This entire feature is asymmetrically aligned with the main hall. Layers of plaster around this and the other column bases in the palace preserved impressions of fluted wooden columns. The *propylon* gives access to a small court (3) which leads to the porch and forehall of the *megaron*. Raised rectangular areas next to this series of doorways have been interpreted as guard stands based on their context or positioning.

Adjacent to the *propylon* on the west are a pair of small connecting rooms 7 and 8 which contained the vast majority of the some 1,200 Linear B tablets found at Pylos [**98**]. The term Linear B (discussed briefly in Chapter 1) refers to the fact that the pictographic characters written on clay tablets with a stylus to represent syllables or entire words have a linear character. The 'B' refers to the fact that it developed later and out of Linear 'A', the undeciphered Minoan writing system. Linear B was initially discovered at Knossos [**99**] by Evans and caused great surprise when it was discovered later at Pylos by Blegen. It remained undeciphered until 1952 when a young British architect by the

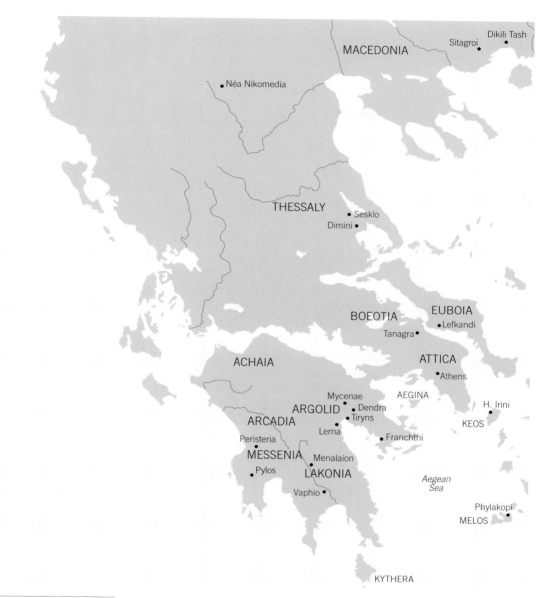

MACEDONIA

Dikili Tash
Sitagroi

Néa Nikomedia

THESSALY
Sesklo
Dimini

BOEOTIA

EUBOIA
Lefkandi

Tanagra

ACHAIA

ATTICA
Athens

AEGINA

ARGOLID
Mycenae
Dendra
Tiryns

H. Irini

KEOS

ARCADIA
Peristeria
Lerna

Franchthi

MESSENIA
Menalaion
Pylos
LAKONIA

Aegean
Sea

Vaphio

Phylakopi
MELOS

KYTHERA

Map 3

Greek mainland: Neolithic
and Bronze Age sites

name of Michael Ventris worked out that it was an early form of Greek, since dubbed Mycenaean Greek by scholars.[3] Linear B reflects an adaptation of the Minoan Linear A script to write Greek in much the same way that our modern alphabet is used to write a number of different languages. The fact that Linear B was adapted and adopted to write a language that it was not really suited for is reflected in a certain awkwardness of form. For example, the Greek word 'tripod' which is a pot with three legs is written '*ti-ri-po-de*' using the Linear B script.

Most of the Linear B tablets found in rooms 7 and 8 were kept in baskets on shelves in these two rooms. Many miniature votive cups

were also found in association with the tablets, indicating a ritualistic aspect to the functioning of the record-keeping centre. Although these rooms are often referred to as the 'archive', they were not an archive in the sense that the tablets were intended to be kept permanently. Such an intention would be indicated if the tablets had been purposely baked to preserve them. These rooms served more as a temporary record-keeping facility where the tablets might be disposed of when they ceased to hold any relevance for the palace bureaucracy. Other tablets were distributed within the building in such a way as to constitute a sophisticated network of administrative control over palatial collection, distribution, and manufacture. The distribution of the tablets has enabled scholars to reconstruct pathways followed by these early scribes in the performance of their daily routines.[4]

The main hall of the palace is dominated by a large stuccoed hearth some 4 m in diameter with an inner ring of 3 m in diameter. It is decorated with a painted stucco design depicting a running spiral motif around the top, and a flame pattern around the side. The four fluted columns that surrounded it probably supported a clerestory with a balcony to admit light and draw off smoke through the clay chimney which was composed of two sections. The floor of this hall was also coated with plaster that was decorated by means of an incised grid consisting of over 100 small squares painted with non-figural patterns (see **97**). The absence of symmetry in the arrangement of the grid has been contrasted to earlier Minoan floor patterns which were executed with more precision and logically related to the architecture.[5]

There have been two suggested sources for the inspiration of these painted floors. One idea is that they imitated carpets. Another is that the non-figural patterns resemble various types of stone in imitation of Minoan paved slab floors. The only figural element on the floor of the main hall is a solitary octopus, perhaps serving as a focal point towards where something was placed in the small hollow set against the wall, possibly a throne. What evidence do we have for a throne besides a painted octopus, an empty space, and an analogy with the Throne Room at Knossos which is amplified by the evidence of a griffin fresco at both sites?

Pylos is the only Bronze Age Aegean palace whose royal function has been verified by Linear B tablets. The title 'wanax' from which the Greek word for palace is derived is attested at Pylos. The word for throne is attested in a Linear B text from Pylos as *to-no*, a chair made out of valuable imported materials such as ebony and gold.[6] Similar chairs are known from both Egyptian art and texts. A narrow channel with depressions at either end was cut in the floor so that one depression sits next to the hollow interpreted as supporting a throne. It has been suggested that this channel served as a place to pour liquid offerings or libations as homage to a powerful leader.

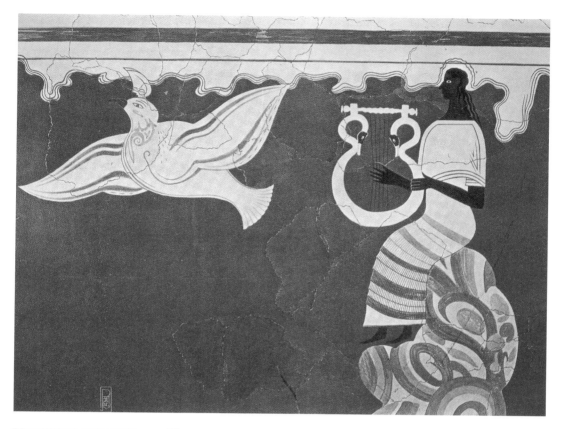

The *megaron* was decorated with an elaborate, though now fragmentary, fresco programme that can be related to the layout and arrangement of the architecture. Scholars have advanced two competing reconstructions for the arrangement of the frescoes in the Throne Room or main hall. The more well-known reconstruction has antithetic pairs of lions and griffins flanking the throne, based on an analogy with Knossos. It is strengthened by the long iconographic tradition in the Aegean and the Near East of powerful or exotic animals flanking revered objects. Evidence, however, only exists for a single pair of animals at Pylos and seal representations often depict seated figures with animals to one side. One pair of animals must be given serious consideration as a distinct possibility. Their placement in the hall may be to provide the occupant of the throne with protection, strength, and stability, perhaps even placing him or her in the realm of the fantastic or supernatural (or on an island as a living hero).

A recent study of the fresco remains from the forehall 5 and main hall 6 by Lucinda McCallum ties them together thematically and compositionally.[7] These fragments include individuals carrying offerings, the face of a bull, a bull that appears to be trussed up on a table, banqueteers, a musician playing a lyre [100], and a fantastic bird. McCallum

looked at the frescoes in combination with the painted floor which she sees as providing a unifying motif linking the two rooms and placing the frescoes in a compositional unity tied to the political function of the throne.

The programme treats procession as a theme that consists of leading the bull among a procession of gift bearers in forehall 5 [**101**]. This theme is continued in the main hall with a scene of tribute in the form of bull sacrifice along with an accompanying banquet that includes the lyre player. Such themes enjoy a long history in the ancient Mediterranean stretching from Crete to the Near East.

Bull sacrifice is represented on the Haghia Triadha sarcophagus and plays a role in classical Greek festivals. The leading of bulls in procession is depicted in the frescoes in the palace of Zimri-Lim in Mari, the New Kingdom Egyptian palace at Malkata, as well as the Mycenaean phase of the Minoan palace at Knossos while ritual banqueting is frequently represented in Minoan and Near Eastern art. Gift bearing in the Mycenaean world is further attested in a Linear B tablet in which gifts are brought to various deities.[8]

A second, smaller *megaron* or hall at Pylos containing fresco decoration and a painted plaster hearth is part of a cluster of rooms (45–55) making up the southeast wing of the main building. Though smaller in size, the hearth repeats the flame and spiral design of the main hall. Also, as in the main hall, the smoke may have been carried off by a chimney made of large clay pipes. Blegen's interpretation of the room as a Queen's hall is unusual considering the fresco decoration. The preserved evidence indicates a frieze of ten lions and several griffins running to the left. Blegen's reading is based on an analogy or comparison with modern assumptions made about the function of the smaller of two decorated halls in the east wing at the Palace of Knossos. He tries to reconcile what he terms a 'bold masculine spirit' of the frescoes with the 'delicate' style of the decoration of the hearth. McCallum's more sophisticated reading of the evidence sees the display of powerful animals as a metaphor for the king's power that is further echoed by the familiar arrangement of the room and the presence of the hearth.

Although no less accessible than the main hall, the route to this small *megaron* is less straightforward, indicating that it may have served as a more private meeting chamber for palace elites. The later addition of courtyard 47 blocked the eastern entryway to this room and further heightened its atmosphere of privacy. Scattered holes in the courtyard led Blegen to suggest that looms were set up here for the manufacture of textiles while Shelmerdine sees this as a workspace for making perfume.[9] The numerous stirrup jars found in the court, however, make it more likely that manufactured perfume was kept here while the steeping process was carried out elsewhere.

Near the smaller *megaron* was a small rectangular room (43) that contained a clay bathtub permanently set into a clay bench. It has been dubbed a bathroom and connected with the smaller *megaron* with which it shares a common wall. The bench is accompanied by a step to aid the user in getting into it. The bathtub itself is decorated with a running spiral motif. The stuccoed floor of the room slopes towards a hole connected to an underground drainage system. Drainable bathtubs are mentioned in a Linear B tablet, as is a servant acting as a bath-pourer.[10] Also in the room are two large jars set into a stuccoed stand. One of these was used to store pottery including a number of *kylikes*, possibly for taking liquid refreshment out of the other jar.

Despite the fact that the smaller *megaron* and the bathroom share a common wall, they cannot be considered related to each other in terms of use. The two rooms are separated from each other by five thresholds which would require an individual to pass alongside an open court (3) to get from one room to the other, making such a connection unlikely. The bathroom is more logically connected with the east entrance (41) which is just two thresholds away. The close relationship between the bathroom and the east entry may indicate a connection between entering the palace, cleansing, and purification. This nexus of relationships replicates an arrangement that was somewhat common on Crete, namely the association of basins of various types with entryways.[11] The later blocking of the east entrance by court 42 indicates a change in function for this area, first of all by limiting external points of access to the main building, and second by creating additional space for the performance of some activity through the addition of the court.

The rear of the palace behind the main hall seems to have been devoted to a row of rooms used for the storage of oil. Many of the storage jars were permanently fixed into place in clay benches in adjoining rooms which could be directly reached from the outside through room 21 in the northwest corner of the palace. It has been suggested that the oil from these jars exacerbated the fire that destroyed the palace, perhaps even giving rise to a tremendous explosion that caused the west wall to blow outward.

101

Reconstruction of part of the fresco programme of the *megaron*, Palace of Pylos. The reconstruction shows a procession in which a bull is being led among a group of gift bearers.

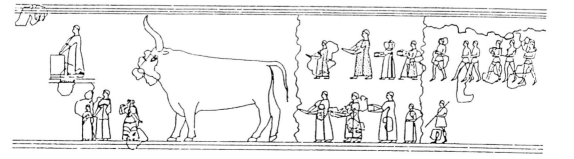

In its final phase of existence, the main building underwent several modifications. The addition of walled courts on the southeast has already been discussed. Access to the northwest part of the building was restricted by blocking the northwest corridor (18) and adding doorways to rooms 20 and 21.

The northeast wing consists of a row of storerooms that corresponds roughly to a similar group of rooms along the northwest. Both groups of rooms contained large quantities of various types of pottery. Blocking corridor 18, and emphasizing rooms 20 and 21 as points of contact between the storage areas of the palace and the outside, would have served to minimize contact between the storage areas and the ceremonial core of the main building. These changes seem more in keeping with the use of the building as an administrative and industrial centre where goods were produced and exchanged.

We would like to finish our survey of Pylos by briefly considering the surrounding buildings in the immediate area of the main building. The rectangular structure to the northeast of the main building has been identified as a wine magazine based on the character of finds. The main hall of this building contained storage jars arranged in a double row down the centre and along the wall. They are associated with a large number of clay sealings that carry the Linear B sign for wine.

The Northeastern Building is located to the southeast of the main building. In the court (92), a small block painted with a scallop design is interpreted as an altar. Behind the altar is a small room (93) with two massive *antae* bases that Blegen refers to as a shrine. However, there is nothing about the character of the reported finds to support this assumption. The other rooms (97–100) that make up the adjacent structure suggest a storage and industrial annexe. They contained obsidian cores, pottery, sealings, Linear B tablets, and hundreds of bronze projectile points.

The Southwestern Building shares a number of similarities with the main building including its *megaron*-style hall, and ashlar walls. Additionally, it has the indented trace which is so well known in earlier Minoan buildings. The arrangement of four interior columns is not symmetrical. Blegen hypothesized the presence of an additional two columns for a total of six and he is tempted to reconstruct a hypostyle hall based on similar features in earlier Minoan buildings.[12] However, given the arrangement of the remaining columns, it is not possible to symmetrically reconstruct a hypostyle hall in the Southwestern Building.

A complex network of rooms lies to the north behind the entrance (64) and *megaron* of the Southwestern Building. Many of them contained concentrations of pottery while room 78 at the back contains a drain and possibly served as a toilet. The suite of rooms including 77–81 becomes progressively smaller and can only be accessed by a tiny door-

102
View of western magazines
or storage areas, Knossos
Palace, Third Palace Period,
reused and partially modified
during Mycenaean control
of the palace.

way. All of this suggests that space within these rooms was highly manipulated, even 'devious', as Blegen maintains. Two adjoining cupboards (67–68) contained an excessive amount of cookware and wine jars. The cookware stored here, the massive quantities of drinking vessels in the main hall, the storage of wine, and the fresco decoration of the main hall all point to the performance of communal feasting for the promotion of loyalty and group solidarity. Because of its spaciousness or proximity to the palace proper, courtyard 63 might have been an appropriate location for such activities. With the character of the finds in the Southwestern Building, its less than careful construction, and its close relationship to the main building with two elaborately decorated halls, the Southwestern Building seems to be another likely candidate for a storage and work annexe.

We have briefly discussed the four separate structures that compose the Pylian compound, its decoration, patterns of access and circulation, and the character of the items found within. In considering the totality of these relationships, we have indicated that the palace was functionally zoned. We have also discussed how its use was modified over time by changing those same patterns of access. It is of interest to note that in its final architectural phase access in the villas at Haghia Triadha was similarly restricted.

The Mycenaean palace at Knossos

It appears that the Minoan palace at Knossos was taken over by Mycenaen Greek-speaking mainlanders, who modified the remains of the ruined structure to serve their own mercantile ends [102]. This period is also characterized by the so-called 'palace style' of pottery

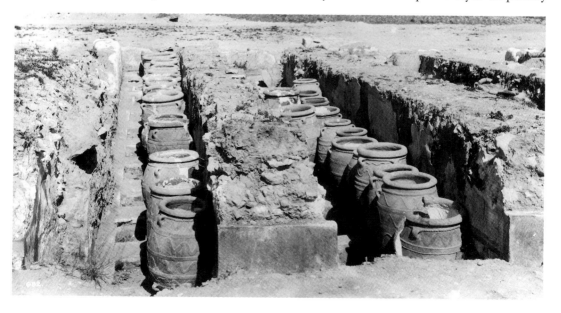

103

'Palace-style' storage jar from
Knossos, Third Palace Period.
Pot decoration in this style
frequently uses somewhat
formalized floral motifs
painted on a light ground.

104

The so-called 'La Parisienne'
fresco, Palace of Knossos,
Third Palace Period. Although
the context of this fragment is
unknown, it may have been
part of the 'Camp Stool' fresco
shown in **105**.

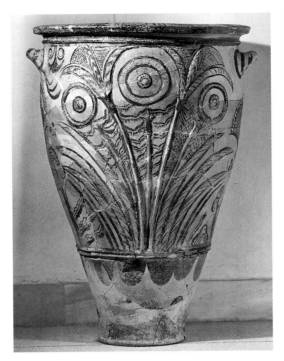

105

Detail of the reconstructed
'Camp Stool' fresco, Palace
of Knossos, Third Palace
Period, depicting groups
of seated men drinking
from chalices in the pres-
ence of two larger female
figures, possibly goddesses
or priestesses. Shown here
are two robed individuals
seated on camp stools,
one raising a chalice.

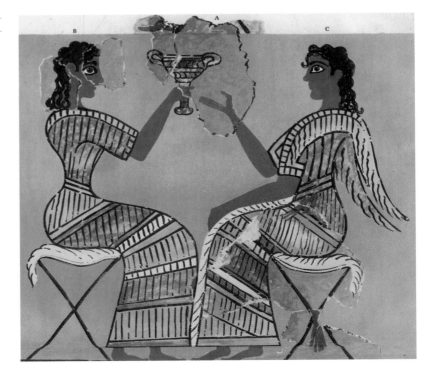

which is only attested in Crete at Knossos in the Third Palace Period (LM II). Large, imposing, and stiffly portrayed, the representations of this style indicate a mainland influence to many scholars. Remembering that the vast majority of pottery used in these cultures is undecorated, the elaborateness of the painted designs and their rigid monumentality surely also connote the power and authority of a new ruling elite that was installed at Knossos, now the dominant centre on the island.[13] It is to this period that the present state of the Throne Room is dated, along with its fresco decoration (**51**). In addition, there are a number of frescoes and fragments from the palace and surrounding neighbourhood that are stylistically dated to this Third Palace Period [**103**]. Included among these are the procession frieze found in pieces in what Arthur Evans called the Corridor of the Processions, on the southern side of the compound, and the fragment known to modern scholars as La Parisienne [**104**].

The original context of the latter fragment is unknown; it may have been part of a sequence of seated figures, collectively known as the Camp Stool fresco [**105**], which depicts groups of seated men drinking from chalices, in the presence of two larger female figures, possibly goddesses or priestesses. Standing male figures in robes seem to be servers. The knot which is prominently depicted binding the hair of the larger female figure known as La Parisienne turns up as an artistic motif in a number of different contexts: in ivory (from Knossos), in faience (from the Mycenae shaft graves); and on seals: where it appears in pairs, suspended from a column flanked by antithetic lions, associated with a double axe, and alone. As a result of these numerous depictions it has come to be regarded by many scholars as 'sacred'. Recent research has shown that various representations of the 'sacred knot' had significance as apotropaic devices and as a representational symbol of a Minoan goddess.[14]

The former Procession fresco [**106**], very substantially reconstructed by Evans' team, depicted what may originally have been a long sequence of individuals, apparently carrying offerings or other objects into the palace from the direction, most probably, of the main southwest entrance from the west court. As is typical of many Minoan frieze paintings, the background is decorated with undulating bands of contrasting colours as depicted in the fresco of antelopes from Akrotiri on Thera. The marchers are both men and women.

The fragments making up the 'Taureador' fresco [**107**] were found in the north half of the east wing of the Palace at Knossos where they had fallen from a room on the upper floor. General consensus arrived at through the study of stylistic details such as the border design which occurs in the depiction of chariot wheels on the mainland places them in Late Minoan II–IIIA (*c*.1450–1375 BCE)—after the Mycenaean takeover of Knossos and the general destruction of other Minoan

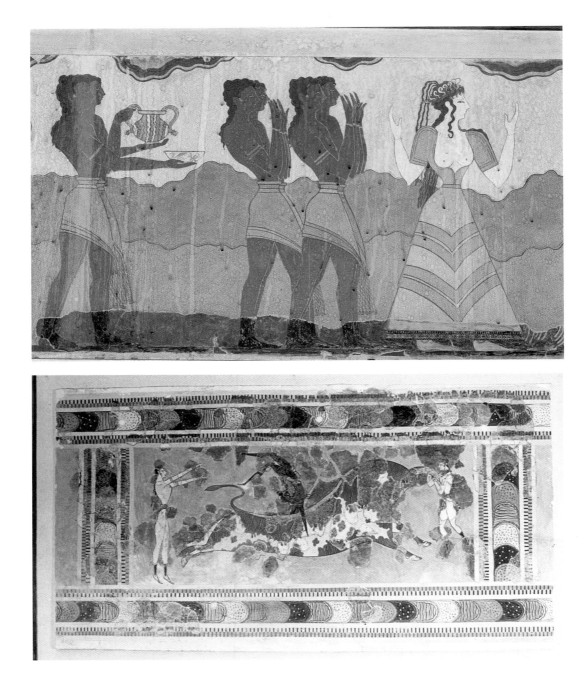

106

Detail of the heavily
reconstructed 'Procession'
fresco. Note, only the feet
are original in this particular
segment. This fresco is part
of what may have been a long
sequence of individuals
carrying offerings or other
objects into the palace.
The undulating bands in
the background are typical
of many Minoan paintings.

107

The so-called 'Taureador'
or 'Bull-Leaping' fresco
from the Palace of Knossos,
Third Palace Period, whose
reconstruction has elicited
controversy about the gender
identity of the figures, as well
as about the possibility of
bull-fighting ceremonies in
Minoan Crete. See also **127**.

centres. From these fragments it is possible to restore five panels, although it is only possible to restore the entire composition in one of them. In the words of Evans,[15] the fresco depicts a 'male performer, of the usual ruddy hue, who is turning a back-somersault above the bull, . . . two female taureadors [are] distinguished not only by their white skin but by their more ornamental attire': a reference to the variegated hue of the kilts worn by the white figures in contrast to the plain yellow worn by the reddish figure. Evans goes on to tell us that 'the girl acrobat in front seizes the horns of a coursing bull at full gallop, one of which seems to run under her left arm-pit. The object of her grip . . . seems to be to gain a purchase for a backward somersault over the animal's back, such as is being performed by the boy. The second female performer behind stretches out both her hands as if about to catch the flying figure or at least to steady him when he comes to earth the right way up.' No doubt influenced by a romantic nostalgia for the American West, Evans placed these scenes in what he called the 'cowboy' class of bull sport representations.

Most discussions of Minoan bull sports focus on whether the acrobatics depicted on the fresco are possible and where they would have taken place: whether in the central courts of the palaces or nearby, or whether they occured at all.[16] Enough representations exist in other media including seals, vessels, sculpture, and most recently on a Minoan fresco found in Egypt to indicate that some sort of contest between humans and bulls took place. In a few instances, such as on the Boxer *rhyton* (see Chapter 4), the depictions are violent.

Until recently, most Aegean archaeologists tended to accept Evans' assumption that the white bull leapers were female. Other possibilities include: (1) recent suggestions that the colour of the bull leapers was used to indicate a temporal sequence of steps in the representation of the individual carrying out the leap; (2) the emergence of young males from a 'feminine guise' through rites of initiation such as demonstrating the superiority of human males over the bull through a test of strength; and (3) alternative constructions of gender identity such as males appropriating female characteristics of gender identity for ideological purposes.[17] With regard to the purpose of the games, it has recently been suggested that bull games are symbolic re-enactments of the hunt that played a crucial role in the earlier process of domestication of the wild stretching back to the Neolithic Period.[18]

The fresco fragments known as the Captain of the Blacks [**108**] were found outside the palace of Knossos near the House of the Frescoes. Although this piece is very fragmentary and lacking a context, it is dated stylistically to the Third Palace Period. While its lack of context provides little information about how it was experienced, we mention it here for the significance of its subject matter. This piece serves as important evidence in addition to the Blue Monkey fresco

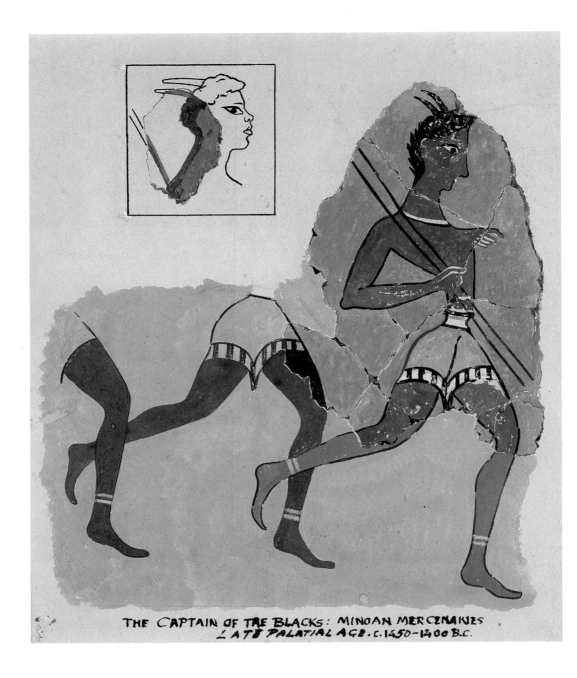

THE CAPTAIN OF THE BLACKS: MINOAN MERCENARIES
LATE PALATIAL AGE. c. 1450-1400 B.C.

Fresco fragment called
by Evans the 'Captain of
the Blacks', Knossos, dated
stylistically to the Third Palace
Period. The 'captain' wears
a bristly hat with horns that
resembles a Nubian cap, and
may be carrying a spear. Note
the different skin colours of
the two individuals.

discussed in Chapter 4 of Minoan contact with Africa. The 'captain' is depicted wearing a bristly cap with horns that resemble a Nubian cap. He appears to be carrying a spear and he is being followed by at least one individual whose black skin indicates an African origin. Despite the different skin colour of the 'captain' and the individual behind him, the similar black and white border on their kilts indicates a connection. This piece is too fragmentary to reveal what was going on with certainty and there is no reason to assume that the 'captain' is in command. The peoples of Nubia were renowned in antiquity for their skill as soldiers and Nubian archers served as Egyptian mercenaries. Evans believed that this fresco represented palace guards. It serves as an important testament to the multiculturalism of the Late Bronze Age Mediterranean.

Haghia Triadha and Kommos

What appears to be a *megaron* was constructed over the ruins of the Second Palace Period villa annexe compound at Haghia Triadha [**109**] (discussed in Chapter 4). The Haghia Triadha building is contemporary with other megaroid structures that appear on Crete at this time, for example at Gournia, where adjacent to the ruins of the small palace there were built two megaroid compounds virtually identical in plan to compounds found elsewhere in the Aegean since the time of Early Bronze Age Troy.[19] This building is virtually denuded of all but its foundation courses, which, however, are sufficient to suggest a *megaron* of familiar rectangular type, with a large inner hall and smaller porches arranged axially.

The Haghia Triadha *megaron* was built on the north edge of what in earlier times was part of an upper courtyard belonging to the villa annexe compound. Its foundations were sunk deeply into earlier levels. There may have been additional rooms and buildings in this area forming part of a larger megaroid palace, but all that remains is what appears to have been the main building or main hall area. Traces of pavement and drainage were uncovered along the south edge of the hall as shown in the plan.

The site plan (looking from west to east) of the area to the northeast of (and on a lower level than) the *megaron* reveals walls and rooms built from the Late Minoan I to III Periods. The most striking section is the suite of eight rooms and an adjacent stairwell, fronting on a colonnade with alternating square piers and round columns [**110**]. The plan is virtually identical to the common types of *stoa* building familiar in classical times, which served a wide variety of purposes in the public squares or *agoras* of Greek cities, from shops and storerooms to meeting halls, banqueting facilities, and hostels or visitors' shelters associated with certain shrines.

Here at Haghia Triadha we have the form of a *stoa* a millennium older than these, whose usage may well have been similar to Hellenic

109

Reconstruction of the *megaron* compound at Haghia Triadha, built in the Third Palace Period over the remains of the Villa A and B complex.

0 10m

110

Plan of the northern section of the *stoa* building at Haghia Triadha, contemporary with and to the north of the *megaron* palace in **109**. It is very similar in design to a *stoa* building just inside the entrance to the mainland Mycenaean citadel of Tiryns.

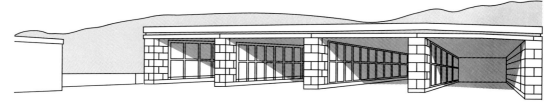

ones, although evidence for its function is quite meagre. It most probably served a function similar to a virtually identical compound in the mainland Mycenaen citadel of Tiryns, which occupies a comparable position between the palace compound and the outer town area. Like the storage magazines of the earlier Minoan palaces, the Haghia Triadha and Tiryns compounds may have served a wide variety of uses in the manufacturing, storage, import, and export businesses of the palaces.

No such *stoa* building has been found at Mycenae or Pylos; if any existed, they might have been outside the citadels proper. Traces of a *stoa* have been identified at Tylissos (see **112**), suggesting that the format was not unique to Haghia Triadha on Crete. At Mycenae, just inside the main citadel entrance (the Lion Gate), is a building referred to by excavators as the granary (visible in **113** below, adjacent to the ancestral Grave Circle A), which seems to have been used for the temporary storage of grain and other agricultural produce brought in from the estates or farms controlled by the palace. It is possible that the Haghia Triadha and Tylissos *stoas* had similar functions.

A *stoa*-like building is shown in [**111**], which depicts a reconstructed view of a building whose foundations were discovered not far from Haghia Triadha, at the port of Kommos.[20] The structure has been reasonably taken to be a compound of ship-sheds, whose long rooms open on to the sandy beach on which boats would be drawn up. The vessels could be stored and sheltered in the long chambers. There is no evidence that Kommos ship-sheds had any system of closure. It is likely, however, that the open ends of the sheds were closed off with wooden doors or fences.

The continuation of Minoan building techniques in the Third Palace Period

Although some isolated features of Minoan palatial architecture continue into the Postpalatial or Third Palace Period, the character of ordinary houses on Crete in the Postpalatial Period differs greatly from houses of the Second Palace Period. They tend to consist of one or more rooms of equal size arranged along an axis with doors placed in the short walls.[21] Like their predecessors, these later inhabitants of Crete continued the earlier practice of terracing into the hillside when practical in order to take full advantage of the natural terrain.

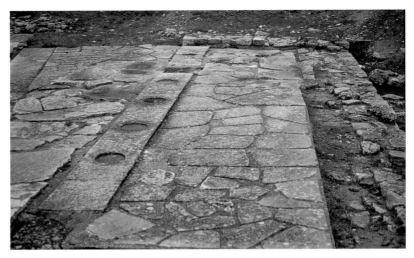

View of the foundations of *Stoa* P, Late Minoan III, Tylissos, Third Palace Period.

Several Minoan building techniques which continue into this period can be observed most clearly at Tylissos. The use of a saw-cut threshold block can be observed in a building constructed above Tylissos House C where it lies *in situ* above corridor B. Among the other Postpalatial remains at Tylissos is a *stoa* that continues the Minoan building practice of setting column bases into the stylobate. This *stoa* takes the form of a rectangular structure fronting on to a court in a manner similar to the Neopalatial *stoa* at Haghia Triadha [**69**]. All that remains are the rubble wall foundations, a small section of the stylobate, and parts of two column bases set into it [**112**].[22]

Burial practices

The monumentalized Grave Circle A at Mycenae
Two views of the Grave Circle A section of the citadel at Mycenae, and a reconstruction of the area at the bottom, are shown in **93** and **113**. Grave Circle A was the second of two large cemeteries (possibly of dynastic significance) at Mycenae outside and to the west of the city walls. Some time after its original construction, this grave circle was surrounded by a newly extended citadel wall and thus brought into the citadel proper. It was monumentalized as shown in the drawing. The two grave circles (A and B) were a specialized setting-off of two elite groups from the rest of the population. The *stelai* discussed in Chapter 4 were removed; the ground level was raised several metres to form a new platform that could be accessed directly from the ascending main road of the town; a roughly circular (and hollow) parapet of limestone slabs was erected, with a formal entrance in the northeast corner, next to the road; and the *stelai* were re-erected over the general position of the original (and now much more deeply buried) graves, all orientated westwards.

113

Reconstruction of Grave Circle A, Mycenae, remodelled in the form shown in the Late Helladic III Period. Drawing by George Dexter and Piet de Jong. The six shaft graves date from the late Middle Helladic Period, when this part of the royal cemetery was still outside the citadel wall.

It seems likely that this monumentalizing of a set of graves, involving the creation of a round gathering or commemorating place (a *choros*, to use a later Greek term), the preserving (and possibly the renewal) of ancestral tombstones, and the incorporation of the old cemetery into the protective fabric of the citadel itself, no easy feat, reflected a great increase in and centralization of power by the Mycenae elite.

The Treasury of Atreus at Mycenae

Even more spectacular is the appearance, beginning by the Late Bronze Age II Period, of the great beehive or *tholos* tombs, first in other parts of western and central Greece, and then at Mycenae itself, where they become monumental symbols of unprecedented wealth and power. They constitute the most prominent constructions of the period when Mycenaean contacts and connections (through trade, piracy, and settlement) begin to stretch from Palestine to Sicily and beyond. The most famous and most finely designed and finely built of the nine *tholos* tombs constructed to the west of the grave circles and citadel of Mycenae is the so-called Treasury of Atreus.

Consisting of a great circular chamber cut into a hillside, some 15 m in both diameter and height and entered by a corridor (*dromos*) about 36 m long, the tomb was roofed over with a continuous frame of finely

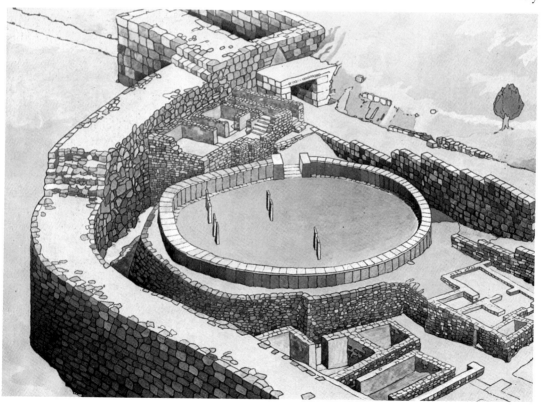

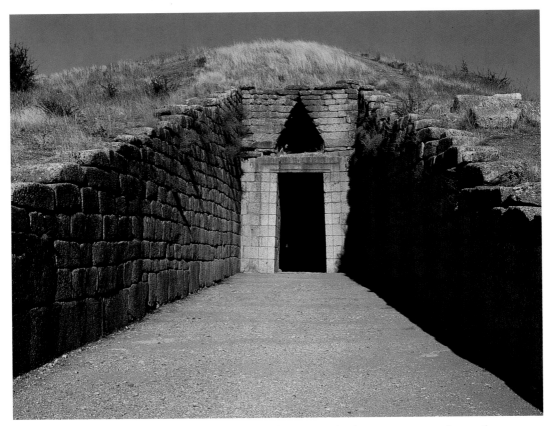

View of the so-called 'Treasury of Atreus' *tholos* tomb, Mycenae, Late Helladic III. This tomb, the most famous and finely designed of some nine such *tholoi* at Mycenae, consisted of a great beehive-shaped chamber cut into a hillside, some 15 m in both diameter and height and entered by a corridor or *dromos* about 36 m long. The tomb was built entirely of finely cut limestone blocks, the whole then covered with earth to form a great conical mound.

cut ashlar block rings, decreasing in size up to a central round capstone. The structure was covered with earth, and the resulting conical hill fringed with stones. Burial was in a side-chamber, beneath the ground; nothing remains of whatever treasure may have accompanied the deceased, as these tombs have been plundered repeatedly since antiquity. The two illustrations show the present state of the entrance façade at the *tholos* end of the *dromos* [**114**], and a reconstructed drawing of its original sculpted façade [**115**]; two columns of porphyry, a stone native to Egypt, finely carved with chevrons and spirals, and above the door a façade of red and green bands of running spirals and lozenges between two smaller carved pillars. Behind the carved façade is the relieving triangle over the lintel (itself a single block of stone estimated to weigh more than 100,000 kg (100 tons)). The relieving triangle of the great Lion Gate of the Mycenae citadel (see p.189 and **125**), filled with a sculpted plaque of antithetic animals, appears not to have been duplicated in this tomb.

The Treasury of Atreus and its companion beehive tombs are among the most monumental structures of Bronze Age Greece. It is evident that these were the tombs of a ruling class, and most likely of families in primary control of the power and resources of entire city states or kingdoms.

115

Reconstructed drawing of the façade of the Treasury of Atreus, Mycenae. Behind the carved façade is the relieving triangle over the lintel. In contrast to the sculpted relieving triangle of the citadel's Lion Gate (see **125**), this was decorated in a manner to conceal its presence.

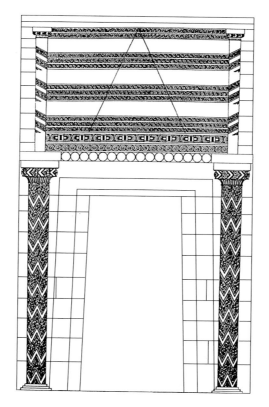

116

Plan and section of the chamber tomb at Haghia Triadha in which was found the painted sarcophagus of **117**.

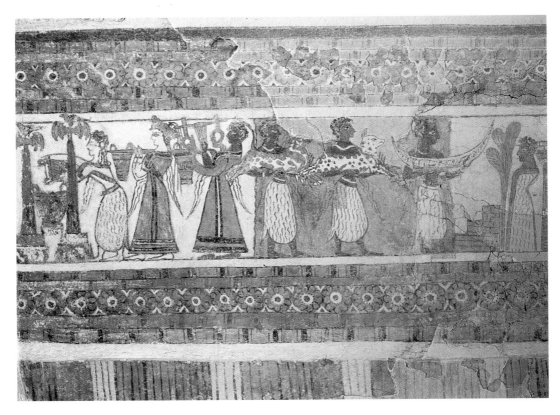

117

117
Haghia Triadha sarcophagus,
Third Palace Period, painted
limestone, long side panel A.
The panel is thought by some
to depict burial ceremonies,
including the giving of offer-
ings to the deceased, who
may be the individual at the
far right, in front of a tomb
or shrine. To the left are two
women pouring liquid offer-
ings into a bucket or *rhyton*
between two large double
axes, followed by a harpist.

The Haghia Triadha sarcophagus

Two sides of a painted sarcophagus found nearly a century ago near
Haghia Triadha and its location are shown in **116, 117, 118**. The
painted scenes on the sarcophagus have fuelled an extraordinary
amount of discussion and debate about the nature of Minoan religion.
Found buried underground in a finely built chamber tomb [**116**], the
sarcophagus originally held the body of a deceased person of some so-
cial status, its painted sides depicting what some have taken to be the
burial ceremonies themselves, including celebrations and offerings to
the deceased.

The scenes, objects, and motifs depicted are familiar in Minoan
painting and other representations on gems and relief work. The long
side panel is divided into three zones marked off by different back-
ground colours [**117**]; to the left is an altar made up of a large bucket or
rhyton between two large standing double axes, into which are being
poured liquid offerings by two women in familiar costume with long,
snaky locks of hair. The sacrificial liquid is visible draining through
the bottom of the bucket, which suggests one way in which Minoan
rhyta may have functioned. To their back is a dark-complexioned lyre
player of indeterminate gender, something well attested in the Near
East by this time.

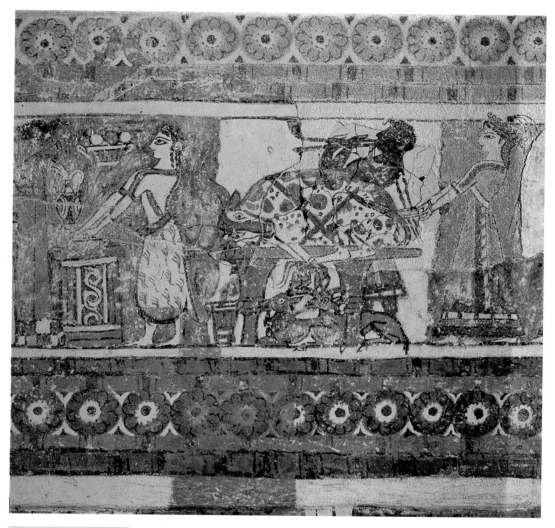

118
Haghia Triadha sarcophagus, long side panel B, Third Palace Period. Partly destroyed, the remainder shows women and a flautist approaching an altar and a shrine with 'horns of consecration' on its roof.

In the centre are three men carrying what may have been models of sacrifical animals, and a model of a boat, possibly for deposit in the tomb itself (see the plan in **116**)—a practice common in contemporary Egypt. They are approaching a standing individual, most likely the deceased, standing before the façade of a shrine or possibly a tomb. In front of him is a tree, adjacent to a stepped platform or altar.

The other long panel has been partly destroyed on the left; the remainder depicts women and a flute player approaching an altar and a shrine with horns of consecration on its roof [**118**]. There is a tree behind the shrine, and one of the women is placing her hands on the altar; behind and above her are richly decorated pots. To her rear is what seems to be a real bull trussed for sacrifice, partly covering a male flute player; a second woman with a richly decorated headdress is laying her hands on the sacrificial table. There appear to have

Late Minoan III. A clay
model of an offering scene,
from Kamilari. Two individuals
bring offerings to altar tables
placed before four larger
seated persons, possibly
the deceased or divinities.
Three windows are shown
at the rear, and the shrine
or tomb is fronted by two
now missing columns.

been three figures behind her, also walking from left to right; only their feet remain.

On one of the ends is a winged griffin drawing a chariot. A great deal has been read into these scenes over the past century regarding Minoan religion and possible Minoan or Aegean beliefs in an afterlife or an underworld or a world of the supernatural.[23] Suffice it to say that what is depicted here is evidently a celebration (and perpetual re-enactment through permanent representation) of funerary ritual, burial, and the offerings in the deceased's honour. The painter(s) chose what would have been a well-known and clearly recognizable series of vignettes (pouring offerings, carrying gifts, sacrificing animals, marching and playing music, on behalf of the figure, statue, or image of the deceased) organized into episodic segments marked both by different characters and actions, and by distinctively coloured backgrounds, strung together in a compact narrative sequence.

It is possible that the first panel alludes to ceremonies marking the burial itself, with the second referring to ceremonies in commemoration of the deceased, though there are other possibilities. The ends of the sarcophagus may have denoted the realm of the supernatural or fantastic, in which case they served to frame the ceremonies in and by supernatural powers, in a manner reminiscent of the flanking deities and heraldic animals both in the Knossos Throne Room or Pylos main hall, and in the crocus-gathering scene from the girls' puberty shrine in Xeste 3 at Akrotiri on Thera.

In any case, the Haghia Triadha sarcophagus is another fine illustration of Minoan narrative frieze painting, of a type that, as we have seen, vividly and poignantly portrays the crisply synopsized characteristics of a story or social ceremony, and with which—if the fragmentary evidence we have is indicative—the Minoans literally and liberally covered the spaces of their lives.

Mycenaean clay *larnax* or sarcophagus from Tanagra (Thebes), Late Helladic III A.2–Late Helladic III B. 1, *c.* fourteenth to thirteenth centuries BCE. The upper register depicts lamenting women tearing at their hair, the lower a scene with antithetic chariots and standing men.

The well-known clay model from Kamilari[24] [**119**] contains a variation on the theme presented on the Haghia Triadha sarcophagus, that is, honouring the dead. The model shows four persons of indeterminate gender seated on low seats placed against the wall of a small rectangular room. There are cylindrical tables resembling stools in front of several of them. Small objects sit on at least one of the tables. Two smaller figures who appear to be holding offerings approach the larger, seated figures. The model is generally regarded as being associated with some sort of ceremony connected with the dead, perhaps making offerings to the dead, the dead making offerings to deities, or some other variation. It was found in the Prepalatial *tholos* tomb discussed above (see Chapter 2 (**31**)) which was reused in the Third Palace Period.

Other dramatic scenes of mourning are depicted on the celebrated *larnakes* (painted clay chests used to inter the deceased) from Tanagra in Boeotia, east of Thebes. Here, the Cretan practice of burying the deceased in clay coffins was combined with the mainland practice of interring the dead in rectangular chamber tombs cut into soft rock and reached by a *dromos* or entrance passage. The one pictured here [**120**] is painted with scenes connected with funerary rites. Though abstract, they are no less poignant than the Haghia Triadha sarcophagus in conveying the emotions connected with the loss of a friend or loved one. It depicts mourning with women tearing at their hair, funeral games in

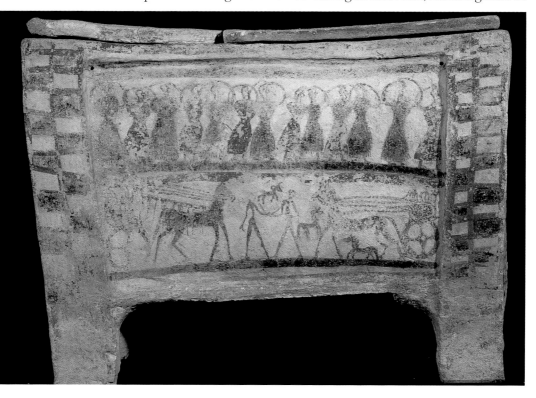

121

Reconstruction drawing
of the west shrine in use
during Phase Ib, Phylakopi,
Melos, Third Palace Period.
The several platforms held
figurines: females on the
southwest bench, in a rear
niche, and in a rear chamber;
males and chariot groups on
the northwest bench.

the form of the hunt and chariot races, and the laying out of the dead. Although it dates from the fifteenth to thirteenth centuries BCE, it anticipates similar subject matter in the much later Geometric Period.

The Mycenaean shrine at Phylakopi

It is clear from the Linear B tablets that a number of deities were worshipped during the Third Palace Period. Furthermore, the archaeological evidence indicates that there were localized practices peculiar to individual sites. The Mycenaean sanctuary at Phylakopi on the island of Melos, however, represents a well-documented example of religious architecture, cult paraphernalia, and ritual during this time.[25]

Religious practice at Phylakopi was a dynamic process, with the sanctuary [**121**] undergoing a series of changes over time. It began as a rectangular hall with two smaller, rear chambers of unequal size along the west wall. Small benches or platforms bordered either side of the doorway leading to the rear chambers. These platforms served as places for the display of cult offerings dedicated to a deity or deities. As the sanctuary was developed further, it came to include another shrine located diagonally and to the east of this first, west shrine. The east shrine consisted of a platform in the northeast corner of a narrow, rectangular room. A court with a stone *baetyl* reinforcing the sacred character of the area was located between the two shrines.

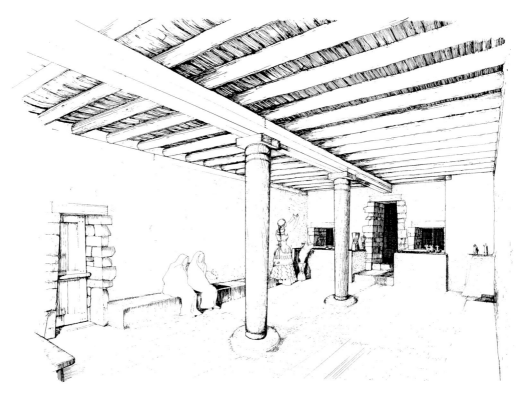

The 'Lady of Phylakopi'
statuette, west shrine,
Phylakopi, Melos. This
wheel-made, painted
clay figure was placed
in the shrine's rear inner
chamber. The offerings
in the reconstruction in
121 are believed to have
been dedicated to this deity.

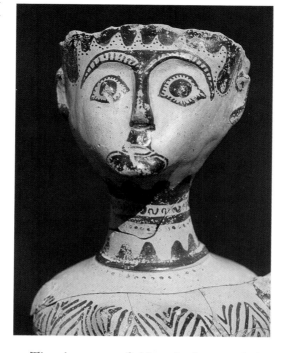

The placement of objects in the west shrine tended to be segregated by gender, with female figurines placed on the southwest bench; larger female figures and bovine figures placed in a niche and in the small back room on the southwest; and male figures, chariot groups, and other animals confined to the northwest bench. These offerings have been interpreted as dedications to a larger and more elaborate, clay wheel-made figure known as the Lady of Phylakopi [**122**]. The Lady was placed in the smaller rear chamber that has been interpreted as a holy of holies.

The Lady is formed out of a pipe-shaped cylinder of buff clay that swells at the top to subtly indicate her chest. The separately sculpted arms were attached to the side of the chest and were probably raised. The wheel-made head has separately modelled features and was attached to a slender cylindrical neck. The jutting chin gives her a certain distinction and is accentuated with red paint that might indicate tattooing. Her long slender nose and upper lip are similarly painted. Her wide, almond-shaped eyes framed with delicate lashes which gaze upward are topped by curved brows. Wavy bands known as rock patterns begin near the hem of her skirt and are repeated on her dress, chest, neck and even form the hair framing her forehead. These rock patterns alternate with concentric bands of both horizontal and vertical zigzags on her dress. Stylistically, the Lady seems to indicate a Mycenaean manufacture and a date corresponding to the early part of the Third Palace Period, between the fifteenth and fourteenth centuries. Her

veneration might be seen as directed at perpetuating the prosperity of the settlement. Additionally, it may represent a continuation of cult activity from the Second Palace Period that focused on a pillar crypt in Minoan Crete.

The isolated shrine to the east was primarily used for depositing animal figurines, including bulls and chariot groups. The purpose of this shrine is less clear. The offering of animals and chariots would seem to indicate that offerings were being made to ensure success or give thanks for success in the male-oriented domain of hunting, gaming, or taming of the wild. The use of the bench as a place to leave offerings at Phylakopi may have its origins in Minoan culture where bench shrines were a common occurrence. Some of the bull figures at Phylakopi had cups on their backs indicating that they functioned as cult vessels. Similarly the use of cultic vessels in the form of bulls was common on Crete as well as in the Near East.

The circuit walls at Mycenae and Tiryns

When we think of the fortified city walls of Mycenae and Tiryns, a warlike image of the Mycenaean peoples of mainland Greece

123
The so-called 'Warrior' *krater*, Mycenae—a virtual icon of Mycenaean militarism to modern archaeologists, contrasting mainlanders with supposedly more civilized and peace-loving Minoans. Much of the vase shows a line of helmeted, marching soldiers with spears and shields; on the handle area are animals and a female figure.

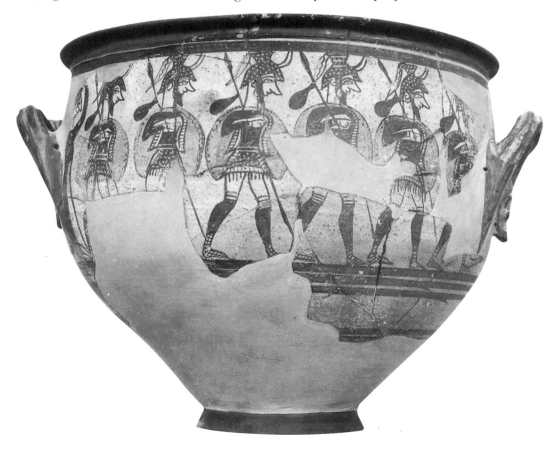

sometimes comes to mind [123]. This is often contrasted with a peace-loving image of the Minoans where such highly visible fortifications are seemingly lacking. As we discussed in Chapter 4, the intricate layout of Minoan buildings may have served as internal defence mechanisms, indicating some concern for security on the part of the Minoans. Additionally, the residues of the past tend to leave us with impressions where the timeframes involved become minimized or forgotten.

The time between the construction of the first Minoan palaces on Crete and the destruction of the Mycenaean citadels on the mainland spans some 800 years. It is only towards the end of this 800-year period, and long after the Minoan palaces have been destroyed, that the Mycenaeans fortify their cities. This late and sudden activity implies a reaction to a different set of social and political circumstances from those confronting the Minoans several hundred years earlier. Although it is far from clear what events precipitated this reaction by the different Mycenaean city states, the fortifications were ultimately unable to prevent the destruction of the Mycenaean citadels towards the end of the Bronze Age.

The drive to fortify sites like Mycenae and Tiryns occurred progressively and in stages rather than suddenly. Archaeologists have been able to determine these stages through a study of the decorated pottery sherds found in the foundations beneath the walls. The fortification of Mycenae began around 1340 BCE, some 25 years after the citadel of Tiryns was fortified. The fortification of Mycenae consisted of three construction phases which progressively increased the extent of the area under protection [124].[26]

This first wall pre-dates the construction of the Lion Gate and the Great Ramp leading up the citadel towards the palace. It included a postern (rear) gate and a main entrance formed by an overlapping break in the wall that was located behind and to the east of Grave Circle A. The citadel was nearly doubled in size some 90 years later, around 1250 BCE. It was at this time that the famous Lion Gate was constructed and the west wall was extended to enclose Grave Circle A and a series of buildings connected with religious practices. These changes occurred before the refurbishing of Grave Circle A. At this time, a monumental passageway leading up the citadel and known as the Great Ramp was constructed over the broken slabs of Grave Circle A and an earlier ramp of hard-packed earth and pebbles. A new postern gate to the north and a tower on the southeast were built a short time later. Although the postern gate is undecorated, its design incorporates the same features of the Lion Gate on a smaller scale, as discussed below.

The final changes occur towards the end of the Third Palace Period, that is, around 1200 BCE. At this time the fortifications are extended on

124

Plans of three stages in the evolution of the circuit walls of the citadel of Mycenae, mid-fourteenth to mid-thirteenth century BCE. Grave Circle A, originally outside the walls, was encircled by the new extension and the direction of entry shifted from the south to the north. The new circuit added about 40 per cent to the area of the citadel.

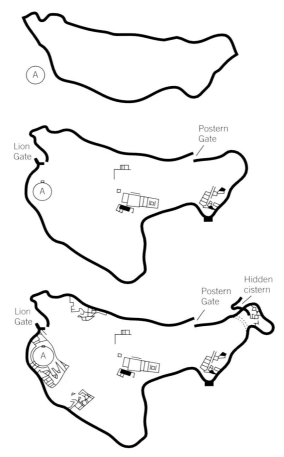

the northeast in order to protect access to a secret underground cistern. The cistern could be reached by a sometimes treacherous zigzag underground staircase leading to a rectangular shaft fed by an aqueduct which led from a nearby spring. The design of the staircase shows a certain sophistication in employing the corbelled arch (see below). It was coated with plaster, allowing for the water level to rise into the lower passage. Sally-ports placed nearby on the north and south would have allowed authorized individuals to exit and enter the citadel without attracting a lot of attention and they could have been easily blocked with a mound of earth to keep enemies at bay. Similar stages in construction took place at the citadel at Tiryns. Such measures are not necessarily the actions of a warlike people. Rather, they indicate that the Mycenaeans were reacting to social and political circumstances that were becoming increasingly tense. The provision of a secured water source should have rendered the citadel impregnable, yet all of the Mycenaean citadels were violently destroyed a short time later. Some of the possible reasons behind this destruction will be touched on in the concluding chapter.

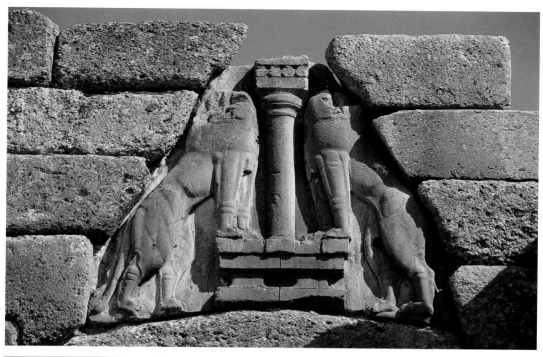

125

The so-called 'Lion Gate' from the exterior, Mycenae, *c.*1250 BCE. This monumental limestone relief, with two antithetic animals with their front legs resting on two Minoan-style altars flanking a central column, masks the relieving triangle over the lintel of the gate. The animals were most likely lions; the overall design is known as early as the fifteenth century BCE on Crete, but in miniature form on seals or ivory carvings. See **126**.

In its final form, the city wall at Mycenae enclosed some 30,000 sq. m with walls averaging 7–7.5 m in thickness and reaching a maximum preserved height of 8 m. The construction technique for these walls is termed Cyclopean, reflecting a later Greek belief that the massive limestone blocks which form most of the wall could only be the work of the Cyclops. It should be noted that this term is not mentioned in Homer or in earlier Mycenaean texts. Modern scholarship would term this technique dry-wall with massive rubble blocks.

There is an occasional use of irregularly shaped stones, termed polygonal, while saw-cut, hammer-dressed blocks, termed ashlar, are used for highly visible sections of the wall including the Lion Gate, North Gate, and Southeast Tower. The appearance of the wall and gates is deliberately monumental. While the bulk of the wall is constructed of limestone, these more formal areas are constructed of conglomerate, a stone consisting of naturally cemented together pebbles, cobblestones, and other sediments, giving the worked blocks a pleasing, variegated appearance. Several storerooms built into the interior of the north wall have been compared by some scholars to the galleries built into the walls at nearby Tiryns. However, these rooms lack the architectural refinements of the Tiryns galleries with their corbel vaulting.

The famous Lion Gate at Mycenae dates to the second extension of the citadel around 1250 BCE [**125**]. This later addition is represented by the gate, a projecting bastion of conglomerate on the west, and a decorative ashlar face on the already existing east wall. The gate embodies

functions that are simultaneously utilitarian and symbolic. The massive bastion on the west projects forward into the space of a would-be attacker leaving his unshielded right side open to assault from defenders manning the bastion. The bastion also serves to narrow the passageway. The effect would have been to spread out an attacking force and further increase its vulnerability. A small chamber built into the rock within the gate on the east side has been interpreted as a guard room. Similar rooms are found at other sites, both Mycenaean and Minoan.

The gate is formed by four massive conglomerate blocks that compose its side-posts, lintel, and threshold. Ruts in the threshold indicate that wheeled vehicles were driven into the citadel. The construction of the wall above the gateway employs the construction technique known as corbelling, in which each successive layer of blocks slightly overlaps the previous layer as they go upward so that they form a pointed arch above the lintel block. The empty space created by this arch is known as a relieving triangle because it relieves downward pressure on the lintel block and prevents it from breaking in the middle.

The Lion Gate is unique for containing the only surviving example of a sculpted panel used to fill a relieving triangle. The panel consists of a relatively thin slab of grey limestone bearing a carved decorative relief. The presence of the triangle suggests to some that the original height of the wall was considerable. The relief depicts antithetic zoomorphs rampant with front legs resting on two incurved altars flanking a central column crowned by the architrave of an entablature. The heads of the animals were gardant, or facing outward, as indicated by dowel-holes for attaching them to the bodies. Both the altars and the column, which tapers downward and is crowned with a bulbous capital topped by an architrave depicting the ends of cross-beams, are Minoan in style.

Despite the fact that the top of the entablature is damaged, a rectangular mortise or hole on the undamaged side may indicate that a decorative element once crowned the entire arrangement. Horns of consecration and birds are the most frequently suggested elements. Both are Minoan in origin. Horns are frequently represented in Mycenaean culture while a bird on each side would balance the arrangement of the lions and the altars. Birds are often associated with representations of Minoan goddess figurines while horns have occurred in architectural settings throughout the Aegean and the ancient Near East.

The origin of the relief, its reconstruction, and its meaning are fraught with controversy. Its uniqueness on the mainland has indicated to some that the relief was brought from elsewhere and recarved to fit it into the relieving triangle. Others have speculated that it was painted, although no evidence exists for this. Since the heads were attached separately, many have believed that a different material was used, with a

126a and b

Seal representations of antithetic animals. These two illustrations attest to the Bronze Age tradition of powerful animals flanking a revered object, person or deity. Illustration **126a** represents a Mesopotamian hero as a 'Master' of animals; **126b** represents an Aegean 'Mistress' of animals.

black stone known as steatite suggested most frequently. The vast majority of scholars believe that the animals represented are lions, although an increasing number prefer lionesses, citing the interpretation of lions as indicative of a sexist bias. Although the famous ancient traveller Pausanias briefly mentions lions, some are willing to dismiss this, suggesting that he did not notice the gate closely, or that the heads were already broken by the time he visited.[27]

A small minority of scholars would like to see the heads of griffins placed on the leonine bodies, based on the frequent representations of griffins in Minoan and Mycenaean art. The most persuasive proponent of this idea believes that wooden heads plated with metal such as bronze would reinforce the notion of the griffin as a composite animal through the use of composite materials.[28]

For the time being, there is no external and objective basis for claiming that any one theory or interpretation, well argued and coherent internally and fitting to the data, is preferable to another theory, equally well argued but based on different assumptions.

At the very least we can see this antithetic sculptural group as leonine. However, in turning to the meaning of this relief we are confronted with at least two possibilities. Guardian animals placed at gateways have been traditionally regarded as apotropaic by many, signifying protection, strength, and stability. They serve this function at contemporary Hittite sites in Anatolia as well as in later contexts of the Assyrian and Persian empires of the Near East. The heavy style and monumentality of the leonine creatures has been compared to the lion sculptures of the Hittites.[29]

The central column with its entablature has been interpreted as representing a structure, possibly the palace or city and its king, a religious building, or the deity of the house. Many other prominent scholars believe that the central column represents an aniconic deity.[30] This interpretation fits within a long Bronze Age tradition attested in both the Aegean and the Near East of powerful animals flanking revered objects [**126**]. If the animals were supernatural, this would certainly place the column in the realm of the supernatural. The characterization of the foliate symbol, the pillar, and the column as sacred in character is well defined in Aegean art by virtue of their association with other sacred symbols. These symbols include altars, offering tables, horns of consecration, and the double axe. In many Aegean examples, the pillar provides a substitute for the tree as the focus of the antithetical group. The tree might be conceptualized as symbolizing the female or as more broadly symbolic of a fruitful harvest. Here, the column might be seen as an architectural representation or even a domestication of the tree as symbol by bringing it within the purview of the palace.

What about the two altars? Some see them as symbolizing the worship of two deities while others interpret them as symbolizing the

unification of two kingdoms. Where did the Mycenaeans get the idea for the subject of the gate? From the Minoans, the Hittites, or another Near Eastern people? And, did borrowing the image from a particular source necessarily imply that the meaning attached by one group would be the meaning attached to it by the peoples of Mycenae and the visitors to Mycenae? If we choose to focus our attention on the significance of the antithetical group and the effect of the entablature we should be aware of the fact that the antithetical group can be inserted into a 2,000-year history of meaning that spans the Bronze Age Mediterranean in its entirety. The significance of the antithetical group would have been readily understandable to an individual living in the Mediterranean Bronze Age whether Mycenaean, Minoan, Syrian, Hittite, or Egyptian. Does the presence of the entablature complicate that meaning by combining or conflating religious significance with secular authority?

In considering the special meaning of the gate to the people of Mycenae, it is perhaps no accident that the construction of the Lion Gate corresponds to the enlargement of the city wall to purposely incorporate Grave Circle A (see **113**). The incorporation of Grave Circle A within the fortification wall at Mycenae corresponds to its renewal and refurbishing at a time when Grave Circle B passed from communal memory and was consigned to oblivion.

The round parapet of the Middle Bronze Age was replaced with a double wall of vertical limestone slabs that is visible today with an entrance constructed on the north. The *stelai* which marked the graves were re-erected, although not in their original place. Retaining walls were also added to help maintain the integrity of the monument. Although the date and arrangement of this renewal have recently been called into question, the fact that it was carried out still indicates a concern with ancestor worship.[31] Furthermore, enclosing the Grave Circle within the wall of the city indicates the desire of the ruling elite to visually strengthen their connection to an ancestral line.

It has recently been suggested that these developments signal the convergence of ideology and political centralization so that the emphasis placed on Grave Circle A was part of the final process in consolidating power in the hands of a single ruling elite.[32] Within this context, the Lion Gate sends a message that might be read as deliberately ambiguous as well as multivalent. The symbolism of the palace embodied in the entablature on the gate is combined with the column. In this way the rulers of Mycenae appropriate a symbol traditionally identified with the divine in the Bronze Age iconographic vocabulary, namely the column as an aniconic representation of the divine. In bringing the column within the domain of the palace, the ruler further legitimates himself.

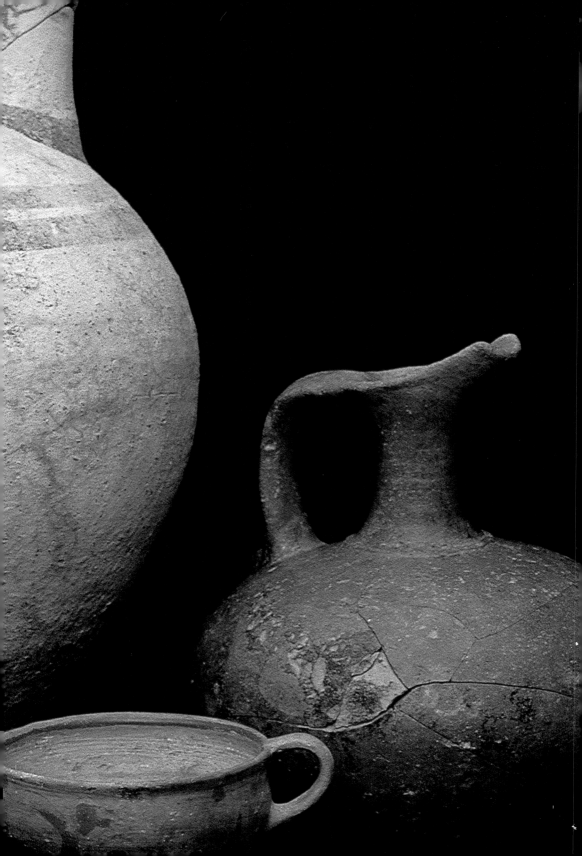

Conclusion: Disruptions, (Dis)Continuities, and the Bronze Age Legacy

6

The fortification of many of the Mycenaean cities in the thirteenth century BCE leaves us with the questions: What were the events that transpired to usher in the end of the Bronze Age? What was the effect of these upheavals and social transformations on art and society? Furthermore, what was the artistic, material, religious, and technological legacy of the Aegean peoples for later Greece and the Near East?

After a century of archaeological scrutiny of the Minoan, Mycenaean, and Cycladic material records, there is a substantial body of historical speculation on these matters. In addition, there are many examples of artefacts which appear to foreshadow practices familiar in later Greek social and religious life. However, only a few attempts to track these trajectories in a systematic way have been successful. We would begin such an attempt by using our concluding chapter to introduce the reader to the following issues: the eastward migration of an Aegean tradition; the development of an 'international style' in the ancient Mediterranean; the disruptions caused by various groups of displaced individuals collectively known as the 'Sea Peoples'; and a look at some of the Aegean traditions that were present after the destruction of the palaces, as well as a glimpse at their continuation into the early Iron Age.

The eastward migration of Aegean traditions

During the period of the Mycenaeans' build-up of their defensive capabilities, a new phase of internationalism, trade, and artistic endeavour was under way. This spirit of internationalism was not entirely new, but was built upon a long existing tradition of foreign influences and cultural exchanges.

Contacts abroad were well established in the Minoan or Second Palace Period, as seen in this fragment of a bull leaper [127] in the Minoan style from the Hyksos capital of Avaris in the Nile Delta. The

127

Fresco fragment of a bull leaper from Tell el-Dab'a, Egypt, *c.* seventeenth century BCE. The Minoan-style fresco fragments found at this Nile Delta town attest to interconnections between the Aegean and Egypt. This fragment is believed to be part of a larger scene of an acrobat somersaulting over the back of a bull. Compare this with the 'Taureador' fresco from Mycenaen Knossos (**107**).

fragment is part of a larger scene that has plausibly been reconstructed as an acrobat somersaulting over the back of a bull comparable to the so-called Taureador fresco from Mycenaean Knossos (**107**). However, the Avaris frescoes are earlier, dating to the Second Palace Period. This fragment is just one of many representations from Avaris painted in the Minoan style. The suggested reasons for this preference for Minoan fresco paintings range from speculation about a dynastic marriage to a Minoan princess to more reasoned inferences regarding elite patronage of itinerant Minoan craftspersons. The fragments from Avaris join a growing list of Near Eastern sites where Minoan-style fresco paintings have been discovered. Others include Alalakh, Kabri, and Qatna.

Many, but not all, scholars are content to see the fragments from Avaris as the product of Minoan workmanship, despite the obvious similarities in the representations of the Avaris bull leapers to Minoan ones with their 'wasp' waists, kilts, and long, snaky locks of hair. Representations of bull leaping, however, were not restricted to the Aegean as once believed, as shown by the depiction of bull-leaping scenes on Near Eastern cylinder seals from northern Syria [**128**].[1] These Syrian scenes are roughly similar to Minoan ones, but completely omit architectural elements while mythical elements such as deities are sometimes indicated. Although these Syrian representations are independent creations, their tendency towards artistic as opposed to realistic treatment resembles Minoan scenes. The long history of

128

Detailed drawing of seal impression depicting bull sports, Aleppo, Northern Syria, *c.* seventeenth century BCE.

bull contests in the Near East and the fact that the Syrian scenes seem
to antedate the Minoan ones have led one scholar, Dominique Collon,
to postulate a Syrian origin for Minoan bull leaping.

Mycenaeans and Hittites at Miletus / Milawatta

The settled presence of Aegean peoples in the Near East dates from
the First Palace Period. This is first attested by a wide range of Minoan
pottery, followed, after a violent destruction, by the presence of
Mycenaean pottery in Miletus [**129**], ancient Milawatta. The high
quality of this Mycenaean pottery initially led many Aegean scholars to
believe that it was exported to Miletus from the region known as the
Argolid in mainland Greece. Recent scientific studies of the mineral
content of the pottery, however, have shown that it was locally made in
Miletus. Such studies would tend to reinforce the belief held by some
that these Mycenaeans of Miletus are the people referred to as the men
of Ahhiyawa in the cuneiform texts of the Hittite peoples who ruled
Anatolia in the Late Bronze Age.

The annals of the Hittite King Mursilis II record a destruction of
Milawatta after the King of Ahhiyawa and the Land of Milawatta
joined forces against him with another enemy near the end of the four-
teenth century BCE. In the thirteenth century BCE, a wall was con-
structed around Miletus using the casemate technique popular among
the Hittites [**130**]. The construction of a wall built in the Hittite style
and the continued presence of Mycenaean pottery indicates a coexis-
tence of different cultural traditions, although a Hittite document
known as the Tawagalawas letter refers to Milawatta as non-Hittite.
This letter also accuses the King of Milawatta of harbouring a rene-
gade known as Pijamaradus who may have conducted raids on Lesbos
and Wilusa (Troy). More importantly, the date of the wall at Miletus
seems to correspond to the fortification of Mycenaean sites on the
Greek mainland. Could both areas have been reacting to the same
perceived threat?

Hattusas

Miletus

Map 4

The ancient Mediterranean
of the Late Bronze Age

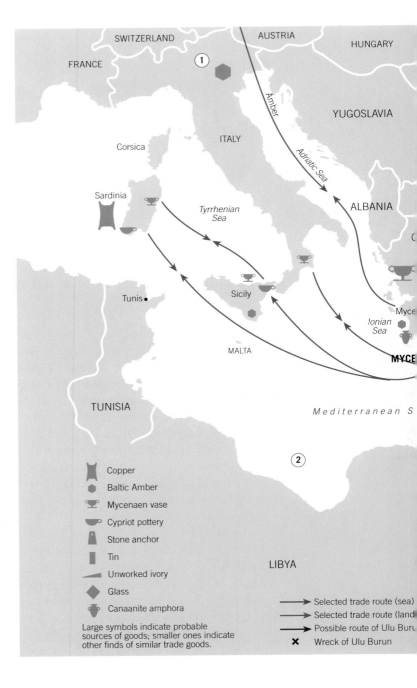

Copper

Baltic Amber

Mycenaen vase

Cypriot pottery

Stone anchor

Tin

Unworked ivory

Glass

Canaanite amphora

Large symbols indicate probable
sources of goods; smaller ones indicate
other finds of similar trade goods.

→ Selected trade route (sea)

→ Selected trade route (land)

→ Possible route of Ulu Buru

✖ Wreck of Ulu Burun

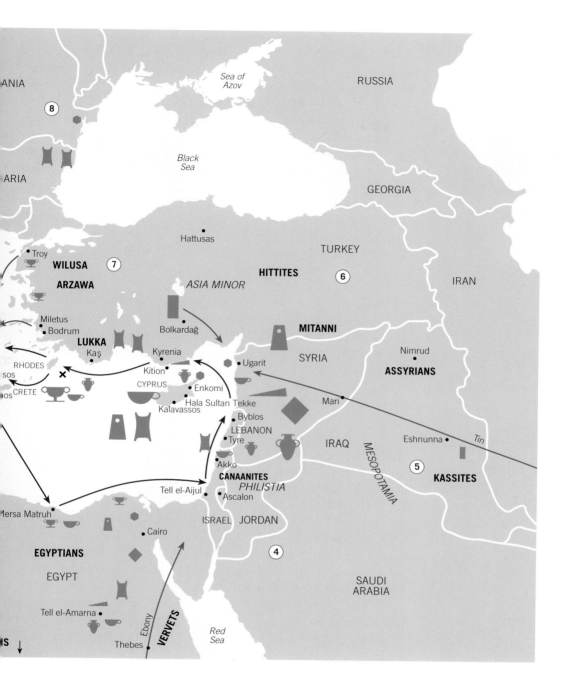

ANIA

⑧

ARIA

Sea of
Azov

RUSSIA

Black
Sea

GEORGIA

• Hattusas

TURKEY

IRAN

• Troy

WILUSA ⑦

ARZAWA

ASIA MINOR

HITTITES ⑥

MITANNI

• Nimrud

SYRIA

ASSYRIANS

• Miletus
• Bodrum

LUKKA

• Kaş

Bolkardağ

• Kyrenia

Kition

CYPRUS

• Enkomi

• Ugarit

RHODES

SOS

OS CRETE

✕

• Hala Sultan Tekke

Kalavassos

• Byblos

LEBANON

• Tyre

• Akko

Tell el-Aijul

CANAANITES

PHILISTIA

• Ascalon

ISRAEL JORDAN ④

• Mari

MESOPOTAMIA

IRAQ

Tin

• Eshnunna

⑤

KASSITES

Mersa Matruh

• Cairo

EGYPTIANS

EGYPT

SAUDI
ARABIA

• Tell el-Amarna

Ebony VERVETS

Red
Sea

S ↓

Thebes

The international style

Trade routes between the Aegean peoples and their Near Eastern neighbours were well established by the end of the Bronze Age [see **Map 4**]. Seafarers must have taken a circular route, following the ancient coastlines as much as possible for safety and making many stops to exchange one precious commodity for another. A wreck excavated at Ulu Burun [**131**] off the south coast of Turkey by a team led by George Bass revealed a fourteenth-century BCE Phoenician trading ship that tells such a story.[2] It contained goods from around the Mediterranean including an Egyptian scarab, copper ingots, Mycenaean [**132**] and Canaanite pottery, a wax writing tablet for keeping inventories, ivory, and Mesopotamian seals in quantities that suggested a route proceeding from east to west. The evidence from Ulu Burun indicates that many trade transactions were private, while tomb paintings of the Egyptian New Kingdom showing Aegean envoys bearing gifts suggest a concomitant practice of elite gift exchange.

The growing intensity of contacts between the Aegean and its Near Eastern neighbours led to the development of what has been termed an international style in which a series of similar iconographic motifs as well as architectural features spread throughout the Mediterranean.[3] Few items illustrate the internationalism of the Late Bronze Age better than the famous carved lid of a box [**133**] from a thirteenth century BCE tomb at the Syrian site of Ugarit. This piece is decorated in an Aegean style on an imported material, namely ivory, in the possession of an owner dwelling in the Levant. The decoration represents a common theme of the Mediterranean Bronze Age, a Mistress of Animals, portrayed with the flounced skirt and exposed breasts typical of Aegean art since Minoan times. She is seated in the midst of a rocky landscape and holds sheaves of grain in her upraised arms as she is flanked by a pair of rampant goats. The iconography of this lid recalls the Mother of the Mountains seal from Knossos (see **55**) as well as the many depictions of the antithetic group discussed in Chapter 5. The iconography of the antithetic group, loosely defined as animals flanking a revered object, is one example of the international style of the Late Bronze Age.

Many scholars have been tempted to see this lid as a product of Near Eastern craftsmanship in imitation of Mycenaean pieces, referring to the representation of the female as 'ugly', with 'bulging muscles', and 'generous oriental curves'. Such statements illustrate the way present norms, values, and prejudices inform the scholarly mediation of the past for consumption in the present. The implication of such statements is, of course, that Near Eastern workmanship is somehow inferior or derivative or that oriental females were uglier and more generously endowed than western women. This historical tendency among western scholarship to portray the East in an unflattering light or as something 'exotic' or 'other' has been referred to as 'orientalism'.

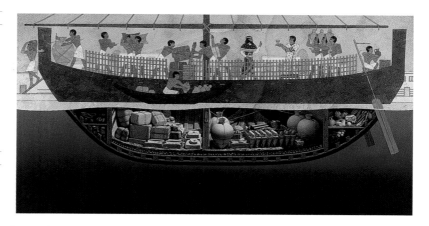

131
Reconstruction of a ship wrecked off Ulu Burun, Turkey, Late Bronze Age III, *c.* fourteenth century BCE. The cargo of the ship included objects from around the Mediterranean.

132
Assortment of Mycenaean vessels from the Ulu Burun shipwreck, Late Bronze Age III, *c.* fourteenth century BCE.

133
Goddess on the ivory lid
of a *pyxis* (box) from a tomb
at Ugarit, Syria, thirteenth
century BCE. This 'Mistress
of Animals' figure is of interest
in its combination of Aegean
style and motifs (note the
flounced skirt and bare
breasts of the woman) with
ivory workmanship common
to the Levant. Compare the
'Mother of the Mountains'
seal from Knossos (**55**)
and the depictions of the
antithetic group.

Orientalism emerged out of the British and French colonialist adventures of the nineteenth century that treated the cultures of the Near East as objects of study that uncoincidentally facilitated the abilities of these European colonizers to govern these newly conquered territories.[4] Recent scholarship places the ivory lid squarely within the tradition of Mycenaean workmanship and treats it as what it is: a remarkable testimony to the internationalism of the period either from the Greek mainland, or possibly from the ivory workshops that are believed to have been active on Cyprus at the end of the Bronze Age.[5]

Cyprus, Palestine, and the Peoples of the Sea

The transmittal, influence, and survival of Aegean social practices at the end of the Bronze Age and after can be found in Cyprus as well as in the artistic traditions of the so-called Sea Peoples and Philistines in the Levant.

The island of Cyprus served as both a geographical and cultural bridge between the Aegean and the Near East, as indicated by the material remains which show clear evidence of cultural influences from both regions. Nothing more clearly demonstrates the multiculturalism found on Late Bronze Age Cyprus than the conical *rhyton* from a thirteenth-century BCE tomb at Kition [**134**]. The *rhyton* is made of faience, a complex, glassy substance composed of crushed quartz, sand, and sodium carbonate with mineral-based pigments added for colour and fired to give the outside a shiny surface.

Although we tend to associate the use of faience with the Egyptians, it was used for a wide variety of objects and decorative inlays throughout the Aegean as far back as the First Palace Period. The blue colour of the Cypriot *rhyton* was formed through the use of copper compounds

Conical *rhyton* with bull-hunting scenes, from a tomb at Kition, Cyprus, Late Cypriot II, *c.* thirteenth century BCE. The use of faience, running spirals, bull-hunting scenes, and the 'flying gallop' of the animals are motifs closely associated with Aegean art.

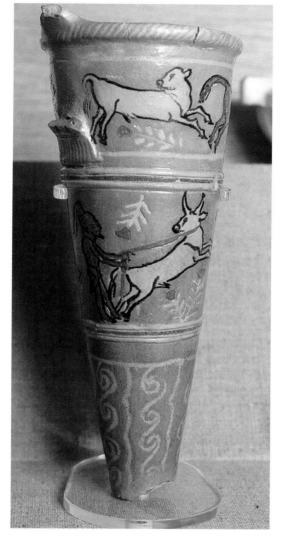

while the use of black outline and various other colour inlays were used to render the three registers of decoration.[6] The conical shape of the *rhyton* as well as the running spiral motifs, bull-hunting motifs, and flying gallop attitude of the bovines and caprids (sheep and/or goats) that decorate it are readily associated with Aegean art. The flying gallop pose in which an animal runs with its front and back legs fully extended originated in Crete around the end of the third millennium and spread to Egypt and the Near East by the end of the Bronze Age. It serves as another example of what has been termed the international style.

The hunter in the central register is of particular interest. The conical cap he wears and the raised right arm with dagger recall the White Crown and smiting pose of Egyptian kings that originated

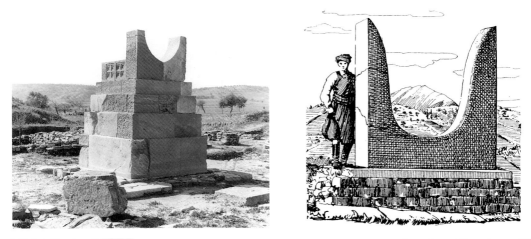

135a and b

Cypriot (Myrtou-Pigadhes) and Minoan (Knossos) 'horns of consecration', Late Cypriot II, c. thirteenth century BCE. Although slightly different in style, double horns were important in both Crete and Cyprus.

in Predynastic representations of the late fourth millennium. The smiting posture was borrowed into Near Eastern art from Egypt as early as the nineteenth or eighteenth centuries BCE. The smiting god has been associated with the Syrian warrior god, Reshef, and with the storm god, Adad in Mesopotamia. He is also frequently associated with the bull as on this *rhyton*. It is significant that the iconography of the smiting god as a weather god continued throughout the Ancient Near East in the first millennium in Neo-Hittite Syria, the Levant, Cyprus, and Egypt until it was adopted by the Greeks to represent Zeus.[7]

The architecture of Cyprus also manifests a combination of characteristics that point to cultural and design influences from the Aegean and the East, but interpreted in a local style of workmanship. The most notable of these influences is the widespread distribution of horned altars such as this one from Myrtou-Pigadhes [**135a**]. They call to mind the horns of consecration often associated with the Minoan palaces, although the Cypriot horns are rendered with flattened rather than rounded tips. In Minoan culture, the horns were frequently used to mark important entryways whereas in Cypriot culture they seem to be primarily associated with altars.

The stepped shape of the Cypriot altar base calls to mind a monumentalized version of the stepped double-axe bases found earlier in Crete as depicted on the sarcophagus from Haghia Triadha (see **117**). We caution the reader that not all scholars accept the reconstruction of this altar which was based on careful and cogent study, however; smaller stepped features found elsewhere on Cyprus may have served as both bases and capitals. Some of these features begin to occur in the thirteenth century BCE and are interpreted by some as emblematic of the arrival of Mycenaean Greeks on the island. The depiction of *bucrania* (the Latin word for the head or horns of a bull) on clay sanctuary models from the Early Bronze Age, however, indicates

that the cultic significance of the bull was long recognized in local Cypriot culture.

Another tantalizing feature with Aegean affinities is the twelfth-century BCE 'bath' or 'well' room [136] located in House A at the site of Hala Sultan Tekke. Particular characteristics including its rectangular shape, use of rectangular ashlar pavement slabs, and stepped entryway leading below the floor level call to mind the Minoan lustral basin. However, the lead waterproofing filling the interstices of the pavement slabs and the addition of a hole in the floor, possibly for drainage, indicate a more specific use incorporating water than its earlier Minoan counterparts which lack this combination of waterproofing and drainage.[8]

Closer in function, if not in form, to a palatial Minoan structure is the interesting court-centred building at the Cypriot site of Kalavassos-Ayios Dhimitreos known as Building X, the Ashlar Building [137]. Its thirteenth-century BCE date corresponds to the period after the abandonment and subsequent destruction of the Second Palace Period palaces and villas on Crete. Building X exhibits a local variation or interpretation of features we tend to associate with Minoan buildings in the form of a slightly recessed façade on the south, a main southern entrance, and a wing devoted to the storage of *pithoi* on the west in association with ashlar pillar supports. A different arrangement, but with an identical location for storage areas, was a regular feature of the earlier Minoan palaces.

The use of the pillar in Minoan buildings has been symbolically linked to the worship of stalactites and stalagmites in sacred caves as discussed earlier (Chapters 4 and 5). Its recurring use in association with storage areas has been interpreted as serving to protect the storage area while the stored goods could have been periodically released for

136

Bath or well room from House A at Hala Sultan Tekke, Cyprus, Late Cypriot III A1–2, *c.* twelfth century BCE. The rectangular shape of the room, its ashlar pavement slabs, and stepped entryway leading below floor level, bear a superficial resemblance to Minoan 'lustral basins'.

137

Building X, the 'Ashlar
Building' at Kalavassos-
Ayios Dhimitreos, Cyprus,
Late Cypriot II, *c.* thirteenth
century BCE; note the central
court, southern main
entrance, and western
strorage area.

purposes of communal feasting. Based on its monumental size, arrangement of features, and quality of workmanship, a similar scenario drawing out the relationships between ritual, storage, and communal feasting or redistribution of a particular commodity might be assumed for Building X. Here the pillar represents a certain economy of function, taking on the symbolic characteristics of an aniconic deity while also serving a structural purpose. Aniconic representations of deities have a long history on Cyprus while the pillar hall at Building X appears to be the most carefully constructed room of the building, further reinforcing the importance of monumental storage areas in the Aegean.

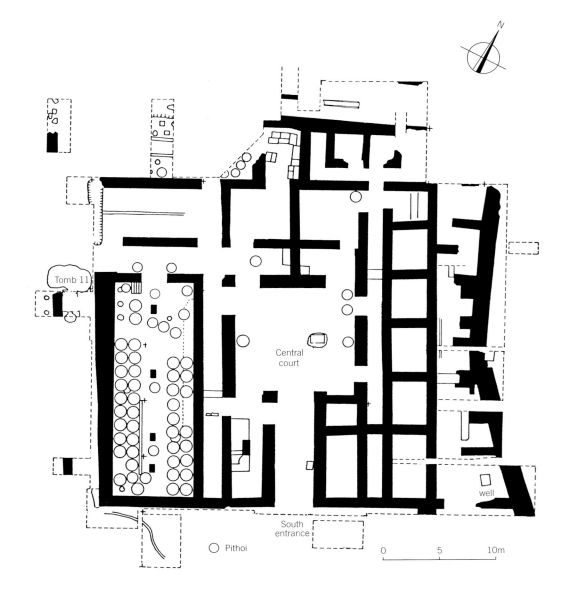

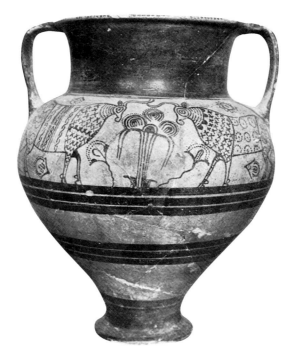

138

Amphoroid *krater* from
Enkomi, Cyprus, Third
Palace Period. The scene
of two bulls flanking a sacred
tree is yet another variant of
the antithetic group common
in the Aegean.

It can be suggested from this brief survey that Aegean artistic and architectural features were co-mingled with other traditions, transformed, and ultimately preserved in the archaeological memory of the Cypriot remains. The widespread distribution of Mycenaean-style pottery occurring along with local and Phoenician styles as well as the use of a script termed Cypro-Minoan may indicate a sizeable Aegean population on the island. The amphoroid *krater* (a large bowl used for the mixing of wine and water) from Enkomi [**138**] pictured here is decorated in the pictorial style that became popular during the Third Palace Period. Although some modern art historians have remarked on the seemingly careless representations of the figures during this period, such modern impositions and biases with regard to form and taste neglect the communicative purpose of these motifs. While most examples of this style come from Cyprus, scientific analyses have revealed that some were imports that originated on the Greek mainland. The depiction of two bulls flanking a sacred tree on the shoulder is just one more variation of the antithetic group that became so popular throughout the entire ancient Mediterranean.

Mycenaean pottery motifs are also a common feature in imports to the east as well as the later material culture of the early Iron Age Philistines in what is today the state of Israel, as shown in this stirrup jar with bird motif [**139**]. Many archaeologists and art historians view pottery as the hallmark and chief indicator of Philistine culture. It typically includes many shapes and motifs well known from Mycenaean

culture painted in the distinctively Philistine style of red and black on a white background.[9] The appearance of this pottery in the first half of the twelfth century to the eleventh century BCE coincides with the accounts and legends of the mysterious Sea Peoples.[10] Earlier pottery pre-dating the Philistine pottery also has Mycenaean prototypes in terms of both shape and decoration. The presence of Cypriot, Egyptian, and local Canaanite elements in Philistine material culture testifies to wide-ranging cultural contacts and influences which intensified by the end of the Bronze Age. To focus entirely on pottery style does not adequately illustrate or explain these relationships.

The origin of the Philistines and their Aegean connections has been debated based on linguistic evidence, literature, and material culture. They are believed to have been among the Sea Peoples who appeared in the eastern Mediterranean in the thirteenth century BCE, as recounted in texts and monuments from the reign of Ramses III of Egypt. Who were the Sea Peoples? Among the various tribes mentioned are groups believed to be from Anatolia such as the Tjekker, Weshesh, and Ekwesh. Other groups such as the Peleset, Denyen, Sheklesh, and Sherden indicate several points of origins for the Sea Peoples as well as the Philistines. The Peleset are associated with the Philistines of the Levant as well as the Pelasgians of the Aegean. The Denyen have been associated with the Tribe of Dan of Israel as well as the group of Greeks known as the Danaans. The Sheklesh have been associated with Sicily and the Sherden with Sardinia.

Rather than looking for a single origin for the Sea Peoples, it might prove more helpful to think of them as different tribes or groups of displaced persons coming from different parts of the Mediterranean after having being driven from their homes in the chaotic atmosphere at the end of the Bronze Age. Some of them are believed to have settled in Egypt where they served as mercenaries in the Egyptian army after their defeat while others seemed to have ended up in Anatolia, northern Syria, and the Levant.

To survey the Aegean connection with the Sea Peoples we need to return to the discussion of Mycenaean fortifications at the end of Chapter 5. The destruction of the Mycenaean fortifications was just one of a series of cataclysmic events that marked the end of the Bronze Age, along with the introduction of iron-working technology, and a change in the political fortunes of many Mediterranean cultures. Art was just one of many social structures that was affected. There are a number of theories and models that have been put forward to explain these cataclysmic events and just a few brief remarks can be made here to explain what many textbooks refer to as a period of artistic decline divorced from historical events. In his book on Greek fortifications, Frederick Winter states that 'the Mycenaeans were able to construct artificial defenses so immense as to withstand any hostile assault', yet

their walls were breached. How could the mighty citadels of the Mycenaeans with their supposedly impregnable walls, internal water supplies, underground passageways, and massive defensive bastions fail? The gradual modifications of the fortress at Mycenae in the thirteenth century BCE suggest a perceived threat.

These walls did not simply prevent attack, but also served to deny access to rustic villagers living in the vicinity. It is noteworthy that a new type of pottery appears in Mycenaean Greece at this time. It was not the brightly painted wheel-made pottery of the Mycenaeans that attracts the interest of modern art historians, yet it is significant nonetheless. The simple, hand-made works of country rustics, termed 'barbarian' wares, have been found in Greece, the Danube, and as far away as Troy. It is part of the basic everyday repertoire of an uncomplicated, mobile lifestyle that included clothes, weapons, language, and the basic implements of daily life. Archaeologists have hypothesized that these rustic peoples were being recruited by the Myceneans and others as mercenary warriors. As such, they may have been provided with an opportunity to plunder the wealth of the Mycenaean cities from the inside. It is even possible that much of the Mycenean Greek warrior class was already absent from its cities, carrying out raids in the Mediterranean, and leaving its homes poorly defended.

Trade, and the wealth that accompanied it, may have invited piracy by renegade warriors such as Pijamaradus and others, as recounted in the annals of the Hittites. Or, as the Mycenean cities fell to mercenary insiders and bands of rustic marauders from both Greece and central Europe, their inhabitants might, in turn, have been encouraged to flee their homes. If this was the case, then where did they go and what did they do? As refugees, these displaced Mycenaean Greeks may have spread throughout the Mediterranean, displacing other peoples from their cities, who then followed suit, creating a sort of domino effect throughout the Aegean and the East. Some would have settled in the East while others continued plundering or sought their fortunes in the service of foreign armies. In such a context, the glorious tales of victory by Homer's Achaeans against the Trojans may have served as a propagandistic device for transforming the defeat and displacement of being driven from one's home into a tale of victory and heroism.

What other evidence is there to support such a hypothesis beyond an unremarkable type of pottery? Not uncoincidentally, the two-edged or Naue II tanged or flange-hilted sword along with the bronze fibula (a type of large safety pin used for fastening a garment) appear by the end of the thirteenth century BCE. Examples of the Naue II sword are not only found within the citadel of Mycenae, but are also known to have been brandished by the Sea Peoples. The Naue II sword seems to have originated in central Europe, but it is also found in Greece and seems to have spread quickly throughout the ancient Mediterranean

by the end of the Bronze Age. It has been suggested that it was the cut and thrust battle tactics facilitated by this new weapon that inspired the transition to iron technology as a means of producing a stronger sword to counter its effect. It is believed by some that iron technology was first developed on Cyprus in the twelfth century BCE where it was a naturally occurring by-product in the process of copper smelting. It was discovered that iron could be refined through tempering, a process of repeated heating and cooling in which carbon was introduced to harden it by heating it in charcoal. This technology spread to Palestine in the eleventh century BCE, and then reached Greece.

Hebrew bible references to *Caphtor* associate Crete with the homeland of their contemporary Philistine or Palestinian neighbours. Not all scholars are willing to accept this association despite corroborating evidence from Near Eastern cuneiform references to *Kaptaru* and the linguistically similar Egyptian word for Crete, *Keftiu*.[11] Others place Philistine origins in Anatolia, in Cilicia. The Aegean as one of several points of origin for the Sea Peoples and the Philistine culture of the Early Iron Age Levant seems inextricably connected.

Material culture is more convincing. We have already noted similarities between the pottery of the Philistines and that of the Mycenaean Greeks. Specific details corroborate the representations found on Egyptian reliefs of Ramses III. The bird-headed prow of the Sea Peoples' ships finds iconographic parallels on Mycenaean pottery. The feathered or spiky headdresses associated with the Sea Peoples are found on the earlier Phaistos disk (see **37**), on an ivory gaming board from Enkomi, Cyprus, and on the 'B' side of the Warrior vase from Mycenae.

The Warrior vase has often been treated by art historians as an emblematic example of the warlike character of the Mycenaean Greek peoples to be simplistically contrasted with representations of the peaceful Minoans that were created in a different era hundreds of years earlier. If we examine the Warrior vase as a product of its time, we shall see that it communicates a great deal of information about both the human drama and the military strategy of the period to the modern viewer who chooses to look beyond the artistic skill of the craftsperson who made it.

The date of this piece to the Postpalatial Period marks the persistence of the pictorial style beyond the destruction of the citadel at Mycenae. A woman tearing at her hair looks on as a company of soldiers wearing horned helmets, carrying spears with bags attached, circular shields, and wearing greaves march away to parts unknown. The tearing at the hair as a sign of mourning is also found in Egyptian art and described in Mesopotamian literature and appears again in Greek art of the later, Geometric, Period. The form of the vase is that of a *krater*, which, as we have said, is a large bowl used for the mixing of

wine and water. We might imagine a communal drink-fest before these soldiers leave their homes, perhaps never to return, or the funerary banquet at a hero's grave. The greaves or shin-guards on the departing warriors are associated with Greek warriors while the horned helmets and panelled kilts with wide hems and tassels are commonly associated with Egyptian representations of the Sea Peoples, particularly the group known as the Sherden.

The horned headdresses associated with the Sherden are also found on bronze figurines from Iron Age Sardinia, as well as on a figurine from Enkomi in Cyprus known as the Ingot God. Sherden corselets with ribs curving downward and curved round shields are also found on a Mycenaean ivory mirror handle from Enkomi. The two-edged or Naue II sword brandished by the Sea Peoples originated in central Europe, but came into the ancient Mediterranean by way of Greece as discussed above.

Military expansion and commerce spread Philistine culture through Palestine.[12] Its dominance continued in the region through the mid-eleventh century BCE. Their eleventh-century BCE assimilation of local Semitic deities such as Dagon, Baal, and the goddess Ashtoreth seems to eclipse the earlier dominance of a Great Goddess of the Aegean world.

Burial practices employing anthropoid coffins in rock-cut rectangular chamber tombs with stepped entryways and Philistine pottery point to a combination of influences from both Egyptian and Mycenaean Greek burial practices. Coffin lids from the cemetery at Beth-Shean depict the feathered or spiky crown with diadem of the Sea People warriors as depicted on the Medinet Habu reliefs in Egypt and on the rarely depicted 'B' side of the Warrior *krater* from Mycenae.

The stratum X temple at Tell Qasile, a newly founded Philistine settlement in the twelfth century BCE near the coast of what is now central Israel, resembles Mycenaean sanctuaries at Phylakopi on Melos and at Mycenae in layout and in details.[13] Finds included Philistine stirrup jars that were placed in a niche. The stirrup jar is a shape that originates in the Aegean and was frequently used to transport perfumed oil (see **132**). It is characterized by its globular body, strap handles, and false spout. One of these was decorated with a bird pattern—a distinctly Philistine motif with Mycenaean parallels reaching from Cyprus and Crete to the Greek mainland. A bronze double axe that was placed on the altar calls to mind the Minoan practice of venerating the double axe.

Animal-headed *rhyta* and terracotta female figurines, both familiar features in the Bronze Age Aegean, are widely distributed among Philistine sites. An archaeologist who studies the Philistines, Trude Dothan, sees such objects as the last echo of a long Minoan and Mycenaean tradition. While Dothan believes that a female deity was

the focus of the Tell Qasile cult, an Egyptian-style plaque depicting male and female silhouettes also indicates dualistic cult practices. As discussed in Chapter 5, the evidence from the shrine at Phylakopi indicates similar male and female associations. It is significant that two Near Eastern smiting god figurines were found in the vicinity of the sanctuary at Phylakopi. We might imagine these Philistine temples as the inheritors of a long tradition of ritual practice that had its origins on Minoan Crete, as further indicated by features such as this horned altar from Beersheba [**140**].

Tradition and transformation

Aegean religion at the end of the Bronze Age

141
Plan of the Late Minoan III
shrine at Gournia in eastern
Crete, built immediately north
of the earlier palatial
compound.

While many Aegean material, cultural, and social traditions survived for a time in the Near East, where they blended with local practices, some Bronze Age traditions survived into the Postpalatial Period while others continued into the so-called Dark or Iron Age in the Aegean proper. As new studies continue to add to our knowledge of the period, it becomes increasingly clear that the life of the average person continued much as usual while it is modern scholarship that has found itself in the dark about this period until recently. Here, we would like to mention a couple of examples that point to the survival of Minoan religious and social practices in Crete in contrast to changes in artistic and social practice elsewhere within a framework of continuous use.

Cult activity at Postpalatial sites in Crete such as Gazi, Gournia [**141**], and Kavousi tends to be focused on small rectangular rooms with benches running along one wall for placing offerings, commonly referred to as bench shrines or sanctuaries. Sometimes already existing structures were adapted to the needs of the community, as at Kannia and Knossos. The character of the finds from such shrines has been taken to indicate the veneration of a Great Goddess, or perhaps a more general veneration of the chthonic or earthly powers of nature. Offerings are typically of a straightforward character and may include

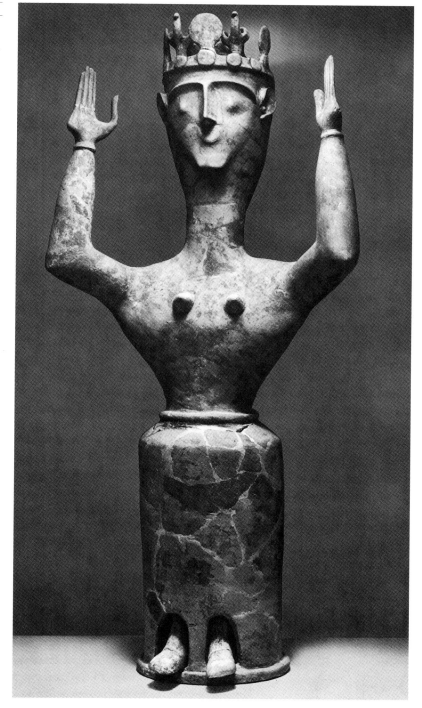

142
Minoan 'Goddess with Upraised Arms', Karphi, eastern Crete, Late Minoan III. Statuettes like this may have been left as offerings in town shrines.

miniature votive vases, human and animal figurines, vases for pouring liquid offerings, especially cups or bowls, items connected with the life-giving power of the sea such as shells of various types, and more personal items such as fragments of tools or simple adornments.

Offerings of a more specialized nature commonly found in such shrines include libation tables, snake tubes, and statues and statuettes representing the so-called Minoan Goddess with Upraised Arms, such as the one pictured here from the mountaintop settlement at Karphi [142] in eastern Crete. The libation tables take different forms and are made out of various materials such as stone or clay, but are distinguished by one or more depressions or cupules thought to function as receptacles for an offering of grain or liquid.

The snake tubes are clay cylinders that served as stands for bowls or other receptacles. Their name refers to the decorative snakes that also served as carrying handles. They call to mind the portable altars found in other ancient civilizations such as Rome and Egypt, and it would not be unreasonable to think of them as taking on a similar function. The number of snake tubes placed in a shrine appears to correspond roughly to the number of goddess figures. Along with cups and bowls placed upside down to allow liquid offerings to empty into the ground, these snake tubes would seem to emphasize the chthonic aspects of Minoan religion.

Like the snake tubes, the main element of the goddess figures is the cylindrical body. This is widened out to form the skirt that is made as a single unit on the potter's wheel. The head and neck were also thrown as a single unit on the wheel and joined to the body. The facial features, knob-like breasts, long rope-like strands of hair, hands, and arms were modelled from separate pieces of clay that were added to the body. Traces of paint indicate that colour was used to accentuate the characteristics of at least some of these representations. Despite the poor quality of the coarse clay which has made it difficult for modern restorers to mend these figures, their importance as a focal point for the Postpalatial cultures of Crete should not be neglected.

Nanno Marinatos points out that the identification of these statues as goddesses began with Evans' interpretation of seal representations.[14] Although this interpretation is accepted by many, it is not grounded in written evidence and remains an assumption. It is also possible that the statues represent effigies of priestesses venerating a deity or deities in perpetuity.

The crowns or bodies of the goddesses are adorned with different objects such as horns, disks, snakes, birds, or poppies. These attributes may indicate different aspects of one deity, different deities, or may even indicate practitioners connected with different cults. The horns may more generally symbolize the power of the bull or more specifically indicate a weather deity, while the poppy with its many seeds

may be a symbol of fertility. The disks call to mind similar depictions on representations of Sherden warriors. The gesture of the upraised arms has been connected with the bestowing of blessings by the goddess, a priestess invoking the appearance of a deity, or the supplication of a priestess to a deity. The gesture of the upraised arms is unusual in the Palatial Period in Crete, but it was common in the Near East where a goddess with upraised arms is involved in presenting a human protagonist to a god or divine king.[15] Could these Postpalatial goddess figures be functioning in a similar manner, that is, as intercessors between a human worshipper and the unseen realm of the divine?

The hollow bodies of the clay goddess figures would have made it possible to carry them on top of poles. This practice may have originated on the mainland where wheel-made figures similar to the Lady of Phylakopi occur in significant numbers at Mycenae in the Third Palace Period. Nanno Marinatos has suggested that these Postpalatial goddess figures on Crete were carried through the local town or village on poles in a procession that ended with their placement on the bench in the shrine or sanctuary. This calls to mind similar processions with larger statues that had a long history in the ancient Near East, as well as the Panathenaic procession to bring a new *peplos* (garment) to Athena in later Athens. The focus of such communal processions on a town shrine marks a shift from the central administrative structures, termed palaces, as a focal point for cult activity and has implications for the emergence of the Greek temple.

The practice of placing offerings or cult dedications on an internal shelf or bench along the wall persisted into the Iron Age in Crete at the Geometric Period temple of Apollo, Leto, and Artemis at Dreros as well as at the Orientalizing Period temple at Prinias. Additionally, the use of a pillar instead of a column to support the front porch at Prinias is believed by some to reflect a continuation of Minoan traditions.

143

Bronze Age terracotta female head from the Ayia Irini Temple, Kea, in an eighth-century BCE context, placed in a ring on the temple pavement as the god Dionysos. The eighth-century BCE placement may be connected with the legend of the god as emerging from beneath the earth.

As mentioned in Chapter 4, the Temple at Ayia Irini at Kea had a long history of use. A cup dating to the end of the sixth century BCE bearing a dedicatory inscription to the Greek god Dionysos provides clear evidence that the Temple had become the site of his cult.[16] However, the change in cult practice may go back even further to the Geometric Period. A head from one of the Bronze Age female statues discussed above was found placed in a ring base on the floor of room 1 in a Late Geometric context, c.700 BCE [143]. Many scholars associate this ensemble with the cult of Dionysos.

Some have connected such abbreviated representations of Dionysos with his chthonic aspect: that is, his rising out of the ground. Alternatively, the ring base has been interpreted as an abbreviated representation of his body which might be likened to an aniconic representation. Although scoring on the chin was done intentionally by the sculptor to promote better melding of the clay pieces, it could have been interpreted as a beard by those using the building more than a dozen generations later. Separated from the original context of its female body, the original history of the head would have been forgotten as it was passed down from generation to generation as an heirloom. Finally, the head acquired a new identity as Dionysos as a result of being re-inscribed into a new context.

Some scholars would like to take the worship of Dionysos back as far as the Mycenaean Period and possibly even the Minoan Period, citing the name of Dionysos on Linear B texts from Mycenaean Pylos and suggesting that the Kean statues were worshippers or participants in a liturgy.[17] However, the Linear B texts do not associate Dionysos with Kea and there is a relative absence of male imagery at the site. A thorough contextual study of the later Mycenaean art works and their relationships to each other and the building might clarify the matter. The continued use of the building for cult purposes does not guarantee that social life, religion, or customs remained static and unchanged for 700 years.

What goes around comes around: Daedalus returns to Crete

Part of the Iron Age legacy of Aegean Art within Greece was dependent on both its survival and its transmission to the Near East and its reintroduction to Greece through the re-establishment of contacts.[18] Two significant points of this reintroduction were by way of Crete and the site of Lefkandi in Euboia, a large island off the east coast of Attica. Lefkandi was the site of both a bronze and an iron foundry in the tenth century BCE. These installations indicate that prosperity continued in the Aegean despite the destruction of the Mycenaean palaces. Here, a tumulus marking the interment of the cremated remains of a warrior chief, accompanied by his horses and his consort covered in gold sheeting, testifies to the re-emergence of wealth and complex social organ-

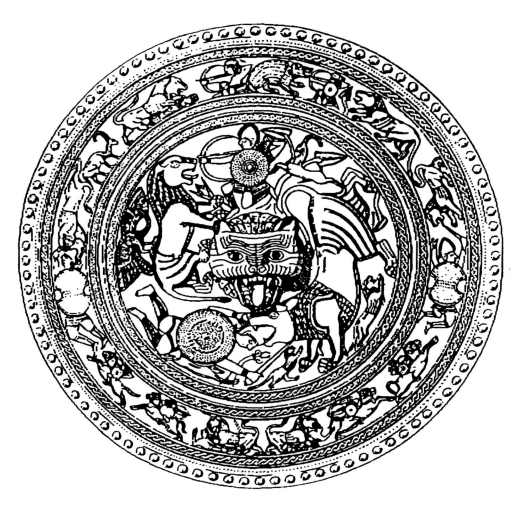

144

Reconstruction of a bronze votive shield from the Idaean Cave, north face of Mount Ida, central Crete, eighth to seventh centuries BCE. Known as the Hunt Shield, it depicts a hunting scene with exotic animals and warriors in Near Eastern attire with conical helmets. Most probably made on Crete and combining Cretan and Levantine motifs. The concentric registers depict turbulent scenes of warriors battling lions, surrounding a central animal face.

ization. The neighbouring settlement became increasingly wealthy with gold and other imports from the Levant while the metal-working and granulation techniques, once present in the Bronze Age, were reintroduced.

The practice of dedicating bronze votive figurines, weapons, jewellery, and other items at open air sanctuaries such as Kato Syme and at sacred caves such as the Idaean Cave continued unabated on Crete, in some cases into the classical period. Many of these later figurines have the columnar form, elongated necks, and simple lines characteristic of art from the Geometric Period. In many instances, however, oriental motifs such as exotic animals and warriors in eastern attire such as conical helmets decorated works produced locally, as on votive shields from the Idaean Cave [144]. We would like to call particular attention to the animals rendered in the flying gallop attitude, a representation that originated in Bronze Age Crete, found its way into Near Eastern iconography, and turns up once again in the Aegean.

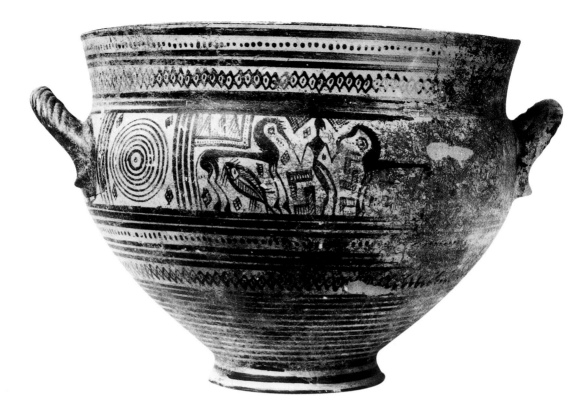

145

Late Geometric *krater*, Argos, Greece, *c.* eighth century BCE. The 'Horse-Leader' motif recalls the Master or Mistress of Animals motif prevalent throughout the Aegean and Near East in the Bronze Age.

146

Plan of the centre of Lato, eastern Crete, eighth century BCE. The compound resembles the later *prytaneia* or assembly-houses of classical Greek cities, while the wide stairway recalls the 'theatral areas' of the Bronze Age Minoan palaces of the previous millennium.

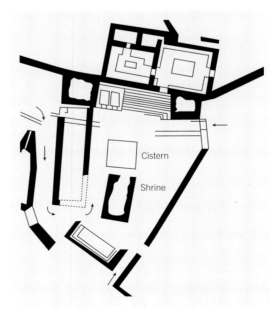

Cistern

Shrine

The Master or Mistress of Animals motif so prevalent throughout the Aegean in the Bronze Age may have come back to Greece by way of the Levant, as shown in this representation of the Horse Leader on a Late Geometric *krater* [145] from the Argolid. It has proved possible to trace Bronze Age examples of this motif in the pictorial style of the Mycenaeans on an amphoroid krater from Ugarit.[19] The East served as a haven of Mycenaean refuge and eventual assimilation until contacts with the Aegean again intensified in the Iron Age.

Lato

This plan, **146**, shows the centre or *agora* of Lato, an eighth-century BCE upland town in eastern Crete, which illustrates one stage in the gradual conversion of sub-Minoan towns into small Greek city states.[20] Lato's town centre is located in the saddle between two peaked hills, on which stood the town's residential quarters proper. On a terrace above a trapezoidal open area (the *agora*, which contained a small temple, a cistern, and a later *exedra* or benched seating area) is a two-part building housing the assembly of the town, and supporting its governmental functions.

This compound, resembling the later *prytaneia* of classical Greek cities, stood above a wide series of steps very reminiscent of the theatral area of the earlier Minoan palaces, for example those at Phaistos or Knossos. It is tempting indeed to see the assemblage and formal stagings of community functions of this eighth-century town as suggesting the continuation of practices which by this time would have been over a millennium old in Crete, possibly surviving changes in population, language, and forms of governance. Lato may be a useful object lesson in this regard, alerting us to the complex interactions between formation and usage, and their sometimes close, sometimes distant relationships.

To end this book it is necessary to return to the place where we started it. This final chapter has been a brief introduction to some of the complicated cultural and historical issues that are key to understanding the end of the Aegean Bronze Age and the transformations and survivals of its artistic and architectural practices. We have attempted to show how it might be possible to place Aegean artistic representations within a context of historical events, not only within those that we might be able to reconstruct from antiquity, but also within our own recent modern contexts and concerns—which have always and will continue to frame all of these endeavours.

The bibliography on many of the topics discussed in this final chapter (no less than of the issues raised in earlier chapters) is quite extensive; a thorough understanding of these problems, and a realistic appreciation of the genuine difficulties in the construction of the

historical (not to speak of the pre-historic) past, requires considerable investigation of the literature in many fields. As with the previous chapters, this final one has been crafted as an introductory window out on to a representative selection of images, objects, sites, controversies, and interpretations which the reader may wish to investigate at length, using the resources of the collected references and bibliography at the end of the volume.

Underlying our understanding of the end of the Aegean Bronze Age, no less than its beginnings and evolutions, is the vexed issue of the relationship of the Aegean world to the origins of a distinctly European civilization which—as we have discussed at some length in Chapter 1—is in no small measure an artefact of modern social and political agendas and needs. As we have indicated, the discovery of the cultures of Minoan Crete, Mycenaean Greece, and the Cyclades; their inscription within a broader context of Mediterranean interrelations; and their post-Bronze Age legacies, have over the past 130 years increasingly challenged prevailing Eurocentric notions of the unique and original properties of Hellenic art, style, and culture.

They have done so in part by rendering less opaque the historical foundations that the early modern European nation states articulated for themselves in (and as) the world of Hellenic Greece—revealing a rich and complex pre-Hellenic antiquity, that of the Aegean Bronze Age, with all of its very complex interactions with the dynamically evolving mosaic of societies, cultures, and artistic practices of the wider eastern Mediterranean region.

In foregrounding these problems, our study has aimed to demonstrate three basic things. First: that no discussion of historical development is complete without a discussion of its complement, namely the means and motivations of historical construction and reconstruction; of history-writing itself. Second: that to articulate identity—whether in the immediate present or in the very distant past—is always to speak of relationships that both link and distinguish individuals and peoples.

Finally: in carrying out our own readings of some of the more interesting examples of the art and architecture of the Aegean Bronze Age that remain to us, we have sought to highlight some of what is deeply at stake in the modern art historical and archaeological enterprises of 'reading' images, buildings, and objects as documents or evidence for the mentality, nature, or character of individuals or peoples—in construing art as history, as it were. We have sought to do this in part by calling attention in our own interpretations and conjectures to the extraordinary difficulties in even imagining what may have been significant to the makers and users of pictures and objects made three to five millennia ago.

As we have seen quite concretely, there are few guarantees that any one interpretation of an object, however seemingly obvious or natural

to our eyes, might replicate anything remotely like what its original makers and users might have made of it. Nor, as we have also seen, are our own favourite or attractive interpretations necessarily guaranteed a long shelf-life. The study of Aegean art is a field which has grown exponentially, and has been evolving in dramatic and not easily predictable ways during its first century. It seems reasonable to expect that the second century of our knowledge of the art and culture of these extraordinary peoples will be at least as exciting, and most likely even more so.

Notes

Note: Short titles for texts are given in the notes; full citations can be found in the Bibliography.

Chapter 1. Introduction: Aegean Art and Architecture

1. See Bietak, 'Minoan Wall-Paintings' (1992), 26–8; and *Avaris: The Capital of the Hyksos* (1996).
2. For an overview of linguistic evidence, see Packard, *Minoan Linear A* (1974). See also Finkelberg, 'Minoan Inscriptions' (1990–1), 43–85.
3. See Preziosi, *Art of Art History* (1998), chps 1 and 2.
4. See, for example, Rivers, *Evolution of Culture* (1906).
5. See Blackwood, *Classification of Objects* (1970).
6. Evans, *Palace of Minos at Knossos* (1921–36), vols 1–4.
7. Lawrence, *Greek Architecture* (1957), 34.
8. See the discussion on the shaft graves in Vermeule, *Greece in the Bronze Age* (1972), 82–110.
9. See, for example, Powell, *Classical Mythology* (1998), 203–25.
10. For an overview of recent scholarship on the Dorian invasion, see Drews, *Coming of the Greeks* (1988), 203–25.
11. See Antliff and Leighten, 'Primitive' (1996), 170–84.
12. Pollitt, *Art of Greece* (1965) and *Art of Rome* (1966).
13. See Preziosi, *Art of Art History* (1998).
14. On connoisseurship, see Preziosi, *Rethinking Art History* (1989), 29–30.
15. Carruthers, *Book of Memory* (1990).
16. See Hobsbawm and Ranger, *Invention of Tradition* (1983).

17. On Bronze Age chronology, see Warren and Hankey, *Aegean Bronze Age Chronology* (1989); and Manning, *Absolute Chronology* (1995).
18. See Bernal, *Black Athena* (1987 and 1991), vols 1 and 2; Lefkowitz and MacLean Rogers (eds), *Black Athena Revisited* (1996).

Chapter 2. The Neolithic Period and the Prepalatial Early Bronze Age

1. Tsountas, *Ai Proiistorikai Akropolis Diminiou Kai Sesklou* (1908).
2. Chourmouziadis, *To neolithiko Dimini* (1979).
3. Renfrew and Bahn, *Archaeology* (1991), 35.
4. See the section by Gimbutas in Renfrew et al., *Excavations at Sitagroi* (1986), vol. 1.
5. For example, see Kokkinidou and Nikolaidou, 'Body Imagery' (1997), 88–112, for a detailed bibliography.
6. See Barber, *Prehistoric Textiles* (1991), 54–5.
7. For a detailed treatment see Renfrew et al., *Excavations at Sitagroi* (1986), vol. 1; and Renfrew, 'Burnt House at Sitagroi' (1970), 131–4.
8. Hodder, *Domestication of Europe* (1990), 60–2.
9. Ibid., 44ff.
10. Ibid., 51.
11. See Preziosi, *Minoan Architectural Design* (1983), 175–91.
12. Caskey, 'Excavations at Lerna' (1954), 3; (1955), 25; (1956), 147; (1957), 142; (1958), 125; (1959), 202.
13. For a more detailed discussion and additional bibliography see Caskey, 'Early Bronze Age Hearths' (1990), 13–21.
14. See Hawes et al., *Gournia, Vasiliki and other Prehistoric Sites* (1908); Zois, 'Pour un schéma évolutif de l'architecture minoenne'

(1990), 75–93.

15. See Gesell, *Town, Palace, and House Cult* (1985), 8; Dickinson, *Aegean Bronze Age* (1994), 262–3.

16. Tenwolde, 'Myrtos Revisited' (1992), 1–24; Warren, 'Myrtos' (1972); Whitelaw, 'Settlement at Phournou Koryphi' (1983), 323–45; and 'Early Minoan Household' (1994), 335–6.

17. Warren, 'Myrtos' (1972), 209–10.

18. Ibid., 86.

19. As reconstructed by Sanders, 'Behavioral Conventions and Archaeology' (1990), in comparison with rooms 79–82.

20. Warren, 'Myrtos' (1972), 87.

21. Ibid., 85.

22. See Brea, *Poliochni, città preistorica nell'isola di Lemnos* (1964–76).

23. For an overview of Aegean burial practices see Dickinson, *Aegean Bronze Age* (1994).

24. See ibid., 211.

25. For an overview of Early Cycladic sculpture, see Getz-Preziosi, *Early Cycladic Sculpture* (1985).

26. Renfrew, *Cycladic Spirit* (1991), 99–104.

27. On forgeries, see Gill and Chippindale, 'Material and Intellectual Consequences of Esteem for Cycladic Figures' (1993), 601–59.

28. For Predynastic slate palettes, see Davis, *Masking the Blow* (1992).

29. For a discussion of these tombs see Xanthoudides, *Vaulted Tombs* (1924), more recently Branigan, *Pre-Palatial* (1970); for a discussion of possible Cypriot influence, see Hood, 'Cyprus and the Early Bronze Age' (1985), 43–9; for a specific discussion of Kamilari see Levi, 'La tomba a tholos di Kamilari presso Festòs' (1961–2), 7–148. For east Cretan house tombs discussed above, see Soles, *Pre-palatial Cemeteries* (1992).

30. For Chrysolakkos see Demargne, 'Nécropoles de Mallia' (1945); and for a recent discussion of the bee pendant, see Kitchell, 'The Mallia Wasp Pendant Reconsidered' (1981), 9–15.

Chapter 3. The First Palace Period

1. See Preziosi, *Minoan Architectural Design* (1983).

2. For the site of Phaistos, see L. Pernier, *Il palazzo minoico di Festòs* (1935 and 1950), vols 1 and 2; Levi, 'The Recent Excavations at Phaistos' (1964); 'Festòs: metodo e criteri di un scavo archeologico' (1968); 'Festòs e la civiltà minoica I' (1976); Levi and Carinci, 'Festòs e la civiltà minoica II' (1988).

3. See Marinatos, *Minoan Religion* (1993), 124–5.

4. Watrous, 'Crete from Earliest Prehistory' (1994), 742–4; Kanta, 'Monastiraki' (1992), 194–7.

5. See Schoep, 'Home Sweet Home' (1994), 189–210, on the significance of building models.

6. See distribution chart in Preziosi, *Minoan Architectural Design* (1983), 150.

7. On sealing practices, see Weingarten, 'Sealing Structures of Minoan Crete' (1986), 279–98.

8. Marinatos, *Minoan Religion* (1993), 112–14.

9. The following summarizes material found in Tsipopoulou, 'Ayia Photia' (1992), 66–9; Tsipopoulou, 'Ayia Photia Siteias' (1988), 31–47; and Watrous, 'Crete from Earliest Prehistory' (1994), 722–3.

10. As illustrated in Barber, *Cyclades in the Bronze Age* (1987), 55, fig. 41.

11. See Davaras, *Guide to Cretan Antiquities* (1976), 128–9.

12. Neopalatial annexes are detailed in Hitchcock and Preziosi, 'Knossos Unexplored Mansion' (1997), 51–62.

13. See Graham, 'Windows, Recesses, and Piano Nobile' (1960), 329–33; *Palaces of Crete* (1987), 162ff.

14. See Watrous, 'Crete from Earliest Prehistory' (1994), 722.

15. A schematic plan of the Knossian Old Palace may be found in MacGillivray, 'Early History of the Palace at Knossos' (1994), 45–55; for a detailed discussion of the problems involved in interpreting the architectural remains at Knossos, see Driessen, 'Early Destruction in the Mycenaean Palace' (1990).

16. See Preziosi, *Minoan Architectural Design* (1983), 84–6, 107, 122–4, 127–8, 140, 146, overview 149–57, and distribution chart 150.

17. See Evans, *Palace of Minos at Knossos* (1921), vol. 1, 207.

18. See, for example, Marinatos, 'Public Festivals in the West Courts' (1987), 135–43; Gesell, 'Minoan Palace and Public Cult' (1987), 123–8.

19. See Halstead and O'Shea, 'A Friend in Need is a Friend Indeed' (1982), 92–9.

20. Preziosi, *Minoan Architectural Design* (1983); Immerwahr, 'People in the Frescoes' (1983), 143–53.

21. See Strasser, 'Koulouras of Knossos and Phaistos' (1994), 306; 'Storage and States on Prehistoric Crete' (1998), 73–100.

22. As argued in Hitchcock, 'Fabricating Signification' (1998).

23. Marinatos, 'Public Festivals in the West Courts' (1987), 138.

24. Cadogan, *Palaces of Minoan Crete* (1976), 111–12.

25. Marinatos, 'Public Festivals in the West Courts' (1987), 137.

26. Such a scenario is recounted by Marinatos, op. cit., who sees it happening at the three major palace sites of Knossos, Phaistos, and Mallia.

27. Hägg, 'On the Reconstruction of the West Facade' (1987), 129–34.

28. This location of a window is consonant with Graham's belief (Graham, 'Windows, Recesses, and Piano Nobile' (1960), 329–33) that such shallow recesses indicated the presence of windows.

29. Branigan, 'Economic Role of the First Palaces' (1987), 247–8.

30. Both Preziosi, *Minoan Architectural Design* (1983), 87 and Branigan, 'Economic Role of the First Palaces' (1987), 249, interpret the west court as a controlled interface between the 'city' and the 'palace'.

31. Preziosi, *Minoan Architectural Design* (1983), 85; Immerwahr, 'People in the Frescoes' (1983).

32. Strasser, 'Koulouras of Knossos and Phaistos' (1994), 306; 'Storage and States on Prehistoric Crete' (1998), 73–100, has recently completed an exhaustive comparative and ethnographic study with important implications for understanding the economic and social functions of these 'palaces'.

33. Detailed in Evans' account of tree and pillar cult(s), 'Mycenaean Tree and Pillar Cult' (1901), 99–204.

34. Evans, *Palace of Minos at Knossos* (1930), vol. 3, 66–9, with a discussion of other representations of 'sacred dancing' following the discovery of the fresco.

35. Marinatos, 'Public Festivals in the West Courts' (1987), 135.

36. Krattenmaker, 'Minoan Architectural Representation' (1991).

37. This programme is detailed in Cameron's 1975 dissertation, 'A General Study of Minoan Frescoes', summarized briefly in Cameron, 'The "Palatial" Thematic System' (1987), 321–8.

38. Cameron dates it to MM IIIB/LM IA (Cameron, 'The "Palatial" Thematic System' (1987), 325), but it is dated to MM IIIB by Evans (Evans, *Palace of Minos at Knossos* (1930), vol. 3, 32).

39. Graham, *Palaces of Crete* (1987), 36; Levi, 'Recent Excavations at Phaistos' (1965), 4; Shaw, 'Minoan Architecture' (1971), 222–3.

40. Evans, *Palace of Minos at Knossos* (1936), vol. 4, 61ff.

41. Hood, 'Religion in Bronze Age Crete' (1996).

42. Branigan, 'Observations on State Formation in Crete' (1988), 65–6.

43. van Effenterre, 'Function of Monumentality in the Minoan Palaces' (1987), 85–7.

44. As detailed in Day, 'A Petrographic Approach' (1991), 2 vols.

45. As noted in Preziosi, *Minoan Architectural Design* (1983), 88.

46. Platon, *Zakros* (1985), 85–91.

47. An idea put forward with regard to Europe by Woolf, 'Beyond Romans and Natives' (1997), 339–50.

48. Dickinson, *Aegean Bronze Age* (1994), 258.

49. Hitchcock, 'Art and Ethnicity in Minoan Crete' (1997).

50. For more detail, see, for example, Rutkowski, *Petsophas* (1991); and Watrous, 'Cave Sanctuary of Zeus' (1996).

Chapter 4. The Second Palace Period

1. See Hitchcock, *Minoan Architecture* (forthcoming) for a new assessment.

2. See Preziosi, *Minoan Architectural Design* (1983), 83–106, for a complete discussion.

3. Shaw, 'Evidence for the Minoan Tripartite Shrine' (1978), 438.

4. Marinatos, *Minoan Religion* (1993), 154–5.

5. Evans, 'The Palace of Knossos' (1900–1), 15–16.

6. The evidence, various arguments for reconstruction, and further bibliography can be found in Niemeier, 'The "Priest King" Fresco' (1988), 235–44.

7. For a detailed discussion of the Master Impression, see Hallager, 'The Master Impression' (1985); for a more recent treatment, see Strasser, 'Horns of Consecration' (1997), 201–7.

8. For a postmodern critique of the Priest-King and its reconstructions, see Hitchcock, 'It's a *Drag* to be a King' (1999).

9. Preziosi, *Minoan Architectural Design* (1983); see also Badawy, *Ancient Egyptian Architectural Design* (1965) for a detailed analysis.

10. Exceptions might be found at Ayia Photia, Petras, and the east terrace walls at Knossos. Whether these were used for defence or served other functions such as terraces remains an open question.

11. See Preziosi, *Minoan Architectural Design* (1983) for a complete study of Minoan planning methods and design principles.

12. See Halbherr et al., 'Haghia Triadha' (1977), 14–296.

13. By Halbherr, 'Scoperti Ad Haghia Triadha' (1903), 6–74.

14. Watrous, 'Ayia Triadha' (1984); or the view favoured by Cadogan, *Palaces of Minoan Crete* (1976), 104–9 and Graham, *Palaces of Crete* (1987), 49–51.

15. LaRosa, 'Preliminary Considerations' (1985), 45–54; Preziosi, *Minoan Architectural Design* (1983), 77–8.

16. McEnroe, 'Minoan House and Town Arrangement' (1979).

17. Watrous, 'Ayia Triadha' (1984), 123–34.

18. Hitchcock and Preziosi, 'Knossos Unexplored Mansion' (1997), 51–62.

19. Haghia Triadha B measures *c.*22.5 m east–west × 18 m north–south; the 'Unexplored Mansion' at Knossos measures 24 × 14.5 m; and Tylissos House B measures 22 × 15.8 m.

20. Watrous, 'Ayia Triadha' (1984), 123–34.

21. Palyvou, 'Circulatory Patterns' (1987), 199.

22. Halbherr et al., 'Haghia Triadha' (1977), 14–296.

23. Immerwahr, *Aegean Painting* (1989), 101–2, 109. More recently see Rehak, 'Role of Religious Painting' (1997), 163–75.

24. As discussed by Kopaka, 'Des pièces de repos' (1990), 217–30.

25. A detailed discussion of Minoan dress may be found in Rehak, 'Aegean Breechcloths' (1996), 35–51; and of textiles in Barber, *Prehistoric Textiles* (1991), 311–57.

26. See Hallager and Hallager, 'Knossian Bull' (1995), 547–56.

27. Younger, 'Bronze Age Representations' (1995), 507–46; see the discussion of the Hallagers' 1995 paper on p. 558.

28. Hood, *Arts in Prehistoric Greece* (1978), 145.

29. For various interpretations see: Hood, *Arts in Prehistoric Greece* (1978), 144–6; Higgins, *Minoan and Mycenaean Art* (1981), 154; Forsdyke, 'Harvester Vase' (1954); Warren, *Minoan Stone Vases* (1969), 176—this text is useful for a general introduction to the subject of Minoan stone vases.

30. For example, Oppenheim, *Ancient Mesopotamia* (1977), 120ff; Postgate, *Early Mesopotamia* (1992), 169ff.

31. See Palaima, 'Maritime Matters' (1990), 308.

32. Rehak, 'Ritual Destruction' (1994), 1–6; 'Use and Destruction of Minoan Bull's Head Rhyta' (1995), 435–60.

33. Koehl, 'Aegean Rhyta' (1981), 179–87.

34. Betancourt, 'Ghyali Obsidian' (1997), 171–6.

35. Ibid., 174, n.37 and 46.

36. Preziosi, *Minoan Architectural Design* (1983), 144.

37. Evans, *Palace of Minos at Knossos* (1930), vol. 3, 404.

38. Halbherr et al., 'Haghia Triadha' (1977), 124.

39. Shaw, 'Minoan Architecture' (1971), 11–12.

40. Ibid., 24–7.

41. Sakellerakis, 'Zominthos' (1988), 165–72.

42. McEnroe, 'Local Styles' (1990), 195–202.

43. Ibid., 195.

44. Preziosi, *Minoan Architectural Design* (1983).

45. See Davaras, 'Architectural Elements' (1985), 77–92; 'Makrygialos' (1992), 172–4; and 'Cult Villa' (1997), 117–35.

46. These observations are indebted to Strasser, 'The Blue Monkeys' (1996).

47. For example, Cummer, 'Itinerant Aegean Builders' (1980), 3–7; Schofield, 'Western Cyclades' (1982), 45–8.

48. Hitchcock and Preziosi, 'Function and Meaning'; see also Driessen's discussion (Driessen, 'Minoan Hall' (1982), 27–92) of the programmatic introduction of the Minoan hall, and the decreasing use of lustral basins over time.

49. Michailidou, 'Room with the Column' (1987).

50. Hitchcock, 'Blending the Local with the Foreign' (1998), 169–74.

51. Hitchcock, 'Best Laid Plans' (1997c), 243–50.

52. See Shaw, 'Excavations at Kommos' (1994), 305–6; Davaras, 'Cult-Villa' (1997), 117–35; Tsipopoulou and Papacostopoulou, ' "Villas" and Villages' (1997), 203–14; Sakellarakis, 'Zominthos' (1988), 165–72.

53. Hatzaki, 'Little Palace at Knossos' (1996), 34–45.

54. McEnroe, 'Local Styles' (1990), 195–202; Hitchcock, 'Best Laid Plans' (1997c), 243–50; Yiannouli, *Reason in Architecture* (1992).

55. See C. Palyvou's seminal study of the architecture of Akrotiri, 'Akrotiri Thiros' (1988).

56. Cadogan, 'Probable Shrine' (1981), 169–71; Graham, *Palaces of Crete* (1987), fig. 31; Evans, *Palace of Minos at Knossos* (1930), vol. 3, 354ff; Hitchcock, 'Minoan Hall System' (1994), 14–43.

57. Yiannouli, 'Reason in Architecture' (1992), 155.

58. McEnroe, 'Minoan House and Town Arrangement' (1979).

59. Cummer and Schofield, *Keos III* (1984), 40.

60. Cameron, 'General Study of Minoan Frescoes' (1975), 217.

61. Shaw, 'Minoan Architecture' (1971), 126–8.

62. Evans, 'Mycenaean Tree and Pillar Cult' (1901); Gesell, 'Town, Palace, and House Cult' (1985); Begg, 'Continuity' (1987); Marinatos, 'Public Festivals in the West Courts' (1987), 135–43.

63. Loeta Tyree, pers. comm.; Hogarth, 'Dictaean Cave' (1899–1901), 94–116.

64. Hitchcock, 'Minoan Hall' (1994), 14–43.

65. See Abramovitz, 'Frescoes' Part I (1973), 284–300; 'Frescoes' Part II (1980), 57–85.

66. Cameron, 'Minoan Frescoes' (1975), 225.

67. Cummer and Schofield, *Keos III* (1984), 41.

68. More recently, MacDonald and Driessen 'Drainage System' (1988), and 'Storm Drains' (1990), have suggested that the toilet at Knossos was some sort of preparation room, citing structural difficulties in actually flushing solid waste.

69. Georgiou, 'Minoan Coarse Wares' (1983), 75–92.

70. See Davis, 'Cultural Innovation' (1984), 159–66.

71. See the collection of papers in Hägg and Marinatos (eds), *Minoan Thalassocracy* (1984).

72. For example, by Wiener, 'Conical cups' (1984), 17–26; Schofield, 'Minoan colonists' (1984), 45–8.

73. See J. Caskey, 'Investigations in Keos, 1963' (1964), 326ff.

74. Ibid.

75. For a discussion of the Knossian Procession fresco, see Immerwahr, *Aegean Painting* (1989), 89; Evans, *Palace of Minos at Knossos* (1928), vol. 2, 704–12; Marinatos, *Minoan Religion* (1993), 65–6. For the Akrotiri Procession fresco, see Doumas, *Wall-Paintings* (1992), figs 109 and 113.

76. Verlinden, 'Statuettes anthropomorphes crétoises' (1984), 83ff, has categorized six different distinctive gestures in the Neopalatial period, and a provisional attempt at their interpretation has been made in Hitchcock, 'Engendering Domination' (1997a), 113–30. The gesture under discussion here is Verlinden's 'Gesture 3'.

77. M. Caskey, *Keos II* (1986), 36.

78. Bittel, *Hattusha* (1970), 90ff.

79. CMS (Corpus der minoischen und mykenischen Siegel) II, no. 3, is an isolated figure not discussed here.

80. CMS I, no. 159, and Nilsson, *Minoan-Mycenaean Religion* (1968), fig. 134.

81. CMS I, no. 126.

82. Aspects of these religious symbols are detailed in Evans, 'Tree and Pillar Cult' (1901) and Warren, 'Of Baetyls' (1990), 193–206.

83. For a different point of view, see Niemeier, 'Cult scenes on gold' (1990), 169.

84. Rehak, 'Use and Destruction of Minoan Bull's Head Rhyta' (1995), 435–60.

85. M. Caskey, *Keos II* (1986).

86. J. Caskey, 'Investigations in Keos, 1963' (1964), 327–8.

87. M. Caskey, *Keos II* (1986), 99.

88. See Lembessi and Muhly, 'Aspects of Minoan Cult' (1990), 315–36. For a discussion of Kato Syme in relationship to other sanctuaries outside the urban sphere see Watrous, 'Cave Sanctuary at Psychro' (1996), 65–70.

89. Shaw, 'Minoan Tripartite Shrine' (1978), 429–48.

90. Lembessi and Muhly, 'Aspects of Minoan Cult' (1990), 334–5. See also Peatfield (1987).

91. Hitchcock, 'Engendering Domination' (1997a).

92. See Frankfort, *Art and Architecture* (1985), 45.

93. Detailed in Lembessi and Muhly, 'Aspects of Minoan Cult' (1990), fig. 14.

94. Verlinden, 'Statuettes anthropomorphes crétoises' (1984).

95. For a discussion of the seal and its authenticity see Pini, 'Einige Falle' (1978), 142–5 and Betts, 'Possible Minoan Forgery' (1965) and 'Some Early Forgeries' (1978), 18, n. 4. See also Evans, *Palace of Minos at Knossos* (1936), vol. 4, 467, and Marinatos, *Art and Religion* (1984), 61–2.

96. See MacGillivray et al., 'Excavations at Palaikastro, 1987' (1988), 267, and 'Excavations at Palaikastro, 1988' (1989), 426–7.

97. Detailed in Sackett and MacGillivray, 'Boyhood of a God' (1989), 26–31.

98. This is detailed in McCallum, 'Megaron Frescoes' (1987); see also Marinatos, *Minoan Religion* (1993), 106–9; and Niemeier, 'Throne Room' (1987), 163–8.

99. See tablets Na58; Ta711; La622; Un03 discussed in Ventris and Chadwick, *Documents in Mycenaean Greek* (1956); on *to-no* see ibid., Ta707.

100. For the Sumerian king list, see Kramer, *Sumerians* (1963), 328–31.

101. Discussed in Marinatos, *Minoan Religion* (1993), 115.

102. See also Hogarth, 'Dictaean Cave' (1899–1901); Boardman, *Cretan Collection* (1961); and most recently, Watrous, 'Cave Sanctuary at Psychro' (1996). Much of the description of the cave and its features is summarized from Watrous which should be consulted by those seeking further information and bibliography.

103. Tyree, pers. comm. and Hogarth, 'Dictaean Cave' (1899–1901).

104. See also Evans, 'Tree and Pillar Cult' (1901); Gesell, 'Town, Palace and House Cult' (1985); Begg, 'West Wing at Knossos' (1987); Marinatos, 'Public Festivals' (1987) and *Minoan Religion* (1993), 95–8.

105. For example, at Tylissos A, South House at Knossos, and Little Palace at Knossos.

106. See Marinatos, *Minoan Religion* (1993), 97, where she very attractively compares the movement between lower floor and upper floor with an actual ritual in the Mesopotamian epic of Gilgamesh.

107. Discussed in Watrous, 'Cave Sanctuary at Psychro' (1996), esp. 69. However, Watrous remains more cautious and does not draw out his conclusions to the same extent as Marinatos.

108. For example, at Haghia Triadha A as discussed above.

109. Younger, 'Stelai of Mycenaen Graves' (1997), 225–39.

Chapter 5. Mycenaean Domination and the Minoan Tradition

1. Blegen and Rawson, *Palace of Nestor at Pylos I* (1966) and *Guide to the Palace of Nestor* (1967).

2. For example, see Darque, 'Pour l'abandon du terme "megaron" ' (1990), 21–31; Preziosi, *Minoan Architectural Design* (1983), 175–93; and Schaar, 'Aegean house form' (1990), 173–82.

3. For a history of the decipherment see Chadwick, *Decipherment of Linear B* (1958).

4. As detailed in Palaima and Wright, 'Ins and Outs of the Archives Rooms at Pylos' (1985), 251–62.

5. Hirsch, 'Painted Decoration on the Floors' (1977), esp. 47–8; Hitchcock, 'Space, the Final Frontier' (1997), 46–53.

6. See Ventris and Chadwick, *Documents in Mycenaen Greek* (1956) for wanax: Na58; Ta711; La622; Un03, and for *to-no*, see Ta707. See also E. Cook, *The Worlds of Homer*, (forthcoming).

7. Much of the following discussion is summarized from McCallum, 'Decorative Program in the Mycenaen Palace of Pylos' (1987).

8. See Tn316.

9. Shelmerdine, 'Perfume Industry of Mycenaen Pylos' (1985).

10. Mycenaean *re-wo-to-wo-ko-wo* or bath-pourer becomes Homeric *Loetroxoos*. See Od. XX.297 and tablets Ab27, Ad676, Tn996 in Ventris and Chadwick (1956).

11. Hitchcock, 'Fabricating Signification' (1998), 179–88.

12. Blegen and Rawson, *Palace of Nestor at Pylos I* (1966), 256–7.

13. Possible reasons for the decline of Neopalatial Crete are detailed in Driessen and MacDonald, *Troubled Island* (1997).

14. Nicgorsky, *Iconography of the Herakles Knot* (1995); see also Evans, *Palace of Minos* (1928a), vol. II, 282ff, 430–5.

15. Evans, *Palace of Minos* (1930), vol. III, 211ff; for the Knossos frescoes in general and the Taureador fresco in particular, see also Cameron, 'The "Palatial" Thematic System' (1987), 320–8, esp. 325.

16. For these different views see Younger, 'Bronze Age Representations' (1976), 125–37; Younger, 'Bronze Age Representations, III' (1995a), 507–46; Evans, 'On a Minoan Bronze Group' (1921), 247–59; Graham, 'The Central Court' (1957), 255–62; Hitchcock, 'Fabricating Signification' (1998), 189–98.

17. Marinatos, *Minoan Religion* (1993), 219–20, 260, n. 162; also Hitchcock, 'It's a *Drag* to be a King' (1999).

18. See esp. Collon, 'Bull-Leaping In Syria' (1994), 81–5; also Hitchcock, 'Fabricating Signification' (1998), 195.

19. Preziosi, *Minoan Architectural Design* (1983), 175–93.

20. Shaw, 'Excavations at Kommos' (1986), 219–69.

21. See also Hayden, 'Late Bronze Age Tylissos' (1984), 37–46.

22. Detailed in McEnroe, 'Minoan House and Town Arrangement' (1979), 277–8; see also Shaw, 'Minoan Architecture' (1971), esp. 113–15.

23. Nilson, *Mycenaean Origin of Greek Mythology* (1972); Marinatos, *Minoan Religion* (1993).

24. Levi, 'La Tomba A Tholos' (1961–2), 7–148, esp. 126–7; Marinatos, *Minoan Religion* (1993), 20–1; Schoep, 'Home Sweet Home' (1994), 189–210, esp. 191–2, 209–10.

25. For a detailed discussion of the cult centre, see Renfrew, 'Archaeology of Cult' (1985).

26. As detailed in Scoufopoulos, *Mycenaean Citadels*.

27. See Pausanias, Book II. 16,5.

28. See Protonotariou-Deilaki, 'About the Gate of Mycenae' (1965), 7–26.

29. See Sandars, *Sea Peoples* (1985).

30. Some 18 scholars including Evans, the discoverer of Knossos, and Alan J. B. Wace who excavated at Mycenae.

31. Gates, 'Rethinking the building history' (1985), 263–74; Laffineur, 'Grave Circle A at Mycenae' (1990), 201–6; and Younger, 'Stelai of Mycenae Grave Circles' (1997), 225–39.

32. Wright and Dabney, 'Mortuary Customs' (1990), 52.

Chapter 6. Conclusion

1. The following discussion is based on Collon, 'Bull-Leaping in Syria' (1994).

2. The painstaking work that led to Ulu Burun giving up its secrets is vividly recounted in

Bass, 'Oldest Known Shipwreck' (1987), while the identity of the traders is discussed in Bass, 'Prolegomena to a Study of Maritime Traffic' (1997).

3. As discussed in Crowley, 'Aegean and the East' (1989).

4. For a detailed discussion of orientalism, see Said, *Orientalism* (1978).

5. For example, Gates, 'Mycenean Art for a Levantine Market?' (1992).

6. For a discussion of faience in the Aegean, see Pollinger-Foster, *Aegean Faience* (1979).

7. As detailed in Collon, 'Smiting God' (1972).

8. See also Hult, 'Bronze Age Ashlar Masonry' (1983), 9, 74.

9. As detailed in Dothan, *Philistines* (1982), 94ff.

10. Detailed in Drews, *Coming of the Greeks* (1988) and *End of the Bronze Age* (1993); see also Sandars, *Sea Peoples* (1985) and Wood, *In Search of the Trojan War* (1985).

11. On Philistine origins see Dothan, *Philistines* (1982), 21–2. For biblical references to Caphtor, see Zeph. 2:5; Ezek. 25:16; Amos 9:7; Jeremiah 47:4.

12. See Dothan, *Philistines* (1982), 24. For biblical references see Samuel 1 and 2.

13. As discussed in Dothan, *Philistines* (1982), 63–6.

14. Marinatos, *Minoan Religion* (1993) presents a useful and informative account of Aegean religion in the Postpalatial Period; see also Gesell, 'Town, Palace, and House Cult' (1985), 41–55, for a discussion of Postpalatial religion; and Gesell and Saupe, 'Methods Used in the Construction of Ceramic Objects' (1997), for a detailed practical account of how these figures were constructed.

15. For a more detailed discussion of Near Eastern presentation scenes see Collon, *First Impressions* (1987).

16. See Caskey, 'Ayia Irini, Kea' (1981) for further references.

17. See Ventris and Chadwick, *Documents in Mycenaen Greek* (1956), Xa 06 and Xa 1419.

18. For a different view see Morris, *Daidalos and the Origins of Greek Art* (1992).

19. As detailed in Langdon, 'Return of the Horse-Leader' (1989).

List of Illustrations

The publisher would like to thank the following individuals and institutions who have kindly given permission to reproduce the illustrations listed below.

Map of the Aegean and chronological chart (pages 5 and 8) from Immerwahr, S.A. *Aegean Painting in the Bronze Age* (University Park and London, The Pennsylvania State University Press, 1990). Copyright © 1990 by The Pennsylvania State University. Reprinted by permission of the publisher.

frying pan. Copyright © Ancient Art and Architecture Collection.

28. Syros, Chalandriani, Early Cycladic II Period. Vase in the shape of a small bear or hedgehog. National Museum, Athens.

29. Walled granary model from the island of Melos, Early Bronze Age. Chlorite.

30. Gournia, northeast Crete, Early Minoan II, built tombs I and II; plan and reconstruction.

31. Kamilari, south-central Crete, Early Minoan II, *tholos* tomb.

32. Mallia, Chrysolakkos cemetery, Early Minoan gold bee pendant. Copyright © Ancient Art and Architecture Collection.

33. Comparative plans of western magazine blocks and west courts of the Minoan palaces at Phaistos, Knossos, and Mallia.

34. Kamares-style jug from Phaistos, Middle Minoan II.

35. Detailed plan of western wing of the First Palace of Phaistos, of the early Middle Minoan Period.

36. West court of the First Palace at Phaistos. Dr Louise Hitchcock.

37. Undeciphered Phaistos disk, Middle Minoan IIIB Period. Copyright © Ancient Art and Architecture Collection.

38. Mallia, plan of Quartier Mu showing the large administrative structure, Building A.

39. Drawings of Cretule sealings with Minoan hieroglyphs, Phaistos, Crete.

40. Photographs of Monastiraki, showing the reception hall and administrative complex. Dr Louise Hitchcock.

41. Plan of the Oval House at Chamaizi in eastern Crete, Middle Minoan I. Published in Marinatos, N., *Minoan Religion: Ritual, Image and Symbol* (Columbia, South Carolina, 1993). Copyright © Professor J. Wilson-Myers.

42. Aerial view of the fortified building at Ayia Photia, Middle Minoan IA. Copyright © Professor J. Wilson-Myers.

43. Plan of the 'sanctuary' of Rousses, Middle Minoan III–Late Minoan I.

44. Aerial view of Palace at Phaistos, Gordon Gahan, Copyright © National Geographic Society.

45. Hypothetical reconstruction of so-called 'Window of Appearances' in the west façade of the Palace at Knossos, Middle Minoan III.

46. West façade of Palace at Knossos before reconstruction.

47. Detail of miniature 'Sacred Grove' fresco of women dancing, Knossos Palace. Ashmolean Museum, Oxford.

48. Figurines from peak sanctuary of Petsophas, near east Crete town of

Palaikastro, Middle Minoan. Hirmer Verlag.

49. Plan of the palace at Knossos, Neopalatial or Second Palace Period.

50. The East Pillar Crypt with incised *labrys* (double axe) signs, Palace of Knossos. Hirmer Verlag.

51. 'Throne Room' in the Palace at Knossos, Second Palace Period. Copyright © Ancient Art and Architecture Collection.

52. Dolphin fresco from 'Queen's megaron' in the east wing of the Palace at Knossos, Neopalatial Period. Copyright © Ancient Art and Architecture Collection.

53. Pier-and-door partition system or *polythyron* (multiple doorway).

54. Grandstand fresco, palace at Knossos, Second Palace Period.

55A. 'Mother of the Mountains' sealing. Archeological Receipts Fund (TAP).

55B. The 'Master Impression' sealing, Chania, Late Minoan I–II.

56. 'Priest-King' fresco and new reconstruction, Palace of Knossos, Second Palace Period. 56A: copyright © Ancient Art and Architecture Collection; 56B: copyright © B. and W. D. Niemeier.

57. Plan of the Second Palace of Phaistos. Preziosi, D., *Minoan Architectural Design* (Mouton, 1983).

58. Central planning grid of the Second Palace of Phaistos. Preziosi, D., *Minoan Architectural Design* (Mouton, 1983).

59. Grand Staircase of the Second Palace of Phaistos.

60. Floral-style jug with a naturalistic rendering of wild grasses. Second Palace of Phaistos, Late Minoan IB, height 29 cm.

61A. Minoan stirrup jar with octopus from Gournia, east Crete, Late Minoan IB. Copyright © Ancient Art and Architecture Collection

61B. Postpalatial stirrup jar with octopus from a tomb at Tourloti, east Crete, LM IIIC.

62. Restored view of the palace at Gournia from the southeast, based on a recent detailed re-examination of the building's remains.

63. Hawes' plan of the palace at Gournia and surrounding area, Second Palace Period.

64. Aerial view of the Palace of Kato Zakro in east Crete, Second Palace Period, copyright © Professor J. Wilson-Myers.

65. Plan of Kato Zakro Palace, east Crete, Second Palace Period.

66. Stone (chlorite) bull's-head *rhyton*, found smashed in the ruins of the west wing hall of the Palace of Kato Zakro. Second Palace Period. Archeological Receipts Fund (TAP).

67. Veined marble double-handled jar from the Palace of Kato Zakro. Hirmer Verlag.

68. Tylissos House C, isometric plan and detail of entry corridor, Middle Minoan IIIB/Late Minoan IA–IB.

69. Haghia Triadha, plan of Villa A and Annexe B with details of pier-and-door partition halls of Villa A. Second Palace Period.

70. Fresco of cat and pheasant, Haghia Triadha Villa complex, room 14.

71. Fresco depicting a woman, possibly a goddess or worshipper, crouching at an altar; from room 14, Haghia Triadha Villa A.

72. 'Boxer' *rhyton*, Haghia Triadha Villa A, steatite or black serpentine. Copyright © Ancient Art and Architecture Collection.

73. The 'Harvester' vase, Haghia Triadha Villa A. Copyright © Ancient Art and Architecture Collection.

74. Bronze figurine, Haghia Triadha Villa A. Scuola Archeologica Italiana di Atene.

75. A tablet with Linear A inscription, from the west wing of the palace at Kato Zakro.

76. The West House at Akrotiri on the island of Thera (modern Santorini), Second Palace Period, Late Minoan IA.

77. The 'Flotilla' fresco from room 5 in the West House at Akrotiri, Second Palace Period, Late Minoan IA. Archeological Receipts Fund (TAP).

78. Reconstruction of room 5 of the West House, Akrotiri, Thera.

79. Plans of the West House and House Xeste 3, Akrotiri, Thera.

80. Reconstruction of room 3 and upper floor of House Xeste 3, Akrotiri, Thera.

81. Young girl gathering crocus flowers; fresco from room 3, House Xeste 3, Akrotiri, Thera. Idryma Theras – Petros M. Nomikos.

82. The 'Blue Monkey' fresco from room 6, House Beta, Akrotiri, Thera. Archeological Receipts Fund (TAP).

83. Bare-breasted female figure from room 1 of the House of the Ladies, Akrotiri, Thera. Copyright © Ancient Art and Architecture Collection.

84. Plan of Houses A and F, Ayia Irini, Kea, Second Palace Period.

85. Plan of the Temple from Ayia Irini, Kea, Second Palace Period through the eighth century BCE.

86. Terracotta female figurine, Ayia Irini, Kea, Late Neopalatial Period.

87. Drawings of seal impressions showing the hands-on-hips gesture, from Mycenae, Late Helladic.

88. Plan of the Neopalatial sanctuary at Kato Syme, Crete, Second Palace Period, and a representation of a shrine on a stone *rhyton* from Zakro Palace.

89. The 'Peak Sanctuary' rhyton from the Palace of Kato Zakro, Second Palace Period. Archeological Receipts Fund (TAP).

90. Bronze male figurine from Kato Syme, Palaikastro, chryselephantine (gold and ivory) statuette, and Minoan seal showing a similar hands-to-chest gesture; all Second Palace Period. Palakaistro; reproduced with permission of the British School, Athens.

91. Plan of the Diktaian Cave, near the modern village of Psychro, Crete. Photograph copyright © AKG, London.

92. Gold votive double axes from the Arkalokhori Cave, Crete, Second Palace Period. Copyright © Ancient Art and Architecture Collection.

93. Reconstruction of Grave Circle A of Mycenae, Late Helladic I, originally outside the citadel wall.

94. Limestone *stele* with charioteer from Grave V, Grave Circle A, Mycenae. Archeological Receipts Fund (TAP).

95. Gold death mask from Mycenae, one of several found in the shaft graves, made of hammered gold sheet. Archeological Receipts Fund (TAP).

96. Bronze blade of a dagger with a gold, silver, and black niello inlay, from Grave IV, Grave Circle A, Mycenae, *c.*24 cm long. Archeological Receipts Fund (TAP).

97. Plan of the Palace at Pylos, Late Helladic IIIA, *c.*1300–1200 BCE; detail of painted plaster floor.

98. The 'Tripod Tablet', a Linear B tablet from the Palace at Pylos, dated to the thirteenth century BCE.

99. Linear B tablet from the Palace of Knossos, Third Palace Period.

100. The 'Lyre-Player' fresco from the central hall or Throne Room at Pylos. Archeological Receipts Fund (TAP).

101. Reconstruction of part of the fresco programme of the *megaron*, Palace of Pylos. Copyright © Professor Jack Davis.

102. View of western magazines or storage areas, Knossos Palace, Third Palace Period. Ashmolean Museum, Oxford.

103. 'Palace-style' storage jar from Knossos, Third Palace Period. Hirmer Verlag.

104. The so-called 'La Parisienne' fresco, Palace of Knossos, Third Palace Period. Copyright © Ancient Art and Architecture Collection.

105. Detail of the reconstructed 'Camp Stool' fresco, Palace of Knossos, Third Palace Period.

north of the earlier palatial compound.
142. Minoan 'Goddess with Upraised Arms', Karphi, eastern Crete, Late Minoan III.
143. Bronze Age terracotta female head from the Ayia Irini Temple, Kea, in an eighth-century BCE context, placed in a ring on the temple pavement as the god Dionysos.
144. Reconstruction of a bronze votive shield from the Idaean Cave, north face of Mount Ida, central Crete, eighth to seventh centuries BCE.

145. Late Geometric *krater*, Argos, Greece, *c.* eighth century BCE. Archeological Receipts Fund (TAP).
146. Plan of the centre of Lato, eastern Crete, eighth century BCE.

The publisher and authors apologize for any omissions or inaccuracies in the above list. If contacted, they will be pleased to rectify these at the earliest opportunity.

Bibliography

Note: The following abbreviations have been used: *AE—L'Année Épigraphique; Aegaeum— Aegaeum: Annales d'archéologie égéenne de l'Université de Liège et UT-PASP; AJA— American Journal of Archaeology; Annuario— Annuario della Scuola Archeologica di Atene e delle Missioni in Oriente; BCH—Bulletin de correspondance hellénique; BSA—Annual of the British School at Athens; CMS—Corpus der minoischen und mykenischen Siegel; Hesperia — Hesperia: Journal of the American School of Classical Studies at Athens; JHS—Journal of Hellenic Studies; JMA—Journal of Mediter- ranean Archaeology; OJA—Oxford Journal of Archaeology; Op. Ath.—Opuscula Atheniensia; SIMA—Studies in Mediterranean Archaeology.*

Chapter 1. Introduction:
Aegean Art and Architecture

Antliff, M. and **Leighten, P.**, 'Primitive' in Nelson and Shiff (eds) *Critical Terms for Art History* (Chicago and London, 1996).

Bernal, M., *Black Athena: Afroasiatic Roots of Classical Civilization* (London, 1987 and 1991), vols 1 and 2.

Bietak, M., 'Minoan Wall-Paintings Unearthed at Ancient Avaris' in *Bulletin of the Egyptian Exploration Society* 2 (1992).

Bietak, M., *Avaris: The Capital of the Hyksos* (London, 1996).

Blackwood, B., *The Classification of Objects in the Pitt Rivers Museum* (Oxford, 1970).

Carruthers, M., *The Book of Memory: A Study of Memory in Medieval Culture* (Cambridge and New York, 1990).

Drews, R., *The Coming of the Greeks: Indo-European Conquests in the Aegean and the Near East* (Princeton, 1988).

Evans, A. J., *The Palace of Minos at Knossos* (London, 1921), vol. 1.

Evans, A. J., *The Palace of Minos at Knossos* (London, 1928), vol. 2.

Evans, A. J., *The Palace of Minos at Knossos* (London, 1930), vol. 3.

Evans, A. J., *The Palace of Minos at Knossos* (London, 1936), vol. 4.

Evans, A. J. and **Evans, J.**, *Index to the Palace of Minos at Knossos* (London, 1936).

Finkelberg, M., 'Minoan Inscriptions on Libation Vessels' in *Minos: Revista de Filologia Egea* (Salamanca, 1990–1), 43–85.

Hawes, C. H. and **Hawes, H. B.**, *Crete: the Forerunner of Greece* (London and New York, 1909).

Hobsbawm, E. and **Ranger, T.**, *The Invention of Tradition* (Cambridge, 1983).

Lawrence, A. W., *Greek Architecture* (Harmondsworth, 1957).

Lefkowitz, M. R. and **MacLean Rogers, G.** (eds) *Black Athena Revisited* (Chapel Hill, 1996).

Manning, S., *The Absolute Chronology of the Aegean Early Bronze Age: Archaeology, Radiocarbon and History* (Sheffield, 1995).

Packard, D. W., *Minoan Linear A* (Berkeley and Los Angeles, 1974).

Pollitt, J. J., *The Art of Greece 1400–31 BC: Sources and Documents* (Englewood Cliffs, NJ, 1965).

Pollitt, J. J., *The Art of Rome, c.743–337: Sources and Documents* (Englewood Cliffs, NJ, 1966).

Powell, B. B., *Classical Mythology* (2nd edn, New Jersey, 1998).

Preziosi, D., *Rethinking Art History: Meditations on a Coy Science* (New Haven and London, 1989).

Preziosi, D., *The Art of Art History: A Critical Anthology* (Oxford and New York, 1998).

Rivers, P., *Evolution of Culture* (Oxford, 1906).

Vermeule, E., *Greece in the Bronze Age* (Chicago and London, 1972).

Warren, P. and Hankey, V., *Aegean Bronze Age Chronology* (Bristol, 1989).

Chapter 2. The Neolithic Period and the Prepalatial Early Bronze Age

Barber, E. J. W., *Prehistoric Textiles: The Development of Cloth in the Neolithic and Bronze Ages, with Special Reference to the Aegean* (Princeton, 1991).

Branigan, K., *Pre-Palatial. The Foundations of Palatial Crete: A Survey of Crete in the Early Bronze Age* (London, 1970).

Brea, L. B., *Poliochni, città preistorica nell'isola di Lemnos* (Rome, 1964–76).

Caskey, J., 'Excavations at Lerna' *Hesperia* 23 (1954), 3; 24 (1955), 25; 25 (1956), 147; 26 (1957), 142; 27 (1958), 125; 28 (1959), 202.

Caskey, M., 'Thoughts on Early Bronze Age Hearths' in Hägg, R. and Nordquist, G. (eds) *Celebrations of Death and Divinity in the Bronze Age Argolid* (Stockholm, 1990), 13-21.

Chourmouziadis, G. H., *To neolithiko Dimini* (Volos, 1979).

Davis, W., *Masking the Blow: The Scene of Representation in Late Prehistoric Egyptian Art* (Berkeley, 1992).

Demargne, P., 'Nécropoles de Mallia, les premiers charniers, l'ossuaire principier de Chrysolakkos, I' *Études crétoises* 7 (1945).

Dickinson, O., *The Aegean Bronze Age* (Cambridge, 1994).

Elia, R. J., 'A Study of the Neolithic Architecture of Thessaly, Greece' (Boston, 1982), unpublished Ph.D. dissertation.

Gesell, G. C., 'Town, Palace, and House Cult in Minoan Crete' *SIMA* 67 (Gothenburg, 1985).

Getz-Preziosi, P., *Early Cycladic Sculpture: An Introduction* (Malibu, 1985).

Gill, D. W. J. and Chippindale, C., 'Material and Intellectual Consequences of Esteem for Cycladic Figures' *AJA* 97 (1993), 601–59.

Hall, E., *Excavations in Eastern Crete, Sphoungaras*, University of Pennsylvania, the Museum Anthropological Publications 3/2 (Philadelphia, 1912).

Hawes, H. B., Williams, B. E., Seager, R. B., and Hall, E. H., *Gournia, Vasiliki and other Prehistoric Sites on the Isthmus of Hierapertra, Crete* (Philadelphia, 1908).

Hitchcock, L. A., 'Space, the Final Frontier: Chaos, Meaning, and Grammatology in Minoan Archi(text)ure' *Archaeological News* 22 (1997), 46–53, 134–42.

Hodder, I., *The Domestication of Europe* (Oxford, 1990).

Hood, S., 'Cyprus and the Early Bronze Age: Circular Tombs of Crete' *Proceedings of the Second Cypriological Congress* (Nicosia, 1985), 43–9.

Kitchell, K., 'The Mallia Wasp Pendant Reconsidered' *Antiquity* 55 (1981), 9–15.

Kokkinidou, D. and Nikolaidou, M., 'Body Imagery in the Aegean Neolithic: Ideological Implications of Anthropomorphic Figurines' in Scott, E. and Moore, J. (eds) *Invisible People and Processes: Writing Gender and Childhood into European Archaeology* (Leicester, 1997), 88–112.

Levi, D., 'La tomba a tholos di Kamilari presso Festòs' *Annuario* 39–40 (1961–2), 7–148.

Preziosi, D., *Minoan Architectural Design: Formation and Signification* (Berlin, 1983).

Renfrew, C. 'The Burnt House at Sitagroi' *Antiquity* 44 (1970), 131–4.

Renfrew, C., *The Cycladic Spirit: Masterpieces from the Nicholas P. Goulandris Collection* (New York, 1991).

Renfrew, C. and Bahn, P., *Archaeology: Theories, Methods, and Practice* (London, 1991).

Renfrew, C., Gimbutas, M., and Elster, E. (eds) *Excavations at Sitagroi* (Los Angeles, 1986), vol. 1.

Sanders, D. H., 'Behavioral Conventions and Archaeology: Methods for the Analysis of Ancient Architecture' in Kent, S. (ed.) *Domestic Architecture and the Use of Space* (Cambridge, 1990).

Seager, R. B., *Explorations in the Island of Mochlos* (Boston and New York, 1912).

Shanks, M. and Tilley, C., *Reconstructing Archaeology* (Cambridge, 1987).

Soles, J. S., 'The Prepalatial Cemeteries at Mochlos and Gournia and the House Tombs of Bronze Age Crete' *Hesperia Supplement* 24 (1992).

Tenwolde, C., 'Myrtos Revisited. The Role of Relative Function Ceramic Typologies in Bronze Age Settlement Analysis' *OJA* 11 (1992), 1–24.

Tsountas, C., *Ai Proiistorikai Akropolis Diminiou kai Sesklou* (Athens, 1908).

Warren, P., 'Myrtos: An Early Bronze Age Settlement in Crete' *BSA Suppl.* 7 (Oxford, 1972).

Whitelaw, T. M., 'The Settlement at Phournou Koryphi, Myrtos and Aspects of Early Minoan Social Organization' *Minoan Society* (Bristol, 1983), 323–45.

Whitelaw, T. M., 'The Early Minoan Household: Methods and Models for Analysis' *AJA* 98 (1994), 335–6.

Xanthoudides, S., *The Vaulted Tombs of the Mesara* (London, 1924).

Zois, A. A., 'Pour un schéma évolutif de l'architecture minoenne: A. Les fondations. Techniques et morphologie' in Treuill, R. and Dargue, P. (eds) *L'Habitat Égéen Préhistorique BCH* suppl. 19.

Chapter 3. The First Palace Period

Barber, R. L. N., *The Cyclades in the Bronze Age* (London, 1987).

Branigan, K., 'The Economic Role of the First Palaces' in Hägg, R. and Marinatos, N. (eds) *Function of the Minoan Palaces* (Stockholm, 1987), 245–9.

Branigan, K., 'Some Observations on State Formation in Crete' in French, E. B. and Wardle, K. A. (eds) *Problems in Greek Prehistory* (Bristol, 1988), 63–71.

Cadogan, G., *The Palaces of Minoan Crete* (London and New York, 1976).

Cameron, M. A. S., 'A General Study of Minoan Frescoes with Particular Reference to Unpublished Wall Paintings from Knossos' (Newcastle-upon-Tyne, 1975), unpublished Ph.D. dissertation.

Cameron, M. A. S., 'The "Palatial" Thematic System in the Knossos Murals' in Hägg, R. and Marinatos, N. (eds) *Function of the Minoan Palaces* (Stockholm, 1987), 320–8.

Cherry, J., 'Polities and Palaces: Some Problems in Minoan State Formation' in Renfrew, C. and Cherry, J. (eds) *Peer Polity Interaction and Socio-Political Change* (Cambridge, 1986), 19–45.

Davaras, C., *Guide to Cretan Antiquities* (Park Ridge, NJ, 1976).

Day, P. M., 'A Petrographic Approach to the Study of Pottery in Neopalatial East Crete' (Cambridge, 1991), unpublished Ph.D. dissertation.

Dickinson, O., *The Aegean Bronze Age* (Cambridge, 1994).

Driessen, J., 'An Early Destruction in the Mycenaean Palace at Knossos' *Acta Archaeologica Lovanensia Monographiae* 2 (Leuven, 1990).

van Effenterre, H., 'The Function of Monumentality In the Minoan Palaces' in Hägg, R. and Marinatos, N. (eds) *The Function of the Minoan Palaces* (Stockholm, 1987), 85–87.

Evans, A. J., 'Mycenaean Tree and Pillar Cult' *JHS* 21 (1901), 99–204.

Evans, A. J., *The Palace of Minos at Knossos* (London, 1921), vol. 1; (London, 1928), vol. 2; (London, 1930), vol. 3; (London, 1936), vol. 4.

Gesell, G. C., 'Town, Palace, and House Cult in Minoan Crete' *SIMA* 67 (Gothenburg, 1985).

Gesell, G. C., 'The Minoan Palace and Public Cult' in Hägg, R. and Marinatos, N. (eds) *The Function of the Minoan Palaces* (Stockholm, 1987) 123–8.

Graham, J. W., 'Windows, Recesses, and Piano Nobile in the Minoan Palaces' *AJA* 64 (1960), 329–33.

Graham, J. W., *The Palaces of Crete* (Princeton, 1987 [1962]).

Hägg, R., 'On the Reconstruction of the West Facade of the Palace at Knossos' in Hägg, R. and Marinatos, N. (eds) *Function of the Minoan Palaces* (Stockholm, 1987), 129–34.

Halstead, P. and **O'Shea, J.**, 'A Friend in Need is a Friend Indeed: Social Storage and the Origins of Social Ranking' in Renfrew, C. and Shennan, S. (eds) *Ranking, Resource, and Exchange* (Cambridge, 1982), 92–9.

Hawes, H. B., Williams, B. E., Seager, R. B., and **Hall, E. H.**, *Gournia, Vasiliki and Other Prehistoric Sites on the Isthmus of Hierapertra, Crete* (Philadelphia, 1908).

Hitchcock, L. A., 'Art and Ethnicity In Minoan Crete: A Near Eastern Perspective' (1997), paper presented at the American Schools of Oriental Research Annual Meeting, November 18–21.

Hitchcock, L. A., 'Fabricating Signification: An Analysis of the Spatial Relationships Between Room Types in Minoan Monumental Architecture', unpublished Ph.D. dissertation (Los Angeles, 1998).

Hitchcock, L. A. and **Preziosi, D.**, 'The Knossos Unexplored Mansion and the "Villa-Annex" Complex' in Hägg, R. (ed.) *The Function of the Minoan Villa* (Stockholm, 1997), 51–62.

Hood, S., 'Religion in Bronze Age Crete', paper presented at the 8th International Congress of Cretan Studies, September 9–14 (Herakleion, 1996), (typewritten).

Immerwahr, S. A., 'The People in the Frescoes' in Krzyszkowska, O. and Nixon, L. (eds) *Cambridge Colloquium on Minoan Society* (Bristol, 1983), 143–53.

Immerwahr, S. A., *Aegean Painting in the Bronze Age* (Philadelphia, 1989).

Kanta, A., 'Monastiraki in Myers, J. W., Myers, E. E., and Cadogan, G. (eds) *The Aerial Atlas of Ancient Crete* (Berkeley and Los Angeles, 1992), 194–7.

Krattenmaker, K., 'Minoan Architectural Representation' (Bryn Mawr, 1991), unpublished Ph.D. dissertation.

Levi, D., 'The Recent Excavations at Phaistos' *SIMA* (Gothenburg, 1965, trans. Aström, P. and Porter, J. (Lund, 1964)).

Levi, D., 'Festòs: metodo e criteri di un scavo archeologico' *Relazione svolta nella seduta ordinaria del 9 marzo 1968* (Rome, 1968).

Levi, D., 'Festòs e la civiltà minoica I' *Incunabula Graeca* 60 (Rome, 1976).

Levi, D., and **Carinci**, 'Festòs e la civiltà minoica II' *Incunabula Graeca* 70 (Rome, 1988).

MacGillivray, J. A., 'The Early History of the Palace at Knossos (MM I–II)' in Evely, D., Hughes-Brock, H. and Momigliano, N. (eds) *Knossos: A Labyrinth of History. Papers Presented in Honour of Sinclair Hood* (Oxford and Bloomington, Ind., 1994), 45–55.

Marinatos, N., 'Public Festivals in the West Courts of the Palaces' in Hägg, R. and Marinatos, N. (eds) *Function of the Minoan Palaces* (Stockholm, 1987), 135–43.

Marinatos, N., *Minoan Religion: Ritual, Image and Symbol* (Columbia, South Carolina, 1993).

Myres, J. L. 'Excavations at Palaikastro, II. The Sanctuary Site at Petsofa' *BSA* (1902–3), 356–87.

Niemeier, W.-D., 'On the Function of the Throne Room in the Palace at Knossos' in Hägg, R. and Marinatos, N. (eds) *Function of the Minoan Palaces* (Stockholm, 1987), 163–8.

Pernier, L., *Il palazzo minoico di Festòs: Scavi e studi della missione archeologica italiana a Creta dal 1900 al 1950* (Rome, 1935 and 1950).

Platon, N., *Zakros: The Discovery of a Lost Palace of Ancient Crete* (Amsterdam, 1985 [1971]).

Poursat, J.-C. and **Schmid, M.**, *Guide de Malia au temps des premiers palais: Le Quartier Mu* (Athens, 1992).

Preziosi, D., *Minoan Architectural Design: Formation and Signification* (Berlin, 1983).

Rutkowski, B., *Petsophas: A Cretan Peak Sanctuary* (Warsaw, 1991).

Schoep, I., '"Home Sweet Home": Some Comments on the So-Called House Models from the Prehellenic Aegean' *Op. Ath.* 20/13 (1994), 189–210.

Shaw, J. W., 'Minoan Architecture: Materials and Techniques' *Annuario* 49 (1971).

Soles, J. S., 'The Gournia Palace' *AJA* 95 (1991), 17–78.

Strasser, T., 'The Koulouras of Knossos and Phaistos' *AJA* 98 (1994), 306.

Strasser, T., 'Storage and States on Prehistoric Crete: The Function of the Koulouras in the First Minoan Palaces' *JMA* 10/1 (1998), 73–100.

Tsipopoulou, M., 'Ayia Photia Siteias: To neo evrima' in French, E. B. and Wardle, K. A. (eds) *Problems in Greek Prehistory* (Bristol, 1988), 31–47.

Tsipopoulou, M., 'Ayia Photia' in Myers, J. W., Myers, E. E., and Cadogan, G. (eds) *The Aerial Atlas of Ancient Crete* (Berkeley and Los Angeles, 1992), 66–9.

Watrous, L. V., 'Crete from Earliest Prehistory Through the Protopalatial Period' *AJA* 98 (1994), 695–753.

Watrous, L. V., 'The Cave Sanctuary of Zeus at Psychro: A Study of Extra-Urban Sanctuaries in Minoan and Early Iron Age Crete' *Aegaeum* 15 (1996).

Weingarten, J., 'The Sealing Structures of Minoan Crete: MM II Phaistos to the Destruction of the Palace of Knossos' *OJA* 5 (1986), 279–98.

Woolf, G., 'Beyond Romans and Natives' *World Archaeology* 28/3 (1997), 339–50.

Chapter 4. The Second Palace Period

Abramowitz, K., 'Frescoes from Ayia Irini, Keos. Part I' *Hesperia* 42:3 (1973), 284–300.

Abramowitz, K., 'Frescoes from Ayia Irini, Keos. Parts II-IV' *Hesperia* 49:1 (1980), 57–85.

Badawy, A., *Ancient Egyptian Architectural Design: A Study of the Harmonic System* (Berkeley and Los Angeles, 1965).

Barber, E. J. W., *Prehistoric Textiles: The Development of Cloth in the Neolithic and Bronze Ages, with Special Reference to the Aegean* (Princeton, 1991).

Begg, D. J. I., 'Minoan Storerooms in the Late Bronze Age' (Toronto, 1975), unpublished Ph.D. dissertation.

Begg, D. J. I., 'Continuity in the West Wing at Knossos' in Hägg, R. and Marinatos, N. (eds) *The Function of the Minoan Palaces* (Stockholm, 1987), 179–84.

Betancourt, P. P., 'The Trade Route for Ghyali Obsidian' *Aegaeum* 16 (1997), 171–6.

Betts, J., 'Notes on a Possible Minoan Forgery' *BSA* (1965), 203–6.

Betts, J., 'Some Early Forgeries: The Sangiorgi Group' *CMS* Suppl. 1 (1978), 17–35.

Bittel, K., *Hattusha: The Capital of the Hittites* (Oxford and New York, 1970).

Boardman, J., *The Cretan Collection in Oxford* (Oxford, 1961).

Cadogan, G., *The Palaces of Minoan Crete* (London and New York, 1976).

Cadogan, G., 'A Probable Shrine in the Country House at Pyrgos' in Hägg, R. and Marinatos, N. (eds) *Sanctuaries and Cults in the Aegean Bronze Age* (Stockholm, 1981), 169–71.

Cameron, M. A. S., 'A General Study of Minoan Frescoes with Particular Reference to Unpublished Wall Paintings from Knossos' (Newcastle-upon-Tyne, 1975), unpublished Ph.D. dissertation.

Caskey, J. L., 'Investigations in Keos, 1963' *Hesperia* 33 (1964), 314–31.

Caskey, M., 'Ayia Irini, Kea: The Terracotta Statues and the Cult in the Temple' in Hägg, R. and Marinatos, N. (eds) *Sanctuaries and Cults in the Aegean Bronze Age* (Gothenburg, 1981), 127–35.

Caskey, M., *Keos II: The Temple at Ayia Irini, Part I: The Statues* (Mayence. *Corpus der minoischen und mykenischen Siegel*, 1986).

Cummer, W. W., 'Itinerant Aegean Builders' *Temple University Aegean Symposium* 5 (1980), 3–7.

Cummer, W. W. and Schofield, E., *Keos III Ayia Irini: House A* (Mainz on Rhine, 1984).

Davaras, C., 'Architectural Elements of LM IB Villa of Makrygialos' *Proceedings of the 5th International Congress of Cretan Studies* (Herakleion, 1985), 77–92.

Davaras, C., 'Makrygialos' in Myers, J. W., Myers, E. E. and Cadogan, G. (eds) *The Aerial Atlas of Ancient Crete* (Berkeley and Los Angeles, 1992), 172–4.

Davaras, C., 'The "Cult-Villa" at Makrygialos' in Hägg, R. (ed.) *The Function of the Minoan Villa* (Stockholm, 1997), 117–35.

Davis, J. L., 'Cultural Innovation and the Minoan Thalassocracy at Ayia Irini, Keos' in Hägg, R. and Marinatos, N. (eds) *The Minoan Thalassocracy: myth and reality* (Stockholm, 1984), 159–66.

Doumas, C., *The Wall-Paintings of Thera* (Athens, 1992).

Driessen, J., 'The Minoan Hall in Domestic Architecture on Crete: to be in Vogue in Late Minoan IA?' *Acta archaeologica Lovanensia* 21 (1982), 27–92.

van Effenterre, H., 'The Function of Monumentality in the Minoan Palaces' in Hägg, R. and Marinatos, N. (eds) *The Function of the Minoan Palaces* (Stockholm, 1987), 85–7.

Evans, A. J., 'The Palace of Knossos: Provisional Report of the Excavations for the year 1901' (1900-1901) *BSA* 7:1–120.

Evans, A. J., 'Mycenaean Tree and Pillar Cult' *JHS* 21 (1901), 99–204.

Evans, A. J., *The Palace of Minos at Knossos* (London, 1928), vol. 2.

Evans, A. J., *The Palace of Minos at Knossos* (London, 1930), vol. 3.

Evans, A. J., *The Palace of Minos at Knossos* (London, 1936), vol. 4.

Forsdyke, J., 'The Harvester Vase' *Journal of the Warburg and Courtauld Institutes* 17 (1954), 1–9.

Frankfort, H., *The Art and Architecture of the Ancient Orient* (Harmondsworth, 1985 [1954]).

Gates, C., 'Rethinking the Building History of Grave Circle A at Mycenae' *AJA* 89 (1985), 263–74.

Georgiou, H., 'Minoan Coarse Wares and Minoan Technology' in Krzyszkowska, O. and Nixon, L. (eds) *Minoan Society: Proceedings of the Cambridge Colloquium, 1981*. (Bristol, 1983), 75–92.

Gesell, G. C., 'Town, Palace, and House Cult In Minoan Crete' *SIMA* 67 (Gothenburg, 1985).

Gesell, G. C., 'The Minoan Palace and Public Cult' in Hägg, R. and Marinatos, N. (eds) *The Function of the Minoan Palaces* (Stockholm, 1987), 123–8.

Graham, J. W., *Palaces of Crete* (Princeton, 1987 [1962]).

Hägg, R. and Marinatos, N., (eds) *The Minoan Thalassocracy: myth and reality* (Stockholm, 1984).

Halbherr, F., 'Scoperti Ad Haghia Triada presso Phaistos' *Monumenti Antichi* 13 (1903), 6–74.

Halbherr, F., Stefani, E., and Banti, L., 'Haghia Triada nel periodo tardo palaziale' *Annuario* 55 (1977), 14–296.

Hallager, B. P. and Hallager, E., 'The Knossian Bull—Political Propaganda in Neo-Palatial Crete?' *Aegaeum* 12 (1995), 547–56.

Hallager, E. (1985) 'The Master Impression,' *SIMA* 69, Gothenborg: Paul Åströms Förlag.

Hatzaki, E. M., 'Was the Little Palace at Knossos the 'little palace' at Knossos?' in Evely, D., Lemos, I. S. and Sherratt, S. (eds) *Minotaur and Centaur: Studies in the archaeology of Crete and Euboea presented to Marvin Popham* (Oxford, 1996), 34–45.

Higgins, R., *Minoan and Mycenaean Art* (New York and Toronto, 1981).

Hitchcock, L. A., 'The Minoan Hall System: Writing the Present Out of the Past' in Locock, M. (ed.) *Meaningful Architecture: Social Interpretations of Buildings. Worldwide Archaeology Series* (Aldershot, Hampshire, 1994), 14–43.

Hitchcock, L. A., 'Engendering Domination: A Structural and Contextual Analysis of Minoan Neopalatial Bronze Figurines' in Scott, E. and Moore, J. (eds) *Invisible People and Processes: Writing Gender and Childhood into European Archaeology* (Leicester, 1997a).

Hitchcock, L. A., 'Space, the Final Frontier: Chaos, Meaning, and Grammatology' in Minoan Archi(text)ure' *Archaeological News* vol. 22 (1997b), 46–53, 134–42.

Hitchcock, L. A., 'The Best Laid Plans Go Astray: Modular (Ir)regularities in Minoan Architecture' *Aegaeum* 16 (1997c), 243–50.

Hitchcock, L.A., 'Blending the Local with the Foreign: Minoan Features at Aya Irini, House A' in Mendoni, L.G. and Mazarakis Ainan, A.J. (eds) *Kea-Kythnos: History and Archaeology Proceedings of an Interested Symposium Kea-Kythnos 22–25 June 1994* (Athens, 1998), 169–174.

Hitchcock, L.A. 'It's a *Drag* to be a King' in Donald, M. and Hurcombe, L. (eds) *Gender and Material Culture: Representations of Gender from Prehistory to the Present* (London 1999).

Hitchcock, L.A. *Minoan Architecture: A Contextual Analaysis*, SIMA pocket-book 155 (forthcoming)

Hitchcock, L. A. and Preziosi, D., 'The Knossos Unexplored Mansion and the 'Villa-Annex' Complex' in Hägg, R. (ed.) *The Function of the Minoan Villa* (Stockholm, 1997), 51–62.

Hogarth, D. G., 'The Dictaean Cave' *BSA* 6 (1899–1901), 94–116.

Hood, S., *The Arts in Prehistoric Greece* (Harmondsworth and New York, 1978).

Hood, S., 'Religion in Bronze Age Crete', paper presented at the 8th International Congress of Cretan Studies, September 9–14 (Herakleion, 1996), (typewritten).

Hult, G., 'Bronze Age Ashlar Masonry in the Eastern Mediterranean' *SIMA* 66 (Gothenburg, 1983).

Immerwahr, S. A., *Aegean Painting In the Bronze Age* (Philadelphia, 1989).

Koehl, R., 'The Function of Aegean Rhyta' in Hägg, R. and Marinatos, N. (eds) *Sanctuaries and Cults in the Aegean Bronze Age* (Stockholm, 1981), 179–87.

Kopaka, C., 'Des pièces de repos dans l'habitat minoan du IIe millenaire avant J.-C?' in Treuill, P. and Darque, P. (eds) *L'Habitat Égéen Préhistorique BCH* Suppl. 19 (1990), 217–30.

Kramer, S. N., *The Sumerians* (Chicago, 1963).

Laffineur, R., 'Grave Circle A at Mycenae: Further reflections on its history' in Hägg, R. and Nordquist, G. C. (eds) *Celebrations of Death and Divinity in the Bronze Age Argolid* (Stockholm, 1990), 201–6.

La Rosa, V., 'Preliminary considerations of the problems of the relations between Phaistos and Haghia Triada' *Scripta Mediterranea* 6 (1985), 45–54.

Lembessi, A., and Muhly, P., 'Aspects of Minoan Cult. Sacred Enclosures. The Evidence from the Syme Sanctuary (Crete)' *Archaeologischer Anzeiger* 3 (1990), 315–36.

McCallum, L. R., 'Decorative Program in the Mycenaean Palace of Pylos: The Megaron Frescoes' (University of Pennsylvania, 1987), unpublished Ph.D. dissertation.

MacDonald, C. F. and Driessen, J. M., 'The Drainage System of the Domestic Quarter in the Palace at Knossos' *BSA* 83 (1988), 235–58.

MacDonald, C. F. and Driessen, J. M., 'The Storm Drains of the East Wing at Knossos' in Treuill, R. and Darque, P. (eds) *L'Habitat Égéen Préhistorique BCH* Suppl. 19 (1990), 141–6.

McEnroe, J., 'Minoan House and Town Arrangement' (Toronto, 1979), unpublished Ph.D. dissertation.

McEnroe, J., 'The Significance of Local Styles in Minoan Vernacular Architecture' in Treuill, R. and Darque, P. (eds) *L'Habitat Égéen Préhistorique BCH* Suppl. 19 (1990), 195–202.

MacGillivray, J. A., 'The Early History of the Palace at Knossos (MM I-II)' in Evely, D., Hughes-Brock, H. and Momigliano, N. (eds) *Knossos: A Labyrinth of History. Papers presented in honour of Sinclair Hood* (Oxford and Bloomington, 1994), 45–55.

MacGillivray, J. A. et al., 'Excavations at Palaikastro, 1987' *BSA* 83 (1988), 259–82.

MacGillivray, J. A. et al., 'Excavations at Palaikastro, 1988' *BSA* 84 (1989), 417–45.

Marinatos, N., *Art and Religion in Thera* (Athens, 1984).

Marinatos, N., 'Public Festivals in the West Courts of the Palaces' in Hägg, R. and Marinatos, N. (eds) *The Function of the Minoan Palaces* (Stockholm, 1987), 135–43.

Marinatos, N., *Minoan Religion: Ritual, Image and Symbol* (Columbia, South Carolina, 1993).

Michailidou, A., 'The Room with the Column in the Minoan House' *Amitos: Festschrift for Manolis Andronikos* (Thessaloniki, 1987) (in Greek).

Niemeier, W.-D., 'On the Function of the "Throne Room" in the Palace at Knossos' in Hägg, R. and Marinatos, N. (eds) *The Function of the Minoan Palaces* (Stockholm, 1987), 163–8.

Niemeier, W.-D., 'Cult scenes on gold rings from the Argolid' in Hägg, R. and Nordquist, G. C. (eds) *Celebrations of Death and Divinity in the Bronze Age Argolid* (Stockholm, 1990), 165–70.

Niemeier, W.-D., 'The "Priest King" Fresco from Knossos. A New Reconstruction and Interpretation' in French, E.B. and Wardle, K.A. (eds) *Problems in Greek Prehistory* (Bristol, 1988), 235–244.

Nilsson, M., *Minoan-Mycenaean Religion and its Survival in the Greek Religion* (2nd rev. edn, Lund, 1968 [1950]).

Oppenheim, A. L., *Ancient Mesopotamia: Portrait of a Dead Civilization* (Chicago and London, 1977 [1964]).

Palaima, T. G., 'Maritime Matters in the Linear B Tablets' *Aegaeum* 7 (1990), 273–309.

Palyvou, C., 'Circulatory Patterns in Minoan Architecture' in Hägg, R. and Marinatos, N. (eds) *The Function of the Minoan Palaces* (Stockholm, 1987), 195–203.

Palyvou, C., 'Akrotiri Thiros: oikodomiki techni kai morphologika stoicheia stin Ysterokykladiki architektoniki' ('Akrotiri, Thera: Building Techniques and Morphology in Late Cycladic Architecture') (Athens, 1988), unpublished Ph.D. dissertation.

Peatfield, A., 'Palace and Peak: The Political and Religious Relationship between Palaces and Peak Sanctuaries' in Hägg, R. and Marinatos, N. (eds) *The Function of the Minoan Palaces* (Stockholm, 1987) 89–93.

Pini, I., 'Echt oder falsch? – Einige Fälle' *CMS* Suppl. I (1978), 135–57.

Postgate, J. N., *Early Mesopotamia: Society and Economy at the Dawn of History* (London, 1992).

Preziosi, D., *Minoan Architectural Design: Formation and Signification* (Berlin, 1983).

Preziosi, D. and Hitchcock, L.A., 'Defining Function and Meaning in Minoan Architecture: New Evidence from the Villa at Makrigialos,' *AJA* 98 (1994)

Rehak, P., 'The Ritual Destruction of Minoan Art?' *Archaeological News* 19 (1994), 1–6.

Rehak, P., 'The Use and Destruction of Minoan Bull's Head Rhyta' in Laffineur, R. and Niemeier, W.-D. (eds) 'Politeia: Society and State in the Aegean Bronze Age' *Aegaeum* 12 (Liège and Austin, Tex., 1995), 435–60.

Rehak, P., 'Aegean Breechcloths, Kilts, and the Keftiu Paintings' *AJA* 100 (1996), 35–51.

Rehak, P., 'The Role of Religious Painting in the Function of the Minoan Villa: the case of Ayia Triadha' in Hägg, R. (ed.) *The Function of the Minoan Villa* (Stockholm, 1997), 163–75.

Sackett, H. and MacGillivray, S., 'Boyhood of a God' *Archaeology* 42.5 (1989), 26–31.

Sakellarakis, J., 'Zominthos' *Ergon* (1988), 165–72 (in Greek).

Schofield, E., 'The Western Cyclades and Crete: A "Special Relationship"' *OJA* (1982), 9–25.

Schofield, E., 'Coming to terms with Minoan colonists', in Hägg, R. and Marinatos, N. (eds) *The Minoan Thalassocracy: myth and reality* (Stockholm, 1984), 45–8.

Shaw, J. W., 'Minoan Architecture: Materials and Techniques' *Annuario* 49 (1971).

Shaw, J. W., 'Evidence for the Minoan Tripartite Shrine' *AJA* 82 (1978), 429–48.

Shaw, J. W., 'Excavations at Kommos 1984–1985' *Hesperia* 55 (1986), 219–69.

Shaw, J. W., 'Excavations in the Southern Area at Kommos, Crete, 1993' *AJA* 98 (1994), 305–6.

Strasser, T., 'The Blue Monkeys of the Aegean and their Implications for Bronze Age Trade', unpublished paper presented at the Archaeological Institute of America Annual Meeting, New York, December 1996.

Strasser, T., 'Horns of Consecration or Rooftop Granaries' *Aegaeum* 16 (1997), 201–207.

Tsipopoulou, M. and Papacostopoulou, A., '"Villas" and Villages in the Hinterland of Petras, Siteia' in Hägg, R. (ed.) *The Function of the Minoan Villa* (Stockholm, 1997), 203–14.

Ventris, M. and Chadwick, J., *Documents in Mycenaean Greek* (Cambridge, 1956).

Verlinden, C., 'Les statuettes anthropomorphes crétoises en bronze et en plomb, du IIIe millenaire au VIIe siècle av. J.-C.' *Archaeologia Transatlantica* 4 (Louvain-la-Neuve, 1984).

Warren, P., *Minoan Stone Vases* (Cambridge, 1969).

Warren, P., 'Of Baetyls' *Op. Ath.* 18/14 (1990), 193–206.

Watrous, L. V., 'Ayia Triada: A New Perspective on the Minoan Villa' *AJA* 88 (1984), 123–34.

Watrous, L. V., 'The Cave Sanctuary of Zeus at Psychro: A Study of Extra-Urban Sanctuaries in Minoan and Early Iron Age Crete' *Aegaeum* 15 (1996).

Wiener, M. H., 'Crete and the Cyclades in LM I: The tale of conical cups', in Hägg, R. and Marinatos, N. (eds) *The Minoan Thalassocracy: myth and reality* (Stockholm, 1984), 17–26.

Xanthoudides, S., *The Vaulted Tombs of the Mesara* (London, 1924).

Yiannouli, E., 'Reason in Architecture: the Component of Space. A Study of Domestic and Palatial Buildings in Bronze Age Greece' (Cambridge, 1992), unpublished Ph.D. dissertation.

Younger, J., 'Bronze Age Representations of Aegean Bull-Games III' *Aegaeum* 12 (1995), 507–46.

Younger, J., 'The Stelai of Mycenae Grave Circles A and B' *Aegaeum* 16 (1997), 225–39.

Chapter 5. Mycenaean Domination and the Minoan Tradition

Blegen, C. W. and Rawson, M., *The Palace of Nestor at Pylos I: The Buildings and Their Contents* (Princeton, 1966), (Part 1, Text; Part 2, Illustrations).

Blegen, C. W. and Rawson, M., *A Guide to the Palace of Nestor* (Cincinnati, 1967).

Cameron, M. A. S., 'The "Palatial" Thematic System in the Knossos Murals' in Hägg, R. and Marinatos, N. (eds) *Function of the Minoan Palaces* (Stockholm, 1987), 320–8.

Chadwick, J., *The Decipherment of Linear B* (Cambridge, 1958).

Collon, D., 'Bull-Leaping In Syria' *Ägypten und Levante: Internationale Zeitschrift für ägyptische Archäologie und deren Nachbargebiete* 4 (1994), 81–5.

Cook, E. *The Worlds of Homer* (Austin, Tx, forthcoming)

Crowley, J. L., 'The Aegean and the East: An Investigation into the Transference of Artistic Motifs between the Aegean, Egypt, and the Near East in the Bronze Age' *SIMA* Pocket-book 51 (Gothenburg, 1967).

Dabney, M. K. and Wright, J. C., 'Mortuary customs, palatial society and state formation in the Aegean area: A comparative study' in Hägg, R. and Nordquist, G. (eds) *Celebrations of Death and Divinity in the Argolid* (Stockholm, 1990), 45–53.

Darque, P., 'Pour l'abandon du terme "megaron"' in Treuill, R. and Darque, P. (eds) *L'Habitat Égéen Préhistorique BCH* Suppl. 19 (1990), 21–31.

Driessen, J. and MacDonald, C., 'The Troubled Island. Minoan Crete before and after the Santorini Eruption' *Aegaeum* 17 (1997).

Evans, A. J., 'Mycenaean Tree and Pillar Cult' *JHS* 21 (1901).

Evans, A. J., 'On a Minoan Bronze Group of a Galloping Bull and Acrobatic Figure from Crete,' *JHS* 41 (1921).

Gates, C., 'Rethinking the building History of Grave Circle A at Mycenae' *AJA* 89 (1985).

Graham, J. W., 'The Central Court as the Minoan Bull-Ring' *AJA* 61 (1957).

Hayden, B. J., 'Late Bronze Age Tylissos: House Plans and Cult Centers' *Expedition* 26/3 (1984), 37–46.

Hirsch, E. S., 'Painted Decoration on the Floors of Bronze Age Structures on Crete and the Greek Mainland' *SIMA* 53 (Gothenburg, 1977).

Hitchcock, L. A., 'Space, the Final Frontier: Chaos, Meaning, and Grammatology in Minoan Archi(text)ure' *Archaeological News* 22 (1997), 46–53, 134–42.

Hitchcock, L. A., 'Fabricating Signification: An Analysis of the Spatial Relationships Between Room Types in Minoan Monumental Architecture' (Los Angeles, 1998), unpublished Ph.D. dissertation.

Hitchcock, L. A., 'It's a *Drag* to be a King,' In Donald, M. and Hurcombe, L. (eds) *Gender and Material Culture: Representations of Gender from Prehistory to the Present* (London, 1999)

Iakovidis, S. E., 'Late Helladic Citadels on Mainland Greece' *Monumenta Graeca et Romana* 4 (Leiden, 1983).

Laffineur, R., 'Grave Circle A at Mycenae: Further reflections on its history' in Hägg, R. and Nordquist, G. (eds) *Celebrations of Death and Divinity in the Argolid* (Stockholm, 1990), 201–6.

Levi, D., 'La Tomba A Tholos di Kamilari Presso A Festos' *Annuario* 39–40 (1961–62).

McCallum, L. R., 'Decorative Program in the Mycenaean Palace of Pylos: The Megaron Frescoes' (Philadelphia, 1987), unpublished Ph.D. dissertation.

McEnroe, J., 'Minoan House and Town Arrangement' (Toronto, 1979), unpublished Ph.D. dissertation.

Marinatos, N., *Minoan Religion: Ritual, Image, and Symbol* (Columbia, South Carolina, 1993).

Mylonas, G. E., *Mycenae and the Mycenaean Age* (Princeton, 1966).

Nicgorsky, A., 'The Iconography of the Herakles Knot and its Use in the Hair of Some Hellenistic Statues' (Chapel Hill, 1995), unpublished Ph.D. dissertation.

Nilsson, M., *The Mycenaean Origin of Greek Mythology*, with an Introduction and Bibliography by Emily Vermeule (Berkeley and Los Angeles, 1972 [1932]).

Palaima, T. G. and Wright, J. C., 'Ins and Outs of the Archives Rooms at Pylos: Form and Function in a Mycenaean Palace' *AJA* 89 (1985), 251–62.

Preziosi, D., *Minoan Architectural Design: Formation and Signification* (Berlin, 1983).

Protonotariou-Deilaki, E. 'About the Gate of Mycenae' *AE* (1965), 7–26. (In Greek)

Renfrew, C., 'The Archaeology of Cult: The Sanctuary at Phylakopi' *BSA* Suppl. 18 (London, 1985).

Sandars, N. K., *The Sea Peoples: Warriors of the Ancient Mediterranean* (New York, 1985).

Schaar, K., 'Aegean house form: a reflection of cultural behavior' in Treuill, R. and Darque, P. (eds) *L'Habitat Égéen Préhistorique BCH* Suppl. 19 (1990), 173–82.

Schoep, I., '"Home Sweet Home": Some Comments on the So-Called House Models from the Prehellenic Aegean' *Op. Ath* 20.13 (1994).

Scoufopoulos, N. C., 'Mycenaean Citadels' *SIMA* 22 (Gothenburg, 1971).

Shaw, J. W., 'Minoan Architecture: Materials and Techniques' *Annuario* 49 (1971).

Shaw, J. W., 'Excavations at Kommos 1984–1985' *Hesperia* 55 (1986), 219–69.

Shelmerdine, C. W., 'The Perfume Industry of Mycenaean Pylos' *SIMA* pocket-book 34 (Gothenburg, 1985).

Ventris, M. and **Chadwick, J.**, *Documents in Mycenaean Greek* (Cambridge, 1956).

Wace, A. J. B., *Mycenae: An Archaeological History and Guide* (Princeton, 1949).

Wright, J. C. and **Dabney, M. K.**, 'Mortuary Customs, Palatial Society and State Formation' in Hägg, R. and Marinatos, N. (eds) *Death and Divinity in the Bronze Age Argolid* (Stockholm, 1990).

Younger, J., 'Bronze Age Representations of Aegean Bull-Games III' *Aegaeum* 12 (1995), 507–46.

Younger, J., 'The Stelai of Mycenae Grave Circles A and B' *Aegaeum* 16 (1997), 225–39.

Chapter 6. Conclusion

Bass, G., 'Oldest Known Shipwreck Reveals Splendors of the Bronze Age' *National Geographic* 172/6 (1987), 692–733.

Bass, G., 'Prolegomena to a Study of Maritime Traffic in Raw Materials to the Aegean During the Fourteenth and Thirteenth Centuries BC' *Aegaeum* 16 (1997), 153–70.

Caskey, M., 'Ayia Irini, Kea: The terracotta statues and the cult in the temple' in Hägg, R. and Marinatos, N. (eds) *Sanctuaries and Cults in the Aegean Bronze Age* (Sweden, 1981), 127–35.

Coldstream, J. N., *Geometric Greece* (London, 1977).

Collon, D., 'The Smiting God: A study of a bronze in the Pomerance Collection in New York' *Levant* 4 (1972), 111–34.

Collon, D., *First Impressions: Cylinder Seals in the Ancient Near East* (Chicago, 1987).

Collon, D., 'Bull-Leaping in Syria' *Ägypten und Levante: Internationale Zeitschrift für ägyptische Archäologie und deren Nachbargebiete* 4 (1994), 81–5.

Crowley, J. L., 'The Aegean and the East: An Investigation into the Transference of Artistic Motifs between the Aegean, Egypt, and the Near East In the Bronze Age' *SIMA* pocket-book 51 (Jonsered, Sweden, 1989).

Dothan, T., *The Philistines and their Material Culture* (New Haven, London, and Jerusalem, 1982).

Drews, R., *The Coming of the Greeks: Indo-European Conquests in the Aegean and the Near East* (Princeton, 1988).

Drews, R., *The End of the Bronze Age* (Princeton, 1993).

Gates, M. H., 'Mycenaean Art for a Levantine Market? The Ivory Lid from Minet el Beidha/Ugarit' *Aegaeum* 8 (1992), 77–84.

Gesell, G. C. 'Town, Palace, and House Cult in Minoan Crete' *SIMA* 67 (Gothenburg, 1985).

Gesell, G. and **Saupe, T.**, 'Methods Used in the Construction of Ceramic Objects from the Shrine of the Goddess with Up-Raised Hands at Kavousi' *Aegaeum* 16 (1997), 123–6.

Hult, G., 'Bronze Age Ashlar Masonry in the Eastern Mediterranean' *SIMA* 66 (Gothenburg, 1983).

Hutchinson, R. W., *Prehistoric Crete* (Harmondsworth, 1962).

Langdon, S., 'The Return of the Horse-Leader' *AJA* 93 (1989), 189–201.

Marinatos, N., *Minoan Religion: Ritual, Image and Symbol* (Columbia and South Carolina, 1993).

Morris, Sarah P., *Daidalos and the Origins of Greek Art* (Princeton, 1992).

Pollinger-Foster, K., *Aegean Faience of the Bronze Age* (New Haven and London, 1979).

Said, E. W., *Orientalism* (London, 1978).

Sandars, N. K., *The Sea Peoples: Warriors of the Ancient Mediterranean* (New York, 1985).

Ventris, M. and **Chadwick, J.**, *Documents in Mycenaean Greek* (Cambridge, 1956).

Watrous, L. V., 'The Cave Sanctuary of Zeus at Psychro: A Study of Extra-Urban Sanctuaries in Minoan and Early Iron Age Crete' *Aegaeum* 15 (1986).

Wood, M., *In Search of the Trojan War* (London and New York, 1985).

	Egypt	Crete	Cyclades	Mainland Greece
3000 BCE	**OLD KINGDOM**	**PREPALATIAL (EM I–III)** Houses: Vasiliki, Myrtos *Tholoi:* Mesara	**EARLY CYCLADIC** 'Frying pans' Marble figurines	**EARLY HELLADIC** House of the Tiles, Lerna
2000 BCE	**MIDDLE KINGDOM** Twelfth Dynasty 1991–1786 BCE Imported MM II pottery Hyksos invasion (?)	**PROTOPALATIAL (MM I–II)** Old Palaces: Knossos, Phaistos, Mallia Kamares ware Destruction of Old Palaces by earthquake (MM II/III)	**MIDDLE CYCLADIC** Minoan trade and settlements Settlement at Akrotiri on Thera	**MIDDLE HELLADIC** Arrival of Greeks (?) Minoan pottery
1700 BCE	**SECOND INTERMEDIATE PERIOD** Hyksos rule Tell el-Dab'a frescoes (?)	**NEOPALATIAL (MM IIIA–B)** New Palaces at Knossos and Phaistos begun Palatial style villas	Neopalatial building programme At Akrotiri on Thera	Grave Circle B, Mycenae
1600 BCE	**NEW KINGDOM** Eighteenth Dynasty 1570 BCE	**LATE MINOAN (LM IA)** Palace at Knossos rebuilt after earthquake	**LATE CYCLADIC** Height of Minoan influence Houses with paintings Thera volcano erupts	**LATE HELLADIC I** Grave Circle A, Mycenae
1500 BCE	*Keftiu* representations on Theban tombs	**LATE MINOAN (LM IB)** Floral/marine-style pottery		**LATE HELLADIC II** *Tholos* tombs
1450 BCE		Destruction of Minoan sites **LATE MINOAN (LM II)** Mycenaeans at Knossos (?) Warrior graves Palace style Late frescoes		**LATE HELLADIC IIB**
1400 BCE		**LATE MINOAN (LM IIIA)**	Mycenaeans in control	**LATE HELLADIC IIIA** Mycenaean palaces Expansion of Mycenaean trade to Levant
1375 BCE		Destruction of palace at Knossos, 1375 BCE Reoccupation of palace		
1300 BCE	Nineteenth Dynasty First raid of Sea Peoples	**LATE MINOAN (LM IIIB)**		**LATE HELLADIC IIIB** Fortification of citadels Great age of Mycenaean palaces and frescoes Burning of palaces
1200 BCE	Rameses III (1198–1166 BCE) Defeat of Sea Peoples	**LATE MINOAN (LM IIIC)**	Mycenaean diaspora	**LATE HELLADIC IIIC** Continued reoccupation of sites

Index

Oxford History of Art

Titles in the Oxford History of Art series are up-to-date, fully-illustrated introductions to a wide variety of subjects written by leading experts in their field. They will appear regularly, building into an interlocking and comprehensive series. Published titles are in bold.

WESTERN ART

Archaic and Classical Greek Art
Robin Osborne

Hellenistic and Early Roman Art
Mary Beard & John Henderson

Imperial Rome and Christian Triumph
Jaś Elsner

Early Medieval Art
Lawrence Nees

Late Medieval Art
Veronica Sekules

Art and Society in Italy 1350–1500
Evelyn Welch

Art and Society in Northern Europe 1350–1500
Susie Nash

Art and Society in Early Modern Europe 1500–1750
Nigel Llewellyn

Art in Europe 1700–1830
Matthew Craske

Art in Europe and the United States 1815–70
Ann Bermingham

Modern Art 1851–1929
Richard R. Brettell

Art 1920–1945

Art since 1945
David Hopkins

WESTERN ARCHITECTURE

Greek Architecture
David Small

Roman Architecture
Janet Delaine

Early Medieval Architecture
Roger Stalley

Late Medieval Architecture
Nicola Coldstream

European Architecture 1400–1600
Christy Anderson

European Architecture 1600–1750
Hilary Ballon

European Architecture 1750–1890
Barry Bergdoll

Modern Architecture 1890–1965
Alan Colquhoun

Contemporary Architecture
Anthony Vidler

Architecture in the United States
Dell Upton

WORLD ART

Aegean Art and Architecture
Donald Preziosi & Louise Hitchcock

Early Art and Architecture in Africa
Peter Garlake

African Art between Antiquity and the Modern World
John Picton

Contemporary African Art
Olu Oguibe

African-American Art
Sharon F. Patton

Nineteenth-Century American Art
Barbara Groseclose

Twentieth-Century American Art
Erika Doss

Australian Art
Andrew Sayers

Byzantine Art
Robin Cormack

Celtic Art

Art in China
Craig Clunas

East European Art
Jeremy Howard

Ancient Egyptian Art
Marianne Eaton-Krauss

Art in India
Partha Mitter

Art and Islam
Irene Bierman

Art in Japan
Karen Brock

Melanesian Art
Michael O'Hanlon

Latin American Art

Mesoamerican Art
Cecelia Klein

Native North American Art
Janet C. Berlo & Ruth B. Phillips

Palaeolithic Art

Polynesian and Micronesian Art
Adrienne Kaeppler

South-East Asian Art
John Guy

WESTERN DESIGN

Nineteenth-Century Design
Gillian Naylor

Twentieth-Century Design
Jonathan M. Woodham

Design in the United States
Jeffrey Meikle

Graphic Design

Industrial design

Fashion

Twentieth-Century Crafts

WESTERN SCULPTURE

Sculpture 1900–1945
Penelope Curtis

Sculpture Since 1945
Andrew Causey

PHOTOGRAPHY

The Photograph
Graham Clarke

Photography in the United States
Miles Orvell

Documentary Photography

Contemporary Photography

SPECIAL VOLUMES

Art and Film
Lynda Nead

Landscape and Western Art
Malcolm Andrews

Art and the New Technology

Art and Science

Art and Sexuality

Art Theory

The Art of Art History: A Critical Anthology
Donald Preziosi (ed.)

Portraiture
Shearer West

Women in Art